JOHN POPE-HENNESSY

ITALIAN GOTHIC SCULPTURE

PHAIDON

AN INTRODUCTION
TO ITALIAN SCULPTURE

BY

JOHN POPE-HENNESSY

PART I

ITALIAN GOTHIC SCULPTURE

PART II

ITALIAN RENAISSANCE SCULPTURE

PART III

*ITALIAN HIGH RENAISSANCE AND
BAROQUE SCULPTURE*

JOHN POPE-HENNESSY

Italian Gothic Sculpture

PHAIDON · LONDON AND NEW YORK

PHAIDON PRESS LIMITED, 5 CROMWELL PLACE, LONDON SW7

PUBLISHED IN THE UNITED STATES BY PHAIDON PUBLISHERS, INC
AND DISTRIBUTED BY PRAEGER PUBLISHERS, INC
III FOURTH AVENUE, NEW YORK, N.Y. 10003

FIRST PUBLISHED 1955
SECOND EDITION 1972

ISBN 0 7148 1465 2
LIBRARY OF CONGRESS CATALOG CARD NUMBER: 70-125304

MADE IN GREAT BRITAIN 1972
PRINTED AT THE CURWEN PRESS · PLAISTOW · LONDON E13

CONTENTS

ITALIAN GOTHIC SCULPTURE

FOREWORD TO THE SECOND EDITION

In presenting a second edition of *Italian Gothic Sculpture* I must admit at once that had I been writing it to-day I should have produced an altogether different book. Its scope would have been wider—it would have opened with Antelami's relief on S. Andrea at Vercelli, not with Nicola Pisano—and the sub-divisions of the text would have dealt with categories of sculpture not with individual artists. So strongly was I convinced of the superior advantages of the form adopted for the two succeeding volumes, that for a time I contemplated writing a new text with sections dealing, among much else, with the pulpit, the tomb, bronze doors and figure sculpture on façades. When, however, I revisited the monuments dealt with in the book, it seemed to me that the present text, in an amended form, should be preserved. A number of revisions or interpolations have been made, and the section on Giovanni Pisano is in large part new. In *Italian Renaissance Sculpture* and *Italian High Renaissance and Baroque Sculpture* not only is the text planned differently, but the notes are considerably fuller than those in the first edition of this book. An effort has been made to bring the notes up to the same standard as those in the two later volumes, and to extend the bibliographies. That this has been accomplished is due to the unstinting help of Dr. Miklos Boskovitz.

In the preface to the first edition I suggested that these books 'will have served their purpose if they are successful in inducing the art lover to consider sculpture *pari passu* with Italian painting, and in persuading students to devote some part of their energies to this rewarding and neglected field'. The suggestion that Italian sculpture is ignored, by either tourists or scholars, is no longer correct. As I have revised this book, forcing my way through sweaty crowds in the Bargello and jostled by sightseers at Pisa, it has been repeatedly impressed on me that people do now look at sculpture, and that by the law of averages some of them must look at it in an intelligent, perceptive way. So far as study is concerned, the additions to the bibliographies since 1955 speak for themselves. They include one monograph of the first quality, Richard and Trude Krautheimer's *Lorenzo Ghiberti*, which has greatly extended our knowledge of Ghiberti's work, and has necessitated some fundamental changes in the conclusions offered in the first edition of the present book. But for this volume, I should be tempted to look on the addiction of scholars to the monograph as one of the factors that have inhibited, or at least slowed down, the study of Italian art. Almost all the notable additions to the study of Italian Gothic sculpture in the last fifteen years have been analyses in depth of single works. Here pride of place belongs to the excellent catalogue of sculptures in the Museo dell'Opera del Duomo in Florence by Luisa Becherucci and Giulia Brunetti, which gives an exemplary account of Arnolfo di Cambio's sculptures from the façade of the Cathedral, Andrea Pisano's sculptures from the Campanile, and Tino di Camaino's sculptures from the Baptistry. On Nicola and Giovanni Pisano I may mention especially the articles of Antje Kosegarten and Max Seidel, which offer a new and fruitful approach to the work of the

Pisani, and on Maitani an admirable study by John White of the Orvieto reliefs. On Jacopo della Quercia I must instance particularly a careful examination of the Bologna doorway by James Breck, and on Florentine sculpture in the late fourteenth century some useful articles by Manfred Wundram. Dr. Carlo Del Bravo generously allowed me to consult the proofs of his then unpublished volume on fifteenth-century sculpture in Siena.

One or two substitutions have been made among the photographs, and four plates have been added, with the result that the external sculpture on the Baptistry at Pisa and Giovanni Pisano's monument of Margaret of Luxemburg are now included in the book. One of the defects in the first edition lay in the photographs of comparative material, many of which were so small as to be practically illegible. Wherever possible, the scale of the smaller illustrations has been enlarged.

JOHN POPE-HENNESSY

1971

ITALIAN GOTHIC SCULPTURE

SCULPTURE in Europe between the Middle Ages and the eighteenth century is generally divided into the five categories of Romanesque, Gothic, Renaissance, Mannerism and Baroque. The last three of these styles spring from the antique and originate in Italy. Romanesque and Gothic, on the other hand, reached Italy from northern Europe, and developed as hybrid styles in which the formal preconceptions of the North were reconciled with the innate classicism of Italian art.

The interaction of these forces can be traced from the early years of the twelfth century, when we find the sculptor Guglielmo at work upon reliefs for Modena Cathedral in which the influence of the antique coexists with that of Romanesque monuments in Aquitaine. In Parma after 1278 a more important artist, Antelami, can be observed applying to the problems of Italian sculpture lessons learned in Provence at Saint-Gilles and Saint-Trophime, and at Ferrara, on the Porta dei Mesi of the Cathedral, one of his followers, who was apparently familiar with the reliefs of Labours of the Months on the west front of Notre-Dame (1210–12), reveals his natural proclivities by carving his figures in greater depth and investing them with grave classicising heads (Fig. 3). On St. Mark's in Venice a rigidly classical tenth-century relief of Hercules is juxtaposed with a thirteenth-century derivative, whose distorted style is due to German influence. The same antithesis occurs at Pisa, where in the Baptistry (begun 1152) the east entrance is surrounded by Italo-Byzantine carvings (Fig. 2), while the pulpit carved by Guglielmo for the Cathedral (1162), now at Cagliari (Fig. 4), uses the idiom of Lombard and Provençal sculpture. Nowhere is this pattern of arbitrary contrast more strongly marked than in South Italy, where the tide of classicism reaches its high water mark at the court of the Emperor Frederick II (d. 1250) in the great proto-Renaissance busts at Capua. In South Italy, moreover, classical influence is affirmed in the cycle of pulpits which runs from the Salerno ambones in the last quarter of the twelfth century to the pulpit at Sessa Aurunca in the middle of the thirteenth, ambitious architectural designs embodying motifs from the antique.

By the middle of the thirteenth century most of the great French Gothic cathedrals had been built or planned. In Italy Gothic architecture makes its first appearance in the Cistercian foundations of Fossanova (end of the twelfth century) and San Galgano (beginning of the thirteenth century) as a constructional technique practised by French architects. For the earliest of the indigenous Italian Gothic churches, S. Andrea at Vercelli, built soon after 1219, Benedetto Antelami draws his inspiration from the Cathedral at Laon, and only towards the middle of the century, when the mendicant orders were establishing their churches through Tuscany and Umbria, does there emerge, in the Franciscan church of S. Francesco at Assisi and the Dominican church of S. Maria Novella in Florence, a native Gothic architectural style. From the outset the scope for sculpture in Italian Gothic churches was limited, with the result first that the scale of sculpture is habitually smaller than in France, and second that the

northern models on which Italian artists drew were transferred to altogether different settings from those for which they were conceived. This is the 'phénomène de rupture' analysed by Focillon. In Italy the gospel of Gothic was preached from pulpits not from tympana, and the unit of the sculptor's thinking was an autonomous, self-consistent work of art.

In the Middle Ages the term Italy denotes not a nation but an assembly of individual states each with its own cultural idiosyncrasies. A detailed knowledge of the changing political alliances of the Italian states in the late thirteenth and fourteenth centuries is not essential for an understanding of the development of Gothic sculptural style. It is important, however, to bear constantly in mind that throughout this period Naples was under Angevin control and therefore in a special sense was subject to French influence; that between 1309 and 1376 the Papacy was established at Avignon, and that in these years Rome, which had formed a focus of artistic activity in the last quarter of the thirteenth century, was not a factor to be reckoned with; that in Central Italy the Guelph state of Florence lay among the Ghibelline centres of Pisa, Siena and Arezzo, and that in the fourteenth century there was in general a greater degree of cultural interchange between these centres than between any one of them and Florence; and that control of North Italy was vested in four dominant states, Milan under the Visconti, Verona under the Scaligers, Padua under the Carrara, and the Republic of Venice. Despite these political divisions there persisted in the greater part of the peninsula a classical tradition far more pervasive and more strongly rooted than in the North. In medieval France the sculptural relics of the Roman occupation exercised an intermittent influence on style, and at Rheims classical forms were absorbed into the tissue of Gothic art. In Italy, on the other hand, the antique existed as a force in its own right, at first resisting and then tempering the new style which filtered southwards from beyond the Alps. For this reason Gothic in Italy evolved not as a dialect of French Gothic, but as an independent language with a syntax, grammar and vocabulary of its own. Gothic consequently covers a greater diversity of style in Italy than in the North, and individual artists made a greater contribution to its development. If Italy offers no complex of Gothic monumental sculpture that can be compared, in consistency and comprehensiveness, with Strasbourg or Amiens, in France there is no artistic personality whose features are as legible as those of Giovanni Pisano. Italian sculpture was the outcome of a personal, strongly defined will-to-form. It is sometimes claimed that the Renaissance in the North was, in its essentials, Gothic. The converse can also be maintained, that Gothic in Italy partakes of the nature of Renaissance art.

NICOLA PISANO

Nicola Pisano, the artist through whom Gothic sculpture was introduced in Tuscany, came from the South. Born probably in Apulia, where, under Frederick II, so many French architects had worked, he may have been trained in Campania in the same circle as Niccolò di Bartolommeo da Foggia, whose pulpit at Ravello, with its combination of proto-Renaissance heads and Gothic foliated capitals (Fig. 5), provides a parallel for the first major work

Nicola carved in Tuscany, the pulpit in the Baptistry at Pisa (Plate 1). The Pisa pulpit was completed in 1259, nine years after Guido da Como's pulpit at Pistoia, and in the context of Tuscan Romanesque the sculptural conceptions it exemplified must have seemed startlingly original. Whereas the Pistoia pulpit is rectangular, Nicola's pulpit is a hexagon supported by seven columns. The upper part is decorated not with strips of narrative, but with five large-scale narrative reliefs, which are separated from each other by clusters of three columns (a French motif which Nicola may have encountered for the first time in Apulia), and rests not on an architrave but on an archivolt with figurated spandrels ornamented at the angles with figure sculpture. Nowhere is the contrast with the Pistoia pulpit more striking than in these statuettes, for whereas the angle figures at Pistoia are clad in the flat linear drapery of Tuscan Romanesque, those of Nicola Pisano are draped in ample robes beneath which we can sense their forms. Even the lions which support three of the external columns of Nicola's pulpit are no longer the conventional lions of the pulpit at Pistoia, but are treated naturalistically, with strongly defined sinews and heavy manes.

The means by which Nicola attained the realism of the angle statuettes were, to a large extent, derived from the antique. His attitude towards antiquity, however, differed from that of Tuscan sculptors in the middle and first half of the thirteenth century, in that he aimed not at employing classical motifs to diversify the idiom of medieval sculpture, but at creating an authentic classicistic style. The Faith of the Pisa pulpit (Plate 4) is represented as a Roman matron, and in the heroic Strength (Plate 5) the treatment of the naked body implies a study of classical technique. When Nicola began work on the pulpit, this style must have been fully formed, and behind the pulpit there may lie decades of activity in southern Italy, probably in Campania, where a bust from Scala, dating from about 1240, offers, both in style and handling, a precedent for the Pisa statuettes. But whereas the Scala bust, like so much proto-Renaissance sculpture in South Italy, is in the nature of an academic reconstruction, Nicola, when we meet him in the pulpit, has developed from study of antiquity a new figurative language through which an individual sense of form and a personal attitude to narrative can be expressed.

The five reliefs are planned not as symbolic narrative, but as convincing renderings of real scenes. In four of the five scenes the figures are depicted (like the figures in classical sarcophagi) on a scale determined by the height of the relief, and only in the concluding scene of the Last Judgment is their size appreciably reduced. Guido da Como, when he carved the pulpit at Pistoia, must also have been acquainted with classical sarcophagi, but his reliefs reveal scant sympathy with Roman art; the simplified figures with which they are filled have more in common with the flattened forms of Early Christian ivories than with sarcophagus reliefs. For Nicola Pisano, on the other hand, as for the sculptors of antiquity, the art of sculpture was concerned principally with the rendering of the human form. All five of the pulpit reliefs contain references to the antique. In the Nativity (Plate 2) the reclining figure of the Virgin is related to Etruscan grave figures, and in the Adoration of the Magi (Plate 3) the

seated Virgin depends from the figure of Phaedra on a sarcophagus carved with the legend of Hippolytus in the Campo Santo (Fig. 6), while a bearded figure on the right of the Presentation in the Temple derives from a Greek vase relief. As they reach the pulpit the motifs adopted by Nicola acquire a new nobility and weight. Transformed into the Virgin of the Adoration of the Magi, the Phaedra exchanges her descriptive drapery for a robe resolved in heavy folds, and the vase figure in low relief introduced into the Presentation in the Temple is re-created with the heavy cutting we would expect had it appeared on a sarcophagus. The sense of volume which Nicola imparts to these and other figures has its corollary in his unceasing effort to produce a space illusion in the relief field. In the Nativity the Annunciation on the left and the Adoration of the Shepherds on the right have a spatial reference to the central scene, and in the Adoration of the Magi the figures are disposed across three carefully demarcated planes. Among the devices taken over from classical reliefs are the cornice of the Annunciation, and, in the Presentation in the Temple, an altar protruding from the relief plane. Yet for Nicola the depiction of space and the rendering of the human form are not ends in themselves, but are a means of enriching the human content and enhancing the expository value of the scenes that he portrays. That his carvings, despite their indebtedness to Roman art, avoid pastiche, is due to his powerful imagination, his unwavering seriousness, and his technical resource. The significance of these three factors can best be judged if we compare Nicola's pulpit with the pulpit by his pupil Fra Guglielmo in S. Giovanni Fuorcivitas at Pistoia (Fig. 7), where the influence of sarcophagus reliefs is no less marked, but the use of undercutting is more restricted, and the emotional repertory is more rudimentary.

So smoothly executed, so well equilibrated is the Pisa pulpit, that we might suppose it the last work of a great sculptor, but in terms of the development of style it marks no more than one stage on a journey of a more extensive and adventurous kind. Our evidence for the change which overtook Nicola's style on its completion is the more elaborate pulpit commissioned in 1265 for the Cathedral of Siena (Fig. 8). Octagonal in form, its upper section consists of seven narrative reliefs, and the clusters of three pillars which separate the reliefs of the earlier pulpit are replaced by figurated carvings. In the reliefs themselves the style remains predominantly classical (two of the nudes in the Last Judgment, for example, were inspired by a Roman sarcophagus now in the Museo dell'Opera del Duomo at Siena), but it is classicism that has been disrupted by the influence of French Gothic art. This is reflected both in the iconography of the reliefs and in their style. Whereas at Pisa the first scene is dominated by the prophetic Virgin of the Nativity, at Siena the scale of the figure is reduced and the pose takes on a more mellifluous character, as the Virgin looks down tenderly at the two women in the foreground who wash the Child. Similarly in the Adoration of the Magi the classical economy of the relief at Pisa is cast aside, and the bulk of the panel is occupied not by the scene of adoration but by extraneous incident. The Crucifixion (Plate 6) affords the clearest illustration of the means by which the compositions of the Pisa pulpit were, at Siena, brought into conformity with Gothic taste. In this scene the Christ retains its prominence,

but the fainting Virgin is represented with head in profile and arm hanging down, and her body forms a single unit with that of the woman at her side; the rhythmic pattern is completed by the complementary form of the St. John, no longer gazing at the Saviour on the Cross, but shown with his head resting on his hand like a figure in some French Gothic manuscript or ivory. The same ambivalence is found in the supports between the narrative reliefs. Gothic influences are particularly evident in the seventh of these, a Christ in Judgment, where the classical head of the Christ at Pisa is replaced by the smooth, feminine features of a Gothic Christ, and in the fifth, a Risen Christ, which is sometimes compared with the Beau Dieu at Amiens. The most pronouncedly Gothic of the carvings are the two groups of angels beside the Presentation and Last Judgment (Plate 10). In the figures on the archivolt (Plates 8, 9) a change of imagery follows from this change of style. The nude Hercules symbolizing Strength is replaced by a Gothic Virtue fully clad, and the Roman matron symbolizing Prudence by a princess with a Gothic scroll. The fact that the controlling mind in the Siena pulpit was that of a Cistercian from San Galgano may be accountable for its French-orientated style and iconography.

At Siena the members of Nicola's studio were more extensively employed than they had been at Pisa, and were allowed more latitude. Thus the parts of the pulpit where Gothic influences are most marked (the two supports with angels blowing trumpets) and those where they are least in evidence (the Liberal Arts grouped round the base of the central support) are manifestly by two different hands. There is a strong case for identifying the first and more Gothic of these artists with Nicola's son, Giovanni Pisano, and the second and less Gothic with his assistant Lapo. We know from documents that Nicola's principal assistant throughout the work was the Florentine Arnolfo di Cambio, and parts of the narrative reliefs can be identified, with a fair measure of confidence, as Arnolfo's. Typical of these are the crouching figures in the lower right-hand corner of the Crucifixion. But the Gothic impulse behind the pulpit, though most clearly apparent in the work of members of the studio, stems from Nicola and forms a new factor in his style. By 1260 French ivories and illuminated manuscripts must already have been circulating in some numbers in Tuscany, and these and drawings made from monumental sculptures at Rheims, Notre-Dame and Auxerre taken together formed a phrase-book of French Gothic art. For Nicola their expressive language opened up new creative possibilities, of which the first symptoms are apparent at Siena and the ultimate consequences are revealed a decade later in the fountain at Perugia.

The fountain (Fig. 9) was designed for the position it occupies today, mid-way between the Duomo and the Palazzo Comunale. A rhymed inscription commemorating its completion in 1278 mentions, in addition to Nicola and Giovanni Pisano, a certain Fra Bevegnate, 'hic operis structor', and it has sometimes been claimed that Fra Bevegnate was responsible for the main features of its design. In so far as these were determined by technical considerations, and by local tradition, this may have been so. But the polygonal form adopted for the fountain offered a problem not unlike that presented by the Pisa and Siena pulpits, and the sculpture

with which it is animated is based on the experience gained in these two works. Beneath, set on a flight of steps, is a twenty-five-sided basin, each face of which is decorated with two upright reliefs. At the angle between one pair of reliefs and the next are three spiral columns, evolved from the angle columns of the pulpit in the Pisa Baptistry. Within the basin are twenty-four external and thirty-four internal columns, supporting a smaller twelve-sided basin, which reverses the scheme of that below, the supports being carved with statuettes and the areas between them being left undecorated. From this there rises on a single stem a plain bronze basin, containing the main sculptural feature of the fountain, a bronze support with three female caryatids (Plate 11). Above this there must originally have been another smaller basin, but in the course of successive reconstructions of the fountain this has disappeared. Among the angle figures a classical statuette which personifies the city of Perugia closely recalls the Justice at Siena, while in the caryatids a motif which appears for the first time soon after 1270 in a holy-water basin at Pistoia, designed by Nicola and executed by his pupil Lapo, is revived and treated with new complexity. These figures, each represented with the left hand raised and the right set on the hip, communicate a sense of overpowering creative vitality.

By the mid-seventies, as the inscription on the fountain testifies, the composition of Nicola's studio had changed. Arnolfo di Cambio, the principal assistant on the pulpit at Siena, had left the workshop before the new commission was begun, and had been succeeded by Giovanni Pisano, who played a more prominent part in the new work than Arnolfo had played in the old. Attributionally the relation of father to son poses many problems. Sometimes the caryatids have been ascribed to Nicola Pisano, sometimes to Giovanni; sometimes the preponderant hand among the statuettes has been regarded as Nicola's, sometimes as Giovanni's; sometimes the bulk of the reliefs beneath has been credited to the older, sometimes to the younger, artist. Of one relief, that with two eagles, we can speak with confidence, since it bears the signature of Giovanni Pisano, and is carved with such individuality that its authorship could not be doubted even if it were unsigned. On twelve of the twenty-five sides of the base the fountain is decorated with representations of the Months, each illustrated in two upright carvings. Typical of them is Nicola's depiction of the month of February (Figs. 10–11), where one figure, that on the left, might derive directly from a French source, while the other is strongly classical. Elsewhere the influence of the reliefs of the Labours of the Months to the left of the entrance to the Baptistry at Pisa is very marked. In the four paired reliefs of the Liberal Arts, which are due to Giovanni Pisano, the style is more homogeneous and cosmopolitan. The carvings differ widely in quality, and were carried out in a short space of time, and even when they were unweathered must have been much inferior to the cogitated carvings of the pulpits. The fountain has, however, a double interest, first as a civic allegory, and second as an index to aspects of Nicola's personality of which we should otherwise be unaware. Just as the caryatids above the fountain are represented as peasant women carrying pitchers on their heads, so the Labours of the Months reveal a freedom and directness

that his earlier work would scarcely lead us to expect. Never could it have been predicted that the sculptor who created the formal, hieratic carvings of the Pisa pulpit would conceive these intimate, yet strangely solemn scenes.

More important because more revealing of Nicola's stature as an artist is a large-scale work, the external decoration of the Baptistry at Pisa (Fig. 1), on which he was engaged after the completion of the Siena pulpit and perhaps from a far earlier time. Whether we examine the confident arcading which he installed, the great busts that surmount it with their dual reference to Capua and Rheims, or the tabernacles over them each containing a colossal half-length figure set forward from the surface of the wall, we find ourselves confronted by a massive imagination of a wholly individual kind. The two heads from this complex that can be studied at close quarters in the Museo Nazionale at Pisa, and the more refined of the colossal figures which are now seen at eye level in the interior of the Baptistry, reveal Nicola as a master of direct expression, that ranges from the mute appeal of Christ in the Deesis group (Plate 12) to the impassive Virgin and Child above the entrance, Nicola's last and largest work.

GIOVANNI PISANO

Born about 1248, Giovanni Pisano was employed as a youth on the Siena pulpit and between 1270 and 1276, alone or in conjunction with his father, may have travelled or worked in France. Certainly if he did so, this fact would go far to explain his reliefs on the fountain at Perugia and certain of his later works, but the theory that he was familiar with northern monumental sculpture, probable as it is, has often been challenged and is not corroborated by firm evidence. Where Nicola Pisano's approach to Gothic style remains, even on the Perugia fountain, that of an innate classicist, Giovanni Pisano is first and foremost a Gothic sculptor, whose work is marked by greater independence and intensity than that of any other Italian Gothic artist.

At Perugia the unit of Nicola Pisano's thinking is the human figure seen in isolation, without reference to the adjacent figures or to the containing frame. In Giovanni Pisano's carvings, on the contrary, the relief surface is continuous and the figures are merged in a linear scheme whose flowing movement is consciously adjusted to the rectangular surround. His paired reliefs are planned as diptychs, of which one side complements the other in a visual as well as in a literary sense. In the register above, Nicola's statuettes are in the main posed frontally, while Giovanni's are turned in such a way that one figure is associated with the next. The difference between his and his father's statuettes is that between the figure conceived as a comma and the figure conceived as a full stop.

How far Giovanni was active in supervising the completion of the half-length figures in the tabernacles of the Baptistry at Pisa we cannot tell, but for one feature of the decoration he was undoubtedly responsible, the statues for the finials over the tabernacles housing the large figures. The finial figures were even more exposed than the large figures beneath them, and

B

in the form in which they are preserved today in the Muzeo Nazionale they represent only the concept in the sculptor's mind when they were carved. Shown in implied movement, they are not, like the carvings beneath, planned with a flat frontal plane, but are shown with the feet slightly withdrawn, the body curving outwards and the shoulders pulled back. Perhaps the most beautiful of them is a Saint, who pulls her robe across her body with her right hand, in such a way that it reveals the full play of the forms beneath (Plate 13). In this case the figure is based on a Hellenistic terracotta statuette (Fig. 12), and like the statuette is planned fully in the round, with side views that have the same validity and strength as the main view from the front. This and the other autograph finial figures have a key place in the story of the free-standing statue.

In abrogating the classical principles on which Nicola had based his style, Giovanni Pisano at the same time set aside the barrier which had impeded the development in Italy of a system of external plastic decoration like that of the great French cathedrals. The scheme that he evolved for the Cathedral at Siena is none the less strikingly different from any employed in France. A convenient comparison is with the Cathedral of Amiens, whose sculpture Giovanni may well have known. Here, as in so many other French cathedrals, the three porches of the west front contain the bulk of the sculptural decoration, and the statuary proper is set low on either side of the three doorways. In this position it is strictly ancillary to the architectural scheme. In the façade designed by Giovanni Pisano for Siena (Fig. 13), on the other hand, the doorways are free of figure sculpture, and the statuary is confined to the part of the façade above the level of the entrances, making its architectural effect not, as in France, through the sheer quantity of figures, but by the use of single statues to punctuate the structural design. Interesting as it is to speculate whether or not the façade sculpture at Siena was influenced by the west front at Amiens, the issue is to some extent an academic one, since the role played by sculpture on the two façades, and as a corollary the style of individual figures, is totally distinct. The fact that the Siena statues were isolated from each other, and set far above eye level, meant that they had in the first place to be pronouncedly recessive, and in the second place to be so clearly individualized that their significance was in no doubt.

In the external sculpture of the Pisa Baptistry it is the expressive content rather than the forms which prefigures the Siena statuary. The finest of them is the Evangelist St. John (Fig. 16); to pass from the pulpit to this great monolith is to close *Coriolanus* and to open *Lear*. But this figure, like its companions, is designed with a flat frontal plane, whereas at Siena head, arms, and drapery are thrust forwards from the wall. Like some of the figures at Pisa, the statues from Siena Cathedral have been removed from their original positions, and are shown under cover at eye level in the Museo dell'Opera del Duomo. The loss is greater at Siena than at Pisa, for on the façade as Giovanni Pisano conceived it a complex intellectual programme had its equivalent in a highly sophisticated visual scheme. When the figures are wrested from their context, their motivation is no longer evident. This is notably the case

with the Mary sister of Moses (Plate 15), where the distorted pose resulted from the fact that it was placed on the south flank of the Cathedral, with head turned towards the façade. The Sibyl (Plate 14) seems originally to have been balanced by a lost figure of Daniel to the left. Emotionally the figures make an even stronger impact than the Evangelists at Pisa. In none of the statues on the Baptistry is the characterization so vivid or complete as in the Siena Habakkuk, while in the Moses and Isaiah (Fig. 17) the suppressed emotional fervour seems to have permeated every detail of the forms. The poses used in certain of the figures are asymmetrical. The Mary sister of Moses, in which this tendency is most pronounced, is probably among the latest of the statues, whereas the Plato, flatter in treatment and posed frontally, is related to figures on the fountain at Perugia, and must be among the earliest. Also among the later statues is the Moses, where the rhetorical design has an authority that looks forward to Michelangelo. Standing before their architectural setting, the figures leant forward from the plane of the façade, and as they were originally placed, with the David and Solomon gazing at each other across the central archway, and the two pairs of the Daniel and Sibyl and the Moses and Joshua at the sides, flanked by the frontal figures of Plato and Habakkuk, they must have invested the architectural forms with a surface movement which has no equivalent in France.

In the career of Giovanni Pisano the Siena façade stands alone. Thereafter, if we seek to trace his evolution, we must do so mainly in smaller works, first in an ivory carving of the Virgin and Child with two Angels and two Passion scenes made for the high altar of Pisa Cathedral in 1298, of which the Virgin and Child survives at Pisa, and then on the pulpit in S. Andrea at Pistoia, on which he was engaged from 1297 till 1301 (Fig. 14). In form the Pistoia pulpit derives from the pulpit in the Baptistry at Pisa, but its effect is utterly dissimilar. The substitution of a Gothic arch for the trilobe arcading in the Pisa archivolt gives the whole scheme a new sense of ascent, and the angle figures are instinct with movement; their function is to deny and not to reinforce the architectural forms. In the archivolt one of the Sibyls (Plate 18), seated to the right, gazes back over her shoulder in a pose which recalls the Mary sister of Moses at Siena, while, above, the beautiful figure of a deacon (Plate 19) beside the entrance to the pulpit reveals the same calculated contrapposto as the Siena Habakkuk. Just as the Siena figures create an illusion of movement on the façade, so the angle carvings at Pistoia serve to link the narrative reliefs between them so that the sculptured decoration of the pulpit is fused into a rhythmic whole.

In Nicola's Pisa pulpit all the reliefs save the first are limited to a single scene, and in the only multiple narrative relief the three separate episodes of the Annunciation, the Annunciation to the Shepherds and the Nativity are so treated that each exists in its own space. At Pistoia (Plate 16) these three scenes are again combined, but the implications of the subject matter have been thought out afresh. The Virgin shrinks back as she listens incredulously to the angel's message, the head of the further shepherd gazes up in rapture at the angel who addresses him, and the Virgin in the centre, with head bowed, fondles the Child with her

left hand. Even St. Joseph, in the bottom left-hand corner, looks with ferocious concentration at the serving maids bathing the Child. Where Nicola's figures are erect, and adhere to the surface of the marble, Giovanni's protrude; the heads of the Virgin Annunciate and the Virgin of the Nativity in this scene indeed have the same relation to orthodox figures in relief that the Mary sister of Moses at Siena has to orthodox monumental statues. But whereas the plane of the Cathedral wall was an inescapable physical fact, the ground of the relief could be eliminated. It seems that even those areas which now read as flat marble surfaces, were covered with patterned *verre églomisé*, so that the effect was not of figures emerging from a marble ground, but of a filigree of carvings superimposed upon a surface which refracted light rather as does the gold background of an illumination.

Giovanni Pisano's powers as a designer emerge even more clearly from the third of the five marble reliefs, the Massacre of the Innocents (Plate 17). In Nicola Pisano's Massacre on the Siena pulpit the emphasis is predominantly vertical; in this it reflects the influence of sarcophagus reliefs (Plate 7). At Pistoia, on the other hand, there is a studious avoidance of verticality; the groups at the bottom form a continuous horizontal through the field, and the right arm of Herod establishes a diagonal across it on which the heads of the mother and the soldier in the centre fall. A proof of the transfiguring imagination of the artist is the addition of two new features to the scene, the spectators who protest at Herod's action and the women before the throne who plead for mercy with outstretched hands. This incomparable carving is perhaps the most sophisticated half-relief in marble before the Battle of the Centaurs of Michelangelo.

The last of the great Pisano pulpits, that in the Duomo at Pisa (Fig. 15), was commissioned from Giovanni Pisano in 1302 and was completed eight years later. It bears the same relation to the pulpit at Pistoia as does the Siena pulpit of Nicola Pisano to the pulpit in the Pisa Baptistry, first in that its form is more elaborate and second in that its quality is more unequal. At Pisa the hexagon of the Pistoia pulpit is changed into an octagon with two protruding sides, and since seven of the nine reliefs are curved our first impression is of a circle rather than of an octagon. The reason for the circular form was programmatic, but to judge from the seven curved reliefs the obligation to carve on a curved surface caused the sculptor continuous difficulty. Moreover the pulpit was a replacement for a twelfth-century pulpit which stood in the Cathedral. The earlier pulpit, which is now at Cagliari, also contained nine panels, with seventeen scenes arranged in superimposed strips; the first panel showed the Annunciation and Visitation at the top and the Nativity beneath, the second showed the Adoration of the Magi at the top and, beneath it, the Magi leaving Bethlehem, the third showed the Wrath of Herod with, beneath it, the Massacre of the Innocents, and the sixth showed the Last Supper with, beneath it, the Arrest of Christ. This method of narration in superimposed strips was taken over, no doubt with some reluctance, by Giovanni Pisano, with consequences that are clearly evident in the fourth relief (Plate 22), which contains four separate scenes, the Presentation in the Temple, Herod and the Magi, the Angel

warning the Holy Family to flee, and the Flight into Egypt. The height of the pulpit is very great, and for this reason Giovanni had recourse to a further innovation for which there is no parallel in any earlier work, that the buildings and figures are conceived in relation to the viewing point of the spectator not to the plane of the relief. Almost all the existing photographs of the reliefs are taken at eye level, and in this form the compositions read in a diffuse, inorganic way. But when they are inspected from the ground the reason for the visual distortions, especially in the two substantially autograph reliefs of the Presentation in the Temple and the Crucifixion, becomes self-evident, though there is an unfortunate dichotomy between the angled figures of the narrative reliefs and the intervening statuettes, all of which are fully vertical. Where the narrative reliefs traverse the same ground as at Pistoia, their qualitative level is debased. Elsewhere, as in the Passion scenes shown in the sixth relief, we are confronted with ideas of great expressiveness inadequately executed; and even in the parts for which Giovanni was himself responsible—the whole of the first relief with the Annunciation, Visitation and Birth of the Baptist, the figure of the Virgin in the Nativity, the groups of the Presentation in the Temple and Flight into Egypt in the fourth relief, and the Crucifixion— the style, by the standards of Pistoia, is static and restrained.

The true interest of the pulpit resides neither in the narrative reliefs nor in the angle carvings, but in the supports beneath. Carved with large-scale figures, these supports form the main novelty of the conception, and mark a retreat from the Gothic extremism of the Pistoia pulpit and the Siena façade. Two of them, the Prudence (Plate 21) and the Hercules, depend from classical originals, and though their style is not properly speaking classicistic, its composure and restraint seem also to have moderated the Gothic forms of the Ecclesia and the Christ (Plate 20). With these latter statues the sculptor's problem was to present a figure which formed an organic part of the structure of the pulpit as though it were divorced from its support. For this reason the head of Christ is slightly bent, creating the illusion that the figure stands forward of the column and is not part of the pier, and the figure of Ecclesia is treated in the same way; with the Christ two cherub heads contribute to the sense of spatial ambiguity, and with the Ecclesia the dove which pours divine wisdom in her ear conceals the relationship between her head and the adjacent capital. The condition to which these two figures aspire is represented by a free-standing work executed at the same time, the Madonna which presides at Padua over the altar of the Arena Chapel (Fig. 19). Once more the source of inspiration stems from France, but though the style is Gothic, it is a Gothic so far refined and classicized that there is no essential incongruity between the figure and the frescoes by Giotto among which it stands.

It is very seldom that a Gothic sculptor's work takes on a political complexion, but in the last years of his life Giovanni Pisano's does exactly that. The background is an alliance between Pisa and the Hohenstaufen Emperor Henry VII, which was negotiated in the summer of 1310. The Emperor reached Pisa by sea in March 1312, and his arrival was celebrated by a propaganda group over the Porta di San Ranieri of the Cathedral. Showing the Virgin and

Child with on one side a kneeling figure of Pisa inscribed with the words 'Virginis ancilla sum Pisa quieta sub illa' (I am Pisa, handmaid of the Virgin, tranquil under her protection) and on the other a figure of the Emperor with the words 'Imperat Henricus qui Christo fertur amicus' (There rules Henry, known as a friend to Christ), it originated in the mind of Burgundio del Tado, who had played so large a part in the planning of the pulpit inside the church. This group seems to have led to the commissioning of a still more important work. In the previous December the Emperor's wife, Margaret of Brabant, had died at Genoa, and one of the Emperor's actions during the two months he was in Pisa was to place a contract with Giovanni Pisano for her tomb. Disassembled in the late eighteenth century, the funerary monument of Margaret of Luxemburg is one of those mysterious masterpieces of which enough survives to whet the appetite but not to satisfy the curiosity. Set in the choir of the main Franciscan church in Genoa, S. Francesco di Castelletto, it was either a deep wall monument or a free standing tomb, which comprised figures of Virtues seemingly grouped round the bier, and above, probably in a lunette, a half-length figure of the Empress woken from sleep by two angels. This group is now in the Palazzo Bianco at Genoa (Plate 23). Its imagery is drawn from a group of French reliefs of the Awakening of the Virgin, of which the earliest is at Senlis. This does not imply, however, that the style in which the group is couched approximates more closely to Northern models than that of the Cathedral pulpit. On the contrary, Giovanni Pisano speaks in these three figures in a voice that is absolutely personal. The awakened Empress has an ease of movement that surpasses even the Ecclesia on the pulpit, and the angels supporting her act as a frame. If we compare it to the Presentation in the Temple on the pulpit, or to the women washing the Child Christ in the Nativity, we shall see the group as what it is, a consummate rendering in the round of a scheme with which the artist had previously experimented in relief. In this tranquil work the turbulent spirit of Giovanni Pisano at last attains repose.

ARNOLFO DI CAMBIO

The development of Arnolfo di Cambio follows a very different course. To trace his origins we must return in time to a work which was commissioned from Nicola Pisano after the completion of the pulpit in the Baptistry at Pisa and was finished in 1267, when the Siena pulpit had already been begun. This is the shrine of St. Dominic in S. Domenico Maggiore at Bologna (Fig. 18). In the form in which it was originally planned, the shrine was composed of a rectangular sarcophagus with a flat top surrounded by a heavy foliated cornice, resting on eight supports, six of them (representing the Archangels and the Cardinal Virtues) at the four corners and in the centre of the front and back, and two (each with three figures of acolytes) in the centre of the monument. The sarcophagus was decorated with six scenes from the legend of the Saint, two each on the front and back and one at either end, with statuettes of Saints at the four corners and figures of the Virgin and Child and the Redeemer in the centre of the front and back. While the caryatids were still in place and before the tomb had been

supplied with an elaborate Renaissance lid, the scheme, whereby the body of the Saint rested in a sarcophagus recounting the main scenes from his life, watched over by Saints and supported by acolytes, Archangels and Virtues, must have been worthy of one of the great shrines of Christendom.

Though he was responsible for the design of the Arca, Nicola Pisano intervened only spasmodically in its execution. The narrative reliefs are on a considerably smaller scale than the carvings of the Pisa pulpit, and fall into two groups which correspond with the main constructional phases of the monument. The first group consists of the two reliefs in front, which were executed largely by Lapo, the most classicizing of Nicola's pupils, with the assistance of Arnolfo di Cambio, while the second and later group comprises the reliefs on the back and sides which were executed by Arnolfo di Cambio with the assistance of Fra Guglielmo and another artist. In all six carvings the sculptors were allowed a large measure of freedom in the working out of detail. Lapo, an imitative artist, in the two scenes in front aims not at the assimilated classicism of the pulpit but at an academic reconstruction of the style of a sarcophagus, and it is only with the intervention of Arnolfo, in such details as the figure of the praying Saint in the first scene, that the reliefs take on a sudden overpowering reality. As Arnolfo's sphere of responsibility increases, in the carvings on the sides and back, the compositions are invested with the easy rhythms that spring from an instinctive sense of interval. The figures are inspired by greater urgency, and in those for which Arnolfo was himself responsible this is accompanied by a grasp of volume which is reflected in the rounded heads and the recessive drapery (Plate 24). In Arnolfo's contribution to the carvings of the Siena pulpit this grasp of volume becomes still more pronounced.

Possibly Arnolfo was responsible, before work began on the Arca of St. Dominic, for carving two capitals for Siena Cathedral, and probably he was engaged, after the completion of the Siena pulpit, on the busts over the arcading of the Pisa Baptistry. But he did not, like Giovanni Pisano, continue as a member of Nicola's studio, and instead, before 1276 and perhaps as early as 1272, entered the service of Charles of Anjou. Thereafter, for upwards of twenty years, Rome was the focus of his activity. In Rome the sculptural scene was monopolized by the Cosmati, from whose workshop there emerged the principal sepulchral monuments executed in the third quarter of the century. In the earlier of them, of which the Fieschi monument in S. Lorenzo fuori le mura is typical (Fig. 22), a classical sarcophagus is set in simple classicising ciborium, but soon after 1268, in Pietro di Oderisio's monument of Pope Clement IV at Viterbo, the ciborium is replaced by a Gothic canopy and the effigy itself takes on Northern character. This tomb type was taken over by Arnolfo in the monument of Pope Adrian V (d. 1276) (Fig. 23), also at Viterbo, where the importance of the architectural component is much enhanced and the effigy is more strongly carved. In the tomb of Pope Clement IV the sarcophagus is encrusted with the coloured tesserae that are so common a feature of works from the Cosmati studio, and this practice is taken over by Arnolfo in the Adrian V monument and in his later Roman tombs. None of these survives in its entirety, but

some impression of them can be gained from the surviving parts of the tomb of Cardinal Annibaldi della Molara (d. 1276) in St. John Lateran. Like the tomb of Pope Adrian V, the Annibaldi monument rested on a mosaic base, and was in this respect indistinguishable from the monuments of the Cosmati. The effigy, however, lay beneath curtains caught up on two pillars at the sides. The treatment of the figure and the bier-cloth were rapidly embodied in a Roman monumental tradition by Giovanni di Cosma in the Rodriguez and De Surdis monuments (1303) (Fig. 24). What was not assimilated by Roman sculptors is a frieze originally set behind the effigy showing six deacons assisting at the office for the dead (Plate 25, Fig. 21). Treated with the same sensibility and the same unerring sense of interval as those parts of the Arca of St. Dominic for which Arnolfo was responsible, it seems to have been inspired by drawings of French monumental sculpture, and has been related both to a relief of the legend of St. Honoré at Amiens and to the Porte St. Sixte at Rheims.

The full fruits of this union between two disparate traditions appear six years later in S. Domenico at Orvieto in the tomb of Cardinal de Braye (Fig. 25). Once more the tabernacle in which the tomb was set has been destroyed, though a number of pieces from the canopy are in the Museo dell'Opera del Duomo, but the two bottom registers survive to their full width, the lower with four inlaid rectangles and the upper with a system of arcading supported by spiral columns. The depth of the tomb was originally greater than it is now, and it must have appeared as a strongly conceived polychromatic architectural unit, in which figure sculpture played a secondary part. In practice the sculptures are confined to an upper zone, where the Cardinal is presented by his patron saint, St. Mark, to the Virgin and Child, and to the area of the effigy. In the majestic Virgin at Orvieto the incipient classicism of Arnolfo's earlier works is transformed into a truly classicistic style, and the figure, her robe drawn across her knee in tight folds, presides like an Agrippina above the tomb. Among the most beautiful figures in the monument are the two angels who draw back the curtains shielding the body of the Cardinal (Plates 26, 27). With the figure on the left the curtain is held free of the body, so that the volumes are clearly emphasized, while in that on the right, represented in movement and from behind, the muscular tension of the limbs beneath the drapery is portrayed with a confidence which can have resulted only from continuing study of the antique.

The sculptures of the De Braye monument were completed two years before Giovanni Pisano's statues for the Duomo at Siena were begun, and it is difficult, within the limits of a single style, to imagine a greater contrast than that between them. Had Arnolfo and not Giovanni Pisano received the commission for the Siena façade, its sculpture would certainly have had a very different character. And when, about 1296, Arnolfo was at length awarded a comparable commission, that for the façade of the Cathedral in Florence (Fig. 37), his project, in so far as it can now be reconstructed, diverged in every respect from Giovanni Pisano's. Where the portals of Siena Cathedral were left free of figure sculpture, the areas above the doorways of the Cathedral in Florence were the main sculptural focus of Arnolfo's

scheme; and where the single statues at Siena lent a sense of movement to the architecture, the figures of the Florentine façade were conceived as static units and for the most part were posed frontally. The role played by figure sculpture on the façade as a whole must have been profoundly classical, and in the individual figures Gothic forms are held in check by the sculptors' memories of Roman art. In this combination of the Gothic and the classical we are sometimes reminded of French prototypes of more than half a century before, like the statues of the Portail des Confesseurs at Chartres. Arnolfo may even have been acquainted at first hand with these sculptures, since the lunettes above the lateral doorways were filled with large tableaux vivants of the Nativity and the Dormition of the Virgin, which have no precedent in Tuscany but are related in composition to carvings at Chartres and elsewhere in the Île de France. Each scene was dominated by a figure of the Virgin filling almost the whole width of the lunette. For the Dormition Arnolfo devised, in the recumbent Virgin with the mourning figure of St. John crouched at her feet (Plate 28B), one of the most moving groups in Italian medieval art. Here the depth of feeling which had found expression in the clerics of the Annibaldi monument is proclaimed on an heroic scale. Heroic too is the Virgin of the Nativity (Plate 28A), raised on one elbow, with head turned towards the manger containing the Child Christ. The Virgin of Nicola Pisano's Nativity at Pisa must have been present in Arnolfo's mind when this figure was conceived, for though the pose has been reversed, Arnolfo remains faithful to Nicola even in details like the jagged folds of drapery by which the figure is weighed down. The bonds linking Arnolfo to Nicola and the gulf which divides him from Giovanni become still more apparent if we compare the Virgin and Child (Plate 29) which was set above the central doorway with the exactly contemporary Virgin of Giovanni Pisano in the Arena Chapel (Fig. 18). The latter, a standing figure with head in profile gazing intently at the Child, depends for its effect on the uninterrupted rhythm of its drapery. The former, a seated figure, makes its impact not by means of line, but through firm definition of the planes. Of Giovanni's intimacy there is not the smallest trace. Instead the Child is shown in benediction, and the Virgin, austere and challenging, looks out in front of her with the proud detachment with which the Virgin on the Pisa pulpit had greeted the adoring Magi half a century before.

TINO DI CAMAINO

When Arnolfo di Cambio died, in or before 1310, he left behind him no major follower; Giovanni Pisano, on the other hand, stands at the head of a long line of sculptors which extends throughout the first half of the fourteenth century. The most gifted of these was Tino di Camaino. A native of Siena, Tino belonged to the generation of Simone Martini and Pietro Lorenzetti, and his work has a smoothness and fluency of handling that is reminiscent of their paintings. Reflective and lyrical, his style, as it developed, relied increasingly on line for its appeal. Tino di Camaino bears to Arnolfo the same relationship that the brothers Lorenzetti bear to Giotto, in that his block-like style conceals a fundamental

unawareness of the three-dimensional significance of the forms which he describes. The difference between the work of Tino and the Lorenzetti on the one hand and Arnolfo and Giotto on the other is that between limited and unrestricted plasticity.

The Emperor Henry VII died in August 1313, and in 1315 his tomb in Pisa Cathedral was commissioned not from Giovanni Pisano, who had moved from Pisa to Siena a year earlier and died about this time, but from the new Capomaestro of the Cathedral, Tino di Camaino. Like Giovanni Pisano's tomb of Margaret of Luxemburg, Tino di Camaino's monument of the Emperor Henry VII has been in large part destroyed, but we know from those parts which survive that the effigy rested on a sarcophagus carved with small figures in relief and that above it in a second register was a seated figure of the Emperor with four counsellors. Though the imagery has nothing in common with that of the tomb of Margaret of Luxemburg, it too was a figure-dominated monument. With the tomb of Cardinal Petroni in Siena Cathedral (1318), we reach a monument which is preserved in its intended form (Fig. 26). The contrast with Arnolfo's De Braye tomb is very marked. Architecture plays a secondary role; indeed it is only in the tabernacle at the top that we are aware of any specifically architectural element. The effigy of Cardinal Petroni (Plate 31) registers not as a strongly tactile figure, but as a linear silhouette, and the curtains held against the figures of the angels and merging with their drapery are not used to enhance the effect of recession in the centre of the monument. Below, the tomb rests on four slender caryatids of the Virtues, which invest the whole design with a sense of lightness and buoyancy, and above is a deep platform carved with three reliefs separated by statuettes. As a narrative artist Tino di Camaino stands at the opposite pole to Giovanni Pisano; the tempestuous emotions of the Pistoia pulpit never disturb his placid consciousness. Instead his scenes (Plate 30) are reduced to their essentials, and portrayed with rapt sincerity and compelling seriousness. Tino's main contribution to Italian sculpture lies in the field of the sepulchral monument. Not only is the figure sculpture of the Petroni tomb inspired by a poetic imagination that is highly individual, but it is realized with a consistency of style that makes this one of the greatest Italian monuments.

Tino's appointment as Capomaestro of Siena Cathedral seems to have ended in 1320, and from 1321 till 1323 he was at work in Florence. The main surviving relics of these years are disassembled fragments of two further tombs, those of Gastone della Torre, Patriarch of Aquileia, and Antonio Orso, Bishop of Florence, and parts of a Baptism of Christ which originally stood above the entrance to the Baptistry. The Orso monument pursues to its logical conclusion the style of the Siena tomb. In one of the caryatids the neck and the bowed head form a continuous horizontal line with the left shoulder, as though the figure were weighed down by the sarcophagus; another raises her cloak as if to dance. This linear emphasis extends to the Virgin and Child above (Plate 32), which formed the visual climax of the monument. In time and style this group stands midway between the Vico l'Abate Madonna of Ambrogio Lorenzetti and the Carmelite Madonna of his brother Pietro. An

innovation is the seated figure of the Bishop (Plate 33), which replaces the recumbent effigy of the Petroni tomb. In the confident delineation of the head, devoid of all naturalistic detail, and the smooth handling of the embroidered chasuble, the figure shows its kinship with the Siena effigy. Yet here again the scheme is, in a linear sense, more highly organized, and the serene statue of the Bishop, his nerveless hands crossed on his breast and his eyes closed in death, is one of the most memorable images in trecento art.

The splendid heads of Christ and the Baptist from the baptismal group and two heads of Virtues which are all that survive of the sculptures from the Baptistry suggest that Tino di Camaino, had he remained in Tuscany, would have developed into a great large-scale sculptor. Instead in 1323 or 1324 he received a summons to Naples, and the remainder of his life was spent in the service of the Angevin court. Despite the presence of Tuscan artists, with Simone Martini (1317–20) and Giotto (1329–33) at their head, the aesthetic atmosphere of Naples was more relaxed than that of Tuscany, and it seems to have been prejudicial to Tino's art. The monuments he undertook in Naples are tabernacle tombs, free-standing or set against the wall, and all of them are marked by the subordination of the figure sculpture to an architectural scheme and by dependence on polychromy in the form of gilding on the figures and Cosmatesque inlay in the ground. None of them achieves the richness or unity of the Petroni monument. We know that one, the tomb of Mary of Hungary, was planned by a Neapolitan architect, and the same architect may also have been responsible for the structure of Tino's first work in Naples, the tomb of Catherine of Austria in S. Lorenzo Maggiore. Imperfect as a work of art, the tomb of Catherine of Austria none the less includes some of the most successful sculpture Tino carried out in Naples, and the beautiful group representing Charity (Plate 34), if it lacks the vitality of the Orso caryatids, reaches a high level of decorative accomplishment. Particularly beautiful is the device by which the entire support is carved with foliage, and the figures emerging from it are depicted in deep relief. This caryatid has no counterpart in Tino's later works in Naples, and the few figures of comparable quality, such as the well-articulated Charity and Hope which support the monu-ment of Mary of Valois in S. Chiara (Plate 35, Fig. 28), are less enterprising and original. So seductive is the softness of these sculptures that we are hardly conscious of the sacrifice by which their tranquil, smoothly flowing forms have been attained. Yet when we compare the tired Madonna at Cava dei Tirreni with the energetic group above the Orso monument, or the flaccid surface of the Stigmatization of St. Francis above the tomb of Catherine of Austria with the tactile forms of the Noli Me Tangere at Siena, it seems that Tino, of the effort of self-adaptation to the enervating climate of court art, has abrogated much in the essential character of Tuscan sculpture.

Tino di Camaino died in 1337, but his style remained an active force for many years after his death, and his tombs had a decisive influence on later Neapolitan sepulchral monuments. The most notable of these is the tomb of King Robert of Anjou in S. Chiara (Fig. 32), exe-cuted by two Tuscan sculptors, Giovanni and Pacio da Firenze, about 1345. This tomb has

as its model the Mary of Hungary monument of Tino, and it is from this work that the pigmented sarcophagus, with its seated figures beneath Gothic canopies, the angels drawing curtains (Plate 36) and the figurated lunette derive. Yet its pedestrian figure sculpture is strikingly deficient in linear sense, as though the two artists, whose style must have been formed in Florence and not at Pisa or Siena, found Tino's spirit more elusive than his forms. A prototype by Tino (in this case the sarcophagus of the Charles of Calabria monument in S. Chiara, where figures in low relief are set on a dark marble ground) also dictated the idiom of a cycle of Scenes from the Legend of St. Catherine of Alexandria carved by the same sculptors for S. Chiara (Plate 37). Here, however, the treatment is more personal, and we may be confident that in the hands of Tino these little scenes would have lost in narrative compulsion what they might have gained in mellifluousness of form. The persistence of Tino's influence in Naples in the last half of the century is due to innate conservatism as much as to the strength of the sculptor's personality. As late as the seventies and eighties of the century anonymous sculptors were filling the churches of Naples with Tinesque tombs and tomb slabs, distinguished by their lack both of linear appeal and of three-dimensional significance, and it is not till 1428, more than a century after Tino had arrived in Naples, that the tomb of King Ladislaus in S. Giovanni a Carbonara marks the eclipse of the Angevin sepulchral monument.

AGOSTINO DI GIOVANNI AND GIOVANNI DI AGOSTINO

In Siena the influence of Tino was more fruitful if less long-lived. Initially it is apparent in the work of Agostino di Giovanni and Agnolo di Ventura, who were probably active in Siena while Tino was Capomaestro of the Cathedral and who were working in Volterra while he was engaged in Florence on the Orso and Della Torre monuments. Their principal surviving work, the Tarlati monument in the Duomo at Arezzo (Fig. 27), was executed in the same bracket of years as the Mary of Valois monument in Naples. But whereas the Mary of Valois monument has its place in the context of court art, the Tarlati monument belongs in the democratic tradition of Tuscan sculpture. Lacking the refinement and elegance of Tino's tomb, it celebrates in simple, graphic style Tarlati's administration of Arezzo, and as a civic record stands beside the Buon Governo frescoes of Ambrogio Lorenzetti in the Sienese Palazzo Pubblico. Its style, too, has affinities with the Lorenzetti, especially in the beautiful relief of the funeral of Tarlati (Plate 38), where a unified linear design is successfully imposed upon the stolid forms. In the work of Agostino di Giovanni's son, Giovanni, these Lorenzettian elements are much reduced, and in the reliefs of the Baptismal Font in S. Maria della Pieve at Arezzo (1333) the father's weighty forms give way to a lyrical style which is reminiscent of painters in the following of Simone Martini. Despite its rather rudimentary technique, the scene of the Young Baptist entering the Wilderness (Plate 39) on the Arezzo font is one of the few carvings of its time which communicates something of the rapture of Simone's frescoes and predella panels. The third of this trinity of sculptors, Goro di Gregorio, is an

artist on a smaller scale. His best-known work, the Arca di San Cerbone at Massa Marittima
(1324), contains a number of narrative scenes in which the predominantly decorative treat-
ment recalls contemporary metalwork rather than sculpture.

A more substantial artist is Gano da Siena (d. 1318?), who carved two monuments at
Casole d'Elsa, the later of them, with the standing full-length figure of Ranieri del Porrina
beneath a tabernacle, unique in the Tuscan sculpture of its time. The sculptor of this incon-
gruously realistic figure seems to have had contacts with North Italy, and a group of the
Virgin and Child between SS. Imerio and Omobono on the façade of the Cathedral at
Cremona is also by his hand.

LORENZO MAITANI

In 1288, when Giovanni Pisano was at work on the Siena façade, there returned to Siena a
native sculptor, Ramo di Paganello, who had worked in the North, probably in France.
Five years later Ramo di Paganello's name occurs once more at Orvieto, and in 1314 he
preceded Tino di Camaino to Naples. No documented work by him survives but he may
well have been responsible for the tomb of Philippe de Courtenay in the Lower Church at
Assisi (Fig. 29), where the seated figure on the left is based on a figure of Solomon at Auxerre.
Ramo di Paganello has also been connected conjecturally with the greatest single project
undertaken by Sienese sculptors in the first half of the fourteenth century, the decoration of
the façade of Orvieto Cathedral, and though his work for the Cathedral cannot be isolated,
it may well have exercised some influence on the sculptural style of the architect of the
façade, Lorenzo Maitani.

Maitani is one of the most baffling artists of the fourteenth century. Summoned to Orvieto
from Siena in 1308 to repair the structure of the church, he became Capomaestro in 1310
and held this post until his death in 1330. Two drawings by Maitani for the façade of the
Cathedral contain faint indications of sculpture, but the only sculpture on the façade for
which his direct responsibility can be proved from documents is one of four bronze symbols
of the Evangelists. Maitani's magnificent design for the façade (Fig. 30) has its origin in
Giovanni Pisano's façade of Siena Cathedral, and the Symbols of the Evangelists of Giovanni
Pisano likewise provided a point of departure for the Symbols of the Evangelists at Orvieto.
No more than a point of departure, however, for at Orvieto the Symbols are of bronze, while
the lunette above the central doorway, which had been left vacant by Giovanni Pisano, is
filled with a marble Virgin and Child beneath a canopy with three bronze angels on either
side (Fig. 31). Another innovation occurs in the reliefs below. At Siena the central doorway
is framed by massive columns and the piers flanking the outer doorways are recessed. At
Orvieto, on the other hand, the four piers protrude, and their flat surfaces are covered with
reliefs.

Umbria, unlike Tuscany, possessed a long-standing tradition of bronze casting, and the
bronze sculptures of Maitani form one link in a chain which descends from the caryatids of

the fountain at Perugia and the lion and gryphon on the Palazzo Comunale. Whereas Giovanni Pisano's figures are confined within their marble blocks, Maitani's make use of open poses which could not have been arrived at in any other medium than bronze. Thus the angels beside the Virgin (Plate 40) stand in profile with arms and wings extended and legs apart. The types of these figures, with long, straight noses and wavy hair, and drapery drawn tightly in cursive folds over a thin skeleton, recur in the reliefs beneath. The Virgin and Child under the canopy (Plate 41) approaches more closely than the Virgins of Giovanni Pisano to the norm of Northern Gothic sculpture, and the unknown sculptor of this work must have adopted as his model some French prototype in wood or ivory.

In his decision to cover the wall surfaces beside the doorways with reliefs, Maitani seems to have recalled an Umbrian Romanesque tradition, exemplified by S. Pietro at Spoleto, where the façade is treated in somewhat the same way. There is no precedent, however, for the reliefs that he produced, whereby a substantial area of wall surface is covered with super-imposed horizontal strips of carving. In all four piers the upper reliefs are unfinished, and it must for this reason be assumed that they were erected simultaneously and were carved in the lifetime and under the supervision of Maitani. None the less they fall into two groups, one of which, comprising the two outer piers, is closely associable in style with the bronze sculptures, and therefore with Maitani (Figs. 33, 36), while the other, comprising the inner piers, though executed in the same workshop, seems to reflect a different mind (Figs. 34, 35). The sculptor of the inner piers seems to have studied the work of Giovanni Pisano, for his fine Visitation (Plate 42) depends from the pulpit in Pisa Cathedral. But his feeling for the relief surface is less plastic than Giovanni's, and the small figures, widely spaced and relatively lightly carved, read as figurated islands in a flat decorative expanse. The best of the reliefs are the lower carvings on the outer piers, where the types of the bronze angels are found again. Unity is obtained in these pilasters by a vine rising from the base of the relief and subdividing it into wide oblong fields. In the second and third pilasters the vine is replaced by a Tree of Jesse employed conventionally so that it creates a number of circular medallions on each side of the central stem. This use of foliage to break up the relief surface depends in the last resort from late antique reliefs, but at Orvieto the foliage is treated in the spirit of Northern Gothic art, and the vine tendrils and leaves have a freshness and fluency like that of the carving on French Gothic capitals. On all four piers the scenes are treated as a frieze strung out across a single plane, and save to a limited extent in the Last Judgment are not designed in depth. Whereas the Master of the Visitation is staid and classical, the sculptures of Maitani are conceived mainly in terms of line (Plates 43, 44). Until we reach the Last Judgment on the fourth pilaster, the reliefs are without urgency or tension, lyrical fantasies with the pellucid texture of a fairy tale. No other Italian Gothic carvings ring the same note of beguiling innocence as these enchanting scenes. But with the final cycle of reliefs this calm is suddenly dispelled, and in the two carvings at the base, one on the left showing the resurrection of the body and the other on the right the damned (Plate 45), Maitani, with the

delicacy and precision of an ivory carver, translates into the language of small sculpture the monumental Last Judgments that are some of the supreme achievements of Northern Gothic art. We might expect that the author of these carvings would have exercised considerable influence, but his style was confined to Orvieto, and the only works apart from the Cathedral sculptures than can be ascribed to him are a handful of wooden figures of Orvietan origin. None the less there is a possibility that Maitani's was among the influences that went to the formation of the greatest sculptor active in Tuscany in the second quarter of the century, Andrea Pisano.

ANDREA PISANO

The name of Andrea Pisano is mainly associated with the first bronze door of the Baptistry in Florence (Fig. 39), and we hear of him for the first time in 1330 in connection with this work. A decade or so younger than Tino di Camaino, he seems to have been trained in Pisa. Ghiberti tells us that in his day 'moltissime cose' by Andrea existed in S. Maria della Spina, and these may have been early works, made under the shadow of the late sculptures of Giovanni Pisano. When we encounter him on the bronze door, however, Andrea Pisano is already a proficient metalworker and the possessor of a style as personal as Tino di Camaino's or Maitani's. One of its determinants was Northern Gothic art, from which, among much else, the quadrilobe medallions employed to frame the scenes set in the door derive. Though analogies for them occur in monumental sculpture, the principal source of this decorative aspect of Andrea's style is likely to have been French Gothic metalwork. In the high finish of the figures and in the use of the bronze ground to set off the gilded surfaces of the relief, Andrea appears as a metalworker rather than as a sculptor. The other determinant was Giotto, whose frescoes in Santa Croce are fundamental for Andrea's figurative style. Throughout the door the compositions give the impression of having been thought out in relation to the external rectangle rather than to the quadrilobe within. In twenty-three out of the twenty-eight reliefs the action takes place on a flat platform parallel with the base of the relief, and in all save the landscape scenes the setting is constructed with a dominant vertical and horizontal emphasis. A typical example is the scene of St. John in Prison visited by his Disciples, where the architecture forms an internal containing rectangle. One of the most Giottesque of the reliefs is the Presentation of the Baptist's Head to Herodias, where the setting and poses alike derive from the Peruzzi Chapel. Giottesque, too, is the magnificently vital executioner in the Decollation of the Baptist (Plate 48); in this scene the kneeling Saint, his body parallel to the base of the relief, reproduces a motif from Giotto's Ascension of St. John the Evangelist. Andrea Pisano's feeling for the human figure, while never merely decorative, is none the less more rhythmical than Giotto's, and the beautiful Virtues (Plate 46) in the lower rectangles on each wing of the door (some of the only allegories worthy to be mentioned in the same breath as the Virtues of Giotto in the Arena Chapel) have a grace of line which Giotto, in his remorseless search after tactility, abjured.

In 1334, two years before the bronze door was set up in the Baptistry, Giotto became principal architect of the Cathedral, and between this date and his death in 1337 he designed and supervised the building of the lower section of the Campanile on the south side of the church (Fig 38). Giotto's scheme provided for two rows of reliefs, and the lower of these poses the problem of the relation between the painter and sculptor still more acutely than does the bronze door. The reliefs represent a coherent philosophic programme, showing beneath the creation of man and the mechanical, social and liberal arts, and above the seven planets and seven sacraments, and depend from a variety of sources, of which the most important are Isidore of Seville, Vincent of Beauvais and Brunetto Latini. By two early sources the designs are attributed to Giotto. The splendid God the Father of the Creation of Adam (Plate 50) must, however, have been planned by the same artist as the Baptist in the scene of St. John Baptizing (Plate 47) on the bronze door, and many of the companion scenes are likewise marked by the instinctive sense for linear rhythm which is peculiar to Andrea Pisano. In others the play of line is checked, and the forms are rendered in a more summary fashion with greater emphasis upon plasticity. Characteristic of these is the relief of Agriculture (Plate 51), where the figures are restricted to a central rectangle and are portrayed in depth. It may well be that Giotto's mind, if not his hand, was responsible for this and the related scenes. Whatever the division of labour between them, we may be confident that on the Campanile the two artists worked in close proximity, and even the carvings which seem to be due solely to Andrea, like the scenes from Genesis, have a moral elevation which comes from contact with Giotto's imposing personality.

After Giotto's death work on the Campanile was continued by Andrea, and its sculpture was carried a stage further with the provision of four niches on each flank designed to contain life-size statuary. The bulk of the eight figures from these niches, now in the Museo dell' Opera del Duomo (Plate 49), were designed, and some were executed, by Andrea. Certainly we must credit to Andrea the conception of these majestic figures, their flat surfaces broken by cursive drapery which gives them the effect not of free-standing statuary but of exceptionally deep reliefs. Not their least interesting aspect is the light they throw on the formation of Andrea's son, Nino Pisano.

In 1343 Andrea Pisano left Florence, probably for Pisa, and four years later became Capo-maestro at Orvieto. In 1349 he was succeeded as Capomaestro by his son; this substitution may have been occasioned either by Andrea's death or by his return to Florence. We have no authenticated works by Andrea or his son dating from these six years, and an attempt has been made to assemble from the sculptures generally ascribed to Nino a group of works executed by Andrea at this time. The most important of these is a small Virgin and Child in the Museo dell'Opera del Duomo at Orvieto, which originally stood above a doorway in the Cathedral. Whether this was executed during Andrea's period as Capomaestro, or between 1349 and 1353 when this office was held by Nino, we may never know, but the figure, with its rounded forms and developed Gothic drapery, is very different from the only

figures by Andrea in the same medium and of the same size, two statuettes of Christ and Santa Reparata in Florence, and the balance of probability is that it forms a prelude to the career of Nino and not an epilogue to that of Andrea Pisano.

NINO PISANO

Incomplete as is our knowledge of Andrea, his son in some respects is the more enigmatic artist. What we know of him is derived largely from two signed works, a Madonna and Child in S. Maria Novella in Florence (Plate 54) and a Madonna and Child with two Saints and two Angels surmounting the Cornaro monument in SS. Giovanni e Paolo in Venice (Plate 52). The style of the earlier of these figures, that in Florence, is evolved from Andrea's Sibyls on the Campanile, with the difference that the Gothic movement which is no more than implicit in the Sibyls becomes explicit in Nino's statue. Running from the relaxed right foot to the gently inclined head, it is accentuated by the clinging drapery which serves not, as with Andrea, to enhance the volume, but to accentuate the line. Gone, too, is the impassive gravity of the Campanile statues. Instead, the Virgin's lips are parted in a peaceful smile as she gazes at the Child. In Florence the Child reaches out towards a bird held in her right hand, and in Venice he looks up into her eyes. In all this we have a new facet of the influence of French upon Italian Gothic sculpture. The French sculpture from which Nino Pisano derived his style was that of his own time; a connection has, for example, been established between the Madonna in Venice and the silver-gilt Madonna of Jeanne d'Evreux of 1339. French ivory carvings also offer countless parallels for the forms and the emotional repertory of Nino's work, and from them he may have drawn the practice of surface pigmentation as it is found in certain of his sculptures. In the Cornaro monument (Fig. 41) French influence is limited to the central group, and the heavy angels bearing candlesticks in everything but their ecstatic smiles are typical of Tuscan Gothic sculpture.

The Cornaro monument must have been followed by a Madonna and Child with two Saints in S. Maria della Spina at Pisa, where the pose, according to Vasari, centred on that characteristic Gothic motif, a rose presented by the Virgin to her Son. In another work of the 1360's the emotionalism latent in this group is still further extended. This is the half-length Madonna del Latte (Plate 53, Fig. 40), where Nino introduces, for the first time in Italian sculpture, the motif of the Virgin suckling the Child. Popular in the more intimate medium of painting three decades or more earlier, this theme receives its supreme statement at Nino's hands. In his solution of its problems and in the sinuous design in which the Child's arms encircle the Virgin's breast and the Virgin's arms enclose the Child, his claim to be considered a great sculptor must ultimately rest.

In Florence Nino exercised no influence, but at Pisa eddies of his mellifluous style continue through the last quarter of the century. Wooden figures of the Virgin Annunciate and the Annunciatory Angel were carved in Pisa at least as early as the first quarter of the century and from them Nino, at the extreme end of his career, developed the great marble group in

S. Caterina (Plate 55). The figures combine exceptional beauty of articulation with a wealth of sentiment, and they inevitably exercised a strong, and in some respects decisive, influence on later wooden Annunciation groups. In the drapery the formulae of Northern Gothic are interpreted with the instinctive classicism of the Tuscan artist, and not till the fifteenth century, in Jacopo della Quercia's Annunciation at San Gimignano, do we find a group in which the sense of the angelic message is so lucidly expressed.

ANDREA ORCAGNA

In 1343, the year in which Andrea Pisano is presumed to have left Florence, the great trading house of the Peruzzi announced its bankruptcy. The economic crisis which this presaged continued through the middle forties, and was followed in 1348 by the catastrophe of the Black Death. On the fine arts the impact of these disasters was immediate and direct. In painting it is manifest through the third quarter of the century in a debasement of quality and a change of style, and in sculpture both factors are also present, though to a lesser extent. In these years Florence threw up only one major artist, Orcagna, who was active as painter, architect and sculptor, and it is to him that we owe the most distinguished painting of the time, the Strozzi altarpiece in S. Maria Novella, and the most distinguished sculptural complex, the tabernacle in Or San Michele. This was financed with money collected after the Black Death, and was begun by 1355. Orcagna's tabernacle (Fig. 42) is an outcome of stylistic anarchy. The forms, especially the cupola, are unorthodox, and are heightened by a system of polychromy, based on contrast between the white marble and the blue, red, and gold glass and tesserae with which it is inlaid, that must have been inspired by Arnolfo di Cambio's polychrome façade for the Cathedral. One of the visual devices introduced, by Giotto or Andrea Pisano, into the lower reliefs on the Campanile is the use of fictive curtains to soften or neutralize the hard symmetry of the frame. An example on the Campanile is the Jubal, who sits beneath a kind of tent. This device is taken over by Orcagna in the Annunciation of the Death of the Virgin and a number of other reliefs on the tabernacle, and is also adopted for the frame of the great Madonna by Bernardo Daddi on the altar, which is surrounded by a marble curtain held up by flying angels, and on the forward arch, where another fictive curtain is introduced. The pictorial style which emerged in Florence during the thirteen-fifties was hieratic; its images were symbolic, not realistic, and its effects were made by juxtaposing flat areas of colour and, where this was called for, by heavy expository emphasis. Orcagna's tabernacle forms its sculptural corollary. Round the base runs a cycle of scenes from the life of the Virgin (Plate 57), which culminates in a large Dormition and Assumption of the Virgin at the back (Plate 56, Fig. 43). In this the apostles who crowd round the Virgin's tomb give vent to their emotions with violent rhetoric, as though the expressive idiom of Nino had suddenly turned sour, and it is only in the hieratic Assumption above that we can sense the presence of a sculptor with a feeling for volume and space relationships which, at almost any other moment, would have allowed him to produce great art.

Many of the compositional devices used in the Or San Michele carvings have their origin on the Campanile; in some of the reliefs indeed only the element of visual poetry seems to have been left out. On the Campanile itself the converse occurred, for here Andrea Pisano's work was continued in a series of enchantingly poetical representations of the Seven Sacraments (Plate 58) by a sculptor, perhaps Alberto Arnoldi, who consciously modelled himself on the bronze door rather than on the marble reliefs beneath. As works of art these reliefs are less powerful and less solid than Orcagna's, but they preserve in an inclement period the memory of better times.

GIOVANNI DI BALDUCCIO

In North Italy the development of style proceeded in a contrary direction and at a slower rate. In Genoa, dignified though it was by Giovanni Pisano's monument of Margaret of Luxemburg and by the Fieschi monument by a pupil of Giovanni Pisano in the Cathedral, no local sculpture of importance was produced, and in Lombardy, for the first three decades of the century, sculptural style remained predominantly Romanesque. Typical of Lombard sculpture about 1320 is the tomb of Guglielmo Longhi at Bergamo (Fig. 47), in which the Gothic structure of the tabernacle seems designed to draw attention to the essentially un-Gothic sculptural forms. Never, from the clumsy figures poised above the bier, would we guess at the heights to which Tuscan sculpture had been raised by the Pisani and their followers. It was on sculpture of this class (much of it turned out by carvers from Campione near Lugano) that Tuscan sculpture reacted after the arrival in Milan about 1334 of Giovanni di Balduccio. A younger contemporary of Andrea Pisano, Giovanni di Balduccio was employed by the Duomo at Pisa between 1315 and 1317, during Tino di Camaino's tenure of the office of Capomaestro, and throughout the twenties he was active in the accepted sphere of Pisan sculptors, at Bologna, San Casciano and Sarzana. At Pisa he worked in S. Maria della Spina, and in Florence he was responsible for the salient monument turned out in the decade after Tino's Orso tomb, the Baroncelli tomb in S. Croce. In all these works he reveals himself as a not ungifted but rather phlegmatic member of the generation which separates Nino from Giovanni Pisano.

The first work on which Giovanni di Balduccio was employed in Lombardy is the Arca of St. Peter Martyr in S. Eustorgio in Milan (Fig. 44). We hear of it for the first time in 1335, when a campaign was launched to collect alms for the construction of a shrine 'similar in every respect to that of our father St. Dominic'. No doubt it was the Pisan authorship of the Arca of St. Dominic, and the fact that Giovanni di Balduccio had himself carved the high altar of S. Domenico Maggiore at Bologna, which led the friars of S. Eustorgio to select him for this task. A Pisan monument was what the friars demanded, and a Pisan monument was what Giovanni di Balduccio supplied. Like the Arca of St. Dominic, the shrine rested on caryatids and carried scenes from the Saint's legend round the sides of the sarcophagus, though, in deference to the changed taste of the Trecento, the number both of the scenes and

caryatids was increased. Two novel features are the sloping lid of the sarcophagus and, above, a Virgin and Child with two Saints beneath a tabernacle adapted from that on the façade of S. Maria della Spina. The influence of Giovanni di Balduccio's new environment is evident only in the multiplicity of statuettes above the sarcophagus and tabernacle, and in the actual carving of those parts of the monument on which Lombard sculptors were employed. Typical of the latter are the childish statuettes which intervene between the narrative reliefs. The difference between these and the suave caryatids of Giovanni di Balduccio (Plate 61) is a measure of the latter's superiority to the artisans among whom he had come to work.

Between 1339, when he completed the Arca in S. Eustorgio, and 1349, when he is last heard of in Milan, Giovanni di Balduccio's style underwent a change. Insulated from Tuscan contacts, his once solid execution became weak and generalized, so that in late works like the Settala monument in S. Marco in Milan we have no way of telling whether the execution is by an assistant or by the sculptor himself in a degenerate phase. This is among the factors which obscure discussion of the second of the great Lombard shrines, the Arca of St. Augustine in S. Pietro in Ciel d'Oro at Pavia (Fig. 45). The Arca of St. Augustine was begun after 1350, and the lower part at least was completed by 1362. Where the shrine of St. Peter Martyr is preponderantly Tuscan, the shrine of St. Augustine is preponderantly Milanese. It is supported not on free-standing caryatids, but on a solid base, in which reliefs of Virtues (inspired by the caryatids in S. Eustorgio) are separated from each other by pairs of Saints (Plate 62). The narrative scenes are transferred from the sarcophagus to the upper part of the monument, and in the centre of the tomb is a recumbent effigy under an arcade, lying, like Gulliver among the Lilliputians, amid small standing figures which recall those on the Longhi monument at Bergamo. The supports of the arcade are also encrusted with tiny statuettes. If we approach the Arca with the shrines of St. Dominic or St. Peter Martyr in our minds, it will be objected that the design is heavy and overfilled with ornament. But in its Lombard context it is a conspicuously distinguished work, and though the carving is unequal, the design of the whole monument and the execution of the lower parts may well be the artistic testament of Giovanni di Balduccio.

GIOVANNI AND BONINO DA CAMPIONE

Not till the middle of the fourteenth century was Lombardy raised to the status of an Italian power. Giovanni Visconti, Archbishop of Milan, to whom its resurgence was due, died in 1354, and was succeeded by his nephews, Bernabò and Galeazzo II Visconti. An alliance with Verona was established by the former through his marriage to Regina della Scala. In the field of sculpture these political developments are reflected in a court art which extends in space from Milan to Verona and in time from the middle of the fourteenth to the early fifteenth century. The term court art generally connotes an epicene style such as was promoted by the Angevins in Naples, but the art of the Visconti was of quite another kind, masculine, unsubtle, lacking in technical refinement, and designed to celebrate the prowess of the leaders

of the Veronese and Lombard states. One of the earliest of the Visconti monuments, the tomb of Azzone Visconti in S. Gottardo (1339), was carved by or in the workshop of Giovanni di Balduccio, but the later monuments were hewn out by native artists.

We first encounter the Campionesi in the second quarter of the fourteenth century in the persons of Ugo da Campione and his son Giovanni. Giovanni da Campione was employed in 1340 in the Baptistry at Bergamo (Fig. 46), and he or his father must have been responsible for the reliefs of Virtues (Plate 60) built into the external angles of this building. The iconography of these reliefs is influenced by Giovanni di Balduccio's caryatids in S. Eustorgio, but the style is stiffer, and the defective sense of volume is accompanied by a tendency, inherited from Romanesque, to dispose the drapery calligraphically over the flat forms. We meet Giovanni da Campione once more in a stiff, ill-articulated figure of St. Alexander (1353) over the entrance to S. Maria Maggiore at Bergamo. The type of equestrian figure to which this work belongs was an importation from the North. Adopted by thc feudal society of North Italy, it appears two decades or so earlier in the monument of Can Grande della Scala at Verona (Fig. 51). There is no record of the name of the sculptor of this tomb, but of his mastery the riding figure of Can Grande, unique in its forceful naturalism and strong sense of movement, leaves no doubt. In the equestrian figure on the companion monument erected in the life-time of Mastino II della Scala (d. 1351) these barbaric accents are modified (Fig. 50). A visor conceals the rider's features and his horse looks straight ahead, a heraldic image relying upon decorative accidentals for its effect. This tendency towards decoration also distinguishes the recumbent figure of Mastino from the cruder and more powerful figure of Can Grande, and makes itself felt yet again in the pointed gables with scenes from Genesis above the arcading of the monument. By the standard of these works Giovanni da Campione's St. Alexander appears coarse and spiritless. Yet it was another sculptor from Campione, Bonino, who set the seal upon the Veronese equestrian figure and the Veronese sepulchral monument, initially at Milan in the tomb of Bernabò Visconti and later at Verona in that of Cansignorio della Scala.

The tomb of Bernabò Visconti consists of two parts, a sarcophagus carved after the tyrant's death in 1385 and an equestrian figure (Plate 64, Fig. 52) completed more than twenty-two years earlier. A chronicle of 1363 describes the mounted statue, heightened with gold and silver, over the high altar of S. Giovanni in Conca in Milan, and it needs no effort of imagination to recapture the awe which this particularized, formidably lifelike image must have inspired. The head, with its impassive gaze and cruel mouth, opens a chapter in the history of sculptured portraiture, and the horse (stripped of the accoutrements which hide the horses at Verona) has its place in the history of the equestrian monument. In both respects the Bernabò Visconti figure occupies a special place in the work of Bonino da Campione, for when, between 1370 and 1374, the same sculptor came to carve the equestrian statue at the apex of the monument of Cansignorio della Scala, he reverted to the heraldic convention of the Scaliger tombs.

The history of the free-standing Veronese tabernacle tomb opens about 1320 with the Castelbarco monument outside S. Anastasia (Fig. 48). This supplied the basis of the monument of Mastino II della Scala, where we find the scheme enriched with reliefs above the arches, small tabernacles at the corners of the tomb, and a surrounding grille adorned with statuary. Bonino da Campione's tomb of Cansignorio (Fig. 49) is planned on the same lines, but with far greater complexity. The rectangular surround of the Mastino monument gives way to a six-sided grille, on the supports of which are tabernacles containing statues of warrior Saints. In the tomb proper heavily decorated spiral columns are substituted for the simple pillars of the earlier monuments, the small angels keeping guard over the effigy have an unwonted prominence, and the figurative content of the sarcophagus reliefs is much increased. The carving at the head of the sarcophagus (Plate 63), where Cansignorio della Scala is presented by St. George to the Virgin and Child, served as a precedent for the scene on the sarcophagus of Bernabò Visconti in which the dead tyrant is presented by St. George to the crucified Christ. Above, a heavy cornice lends coherence to the upper section of the monument, where niches with figures of the Virtues take the place of the Genesis reliefs. Nowhere does the sculpture of the Cansignorio monument attain the level of the statue of Bernabò Visconti, but it remains an impressive work, which, in its subordination of sculpture to ornate architectural forms, anticipates the style practised in Lombardy in the last decade of the century.

LATER GOTHIC SCULPTURE IN MILAN

While Bernabò Visconti ruled in Milan, his brother, Galeazzo II, controlled Pavia, and was succeeded, on his death in 1378, by his son, Gian Galeazzo. Seven years later Gian Galeazzo deposed his uncle Bernabò, and rapidly established the united Duchy as the strongest single force in Italy. From Gian Galeazzo's sophisticated court there radiated a new style, which found expression in painting in the work of the miniaturists Michelino da Besozzo and Giovannino de' Grassi and in sculpture in the International Gothic statuary of Milan Cathedral. Unlike some of the works to which the term International Gothic is applied, Lombard sculpture in the late fourteenth and early fifteenth centuries was both Gothic—it represents indeed the extreme point reached by flamboyant Gothic sculpture in Italy—and international, in so far as much of it was due to alien artists. Whereas the art of the Campionesi was indigenous in Lombardy, the developed Gothic sponsored by Gian Galeazzo and his sons, Giovanni Maria and Filippo Maria Visconti, was an imported style. Work on the Cathedral was begun in 1387, and was entrusted to a Lombard architect, Simone da Orsenigo, advised by Bonino da Campione and other local artists. But the project proved too ambitious for these comparatively inexperienced hands, and before long they were replaced by architects with direct experience of the great Gothic cathedrals of the North. In 1389 a Frenchman, 'Nicola de Buonaventuri', was summoned from Paris to act as architect of the Cathedral, and a year later he was succeeded by a German, Johann von Freiburg. In 1391 search was made in

Cologne for a new architect, and in 1392, after an unsuccessful effort to wrest away the architect of Ulm Cathedral, the office of Capomaestro was bestowed on an architect from Schwäbisch-Gmünd, Heinrich Parler. Despite these frequent changes of direction, Milan Cathedral developed as a homogeneous whole, constructed on a scheme which was frequently at variance with its northern counterparts, but was none the less more faithful to the concepts of church architecture in the North than any other building of its time in Italy.

Not unnaturally the sculpture of the Duomo in Milan has more in common with the cathedral sculpture of the North than it has with that of Central Italy. No large building in Italy is decorated with so great a wealth of statuary, and in none is the contribution of the individual artist of so little significance in relation to the whole. The sculptors employed there were drawn from France, like Roland de Banille, and Germany, like Walter Monich, as well as from Venice and Lombardy itself, but one and all were subordinate to the church architects. Much of the sculpture was collaborative—on the central window of the apse four artists worked side by side—and so little were personal idiosyncrasies encouraged that Matteo Raverti, when he completed his statue of San Babila inside the church, was fined for departing from the prescribed design. The main interest of the Cathedral sculpture rests in the style in which the artists worked. As we find it in the sculptures of the most distinguished Lombard artist employed in the Cathedral, Giovannino de' Grassi, this style is decorative and pictorial; Giovannino's relief of Christ and the Woman of Samaria over the lavabo in the south sacristy (Plate 65) is really an illumination translated into carving, and like a miniature it owes much of its appeal to the aptness with which it is set in the surrounding ornament. The capitals of the piers along the nave, with their statues under ornamented tabernacles, seem also to be due to Giovannino de' Grassi, and here too the effect is less plastic than pictorial. A painter, Isacco da Imbonate, was responsible for the cartoons of two of the most striking figures in the interior of the Cathedral, the mellifluous Virgin Annunciate (Plate 66) and Annunciatory Angel, commissioned in 1402 to decorate the window of the apse. In this setting Hans von Fernach, the German author of a relief over the door of the south sacristy, appears as an artist of unusual talent, and the Lamentation over the dead Christ at the base of his design sustains an unwonted level of intensity.

As the fifteenth century advanced, Lombard Gothic sculpture became a force in its own right, reaching its zenith in the figure of Pope Martin V commissioned by Filippo Maria Visconti in 1419 from Jacopino da Tradate (Plate 67). Here the statue of the Pope is set on a plinth rising from naturalistic foliage like that of Giovannino de' Grassi's Christ and the Woman of Samaria, and the features, rendered with the painstaking fidelity of late Gothic portraiture, are submerged in a rippling sea of drapery. Alongside Jacopino there worked a group of Lombard sculptors whose style conceded less to Gothic taste. The most notable of these are Alberto da Campione, creator of the finest of the Giganti which support the waterspouts on the outside of the Cathedral, Giorgio Solari, sculptor of an unadventurous figure of St. George that crowned one of its most striking external features, the Carelli pinnacle, and

Matteo Raverti. The influence of these sculptors, and of the external sculpture of the Duomo as a whole, spread from Lombardy to Venice, and among its progeny is the external sculpture of St. Mark's.

VENETIAN GOTHIC SCULPTURE

The third of the great North Italian centres, Padua under the Carrara, evolved no local style, and though politically the two cities often found themselves in opposition, the history of sculpture in Padua is a mere enclave in the history of Venetian sculpture. Topographically and stylistically, Venice occupies a place apart. Alone of the cities of North Italy, she maintained contact with Greece and the Near East, and the presence in the city of great Byzantine carvings like the Madonna Orans of S. Maria Mater Domini and the Deesis relief outside St. Mark's served to arrest the development of style. In Venice the late Dugento expressed itself in sculpture not in a classical renascence like that of Tuscany, but in regenerated Byzantinism. During the life-time of Nicola Pisano an anonymous Venetian sculptor carved a relief of the Virgin and Child with Saints Peter and Paul outside S. Polo so archaic that for long it was regarded as a work of the eleventh century, and in the Trecento a figure of San Donato at Murano, dated 1310, perpetuates the same retarded style. Only in the Madonna dello Schioppo in St. Mark's (Plate 68) does a first breath of Gothic animate these rigid forms. One of the most interesting examples of this backward-looking sculpture is a relief of the Dormition of the Virgin on the monument of the Doge Francesco Dandolo in the sacristy of the Frari (1339) (Fig. 54). In this the style is in exact conformity with a painted lunette by Paolo Veneziano which was originally set in the upper part of the same tomb. But of the genius of Paolo Veneziano, of his prolific narrative invention and rich decorative sense, neither here nor elsewhere in the sculpture of the second quarter of the century is there the smallest trace.

Alongside these works a more progressive tendency makes itself felt. In the caryatids of the Arca of St. Luke in S. Giustina at Padua (1316) the impress of the Pisani is so clearly marked that they have been ascribed (intelligibly but mistakenly) to a Tuscan artist, and in 1317 the finely composed effigy of St. Simeon the Prophet in S. Simeone Grande in Venice (Fig. 53) was signed by a sculptor, Marco Romano, who was certainly cognisant of the work of Giovanni Pisano. The effigy of St. Simeon in turn served as a point of departure for the Arca of the Beato Odorico da Pordenone in the Carmine at Udine, which was carved by a certain Filippo da Venezia in 1331, and which embodies a narrative relief based upon Tuscan prototypes. At Treviso the effigy of Francesco da Salomone (d. 1321) also has something of the recessive character of the St. Simeon, and the angels to either side are among the few works in the Veneto in which the influence of the angels by Giovanni Pisano in the Arena Chapel is manifest. The tomb of Enrico Scrovegni in the Arena Chapel (Fig. 56) follows the formula used in the upper part of the Treviso monument. A third important monument of this class is the tomb of the Doge Andrea Dandolo (d. 1354) in St. Mark's.

A peculiar feature of these monuments is the treatment of the sarcophagus. In the earliest Venetian Gothic tomb, the shrine of the Beato Enrico in the Duomo at Treviso (1315), two of the four Saints accompanying the Christ in benediction on the front are set diagonally across the corners of the sarcophagus. A rather similar scheme is preserved in the Salomone monument (where the corner figures take the form not of Saints but of the Virgin Annunciate and Annunciatory Angel, which gradually became de rigueur in Venetian tombs) and in the Dandolo monument (where, by exception, the figures are combined with narrative reliefs). These elements were taken up and developed by the most prominent Venetian sculptor of the middle of the century, Andriolo de Sanctis, in the tomb of Raniero degli Arsendi at Padua (1358) (Fig. 57). Here the tabernacles housing the carved figures are raised above the level of the top of the sarcophagus, and the figures themselves are planned as statuettes rather than as reliefs. The tomb of Ubertino da Carrara, also by Andriolo de Sanctis, follows the same plan, and by the end of the decade this spreads to Verona, in the boldly conceived monument designed by Andriolo de Sanctis for Giovanni della Scala.

Andriolo de Sanctis was still active in 1376, when he completed the chapel of San Felice in the basilica of S. Antonio in Padua, but neither the featureless full-length Saints carved in his workshop to decorate the outer wall, nor the related figures on the altar by a certain Raynaldinus, can claim notice in their own right. Much superior are the figures of the seated Virgin and Child between Saints Lawrence and Francis in a lunette above the entrance to S. Lorenzo at Vicenza (after 1344) (Fig. 55). Carved under transalpine influence, the plump, round-faced Virgin in the centre of this group looks forward to the Venetian sculpture of the early fifteenth century. The erection of Nino Pisano's Cornaro monument in SS. Giovanni e Paolo in Venice (after 1365), though reflected in a handful of Venetian imitations of the central group, did not affect the popularity of this Northern type, and by the end of the century it occurs frequently in sarcophagus reliefs.

JACOBELLO AND PIERPAOLO DALLE MASEGNE

More fruitful than contacts with Tuscany in the second half of the Trecento were contacts with Emilia. In the last two decades of the century Venetian sculptors were employed on S. Petronio at Bologna, and in 1394 the figure sculpture of the iconostasis (choir screen) of St. Mark's (Fig. 58) was entrusted to two artists who had made their reputations in Emilia, the brothers Dalle Masegne. Jacobello and Pierpaolo dalle Masegne seem to have been trained in Venice under the shadow of the Cornaro monument, but they were already active in Bologna in 1383, and between 1388 and 1392 were at work upon their masterpiece, the high altar of S. Francesco. This work is planned like a colossal ivory polyptych, in which Saints in full- and half-length set in tabernacles are divided from each other by rows of smaller Saints in smaller tabernacles; in the centre is the Coronation of the Virgin with a figure of God the Father above. Beneath, nine narrative reliefs fulfil the function of the painted predella of an altar-piece. The figures are couched in an ambivalent style, in part Tuscan, in

part redolent of northern Italy. The sentiment of the smiling Angels on the Cornaro monument lies behind the grimacing Annunciation group, and in the Coronation the head of the Virgin likewise harks back to Nino Pisano. But the statues lack the serene classicism by which Nino's ready sentiment was held in check, and the lateral Saints have not a little in common with contemporary German sculpture. In the Venice iconostasis (Plate 69) all memory of Nino's style has vanished, and the Saints are unashamedly Northern in type. Historically the work of the Dalle Masegne is of more importance than its intrinsic merits might appear to justify. It spread to Milan, where the two brothers were employed in 1399 and where it left its mark on the sarcophagus of Marco Carelli in the Cathedral; it reached the Marches, impressing itself upon the doorway of S. Domenico at Pesaro (Fig. 60); and through the work of Jacopo della Quercia at Lucca and Leonardo Riccomanni at Sarzana it penetrated Tuscany.

LORENZO GHIBERTI

In the decades following Orcagna's death in 1368 there was little to indicate that within a generation Florence would become the most progressive sculptural centre in Italy. The most interesting works undertaken at this time fall in the realm of metalwork and not of sculpture. These are the two silver altars for the Cathedrals of Florence and Pistoia. The Pistoia altar (Fig. 62) was ordered in 1287, was extended by Andrea di Jacopo d'Ognabene after 1316, and was amplified by the addition of side pieces between 1361 and 1367; it was again enlarged after 1381, and the upper part was added in 1394–6. The altar in Florence (Fig. 61) was commissioned in 1366, and the greater part of the front was completed in the following decade; in this case the side pieces (to which Verrocchio and Antonio Pollajuolo contributed) were not finished till the third quarter of the fifteenth century. The protracted history of the two altars serves to remind us of the coexistence alongside monumental sculpture of a tradition of work in precious metals, which was to exercise a powerful influence on the great Florentine exponent of Gothic-Renaissance style, Lorenzo Ghiberti.

Though he is the only fifteenth-century sculptor to have written an account of his own life, Lorenzo Ghiberti is a mysterious artist. One reason for this is that none of his work in precious metals survives. When his narrative begins, in the year 1400, he was working as a painter at Pesaro, and we can still form some impression of his pictorial style from the stained glass windows which he designed for the Cathedral in Florence. He also tells us that he 'assisted many painters, sculptors and masons to attain honour by furnishing them with models in wax and clay. Painters in particular received sketch designs in quantities; those who had to execute figures over life size were given rules and the correct method for making them.' Of this aspect of his activity nothing is known, though we can point to certain works (notably the earlier frescoes of Uccello in the Chiostro Verde) in which the figures are impregnated with Ghiberti's style. Another reason is that Ghiberti is neither a purely Gothic nor in the strict sense of the term a Renaissance artist. While his creative mechanism is more delicate and complex than those of the sculptors we have been discussing hitherto, nowhere

does it reveal the fully rational thought-processes of Renaissance art. Ghiberti is a Renaissance artist in the context of Gothic, and a Gothic artist in the context of Renaissance style. A third reason is the dichotomy between those works which survive and Ghiberti's artistic aspirations as they are transmitted to us in the *Commentari*. Of the three *Commentari*, the first deals with the sculpture and painting of antiquity, the second gives a summary of the history of the fine arts from the days of Cimabue down to the sculptor's own time and incorporates his autobiography, and the third and most elaborate is devoted to the theory of art. Ghiberti's preoccupation with art theory (he attempted, he declares in one passage, 'to examine the ways of nature, to discover how pictures are conceived, how the sense of sight works, and in what manner the canons of painting and sculpture can be determined'), no less than his careful and poetical descriptions of antique works of art, might alone lead us to suppose that his interest in Pliny and Vitruvius found its equivalent in a logical, classicistic style. The story told us by Ghiberti's sculptures is less consistent and less predictable.

It begins in the year 1401 with the announcement of a competition organized by the Arte di Calimala for the second bronze door of the Baptistry in Florence. This competition is a landmark in the history of sculpture, in the first place because it brought together all the main Tuscan sculptors of the time, and in the second place because one of the reliefs submitted, that of Brunelleschi, is usually looked on as the boundary stone separating medieval from Renaissance art. There were seven competitors in all, and the palm of victory (to use the classical expression employed by the sculptor himself) was conceded to Ghiberti. Ghiberti was no more than twenty-three, but in the trial relief of the Sacrifice of Isaac (Fig. 63) which he submitted for the competition, there are already present the principal ingredients of his style. The relief is set in a quatrefoil frame like the reliefs on the door of Andrea Pisano. But in contrast to Andrea's scenes, the narrative is represented on three clearly defined planes, the first marked by the two spectators in conversation in the foreground, the second, in the middle distance, by the figures of Abraham and Isaac, and the third, in the background, by the ram, placed at the summit of the rocky landscape, and by an angel on the right pointing towards it. Throughout the scene there is an omnipresent sense of space, though of perspective there is, as yet, no trace. Viewed merely as story-telling, the relief has a marvellous naturalness and clarity. The narrative interest is focused on the sacrificial scene, and this owes much of its effect to the expressive heads of the two figures, which betray the touch of an experienced metalworker. Although Ghiberti's works in precious metals have disappeared, the trial relief leaves no reasonable doubt that he was familiar with French, probably Parisian, goldsmiths' work of the last quarter of the fourteenth century. When describing the work of the mysterious Gusmin (a German goldsmith employed by the Duc d'Anjou), Ghiberti declares that he was 'the equal of the great Greek sculptors, making the heads and naked bodies wonderfully well'. These words offer a clue to the interpretation of the Sacrifice of Isaac, where the figures of Abraham, clothed in Gothic drapery and bending forward as he lifts his knife, and Isaac, his pose taken from an antique torso, represent the two poles of Ghiberti's art. The soft

forms of the two youths in the foreground and the undulating landscape offer a foretaste of the lyrical vein which was later to inspire the poems of the second bronze door.

Between 1403, when the contract for the first of Ghiberti's bronze doors was signed, and 1424, when the door was put into position, Ghiberti's studio was the main training ground of sculptors in Florence. But though Donatello and other artists were employed there, the personality manifest in the twenty-eight reliefs on the door is Ghiberti's, and Ghiberti's alone. There is documentary proof of the slow progress made towards the completion of the door, but none of the order in which the scenes were worked. Internal evidence, however, enables them to be broken down into four groups. In the first, typified by the Annunciation and the Nativity, the style is that of the Sacrifice of Isaac. But slowly the method of narration becomes more complex and the grouping more ambitious, until, in the fourth group, typified by the Christ carrying the Cross, Ghiberti speaks to us with a new authority and eloquence. These later scenes, in which the sculptor reaches forward from the world of Gothic art but is still uncontaminated by Renaissance forms, are perhaps his most congenial narrative reliefs.

Let us look for a moment at three of the reliefs. The Annunciation (Plate 70) is set on a shallow platform like those used in Andrea's door. Above this is a building which also reminds us at first sight of the vertical architectural constructions in so many of Andrea's scenes. But this is a building with a difference, for it projects across the platform and recedes on the left side to a point in the exact centre of the relief field. Where Andrea's scenes are dominated by the containing rectangle, Ghiberti's Annunciation is planned in relation to its frame. A half-length God the Father looks down from the lobe on the left above, the angle below receives the angel's wings and his feet fill the lobe beneath, while the sinuous figure of the Virgin neutralizes the hard line of the portico. That the employment of these devices was deliberate we can hardly doubt. Yet the scene is rendered with such entrancing freshness that it might never have been represented by any previous artist.

In the relief of the Nativity (Plate 71), as in the Sacrifice of Isaac, the landscape foreground follows the frame, and the main figures, the Virgin and the Shepherds, are placed on a central plane. From the left there springs out a herald angel who is first cousin to the angel of the Sacrifice. But in the Nativity Ghiberti induces a greater sense of depth than in the earlier relief. This is achieved by methods of extraordinary subtlety, the clenched left hand of one of the two shepherds protruding beyond the frame, a contrast in scale between the right arm of the second shepherd and the distant tree near by, and above all by the Virgin's head thrust forward from the relief plane and represented looking downwards at the Child. Once more the effect left on our minds is one not of a closely meditated scheme, but of momentary inspiration realized with easy artistry. In the Christ carrying the Cross (Plate 72) the frame has ceased to serve as a proscenium arch, and has receded to a middle plane, so that the action takes place in front of it. To this expedient of projecting the main focus of the narrative outwards towards the spectator much of the impact of this beautiful relief is due.

It is easy to think of Ghiberti's door as a kind of sonnet sequence, a series of small self-

sufficient scenes. But in its entirety (Fig. 65) it is a work of splendid decorative effect. Although it follows the plan of the first door so closely, the character of the design has undergone a change. This change results in part from the continuous movement within the reliefs, in part from their greater depth, in part from the foliated borders round them, and in part from the richer use of gilding on the raised surfaces. So lavish is this that it is no surprise to find that in Ghiberti's next narrative reliefs, on the Siena font, the contrast between the gilded figures and their dark ground is abandoned, and the whole surface of the relief is gilt.

This change may have been consequential on a change in the shape of the reliefs, for the two scenes on the Siena font are no longer enclosed in decorative quadrilobes but are rectangular. One of them, the Baptism of Christ, represents a scene which also figures on the door, and here the contrast of the earlier with the later scene, one with the fluid rhythms and high finish of Ghiberti's early work, the other with the more static forms and the less detailed handling of his maturity, illustrates the transformation which overtook his style about this time. In the second scene, St. John preaching before Herod (Plate 84), the architectural setting is more elaborate than in any of the panels on the door, and the figures are treated realistically, as though the artist were here determined to convince and not to charm.

Though commissioned in 1417, the two reliefs for the Siena font were not delivered until 1427, and thus coincide in date with the first phase of work on the second of the two bronze doors designed by Ghiberti for the Baptistry in Florence. Work on this second door, the Porta del Paradiso (Fig. 66), proceeded even more deliberately than on the first, and occupied a total of twenty-seven years, so that the door, contracted for in 1425, was not set in position till 1452. A literary programme for the door was drawn up by the humanist, Leonardo Bruni. 'I would like,' writes Bruni, 'to stand beside whoever is charged with designing the door, so as to make him take account of the full significance borne by each scene.' In the event Bruni's scheme was not adopted, and was replaced by a programme for which Ambrogio Traversari was probably responsible. Many details in the narrative treatment of the door, as well as its more classical style, must reflect the intervention of Bruni, Traversari, and other learned men. Initially, like its two predecessors, it was to consist of twenty-eight reliefs, eight with figures of prophets and twenty with narrative scenes. At some undetermined point before 1429 this scheme was changed; the prophets were transferred to the framework in the form of statuettes, and each wing of the door as finally executed contained five rectangular narrative reliefs. This change involved more than a superficial change of form. As the door was originally planned, the four scenes of the Creation of Heaven and Earth, the Creation of Adam and Eve, the Fall and the Expulsion from Paradise were to be represented on separate reliefs. But when the twenty narrative reliefs were reduced to ten all of these scenes had ultimately to be represented on one relief. As a result the scale of the figures is smaller than on the Siena font, and the sculptor is concerned throughout with creating a space illusion sufficient to enable the different incidents to be segregated from each other. In what is probably the earliest of the narrative reliefs, the Story of Adam and Eve (Plates 73–5), Ghiberti achieves

no more than limited success in imposing a convincing visual sequence on the scenes. In a rather later relief, the Story of Cain and Abel (Plate 79), on the other hand, the area of vision is extended so that each scene has its place in a consistent spatial scheme. The latest and in some respects the most remarkable of this group of reliefs is the Story of Noah. In this and in all the subsequent reliefs the creation of a space illusion is bound up with the discipline of linear perspective, and use is made of a type of orthodox legitimate construction described in the Treatise on Painting of Leon Battista Alberti.

The ten reliefs were modelled between 1429 and 1436, and are thus contemporary with, or somewhat later than, Donatello's Ascension with the Presentation of the Keys to St. Peter in London and somewhat earlier than Donatello's roundels in the Old Sacristy. Unlike Donatello, Ghiberti had nothing of the virtuoso in his make-up. His methods of space projection are none the less important for their aesthetic consequences in the works to which they were applied. The smooth articulation of the landscapes and the easy diminution of the figures in the Cain and Abel, the Story of Noah and the Story of Abraham could have been arrived at by no other means, and the sense of ease and harmony which they communicate is an outcome of the logical thought-processes by which they were produced. With the introduction of linear perspective, architecture plays a new part in Ghiberti's compositions, but even when peopled with small figures, as in the Story of Joseph, it remains a stage setting imperfectly integrated with the action taking place in front of it. Yet in the Porta del Paradiso the architectural settings are more spacious and lucid than in his earlier works, and comparison between the backgrounds of the Story of Esau and Jacob (Plate 76) on the door and the Baptist preaching before Herod at Siena (Plate 84) will show within what limits Ghiberti, in assimilating the thought processes of the Renaissance, came to employ Renaissance forms. The reliefs at the bottom of the door (particularly the Story of Moses, the Story of Joshua, and the David and Goliath) are more confused. Here Ghiberti seems determined to compress an entire world of action within the picture space, and the scenes fail in their effect because they are inadequately rationalized. That Ghiberti himself was conscious of this deficiency is suggested by the relief of the Raising of the Dead Child on the Arca di San Zanobio (completed for the Duomo in Florence in 1442), where the throng of onlookers is artificially disposed to form a visual pyramid. The true innovation of the Porta del Paradiso is to be found not in the compositional expedients employed in individual reliefs, but in the structure of the door, which embodies a new conception of the relationship of setting to relief. The significance of this was more fully appreciated in the sixteenth than in the fifteenth century, and Ghiberti's scheme is reflected in works as different as the sacristy door designed by Sansovino for St. Mark's in Venice and the bronze doors cast for the Cathedral at Pisa after the fire of 1595.

Also attuned to cinquecento taste were the borders of the door, and especially the reclining figures at top and bottom, one of which was imitated by Cellini. Conceived as a plastic frame for the narrative reliefs, the borders are enriched with small figures in niches and with small busts protruding from round apertures. These medallions make a significant advance on those

of the first door; of the self-portraits which the sculptor introduced in both, the earlier is smooth and generalized, whereas the later is more life-like and modelled with greater plastic sense. The element of naturalism, a legacy from the sculptor's Gothic past, is accountable for much of the fascination of the reliefs themselves. Such details as the team of oxen in the foreground of the Story of Cain and Abel (Plate 80), the youths in the Story of Abraham seated beside their grazing ass (Plate 81), and the touching group of Esau and Jacob (Plate 77) have a directness, a simplicity and a truth to nature which no other artist of the fifteenth century could reach.

The reliefs of the Porta del Paradiso are more pictorial than those of the earlier door, and they have sometimes been criticized on this account. But in the heads and figures in the border Ghiberti is revealed to us, in embryo, as a large-scale sculptor. Ghiberti's only monumental sculptures are the three bronze figures of Saints John the Baptist, Matthew and Stephen on Or San Michele in Florence (Plates 82, 83; Figs. 67, 68), the first completed in 1414, the second in 1422 and the third in 1428. By contemporaries these giant castings seem to have been regarded as a tour de force. In the earliest, the St. John, the pose has the predominantly Gothic character and the drapery that decorative emphasis which the first bronze door would lead us to expect, though there is nothing in Ghiberti's relief style which would prepare us for the firm, recessive handling of the boldly modelled head (Plate 82). The treatment of the St. Matthew (Plate 83) is more classical. Where the St. John is a Gothic figure enclosed in a deep niche, the St. Matthew advances from its shallower setting like some figure from antiquity. It is a matter for discussion whether, for Ghiberti, this closer approximation to an antique style was loss or gain. But in this statue, with its toga-like drapery, its grave, classical countenance and the rhetorical gesture of its right hand, the Ghiberti of the *Commentari* for the first and only time finds full expression in the figurative arts.

JACOPO DELLA QUERCIA

A second great Tuscan sculptor took part in the competition for the bronze door of the Baptistry. This was Jacopo della Quercia, a native of Siena. The work of Quercia is best defined in terms of the contrast it offers to Ghiberti's, and we may begin discussion of it at the point at which the orbits of these sculptors intersect, on the Siena font. In the first quarter of the fifteenth century Quercia was the most prominent artist in Siena, and when plans for the font were drawn up he, like Ghiberti, was entrusted with two narrative reliefs. But whereas Ghiberti fulfilled his contract, Quercia's reliefs were beset by procrastination and delay, so that the contract for one of them, the Presentation of the Baptist's Head to Herod, was transferred to Donatello, and the other, Zacharias in the Temple, was only begun after Donatello had delivered the companion scene. When we compare Quercia's Zacharias in the Temple (Plate 85) with Ghiberti's Baptist preaching before Herod (Plate 84) it is important to remember that this intervening experience of Donatello's compositional technique separates the two reliefs. Donatello's influence is to be traced mainly in the illusionistic treatment of the

brickwork and in the background, with its audacious intimation of the prospect seen through the arcade. But when we come to analyse the method by which the space is represented, we find that this is far less systematic and less logical than in Donatello's scene. Indeed the progressive elements derived from Donatello seem to have been grafted on to an anterior design in which the space recession is depicted as it would have been in a late fourteenth-century French Gothic miniature. The difference is apparent in the disposition of the figures as well as in the architecture. In Ghiberti's Baptist preaching before Herod the figures are grouped together at the front of the relief. In the Zacharias in the Temple, on the other hand, the figures establish a complicated series of diagonals and are disposed at angles to the picture plane. There is drama, as there is in Ghiberti's composition, but it is drama of a more introverted kind.

The Siena relief is something of an exception in Quercia's work, for unlike Ghiberti he practised principally as a marble sculptor. Where he was trained we cannot tell; perhaps at Bologna where, in the last two decades of the fourteenth century, the construction of S. Petronio brought together sculptors from Lombardy and Venice and promoted the growth of a group of local artists inspired by Jacobello and Pierpaolo dalle Masegne, perhaps in Florence among the marble sculptors employed on the Cathedral. Certainly Quercia's first fully authenticated work, a Madonna at Ferrara dated 1406, shows him to some extent under the spell of the Florentine marble sculptor Nanni di Banco, though even here the round, full features of the Virgin and her undulating hair suggest an artist who had some experience of Northern sculpture. The co-existence of classical elements with elements which are utterly unclassical is typical of Quercia's entire œuvre, and is already evident in the first work with which he is generally credited, the tomb of Ilaria del Carretto (Plate 86). Ilaria del Carretto died in 1405, and the tomb, which stands in the transept of Lucca Cathedral, is presumed to have been executed in the following year, but may date from as late as 1408. Part of the difficulty of discussing it arises from the fact that the monument is incomplete, having been broken up during the lifetime of the artist. According to Vasari, only the beauty of the effigy saved it from complete destruction. In its present form (Fig. 69) it is a table tomb consisting of two separate parts, one a sarcophagus and the other a sepulchral effigy. The sarcophagus is surrounded by winged putti bearing garlands imitated (like the little reliefs of Apollo and other classical figures which had found their way a decade earlier on to the Porta della Mandorla in Florence) from Roman prototypes. Not for a moment could we mistake these dancing figures for classical originals, yet in them Quercia appears as the precursor of a style which was to come to full fruition two decades or more later in Donatello's Florentine cantoria and in the Prato pulpit. The effigy is couched instead in the lyrical Gothic idiom of the North. With her head supported by two cushions and her feet resting on a dog, the symbol of fidelity, Ilaria del Carretto lies with closed eyes and crossed hands, serene amid her flowing drapery. The tomb type to which the monument belongs is unique in Tuscany, and must have been modelled on a North Italian or transalpine monument. But in Quercia's mouth the

lingua franca of Northern monumental sculpture acquires a personal inflection, and his model is transformed into a poignant and deeply individual work of art.

Between the completion of the Ilaria del Carretto and the commencement of the Fonte Gaia at Siena Quercia's style underwent a change. In Siena the Fonte Gaia (Fig. 71) had the same prominence as the Fontana Maggiore at Perugia; it occupied a place in the centre of the town, and like the Fontana Maggiore it was designed to illustrate a civic programme, in which the Virgin and Child were flanked by seated Virtues (with the later addition of two narrative scenes of the Creation and the Expulsion from Paradise) and were accompanied by figures of Rea Silvia and Acca Larentia, mother and foster-mother of Romulus and Remus, the legendary founders of the town. Contracted for in 1409, the fountain was originally to have been completed in twenty months, but work seems not to have begun before 1414 and not to have ended till five years later, so that in effect the Fonte Gaia is separated from the Ilaria del Carretto by about eight years. Classical elements there still are; both the Acca Larentia (Plate 89A), which is by Quercia, and the Rea Silvia (Plate 89B), which was carved from Quercia's model by his collaborator Francesco da Valdambrino, ultimately derive from the antique, though we do not immediately sense the presence of a Roman model behind their rippling forms. But in the central relief of the Virgin and Child (Fig. 73) the core of classicism has been dissolved, and is succeeded by handling so personal that, in their present greatly weathered state, the figures seem to have been modelled and not carved. The treatment of the drapery is enlivened by dramatic use of shadow, and the figures, the seat and the curtain in the background are unified into a rhythmic whole. The four Virtues on the rear wall of the fountain (some of them damaged and some totally destroyed) appear to have faced inwards towards the central group. The Wisdom, Faith and Temperance in the wings, on the other hand, are shown with knees turned to the spectator, but with eyes focused on the Virgin, and their poses are rooted in a mannerist opposition between the parts of the figure above and below the waist. In each case the forms are hidden beneath heavy, agitated drapery. A valid parallel for this picturesque style occurs in France, in the work of the Netherlandish sculptor Sluter who was active at Dijon between 1385 and 1406. We shall search in vain on the Fonte Gaia or elsewhere in Quercia's work for unambiguous evidence that he was familiar with Sluter's sculptures, and at first sight the differences between the work of the two artists are no less striking than the points they have in common. Yet the connection, however freely we interpret it, can hardly have been casual, and it may well be that Quercia owed to Sluter not only some of the external mannerisms of his style but what, in Italy, was a novel relationship between figure and ground.

Some impression of this may be gained from the Trenta altar in S. Frediano at Lucca (Fig. 70), which was begun in 1416, when work on the Fonte Gaia was still in progress, and completed soon after the Fonte Gaia in 1422. The impression is the clearer in that the primary source of this altar-piece was a domestic one, an altar carved for S. Francesco at Pisa by Tommaso, the brother of Nino Pisano. From this Quercia drew his formal scheme, the

lateral Saints standing in niches on raised pedestals, the carved predella and the tabernacles with sloping sides. But at this point the resemblance ends, for just as Sluter divorces his figures from their setting, so Quercia, working in deep relief and not, like Sluter, in the round, establishes a deliberate antithesis between the framing of the altar and the figures it contains. The Virgin (Plate 88), bolder and more developed than the Virgin of the Fonte Gaia, is preternaturally tall and swathed in profuse drapery. In this figure the robe which clings so closely round Ilaria del Caretto seems to have assumed an existence of its own, rolling and swelling like the surface of a sea. In comparison with the earlier relief it is as though the first impact of Sluter's sculptures had subsided, and Sluter's naturalistic style, at the hands of an artist devoid of the least tendency towards naturalism, had been irremediably idealized. In the four lateral Saints (Plate 87), as with the Virgin, the effect aimed at is mobile, not monumental, and the main function of the ground is to set off their restless play of form.

This relationship is found again, albeit on a greatly reduced scale, in the reliefs on the tabernacle of the Siena font. Most of the work on the tabernacle seems to have been completed by 1430, among it the prophets carved by Quercia in niches on five of the six sides. Though their setting is in large part Florentine, these prophets form a summary of Quercia's figurative repertoire, the final working out, through a more linear vision and by a more emotional temperament, of aesthetic principles which had guided Sluter in designing the weepers round the tomb of Philippe le Hardi at Dijon thirty years before. The concern with the emotive possibilities of form to which these figures testify reaches its climax at Bologna in Quercia's final masterpiece, the Genesis reliefs on the doorway of S. Petronio. The doorway of S. Petronio (Fig. 74) was commissioned in 1425, and was to be completed in two years. But once more work was protracted, and the door was still unfinished when Quercia died in 1438. Its main sculptural features are three figures in a lunette above the entrance (of which only two, the Virgin and Child and the San Petronio, are by Quercia), five upright scenes from Genesis on each of the lateral supports, and five oblong scenes from the life of Christ running across the architrave. Istrian stone for the Genesis scenes was ordered in 1429, and work on them is thus exactly contemporary with the modelling of the narrative reliefs for the Porta del Paradiso. In its present state, however, the monochrome effect of the Bologna doorway is almost as untrue to the intentions of the sculptor as was the effect made by Ghiberti's door before the gilded surfaces of the reliefs had been revealed. Documents refer to the purchasing of stone in Venice and of Verona marble in Verona, and when the spiral columns beside the entrance were a light yellowish pink, and the reliefs of prophets next to them were white, the doorway must have appeared not the grim, rather austere work it seems now, but an achievement of great brilliance and variety. In the illusionistic statuary of the lunette it is as though the sculptural conceptions embodied in the portal of the Chartreuse de Champmol had been translated to Emilia. Of all Quercia's representations of the Virgin and Child, that at Bologna (Plate 90) is the most remarkable. Once more the figure is posed at an angle to the front of the lunette; the right knee is advanced, the Child is held forward

in the right arm, and the left knee and left arm are drawn back, so that the group falls away on the left side. The planned disequilibrium of this pose has a precedent in the Acca Larentia at Siena, but at Bologna the scheme employed is incomparably richer and more unorthodox.

Quercia's relief style at Bologna is flatter than on the Fonte Gaia. In the Expulsion from Paradise at Siena (Fig. 72) the figures are carved so deeply that the Adam looks like a statuette fixed to the ground. At Bologna (Plate 93), on the other hand, the figures adhere closely to the relief plane. One result of this change is that the compositions, to a far greater extent than any that precede them, are conceived in terms of line. Throughout the fourteenth and fifteenth centuries the style of Sienese painting is predominantly linear, and though Quercia's nervous line has little in common with the linear harmonies that were created by Simone Martini and revived by Sassetta, his avoidance of solid modelling and his treatment of the relief surface as a pattern devoid of space illusion are characteristically Sienese. On the Porta del Paradiso the use of line is a purely aesthetic device which enhances the visual attractiveness of the reliefs. At Bologna, on the contrary, it dictates the imagery of the carvings, and is the method by which their emotive content is expressed. A number of the scenes shown on the Porta del Paradiso are also represented on the Bologna door; this duplication serves to underline the utterly divergent attitude of the two artists to the same narrative demands. In the Creation on the Porta del Paradiso (Plate 74) the solemn God the Father bends towards Adam as though he were performing some antique rite, and the Adam, heavy and somnolent, is slowly awoken from nonentity. At Bologna (Plate 91) the God the Father is a supernatural being and the Adam, young, vigorous and muscular, bends forwards eagerly as he receives the gift of life. For Quercia the relief field is dominated not by an artificially constructed setting, but by the human figure, and certain of the scenes generate great imaginative power. This psychological aspect of the reliefs, the defining of emotions and temperament, is impressed on us most forcibly in the progressive treatment of the head of Adam, where the features register hope, doubt, despair, and finally the grim determination with which he confronts his destiny. In the Sacrifices of Cain and Abel (Plate 95), the brothers are treated as a physical embodiment of the emotions by which they are inspired. No one who has not studied Quercia's carvings at eye level can conceive the directness and confidence of his technique, the delicacy with which, in the Temptation, he depicts the softness of Eve's hair and the movement of her lips, or the eloquence of the hands with which she holds the fruit and of the protesting hand of Adam isolated against the tree (Plate 94). These carvings are certainly more vivid than Ghiberti's Genesis reliefs. Yet despite their astonishing originality it is a not uncommon experience, after studying both sets of reliefs, to feel that Ghiberti, with his rich humanity and strong sense of tradition, penetrated more deeply that Quercia into the nature of each scene.

Like most great innovators, Quercia and Ghiberti trailed behind them constellations of smaller stars. Among the pupils or imitators of the former we have the names of Giovanni da Imola, Pietro del Minella and many more. In some cases we can identify works by these

sculptors, in others not, but none of them emerges as an artistic personality in his own right. Outside Bologna, Lucca and Siena Quercia was not an influential artist, and within these towns his influence was limited to superficial aspects of his style. The difference between his creative capacity and that of other artists in Siena can be assessed most easily in the field of wooden sculpture by comparing his Annunciation group at San Gimignano (Fig. 76) with an Annunciation group at Asciano by Francesco di Valdambrino (Fig. 75), his fellow competitor in Florence in 1401 and his collaborator on the Fonte Gaia. Francesco di Valdambrino's Virgin Annunciate and Annunciatory Angel are exquisitely childlike figures, unsullied by the least trace of interpretative emphasis. In Quercia's, on the other hand, the greater freedom of the forms and the meaningful glances with which the two figures survey each other invest the group with a new character. Of the two artists it is Francesco di Valdambrino who fits more readily into the context of Sienese quattrocento style, and his bust of St. Victor in the Opera del Duomo (which was cut down from a reliquary statue carved for the Cathedral in 1409), refined and rather feminine, appealing for our sympathy with parted lips and wide-spaced eyes, is a figure that we meet repeatedly in Sienese quattrocento paintings. Domenico di Niccolò dei Cori, a less prolific but more significant artist than Francesco di Valdambrino, outlived Quercia by almost fifteen years. Yet his sensitive figure of St. John the Evangelist in S. Pietro Ovile at Siena (Plate 97) reveals the influence not of Quercia but of the young Ghiberti, reflected in an unfamiliar medium and on an unwonted scale.

Ghiberti's powerful personality left a stronger mark than Quercia's on the sculpture of his time. Of the minor artists employed on the Siena font, Giovanni Turini, in his three figures of Virtues, and Goro di ser Neroccio, in his statuette of Strength, though they were natives of Siena, mirrored the image of Ghiberti, not of Quercia; and the relief of the Birth of the Baptist which Giovanni Turini and his father Turino di Sano contributed to the cycle of narrative reliefs is little more than a pastiche of elements from the seminal compositions of the first bronze door. One of Ghiberti's pupils, Giuliano Fiorentino, carried his style as far as Spain, and in Florence it is met with in a pigmented terracotta Coronation of the Virgin above the entrance to the church of S. Egidio. But the means by which Quercia's and Ghiberti's styles were most widely disseminated were stucco and terracotta reproductions of compositions devised by these artists or in their studios. This is controversial ground. If a critic in the late nineteenth century had been asked what was the extent of Quercia's influence, he would have replied that it was very great, since he would have credited Quercia with a vast number of pigmented Madonnas in these mediums. Had the question been put twenty-five years later, it would have elicited the answer that Quercia's influence was very small, since most of these Madonnas were then handed over to Ghiberti. Today our estimate lies somewhere between the two extremes. But though it would be generally agreed that in this sphere as well Ghiberti's influence far exceeded Quercia's, the fact remains that one or two of these Madonnas can be confidently looked upon as works either by Quercia or by his pupil Federighi, while there is no composition of this order which we would be justified in

regarding as Ghiberti's. One of the most attractive of the Ghibertesque Madonnas is at Rochester (Fig. 77) and was modelled by an unknown artist who was also responsible for other works. The relation of the Virgin to the Child in this relief has a touching intimacy which exhales the authentic spirit of Ghiberti. Another Madonna of this class, in Washington, is by a no less graceful but more progressive sculptor, perhaps Nanni di Bartolo (Plate 96). The vogue of these half-length Madonnas, made for the most part for private devotional purposes, extends through the whole fifteenth century.

NANNI DI BANCO

In Florence in 1362 work was resumed on the façade of the Cathedral, and from then on a host of documents testifies to large-scale sculptural activity. The first sculptors to be employed there, Francesco di Neri and Simone Talenti, are mere names, but from the thirteen eighties on there emerge the leading figures in the transitional period to the fifteenth century, Jacopo di Piero Guidi, Giovanni d'Ambrogio, and Pietro di Giovanni Tedesco, a sculptor from Brabant who had worked on Milan Cathedral. Of greater artistic interest than the sculptures for the façade is another contemporary commission in which two of the same artists were involved. This was for the large reliefs of Virtues above the arcading of the Loggia dei Lanzi (Plate 59), which were designed by the painter Agnolo Gaddi in a style which forms a Florentine parallel for the International Gothic sculpture of Milan Cathedral, and which were executed by Giovanni d'Ambrogio and Jacopo di Piero Guidi. The scale of the reliefs is very large, and in them one of the two sculptors, Giovanni d'Ambrogio, proves to be an artist of considerable resource. When work began in 1391 on the lower part of the Porta della Mandorla on the north side of the Cathedral, Giovanni d'Ambrogio, Jacopo di Piero Guidi and Pietro di Giovanni Tedesco were again employed, along with Niccolò di Pietro Lamberti, who may also have been responsible for a frigid, unyielding Virgin and Child with two Angels over the Porta dei Canonici on the south side of the Cathedral. The lower part of the Porta della Mandorla includes among its decoration reliefs of a strongly classicistic cast, and when work was resumed, this time in 1404, on the lunette above the doorway, the forward-looking character of the whole scheme became still more pronounced. At this time a marble group of the Annunciation, now in the Museo dell'Opera del Duomo, was carved for the lunette, by a sculptor who was certainly responsible for some of the more progressive sections of the decorative carving and who may well eventually prove to be identical with Giovanni d'Ambrogio (Fig. 87). Two new names also appear among the sculptors working on the door, those of Antonio di Banco and his son, Nanni di Banco.

Ghiberti and Quercia are not purely Gothic artists, yet neither could legitimately be included in a volume on Renaissance art. Nanni di Banco, on the other hand, can be looked upon at will as a Gothic artist in contact with Renaissance style, or as a Renaissance sculptor who retains some features of Gothic art. His statue of St. Luke in the Museo dell'Opera del Duomo in Florence (Fig. 79) was commissioned in 1410 and completed in 1413, two to three

years earlier than the companion figures of St. Mark by Niccolò di Pietro Lamberti (Fig. 81) and St. John by Donatello (Fig. 80). Stylistically it has a middle place between the less advanced St. Mark and the more advanced St. John. Constricted in pose, the St. Mark is seated stiffly in full-face, with the cloak stretched tight across the body and looped up at the sides in decorative folds. In the St. Luke all this is changed. The head is tilted slightly upwards with the eyes half-closed and gazing down; the protruding elbows enhance the sense of roundness and solidity; both at the neck and waist the robe is rendered with masterly resource; and the cloak is disposed over the arms and legs in heavy folds, from which the statue derives much of its authority. If comparison with the St. Mark enables us to measure the sculptor's innovations, comparison with the St. John enables us to gauge the limitations of his style. A less mature and in some respects a less accomplished work of art, Donatello's St. John is the creation of a more forceful and more independent artist, and it is in this work, not in the St. Luke, that a Renaissance style is predicated.

Nanni di Banco, at this stage in his career, evinces a truer understanding of the sculpture of antiquity than any Tuscan artist since Arnolfo di Cambio. Without close study of antiquity the St. Luke could never have been executed. Its successor, the group of the Quattro Santi Coronati (Plates 100, 101; Fig. 83) which was carved for Or San Michele perhaps concurrently with the Evangelist, perhaps immediately afterwards, also has roots in the antique. But whereas in the St. Luke only the head is truly classicistic, the conception as well as the treatment of the Quattro Santi Coronati depends from the antique. Vasari records a story that when completed the four life-size Saints could not be fitted in their tabernacle, but this can hardly be correct as Nanni di Banco's group seems to have been closely cogitated and derives from Roman grave-altars with figures disposed in half-length in a niche. Roman art too supplies sources for the curtain running round the niche which provides the group with an element of visual continuity, and for the expedient by which the figure on the right is represented gesturing towards his companions and addressing them with parted lips. This view of the niche as a stage occupied by life-size actors was to prove of decisive importance for the Cavalcanti Annunciation of Donatello and the Christ and St. Thomas of Verrocchio. Judged on its own merits, however, not as a stage in a historical development, the group is a cold, rather academic work, the creation of a Michelozzo born before his time, not, as is sometimes claimed, of a frustrated Donatello.

Had Nanni di Banco's work terminated at this point, he could be considered only as a Renaissance artist. But in the last great work he undertook before his death in 1421, a relief of the Assumption of the Virgin over the Porta della Mandorla of the Cathedral in Florence (Fig. 86), the tide of classicism has begun to ebb. It would be wrong to think of the Assumption as a return to Gothic art, since Nanni di Banco's classicism was limited to works for which precedents occurred in Roman sculpture, and was insufficiently far-reaching to enable the canon of classical style to be applied to subjects or types of sculpture for which Roman art did not offer precedents. Indeed the style of the Porta della Mandorla relief is in

some respects less classical than that of its immediate source, Orcagna's Assumption in Or San Michele, from which the Virgin (Plate 102) in her almond-shaped aureole supported by six angels and the tree and kneeling figure of St. Thomas at the bottom of the composition were evidently drawn. Orcagna's Virgin is a heavy frontal figure set on a cushioned throne, whereas Nanni di Banco's, swathed in loose drapery and half turning towards the figure of St. Thomas, floats seemingly without support. In the same way the angels of Orcagna, with staid poses and simple robes that should have proved congenial to the sculptor of the Quattro Santi Coronati, are replaced by six athletic figures (Plate 103), exhibiting what Vasari, more than a century later, termed 'the most beautiful movements and attitudes that had been devised till then, seeming to be in motion and to have pride in flight'. To these is added a seventh angel standing with legs crossed at the apex of the composition. When we look at the angels' buoyant drapery, we feel no surprise that Quercia's name should traditionally have been attached to the relief. In terms of the evolution of Italian sculpture, Nanni di Banco's Assumption is less forward-looking than his free-standing statuary, but it is the work which leaves the strongest impression of his genius, and it reveals potentialities which the Quattro Santi Coronati would not lead us to suspect. Most important of these is a capacity to animate the relief surface by reconciling the conflicting claims of plastic form and linear design, which neither Quercia, with his strong predisposition towards line and limited feeling for plasticity, nor Ghiberti, on the smaller scale of the bronze doors, was able to surpass.

FLORENTINE SCULPTORS IN NORTH ITALY

By the time of the competition of 1401 Florence was established as the main scene of sculptural activity in Italy. Two years later we find the Doge of Venice, Michele Steno, applying for a Florentine architect and sculptor to work on the Palazzo Ducale. Had Nanni di Banco or Ghiberti moved his studio to Venice, the story of Venetian sculpture would have been transformed. But for reasons which can be readily envisaged the Tuscan sculptors who sought their fortunes in north-eastern Italy were secondary artists. The most important of them were Niccolò di Pietro Lamberti and his son Pietro di Niccolò, Nanni di Bartolo, known as Rosso, and a terracotta sculptor Michele da Firenze. Sculpture in terracotta had the advantage over marble sculpture that it permitted works on a large scale to be executed rapidly and at low cost. Michele da Firenze (if indeed he was responsible for the long list of works ascribed to him) was a prolific artist, who transferred his workshop from Arezzo to Verona, and thence to Ferrara and Modena, working in a facile archaizing style, part Ghibertesque, part North Italian, which derives its interest from the sheer volume of the sculptor's output rather than from innate aesthetic quality. His most important work in northern Italy is in the Pellegrini Chapel in S. Anastasia at Verona (Fig. 78), where the wall surfaces are cased with reliefs in terracotta which were originally pigmented and in their painted state must have looked more pleasing than they appear today. The vogue for terracotta sculpture also spread to Venice, where, between 1432 and 1437, it inspired the monument of the Beato Pacifico (Fig. 88). In

this tomb, with its delightfully spontaneous angels and vigorous narrative reliefs, we are more conscious of the merits of the medium than in Michele da Firenze's machine-made designs.

The activity of the studio or studios identified as Michele da Firenze's forms a cul-de-sac in the history of North Italian sculpture. The Lamberti and Rosso, on the other hand, are part of its main stream, and were called on to collaborate both with Venetian artists and with the Milanese sculptors who were extensively employed in Venice. As his St. Mark for the Cathedral in Florence demonstrates, Niccolò di Pietro Lamberti was an unenterprising artist. None the less in Venice, where he arrived in 1416, he seems (confronted with the unfamiliar medium of Istrian stone) to have acquired new confidence, and in the principal work with which he was entrusted there, the sculpture on the upper part of the façade of St. Mark's (Fig. 91), he proved himself not entirely unworthy of his opportunities. The construction of the upper part of the façade and of the north flank of the church was begun in 1385; it consists of a large semi-circular arch over the central window and two smaller arches on each side, surmounted by foliated decoration and divided from each other by open tabernacles. Niccolò di Pietro's most notable successes were achieved not in the free-standing statues in the tabernacles (which are marked by the same poverty of invention as his statues in Florence) but in the sculpture above the arches, which demanded an effort of self-adaptation to Venetian style. In each case the sculptured decoration consists of a single figure on a pedestal rising from the apex of the arch, and of a number of smaller figures springing from the acanthus border with which the arch is framed. Particularly in the central figure of St. Mark, Niccolò di Pietro rises far above the average level of his work.

Of Niccolò di Pietro's son, Pietro di Niccolò Lamberti, little is known. Perhaps he was responsible for the subsidiary figures above the lateral arcades; possibly he carved the frieze with scenes from the Old Testament (one of them based on the Sacrifice of Isaac of Ghiberti) that runs round the window above the entrance; probably he was the author of the four Florentine figures of nude youths supporting water-spouts on the north side of the basilica. His only authenticated work in Venice, the tomb of the Doge Tommaso Mocenigo in SS. Giovanni e Paolo (Fig. 89), was carved in 1423 in collaboration with a sculptor from Fiesole, Giovanni di Martino. This monument is a medley of Tuscan and Venetian elements. Among the latter are the six figures of Saints ranged along the wall (for which there is a precedent in the tomb of Marco Cornaro in the same church), as well as the reliefs of Saints on the sarcophagus (which recall those on the Venier monument of Pierpaolo dalle Masegne). But whereas the niches of the Venier tomb are Gothic (Fig. 59) the shell niches of the Mocenigo monument have the rounded tops which were introduced concurrently in Florence in the Coscia monument of Donatello and Michelozzo.

Nanni di Bartolo, known as Rosso, is a more sharply defined figure than Pietro di Niccolò Lamberti, first because we know more of his work in Florence (where he collaborated with Donatello on a group of Abraham and Isaac and carved a statue of Abdias for the Campanile),

and secondly because his later style is attested by the signed doorway of S. Nicola at Tolentino (1432–5) (Fig. 85). The head of the Abdias (Plate 98) is Donatellesque, but the loosely swathed drapery is Rosso's own, and in the three statues above the Tolentino doorway, this is still preserved. Rosso had left Florence for Venice by 1424, and at some time between this date and 1432 he worked at Verona on the Brenzoni monument in San Fermo Maggiore (Fig. 90). Only in the athletic putti who hold back the curtains at either side, the statue of a Prophet at the top and the sleeping soldiers in the foreground can we feel confident of Rosso's authorship. The remaining figures, a Risen Christ and three angels, must have been executed by a North Italian hand, and may have been designed by Pisanello, who was responsible for the fresco of the Annunciation which surmounts the tomb.

THE SCULPTURE OF THE PALAZZO DUCALE

Most of the problems with which the works of the Lamberti and of Rosso are beset spring from the interaction of their styles with those of native artists who were laying the foundations of fifteenth-century Venetian sculpture. The main focus of their activity was the Palazzo Ducale. We know neither their names nor the precise dates at which they worked, but one of them emerges as a sculptor of considerable distinction in two large carvings of the Fall (Plate 104) and the Drunkenness of Noah (Plate 105) on the outer corners of the palace facing towards the Ponte della Paglia and the Piazzetta, and was also responsible for a figure of Venice on the west flank of the building and a number of capitals in the colonnade beneath. The most primitive of these reliefs, the Fall, may have been carved as early as the last decade of the fourteenth century, and the latest, the Venice, may be as late as 1420. So superior is this artist to all of his contemporaries in Venice, that he is perhaps to be identified with the most prominent Venetian sculptor mentioned in documents, Giovanni Buon, who was already active in 1382. A microcosm of his style is provided by the capital beneath the Fall. On the front are reliefs of the Creation of Adam, Saturn with a ram, and Luna, a virginal figure seated in a boat, and round the sides and back are the remaining planetary deities. These little figures and the foliage in which they are set draw their sustenance from observation of the natural world, and in front of them we might suppose that the arid iconostasis of the Dalle Masegne was not a hundred paces but a hundred miles away. Here, and in the relief above, we are reminded of the Genesis scenes on the monument of Mastino II della Scala at Verona, where, though the quality is lower and the style is less sophisticated we find the same conjunction of ideal figures and meticulously rendered natural forms.

The carved foliage of this relief is carried through, on a considerably larger scale, into the Fall. 'The tree', writes Ruskin of the Fall, 'forms the chiefly decorative portion of the sculpture. Its trunk . . . is the true outer angle of the palace—boldly cut separate from the stonework behind, and branching out above the figures so as to encompass each side of the angle, for several feet, with its deep foliage. Nothing can be more masterly and superb than the sweep of this foliage on the Fig-tree angle; the broad leaves lapping round the budding fruit, and

sheltering from sight, beneath their shadows, birds of the most graceful form and delicate plumage. The branches are, however, so strong, and the masses of stone hewn into leafage so large, that, notwithstanding the depths of the undercutting, the work remains nearly un-injured.' On the two faces of the relief are Adam and Eve, isolated from each other by the central trunk. In point of composition the Drunkenness of Noah is more ambitious than the Fall. Once more a tree trunk fills the angle of the carving, but here the two flat surfaces are linked by the extended hand of Shem covering his father's nakedness. The figures in the Drunkenness of Noah are more expressive than those in the Fall, and the bearded patriarch on the left has often been compared with a bearded Gigante carved by Matteo Raverti for the Duomo at Milan before 1409. Raverti was in Venice in 1418, but the connection of the angle reliefs with his authenticated sculptures is too superficial to enable them to be ascribed to him. Certainly the author of the angle reliefs must have known the sculptures on Milan Cathedral, but he must also have been acquainted with the South German and Austrian sculpture which was in circulation in Venice in the early fifteenth century.

In 1422 it was decided that the façade of the palace on the Piazzetta (Fig. 92) should be continued northwards to the Porta della Carta, and in 1424 the demolition of the buildings on this site began. The presence of Giovanni and Bartolommeo Buon as architects of the new part of the Ducal Palace was a guarantee of continuity between the old building and the new, and the sculptural decoration of the new section consisted, like that of the old, of carved capitals in the loggia below and of a large relief of the Judgment of Solomon (Plates 106, 107, Fig. 93) on the angle of the building towards the Porta della Carta. The finest of the new capitals, that under the angle relief, corresponds with the Genesis capital, and is carved with a figure of Justice and with reliefs of Moses receiving the Tablets of the Law, the Justice of Trajan and other related scenes. There are many Florentine features in these little reliefs, and if the scenes in the border of the central window of St. Mark's are by Pietro di Niccolò Lamberti, the same sculptor may have been responsible for the Justitia capital. Far harder is the problem of the Judgment of Solomon above. This beautiful design takes as its point of departure the relief of the Drunkenness of Noah. Once again a tree trunk runs up the corner of the building, and once again the artist successfully unites the two faces of the relief. But the Judgment of Solomon is a work of far greater genius and vitality than its two predecessors. If the relief, as is sometimes claimed, be by Bartolommeo Buon, how are we to explain a sense of movement and a feeling for dramatic narrative which have no counterpart in this sculptor's documented works? Or if, as has also been suggested, it be by Pietro di Niccolò Lamberti, how are we to account for its pronouncedly Venetian character? There is one authenticated case in which a Tuscan artist collaborated with the Buon studio, in a well-head of 1427 in the Ca' d'Oro by Bartolommeo Buon and Nanni di Bartolo. If the Judgment of Solomon were collaborative in this sense, it is likely to be due to the same artists, and there is indeed a close morphological resemblance between the heads of Solomon and of the executioner and Nanni di Bartolo's documented works.

THE MASCOLI MASTER

In the angle reliefs and the capitals beneath them the influence of the Dalle Masegne is no-
where to be found. But it remained operative at least till the third decade of the century in
the work of the Mascoli Master. This sculptor derives his name from a marble altar-piece
and antependium in the Mascoli Chapel in St. Mark's (Plate 108). In the altar-piece the three
figures stand on pedestals like those used in the Bologna altar of the Dalle Masegne beneath a
typically Venetian superstructure framed with acanthus leaves. The pose of the Virgin
contains a last lingering reminiscence of Nino Pisano's Cornaro monument, but in the lateral
Saints the hard cutting and metallic folds recall the Apostles of the Masegne iconostasis. With
a difference, however, for the two figures fill their niches with a confidence and ease which
suggest that the Mascoli Master must have known Florentine Renaissance statues of the type
of Donatello's St. Mark. In the antependium, in which two kneeling angels cense the cross,
the hair of the two figures is dressed in the International Gothic fashion adopted by Walter
Monich for his statue of St. Stephen in Milan Cathedral. In a later work by the same sculptor,
the lunette over the entrance to the Cappella Cornaro in the Frari (Plate 109), these Inter-
national Gothic angels appear again, one of them proffering a small cross to the Child. This
provides the motivation of what is, from a formal point of view, one of the most pleasing
groups in Venetian Gothic sculpture, in which the Child steps eagerly towards the Cross, and
the Virgin, turning her head, endeavours to restrain him. The Cornaro tympanum is one of
the first Venetian reliefs in which space construction plays some part, in that the angels are
set in a frontal plane and an attempt is made to depict the recession of the throne.

BARTOLOMMEO BUON

The œuvre of the Mascoli Master is very small. His contemporary, Bartolommeo Buon, was
a more prolific if a less adventurous artist. Bartolommeo's name occurs for the first time in
1392 and he seems to have continued work till after 1463. Despite the length of his activity
and his prominence in Venice, where through the second quarter of the fifteenth century
there was no one to dispute his leadship, much about Bartolommeo Buon is problematical.
Like his father, he was employed primarily as an architect, and his sculpture was to some ex-
tent an adjunct to his architectural activity. The organization of his studio must have had
more in common with the workshops of the North than with those of Tuscany, and scarcely
ever does the execution of his sculpture bear the personal stamp which the carvings of even a
secondary Florentine artist like Rosso might lead us to expect. Naturally enough, Buon
derived his inspiration from the North, partly at first hand from South German statues of the
type of the Madonnas which are still preserved in St. Mark's and at Treviso, and partly at
second hand from the Venetian sculpture of the generation before his own. Whether or not
Giovanni Buon was responsible for the Fall and the Drunkenness of Noah, the strong feeling
for nature and the generalized treatment of the human figure manifest in these reliefs formed

the basis of Bartolommeo's sculptural style as we meet it between 1438 and 1442 on the Porta della Carta of the Palazzo Ducale (Fig. 93).

Set between the Palazzo Ducale and the Basilica of St. Mark's, the Porta della Carta was in the fifteenth century, as it remains today, the principal entrance to the Doges' Palace. The area it occupies is narrow and disproportionately high, and is set back from the level of the church on one side and the loggia of the Ducal Palace on the other. To invest it with appropriate architectural emphasis Buon provided that the doorway and the window above it should be flanked by strongly defined vertical supports, each with two tabernacles with statues of the Virtues and a shield supported by two putti, culminating in a pinnacle. Above the doorway and beneath the window is a large oblong relief showing the Doge, Francesco Foscari, kneeling before the Lion of St. Mark. Sculpturally, however, the most remarkable part of the design is the superstructure above the window, which contains in the centre a medallion of St. Mark supported by flying figures and is framed by six putti (Plate 111) climbing resolutely towards the summit through huge acanthus leaves. Of the many foliated friezes in Venetian Gothic sculpture none is more energetically carved than this, and the lusty children clambering up it are Venetian Gothic counterparts to the Florentine Renaissance putti on the singing galleries which Luca della Robbia and Donatello were completing at about this time. At the apex is a foliated platform from which a seated figure of Justice (Plate 110) looks down at the angle relief of the Judgment of Solomon and the Justitia capital below. With the rounded forms and the smooth features of a Schöne Madonna from Salzburg or Tyrol, this bland and benign figure is perhaps Buon's most impressive carving.

Much of the effect made by this figure is due to the fact that it remains in its original position high above the doorway. When Buon's works are examined at eye level (as is possible with a relief of the Madonna of Mercy (Plate 112) carved about the middle of the century for the tympanum of the Scuola Vecchia della Misericordia and now in London) their generalised forms are seen to suffer from lack of tension and from an inadequate technique. The Madonna of Mercy carved by Bernardo Rossellino for the entrance of the Misericordia at Arezzo offers a nearly contemporary Florentine solution of the problem that confronted Buon when he designed this work. Technically the Madonna of Mercy at Arezzo is a work of far greater accomplishment than the relief in London; beside Bernardo Rossellino, master of the refinements of Tuscan marble sculpture, Buon seems little better than an artisan, whose execution, adapted to the working not of marble but of Istrian stone, was insufficiently subtle and diversified to enable him to animate the surface of his relief. Iconographically, moreover, the lunette adheres to a Byzantine convention, in which the Child is displayed symbolically on the Virgin's breast, which would have been unfamiliar and unacceptable in Florence. As in the paintings which Antonio Vivarini was executing in Murano at this time, its strength rests in the artist's feeling for simple formal relationships. Though it contains Renaissance features, these are interpreted in the spirit of a medieval craftsman, not of a Renaissance artist.

With the death of Buon Italian Gothic sculpture reaches its close. In the North the tradition of Gothic style persisted for more than fifty years, but in Italy its day was done. In Florence Brunelleschi was dead, and Donatello was completing the masterpieces of his last years; in Rome the renascence inaugurated by Pope Nicholas V was under way; in Naples Pisanello, in his last medallic images, had created the Renaissance portrait; in Milan the path lay open to a sculptural revival which centred on Pavia; and in Venice itself, by other hands, the foundations of Renaissance style were already being laid. But whereas in architecture and in painting the break between Gothic and Renaissance was a real one, in that a style which was essentially unclassical gave way to a style based on the antique, in sculpture it marked neither an end nor a beginning, for Italian Gothic sculpture forms a prologue, as Italian Baroque sculpture forms an epilogue, to the central chapter of Renaissance art.

PLATES

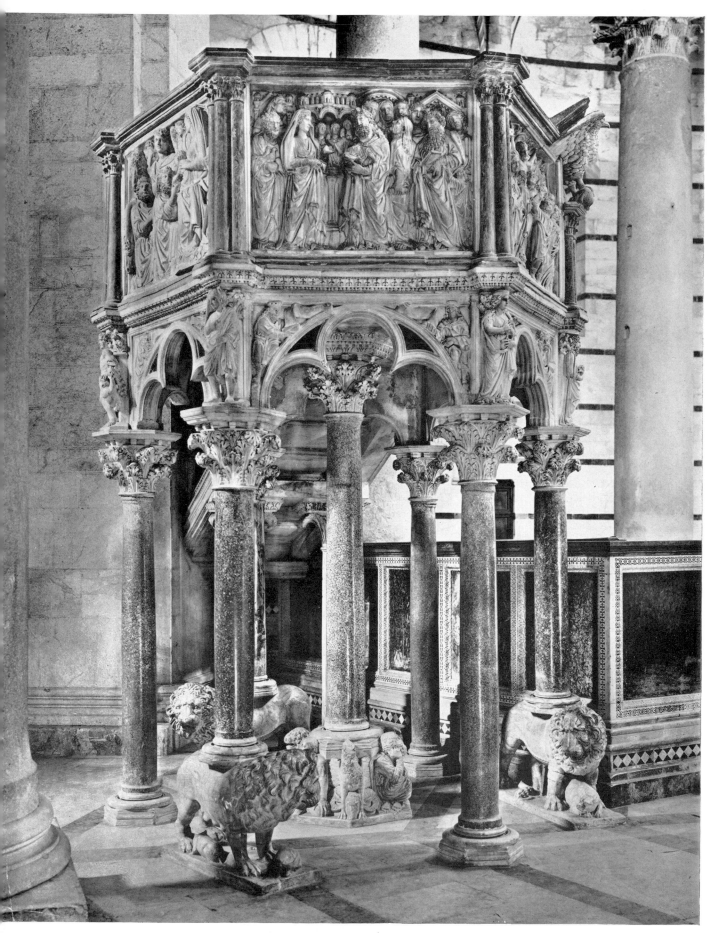

1. Nicola Pisano: PULPIT. Baptistry, Pisa.

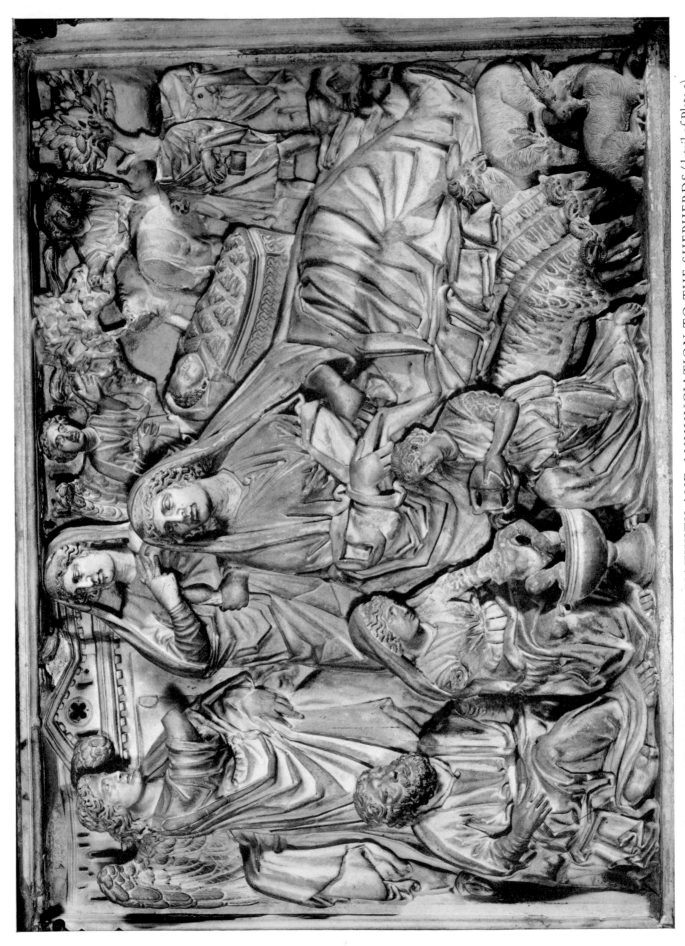

2. Nicola Pisano: THE ANNUNCIATION, NATIVITY AND ANNUNCIATION TO THE SHEPHERDS (detail of Plate 1).
Baptistry, Pisa. Marble (85 × 113 cm.).

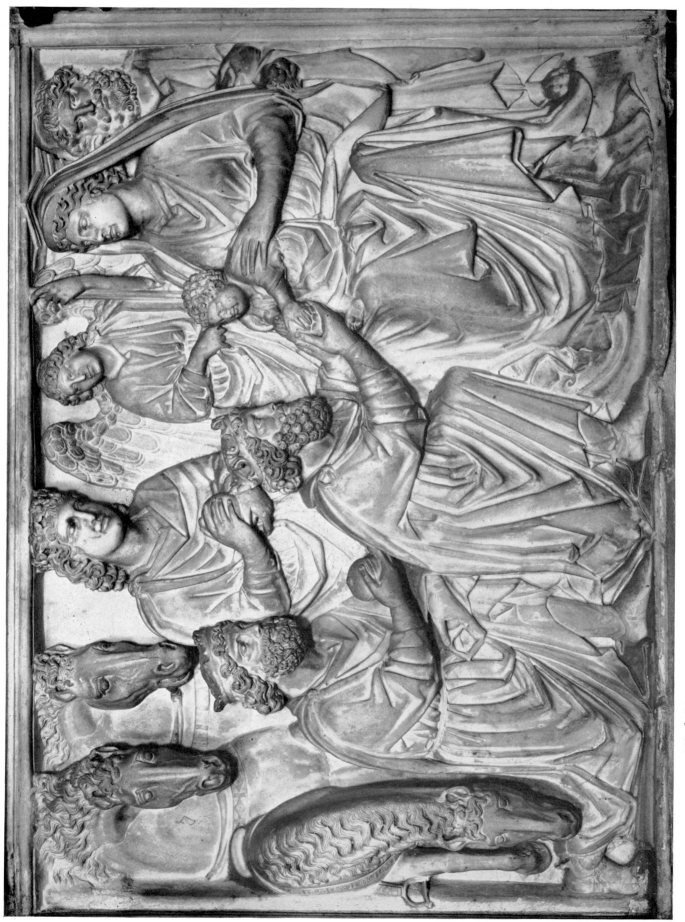

3. Nicola Pisano: THE ADORATION OF THE MAGI (detail of Plate 1). Baptistry, Pisa. (85 × 113 cm.)

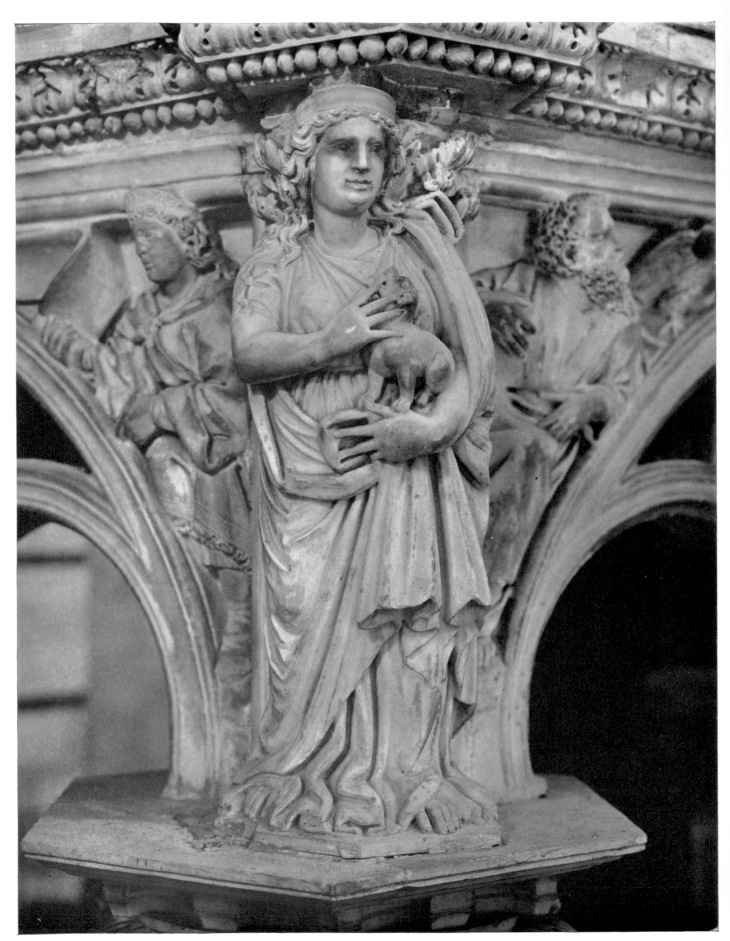

4. Nicola Pisano: FAITH (detail of Plate 1). Baptistry, Pisa. Marble (H. 57 cm.).

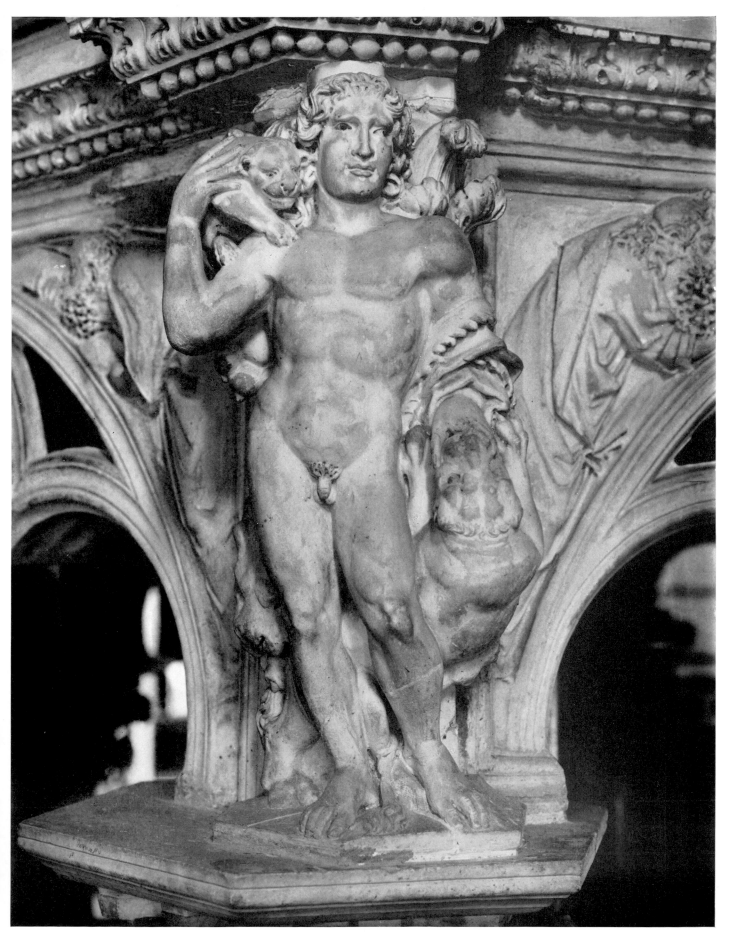

5. Nicola Pisano: STRENGTH (detail of Plate 1). Baptistry, Pisa. Marble (H. 56 cm.).

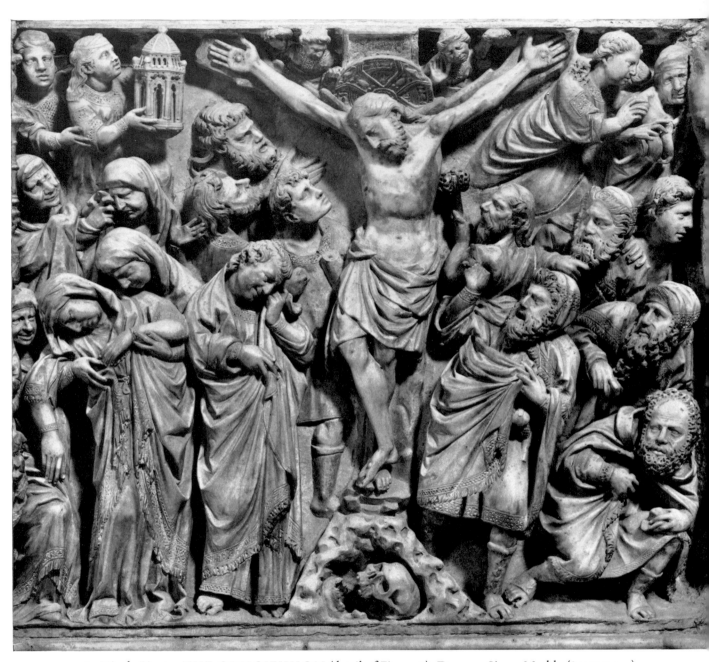

6. Nicola Pisano: THE CRUCIFIXION (detail of Figure 8). Duomo, Siena. Marble (85 × 97 cm.).

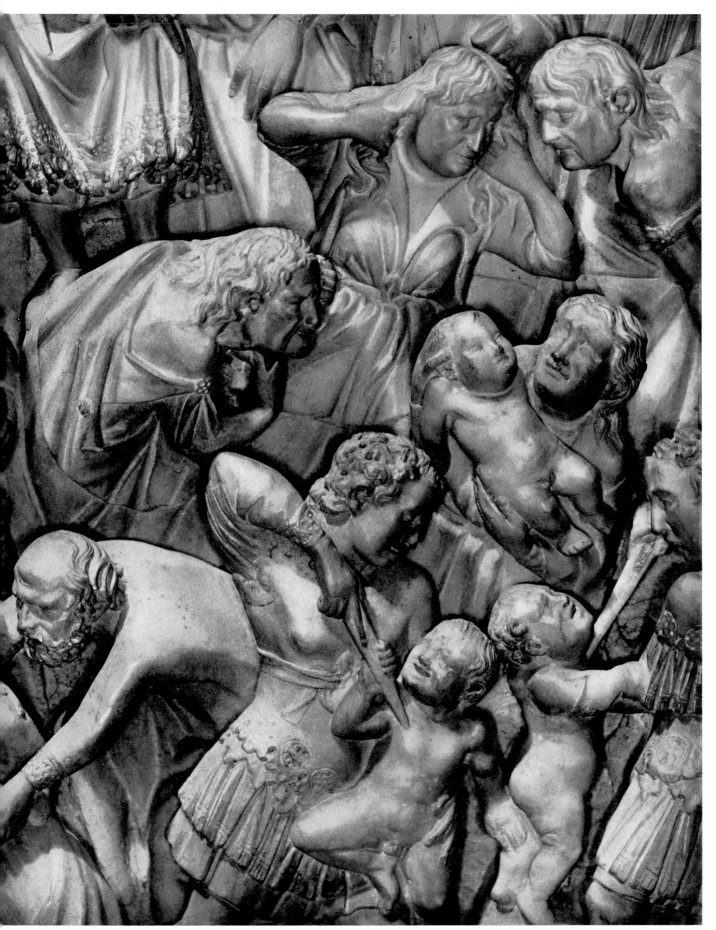

7. Nicola Pisano: THE MASSACRE OF THE INNOCENTS (detail of Figure 8). Duomo, Siena.
Marble (overall 85 × 97 cm.).

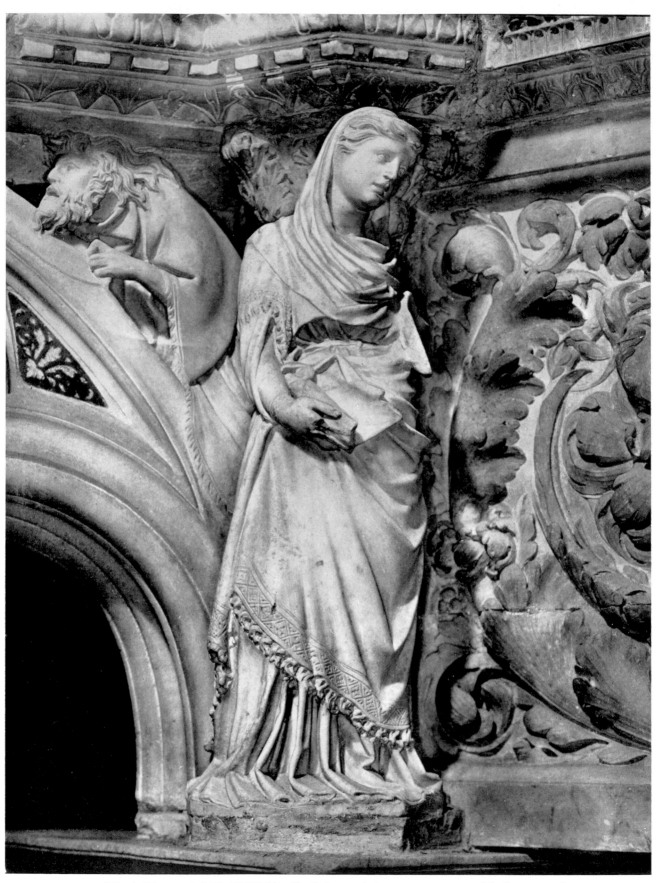

8. Nicola Pisano: A VIRTUE (detail of Figure 8). Duomo, Siena. Marble (H. 61 cm.).

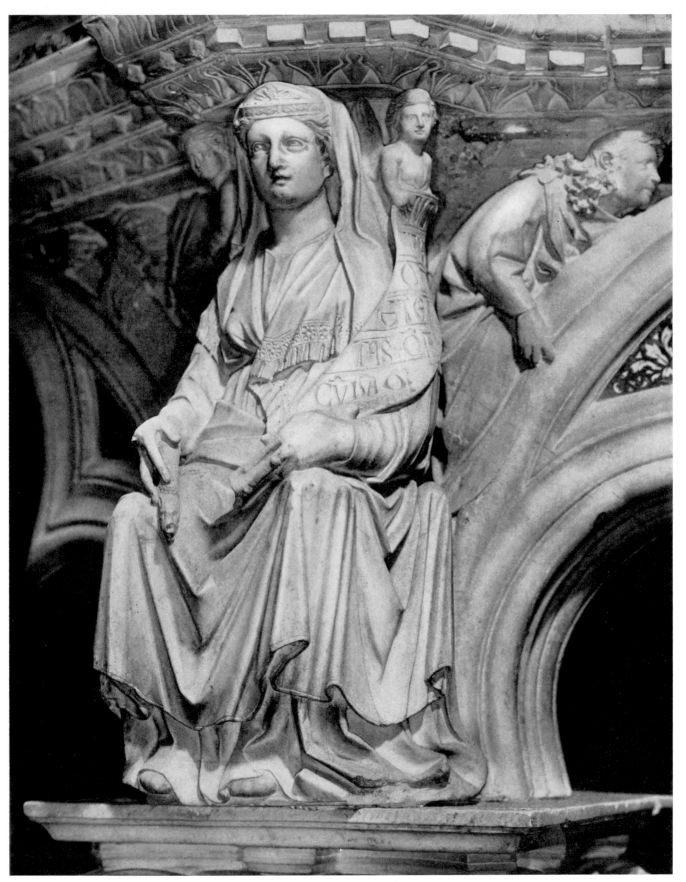

9. Nicola Pisano: JUSTICE (detail of Figure 8). Duomo, Siena. Marble (H. 61 cm.).

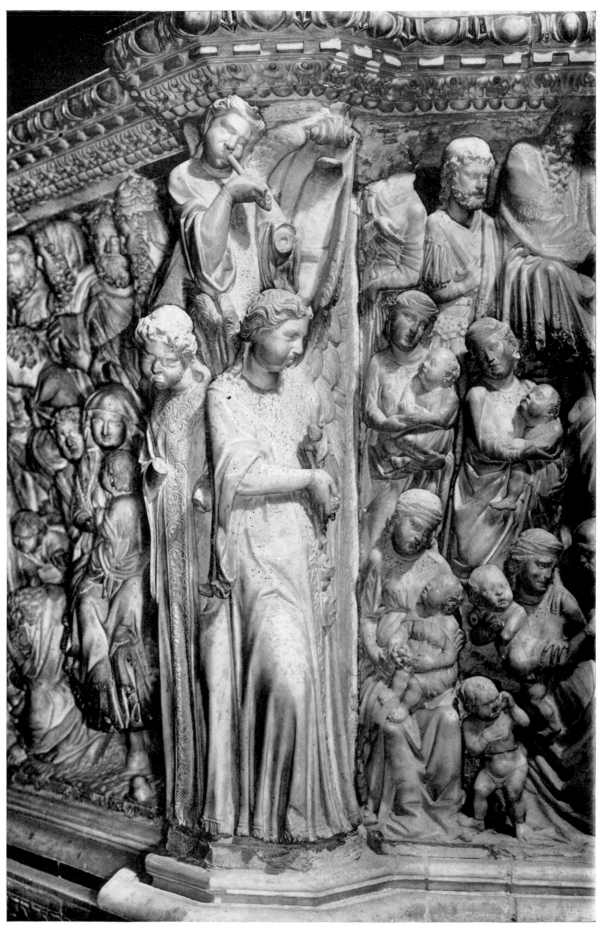

10. Workshop of Nicola Pisano (Giovanni Pisano ?): THREE ANGELS (detail of Figure 8).
Duomo, Siena. Marble (H. 85 cm.).

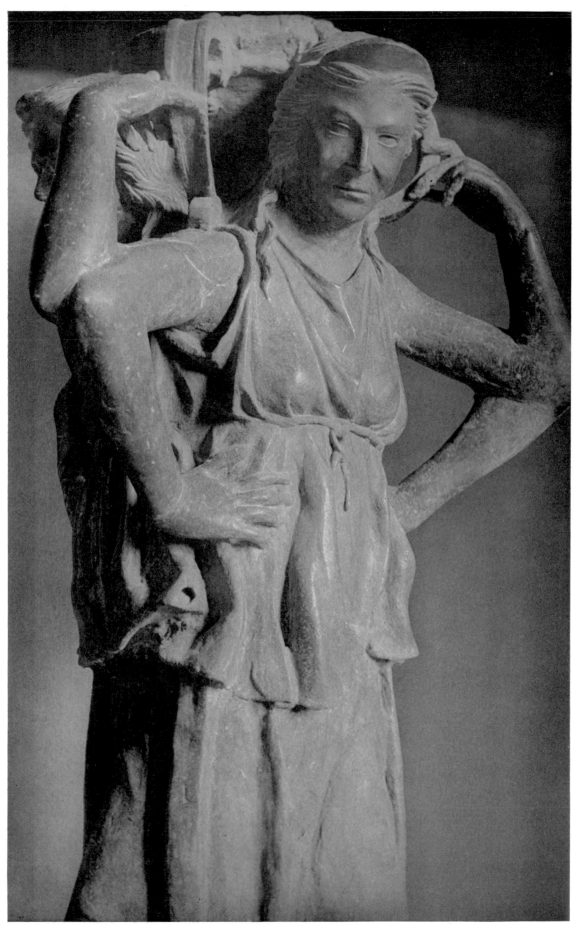

11. Nicola Pisano: CARYATIDS (detail of Figure 9). Fontana Maggiore, Perugia.
Bronze (H. overall 125 cm.).

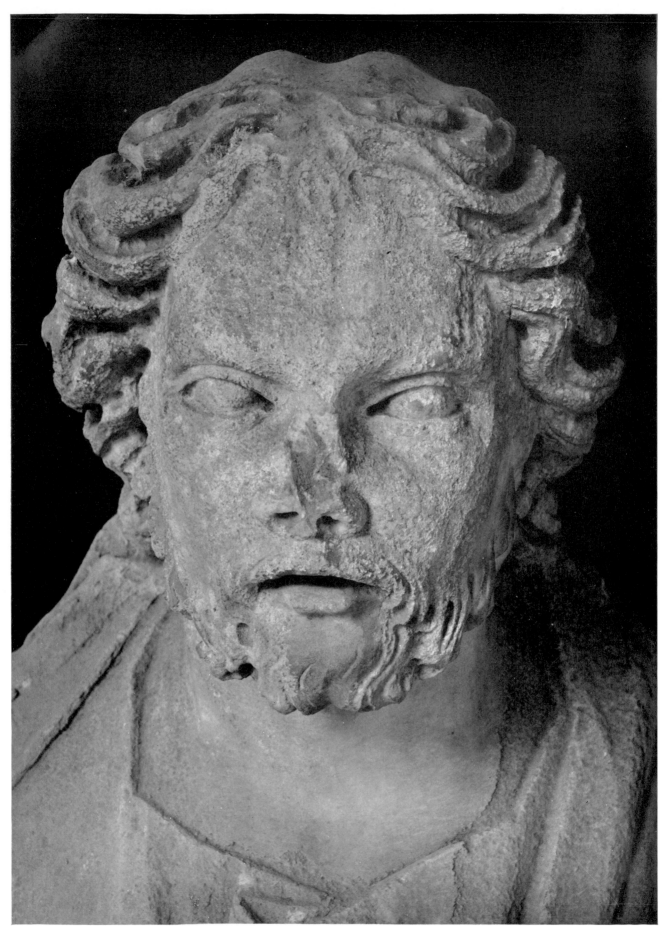

12. Nicola Pisano (?): CHRIST. Museo Nazionale di San Matteo, Pisa. Marble.

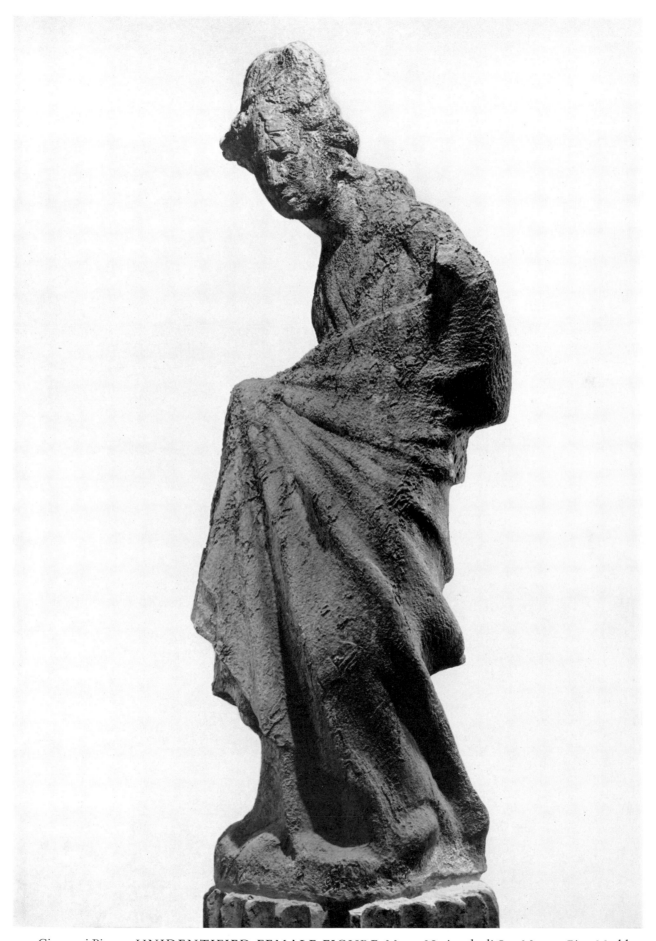

13. Giovanni Pisano: UNIDENTIFIED FEMALE FIGURE. Museo Nazionale di San Matteo, Pisa. Marble.

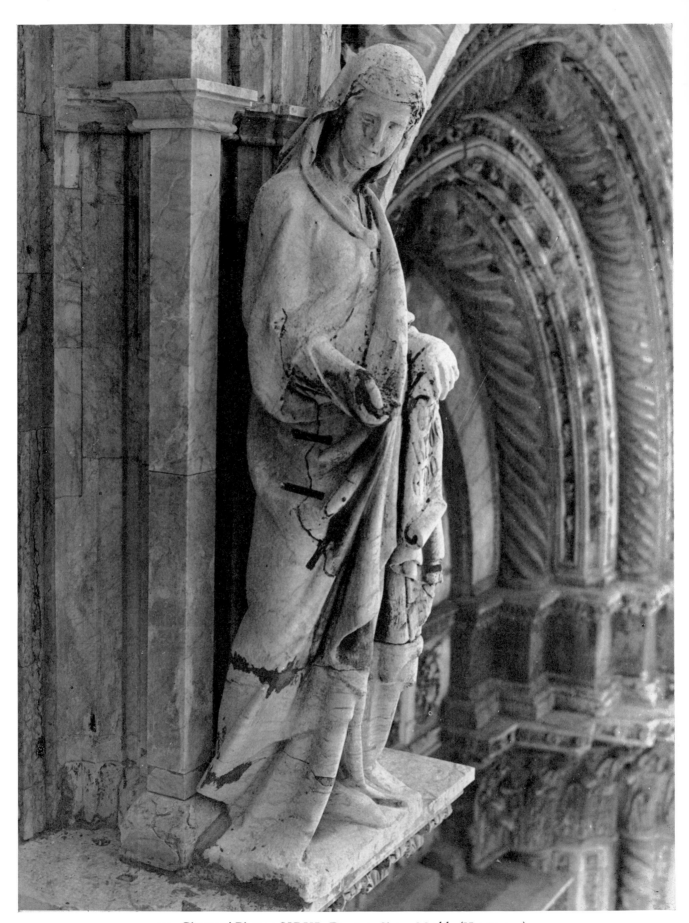

14. Giovanni Pisano: SIBYL. Duomo, Siena. Marble (H. 180 cm.).

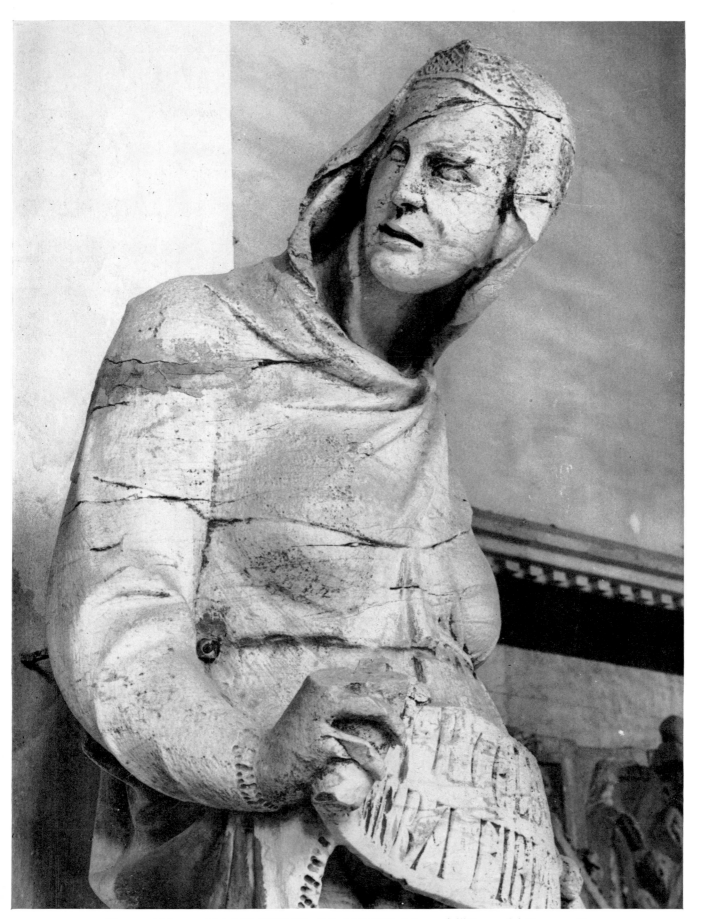

15. Giovanni Pisano: MARY SISTER OF MOSES. Museo dell'Opera del Duomo, Siena.

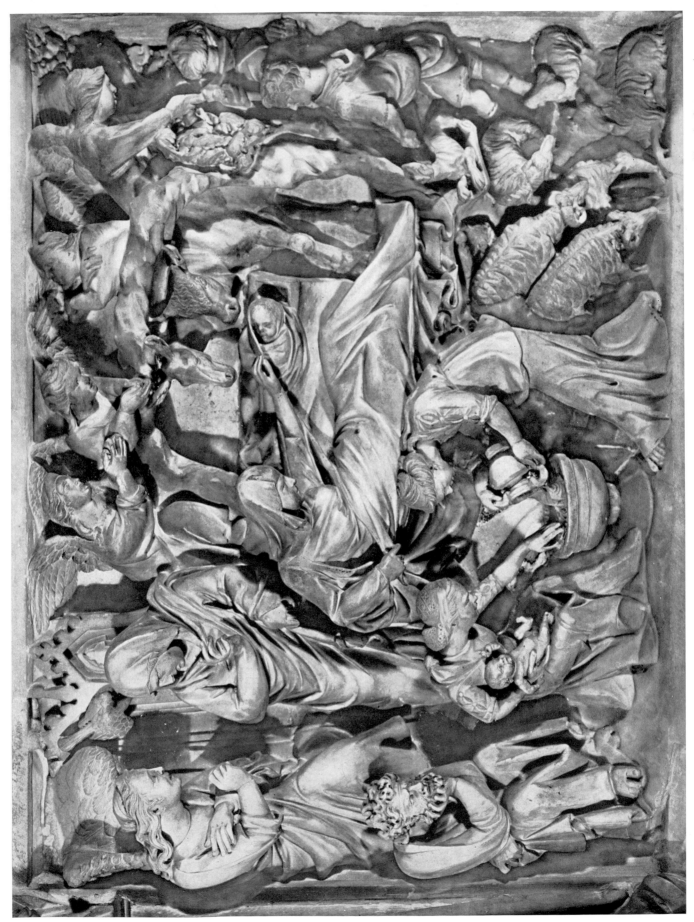

16. Giovanni Pisano: THE ANNUNCIATION, NATIVITY AND ANNUNCIATION TO THE SHEPHERDS (detail of Figure 14).

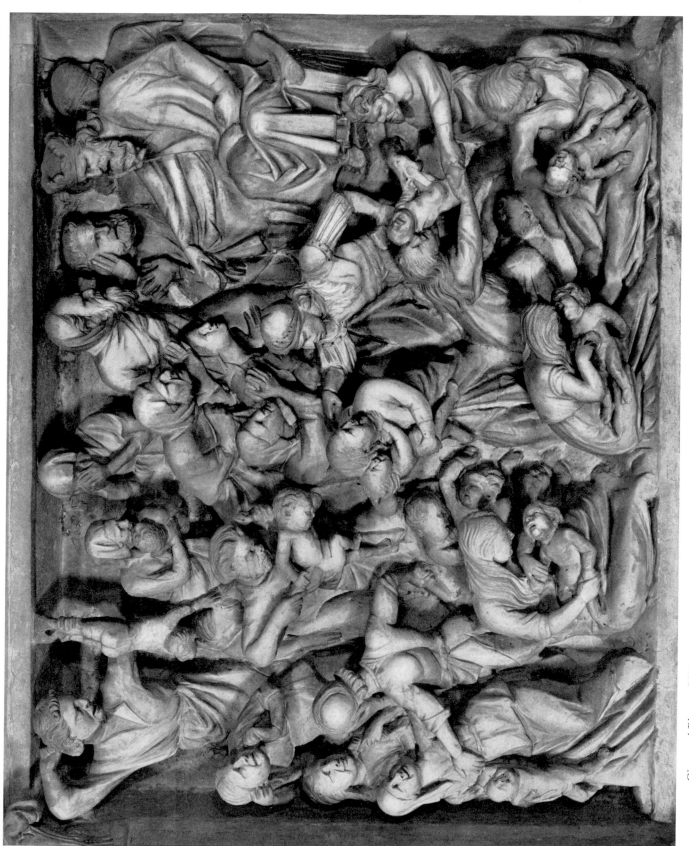

17. Giovanni Pisano: THE MASSACRE OF THE INNOCENTS (detail of Figure 14). S. Andrea, Pistoia. Marble (84 × 102 cm.).

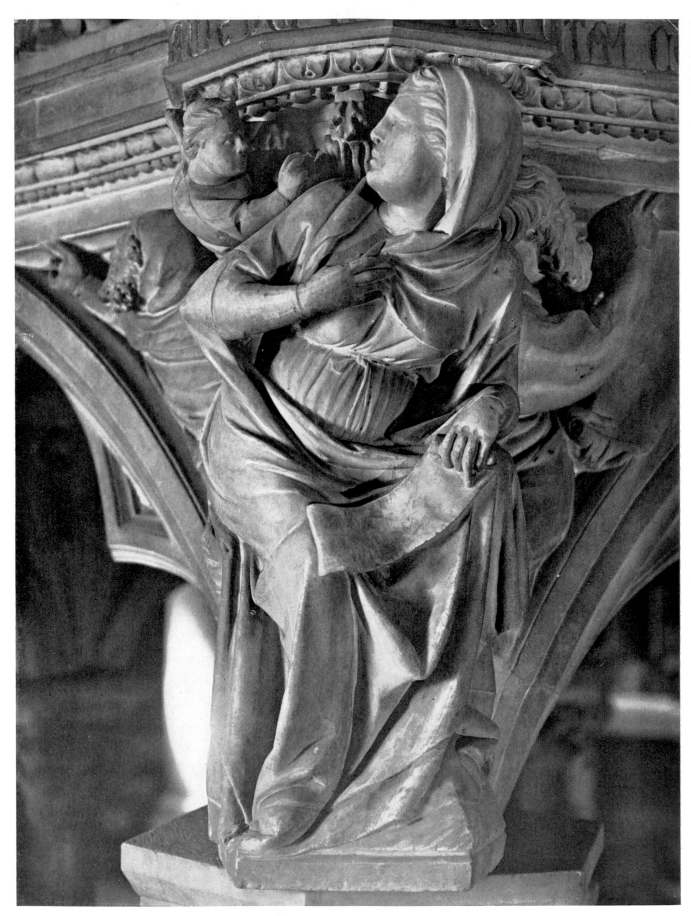

18. Giovanni Pisano: SIBYL (detail of Figure 14). S. Andrea, Pistoia. Marble (H. 62 cm.).

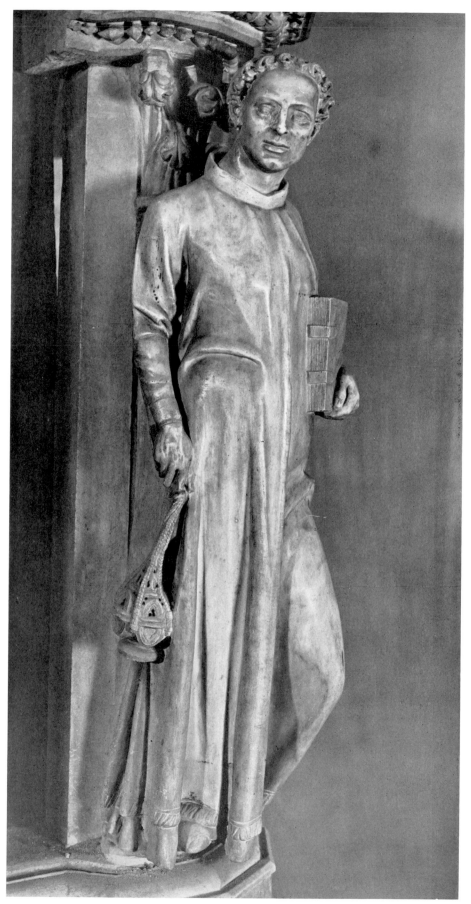

19. Giovanni Pisano: DEACON (detail of Figure 14). S. Andrea, Pistoia.
Marble (H. 86 cm.).

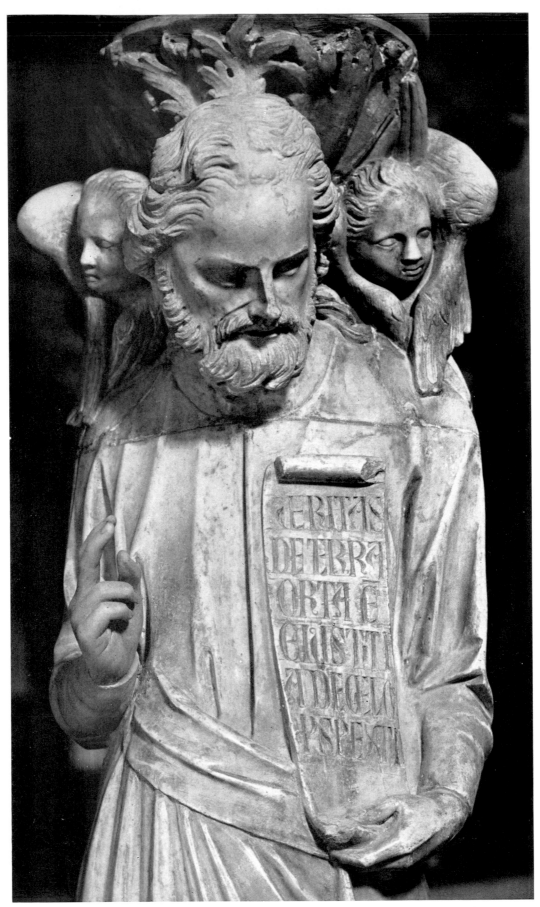

20. Giovanni Pisano: CHRIST (detail of Figure 15). Duomo, Pisa. Marble.

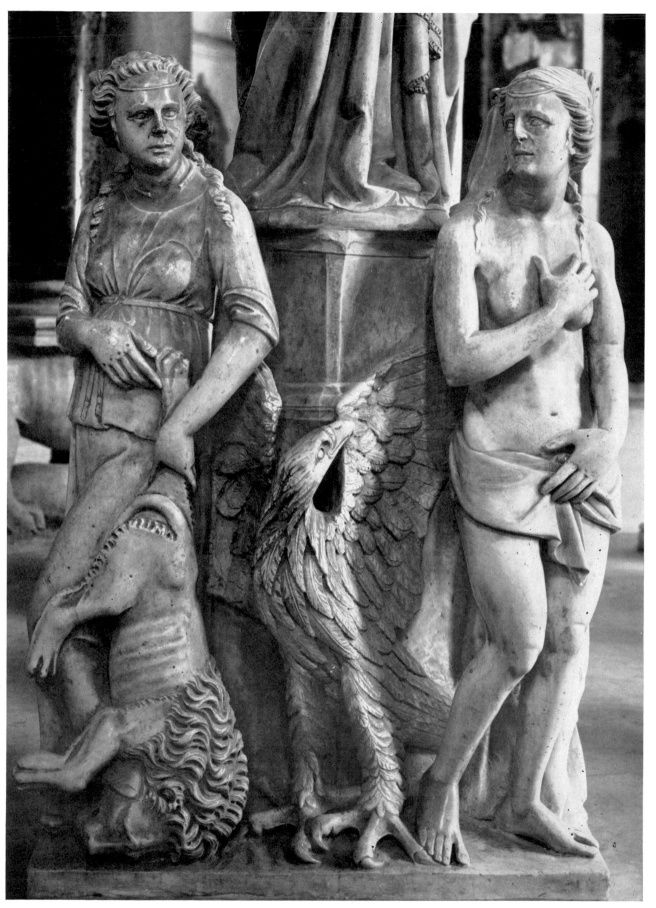

21. Giovanni Pisano: STRENGTH AND PRUDENCE (detail of Figure 15). Duomo, Pisa.
Marble (H. of Prudence 118 cm.).

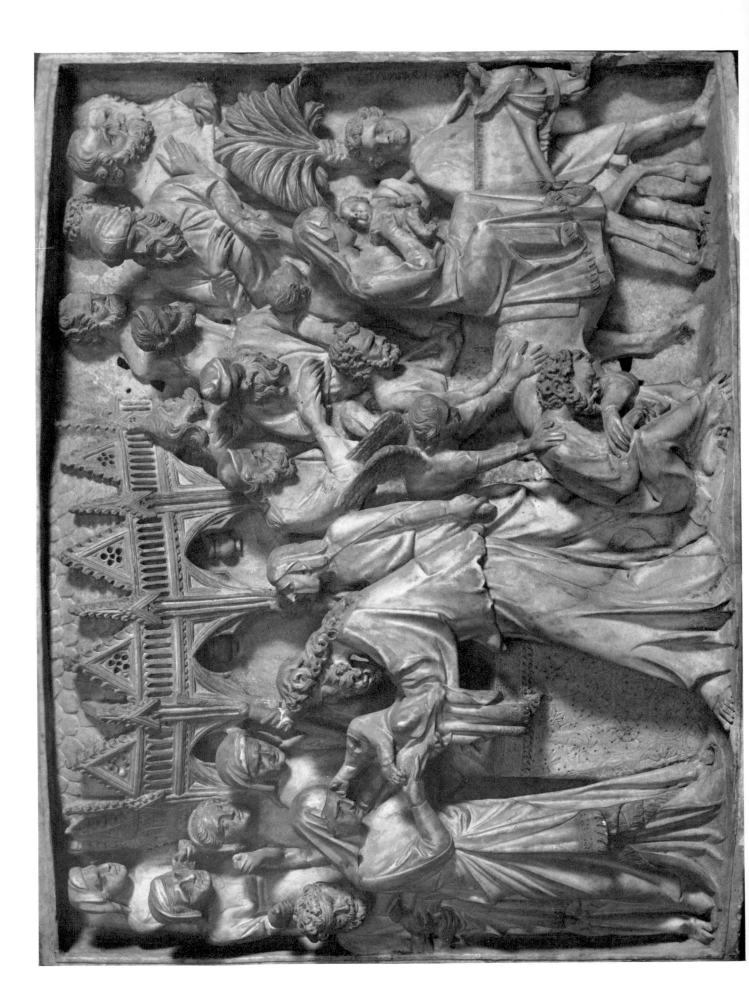

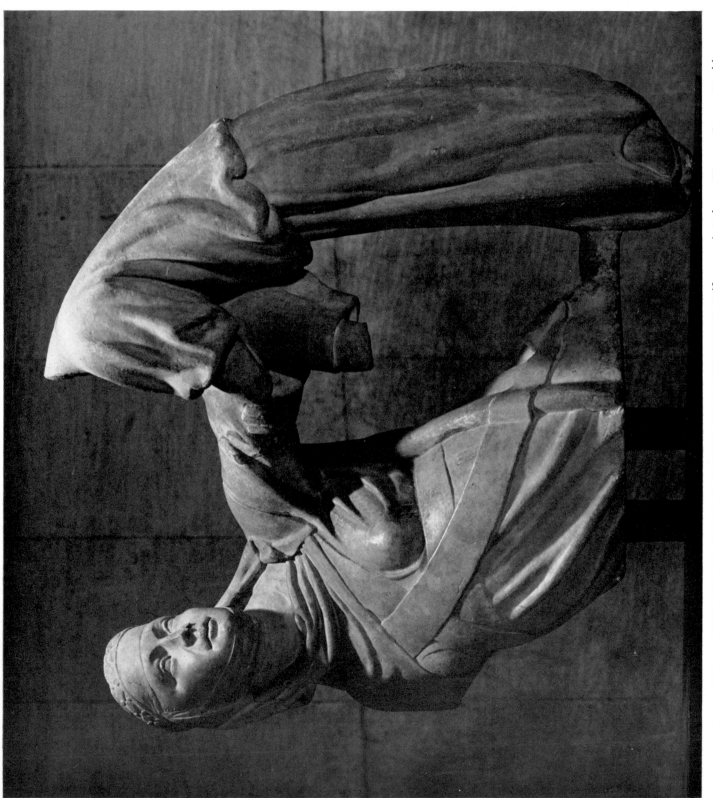

23. Giovanni Pisano: THE TOMB OF MARGARET OF LUXEMBURG (fragment). Palazzo Bianco, Genoa. Marble.

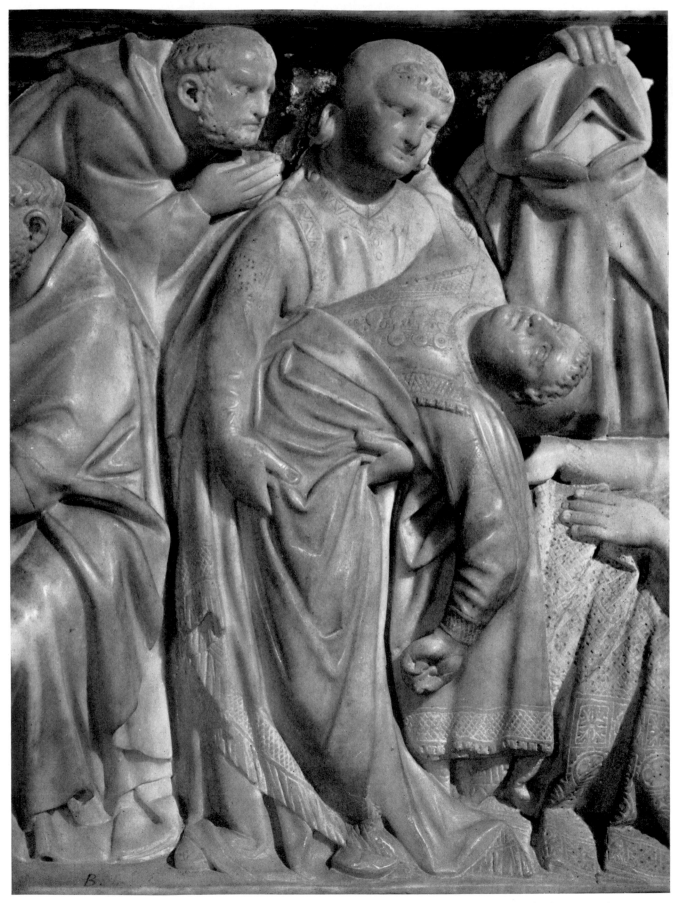

24. Arnolfo di Cambio: THE RAISING OF NAPOLEONE ORSINI (detail of Figure 18).
S. Domenico Maggiore, Bologna. Marble.

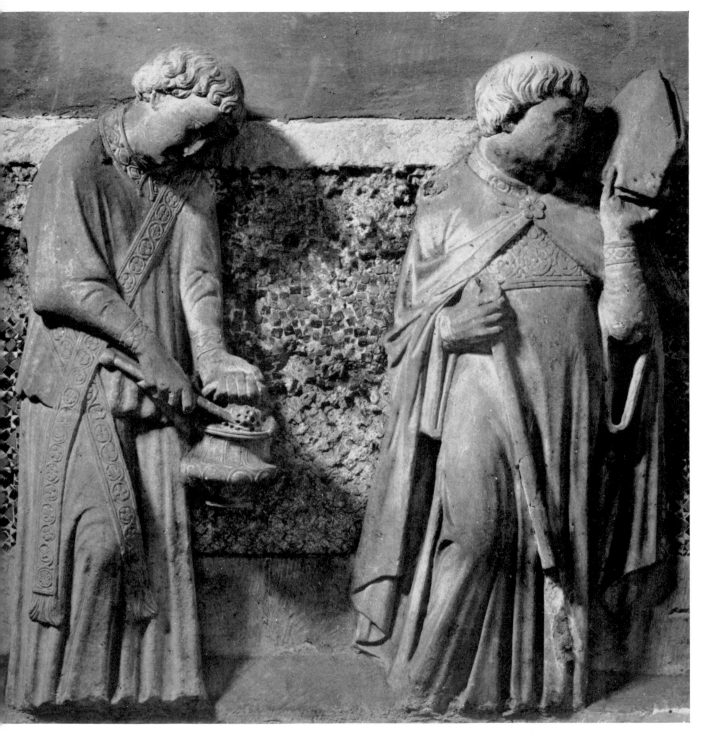

5. Arnolfo di Cambio: TWO CLERICS (detail of Figure 21). S. Giovanni in Laterano, Rome. Marble (overall 68 × 212 cm.).

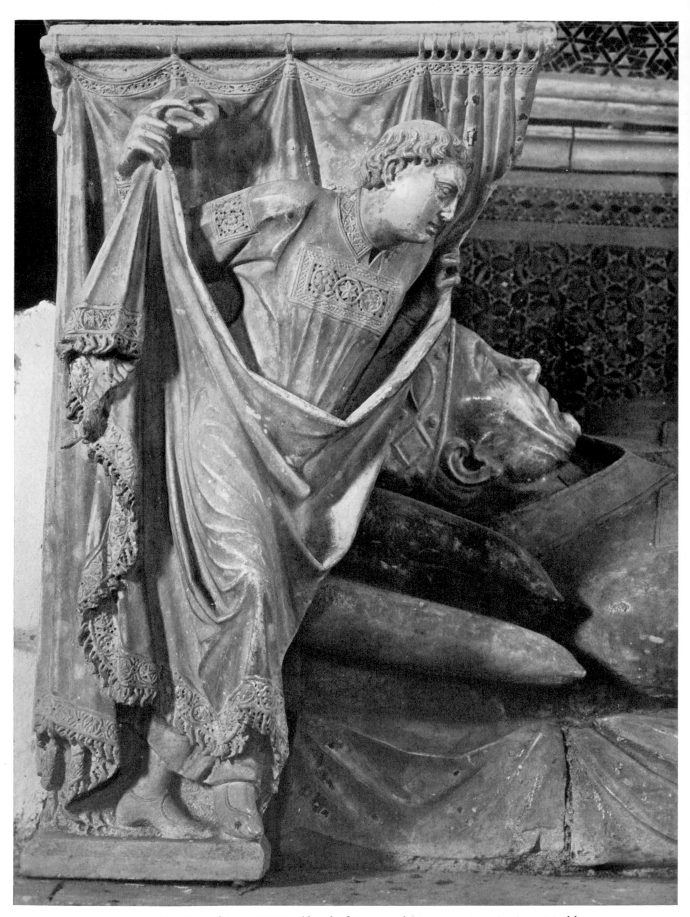

26. Arnolfo di Cambio: ANGEL (detail of Figure 25). S. Domenico, Orvieto. Marble.

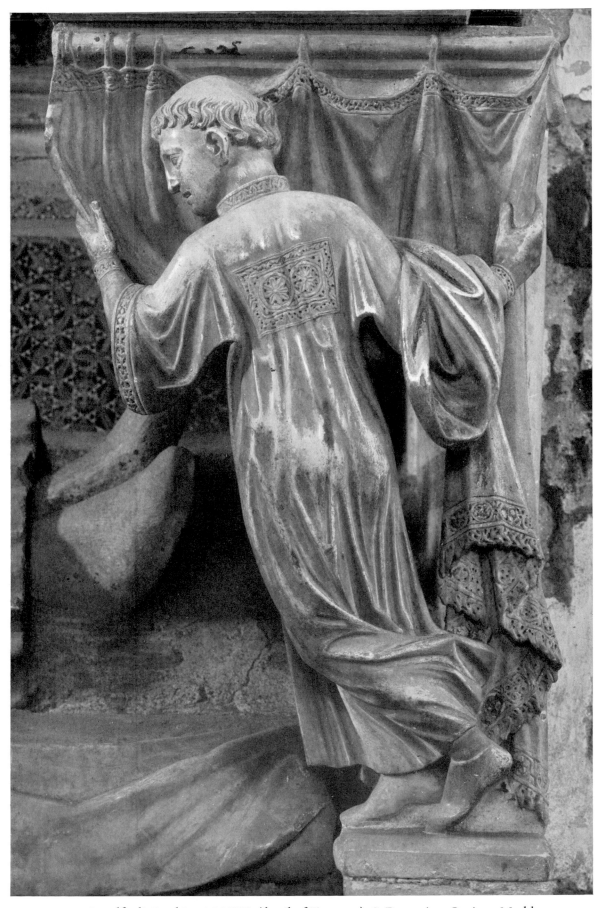

27. Arnolfo di Cambio: ANGEL (detail of Figure 25). S. Domenico, Orvieto. Marble.

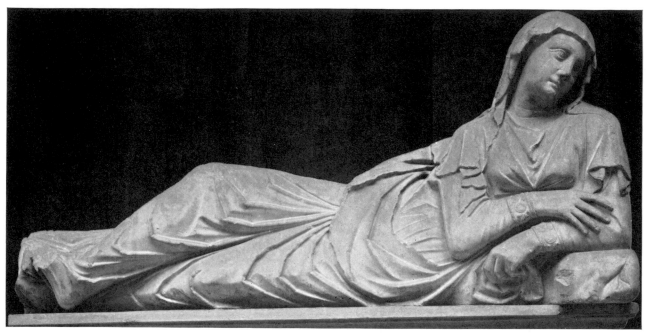

28A. Arnolfo di Cambio: VIRGIN OF THE NATIVITY. Museo dell'Opera del Duomo, Florence.
(L. 174 cm.).

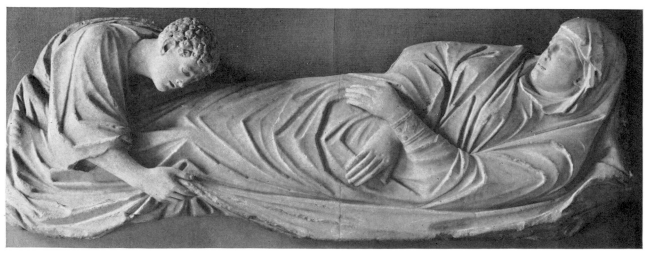

28B. Arnolfo di Cambio: THE DORMITION OF THE VIRGIN. Formerly Kaiser Friedrich Museum, Berlin.
Marble (L. 170 cm.).

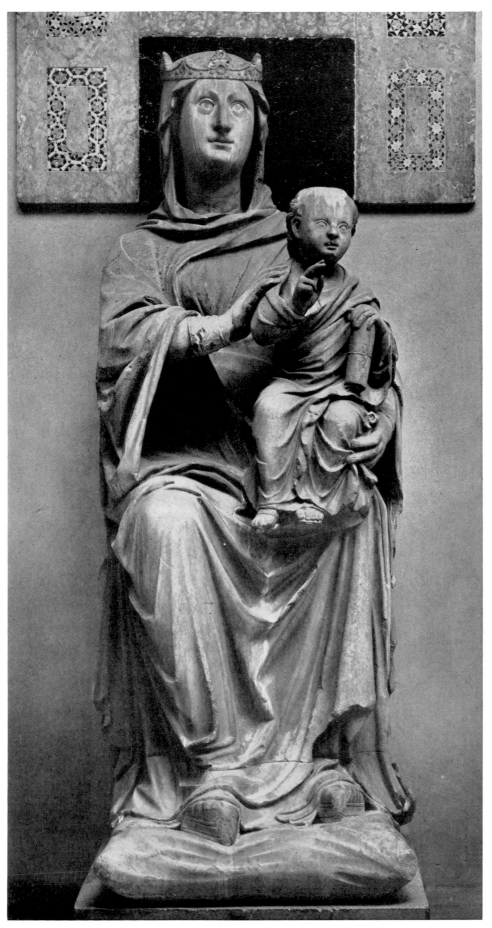

29. Arnolfo di Cambio: VIRGIN AND CHILD. Museo dell'Opera del Duomo, Florence.
Marble (H. 174 cm.).

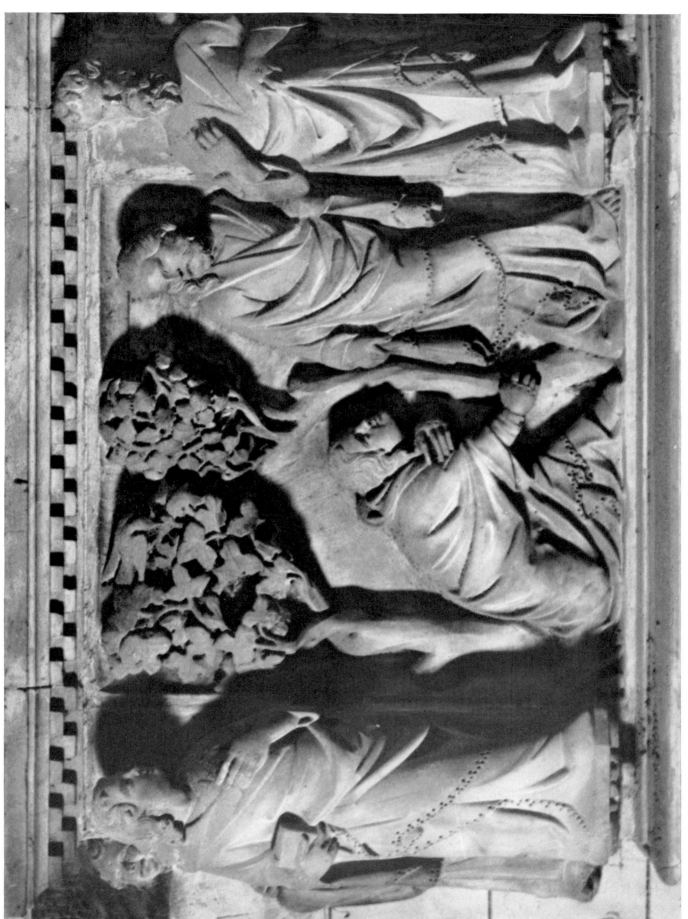

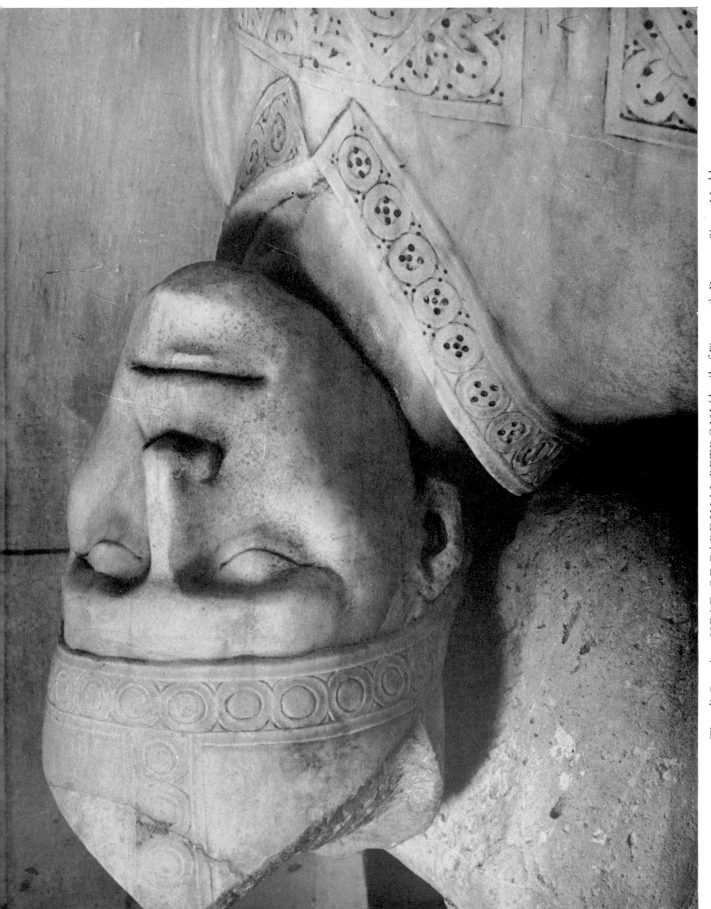

31. Tino di Camaino: HEAD OF CARDINAL PETRONI (detail of Figure 26). Duomo, Siena. Marble.

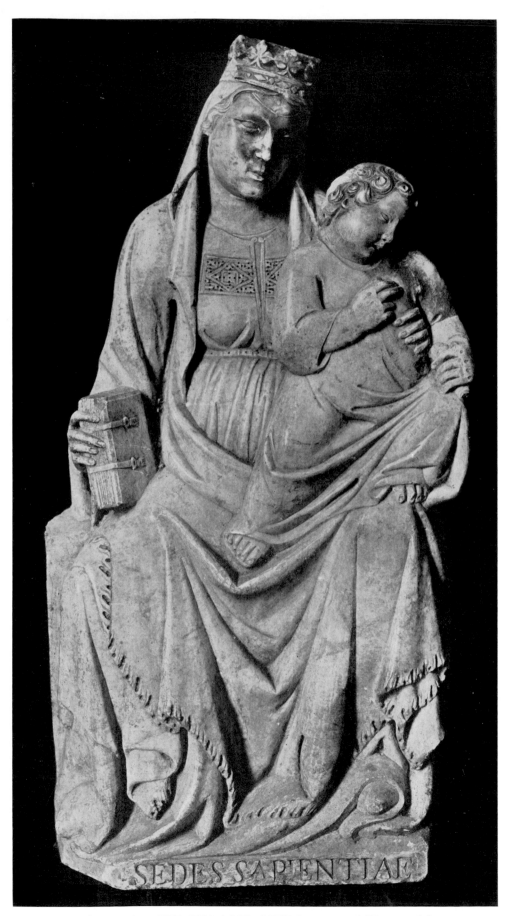

32. Tino di Camaino: VIRGIN AND CHILD. Museo dell'Opera del Duomo,
Florence. Marble (H. 78 cm.).

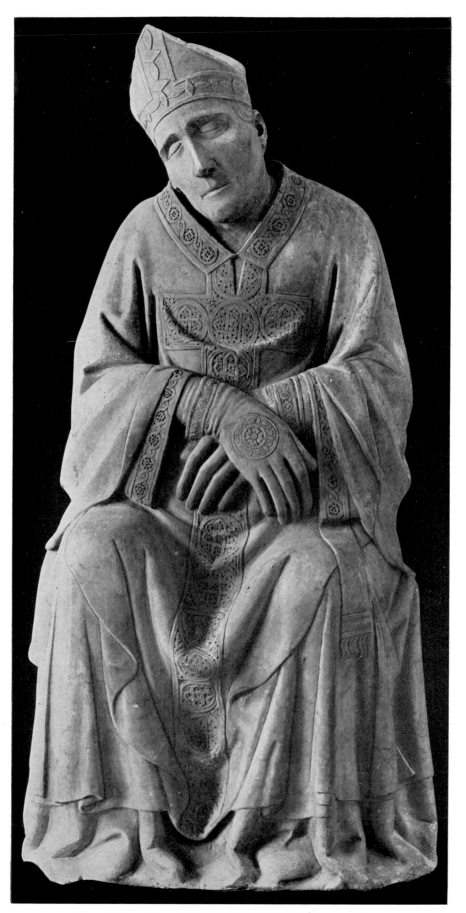

33. Tino di Camaino: ANTONIO ORSO. Duomo, Florence.
Marble (H. 132 cm.).

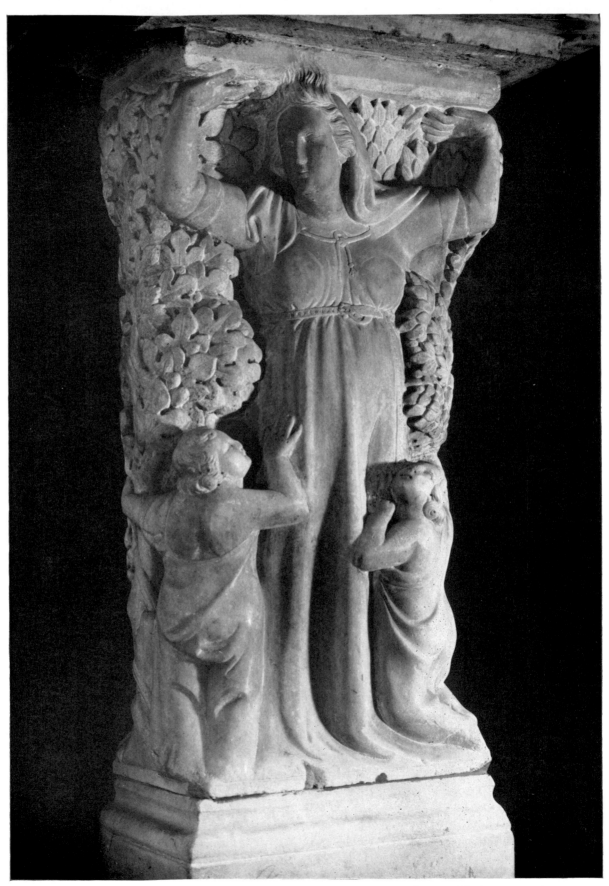

34. Tino di Camaino: CHARITY. S. Lorenzo Maggiore, Naples. Marble (H. 100 cm.).

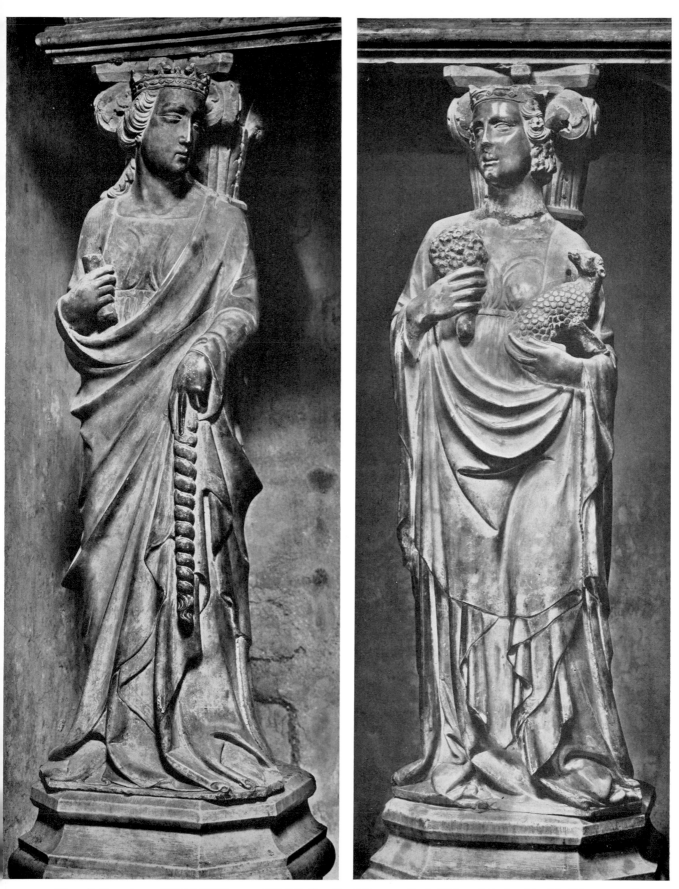

35. Tino di Camaino: CHARITY AND HOPE (details of Figure 28). S. Chiara, Naples. Marble (H. 100 cm.).

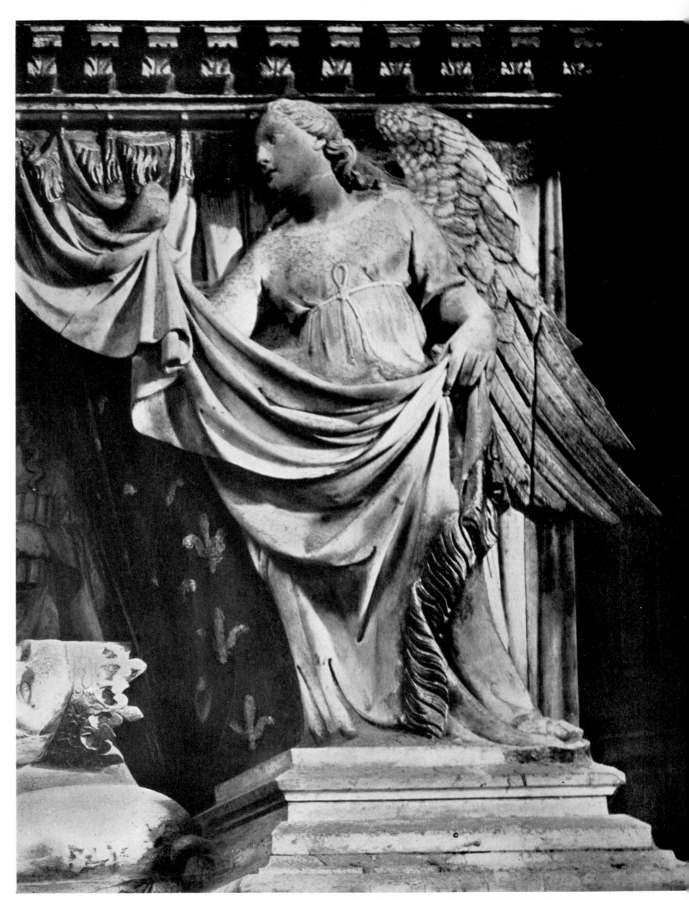

36. Giovanni and Pacio da Firenze: ANGEL (detail of Figure 32). S. Chiara, Naples. Marble.

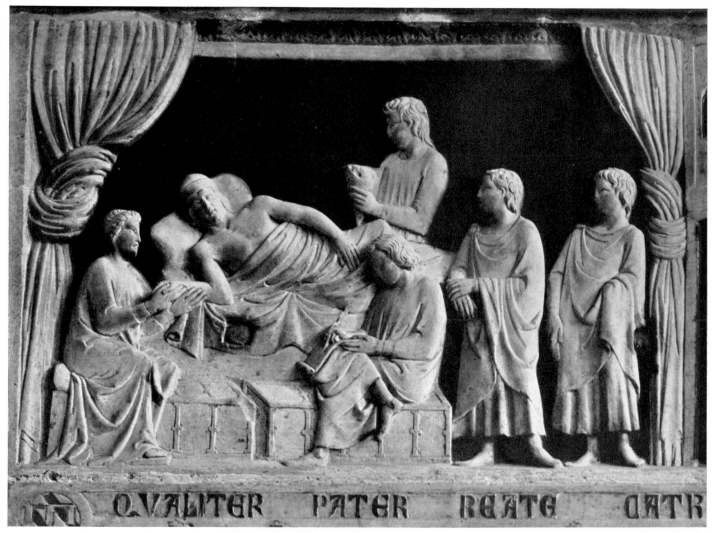

37. Giovanni and Pacio da Firenze: THE FATHER OF ST. CATHERINE OF ALEXANDRIA DICTATES HIS TESTAMENT. S. Chiara, Naples. Marble.

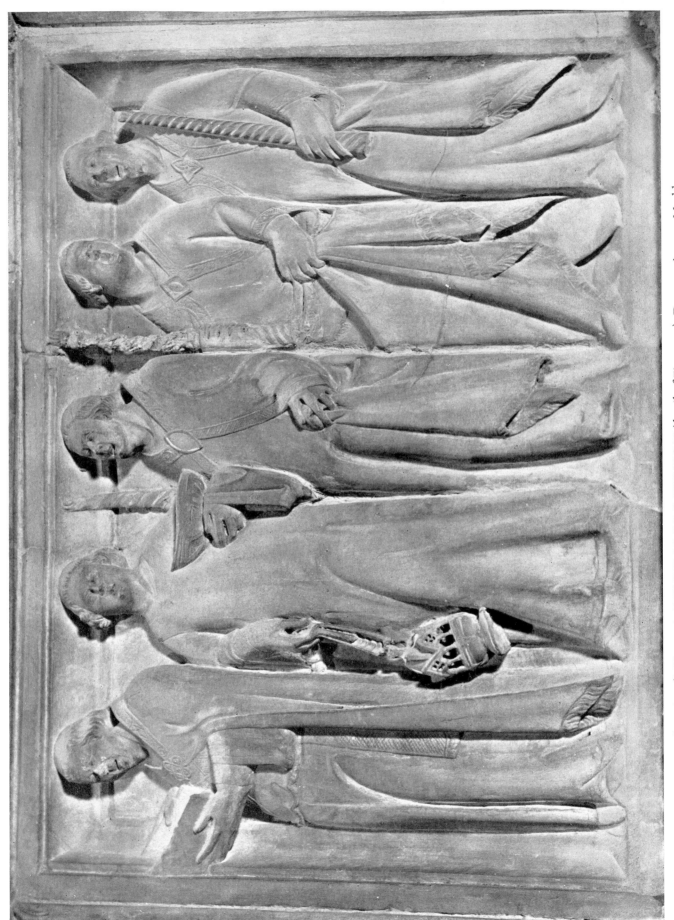

38. Agostino di Giovanni: FUNERAL PROCESSION (detail of Figure 27). Duomo, Arezzo. Marble.

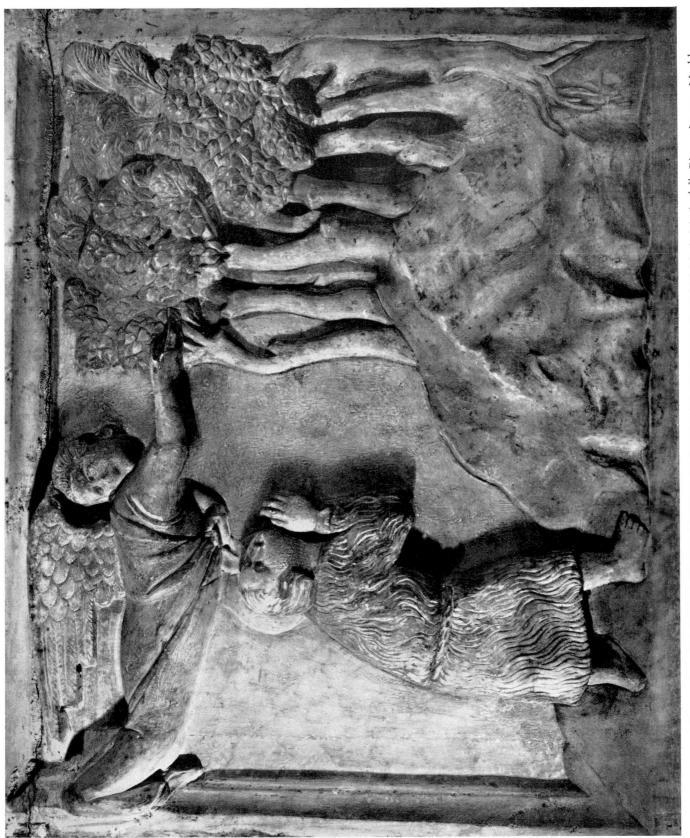

39. Giovanni di Agostino: ST. JOHN THE BAPTIST ENTERING THE WILDERNESS. S. Maria della Pieve, Arezzo. Marble.

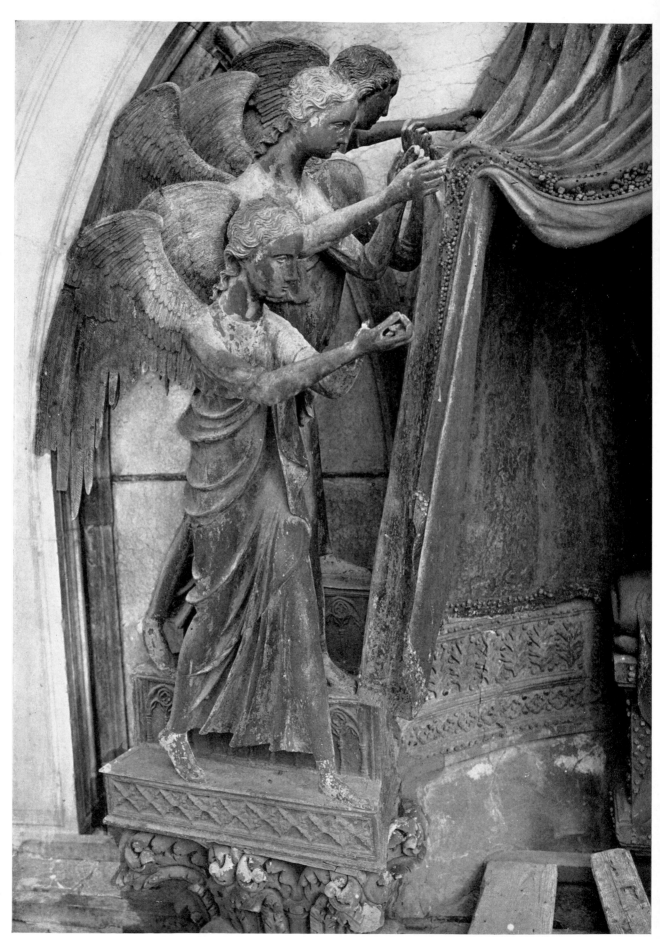

40. Lorenzo Maitani: THREE ANGELS (detail of Figure 31). Duomo, Orvieto. Bronze.

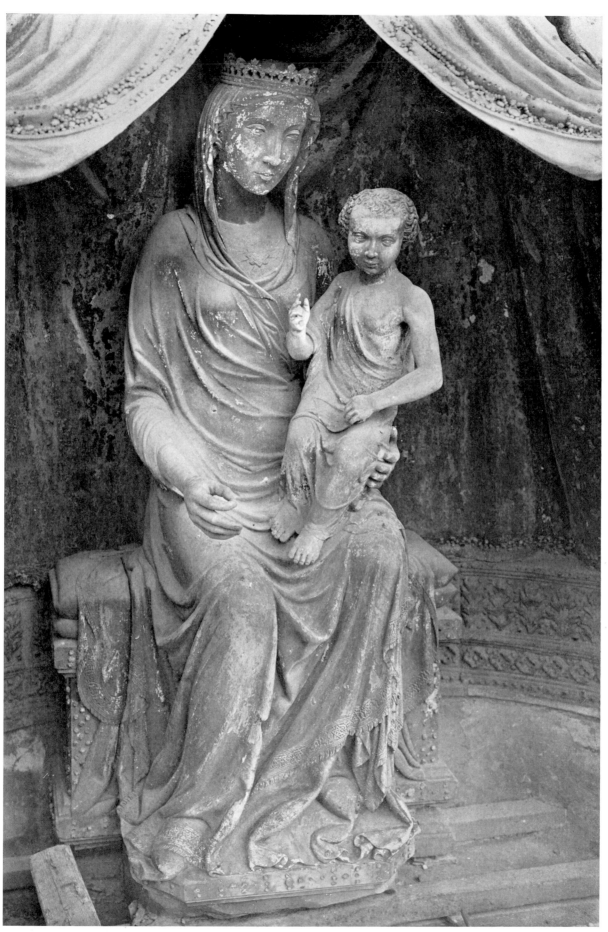

41. Lorenzo Maitani (?): VIRGIN AND CHILD (detail of Figure 31). Duomo, Orvieto. Marble.

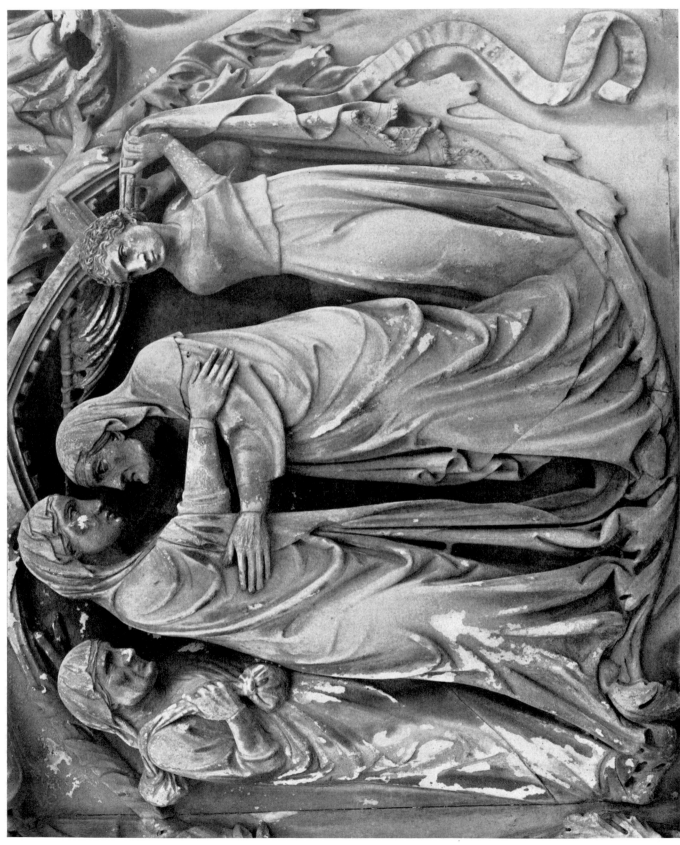

42. Style of Lorenzo Maitani: THE VISITATION (detail of Figure 35). Duomo. Orvieto. Marble.

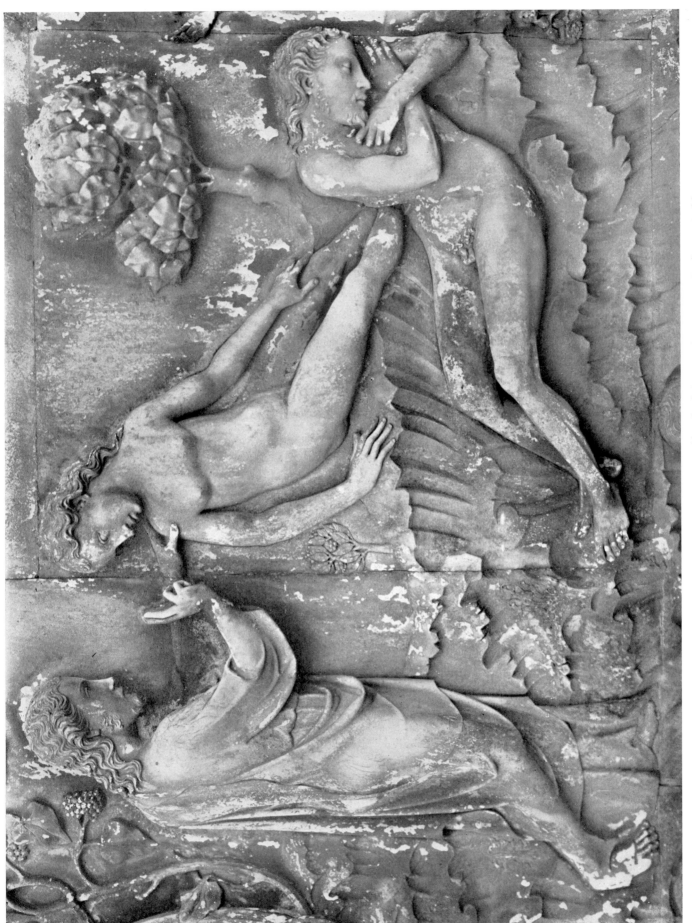

43. Lorenzo Maitani: THE CREATION OF EVE (detail of Figure 33). Duomo, Orvieto. Marble.

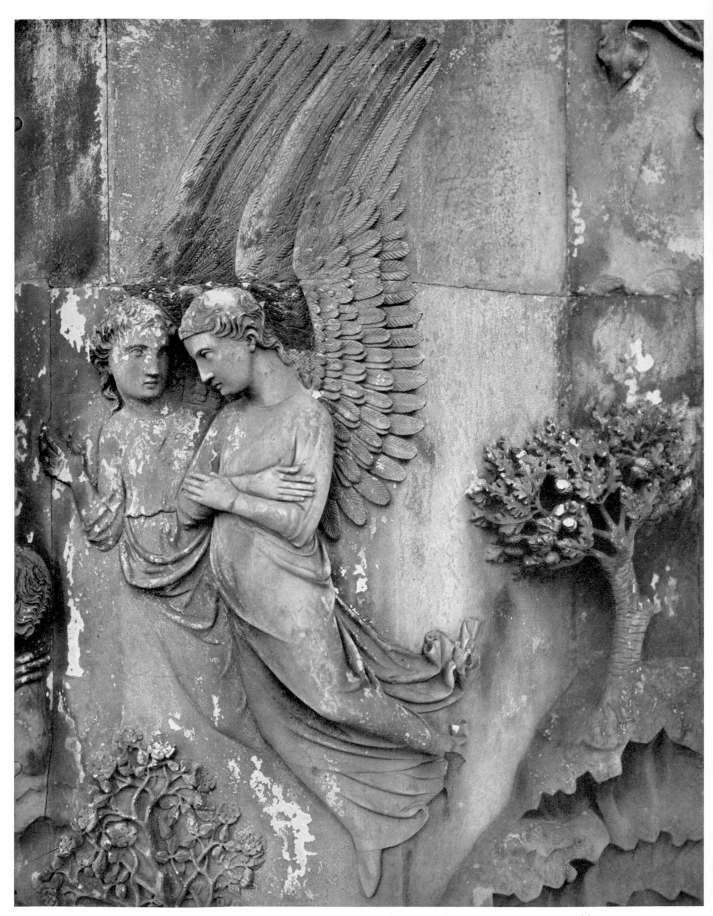

44. Lorenzo Maitani: TWO ANGELS (detail of Figure 33). Duomo, Orvieto. Marble.

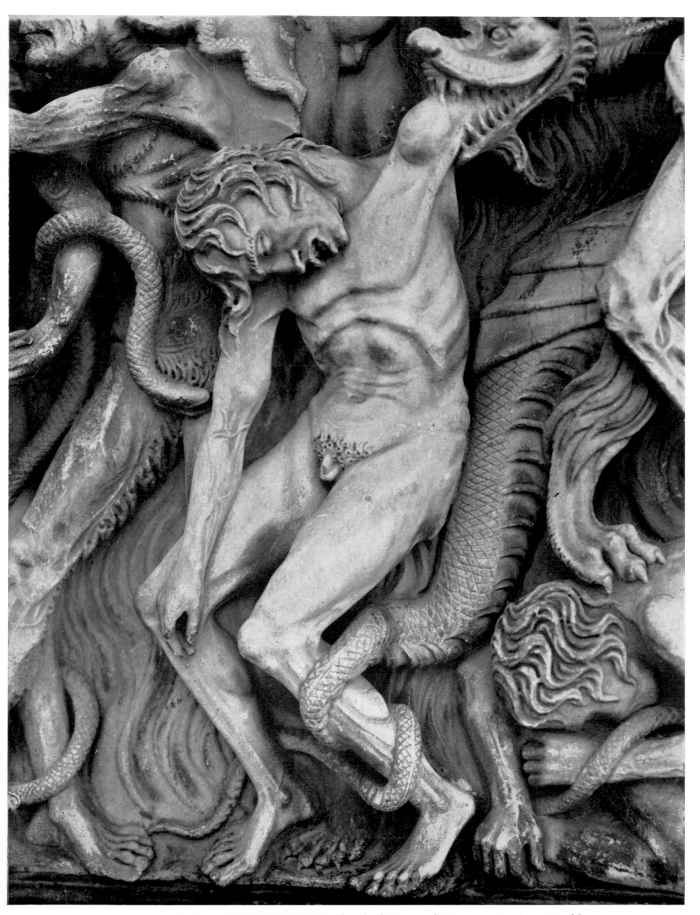

45. Lorenzo Maitani: THE DAMNED (detail of Figure 36). Duomo, Orvieto. Marble.

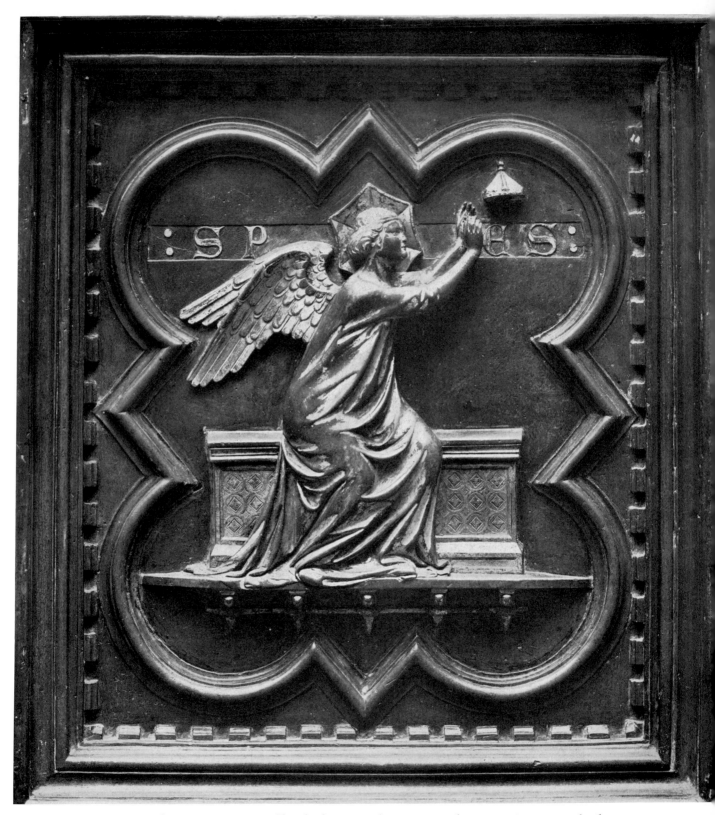

46. Andrea Pisano: HOPE (detail of Figure 39). Baptistry, Florence. Bronze, parcel-gilt
(50×43 cm. inside moulding).

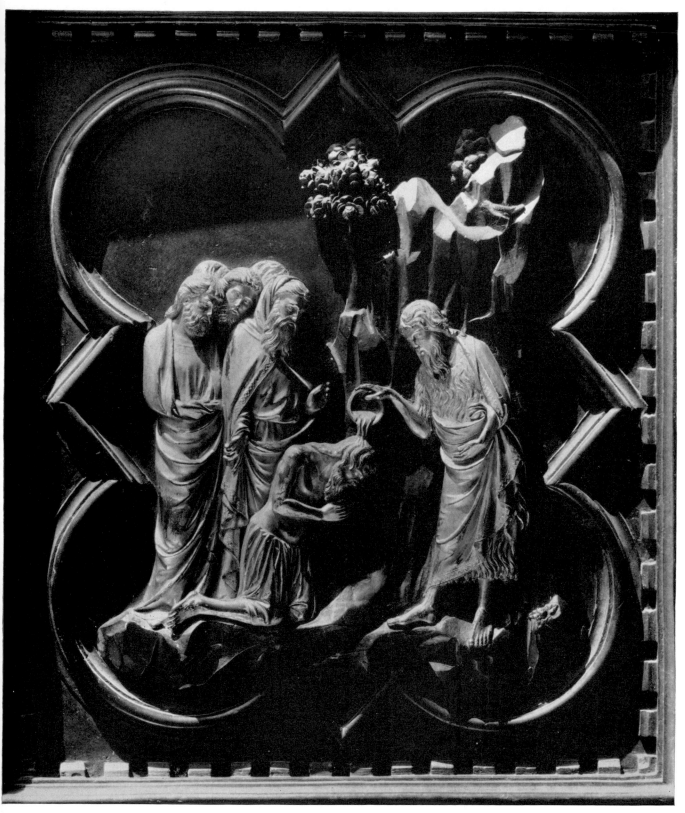

47. Andrea Pisano: ST. JOHN BAPTIZING (detail of Figure 39). Baptistry, Florence. Bronze, parcel-gilt (50×43 cm. inside moulding).

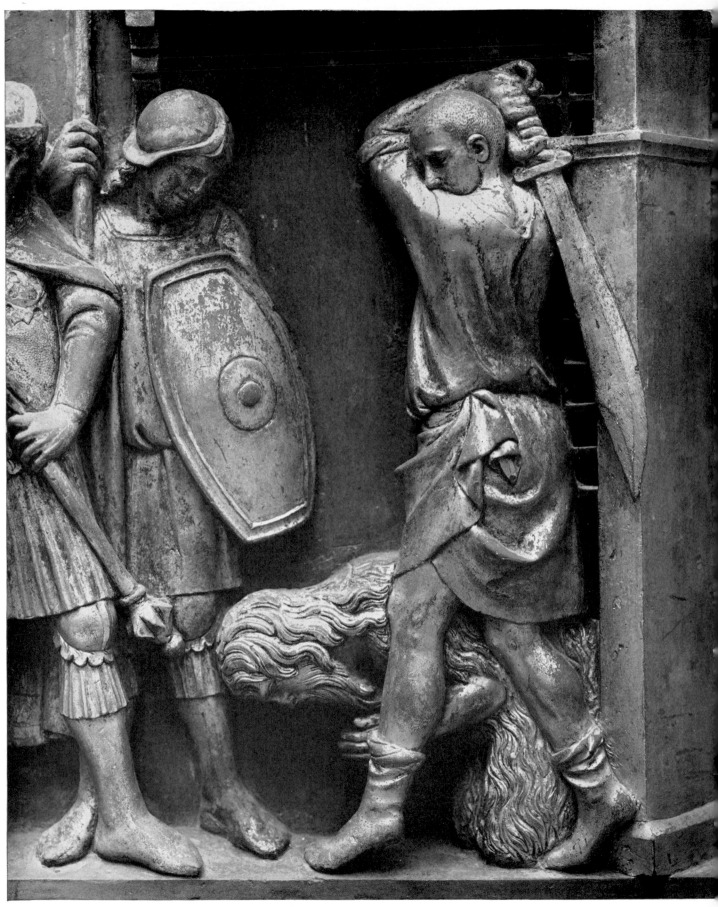

48. Andrea Pisano: THE DECOLLATION OF ST. JOHN THE BAPTIST (detail of Figure 39). Baptistry, Florence.
Bronze, parcel-gilt.

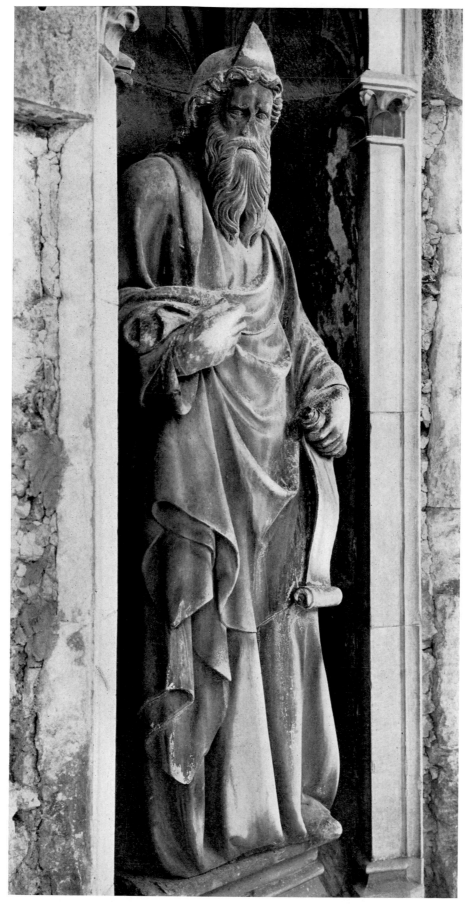

49. Workshop of Andrea Pisano: PROPHET. Campanile, Florence.
Marble (H. 184 cm.).

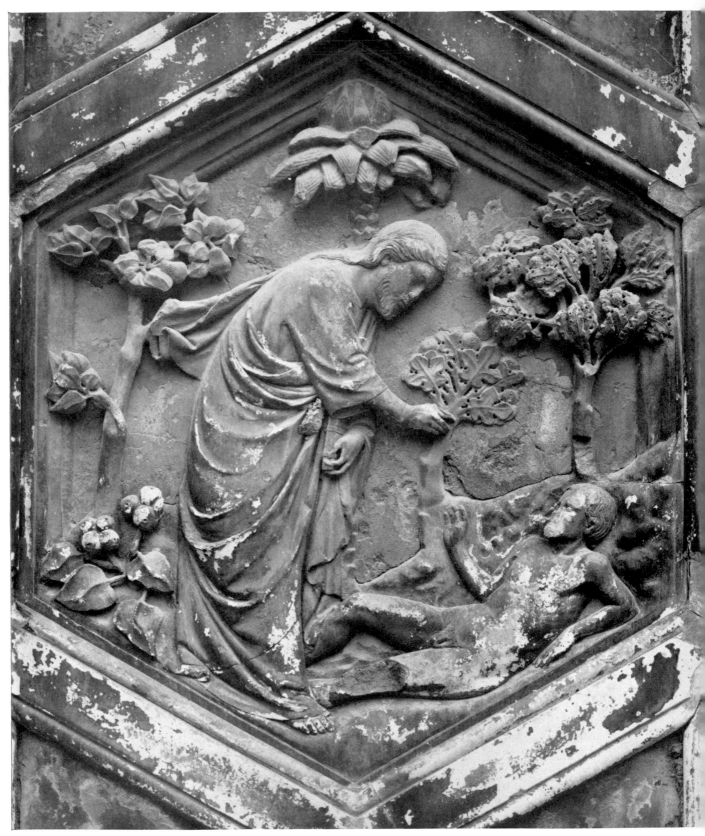

50. Andrea Pisano: THE CREATION OF ADAM. Museo dell'Opera del Duomo, Florence. Marble (83×69 cm.).

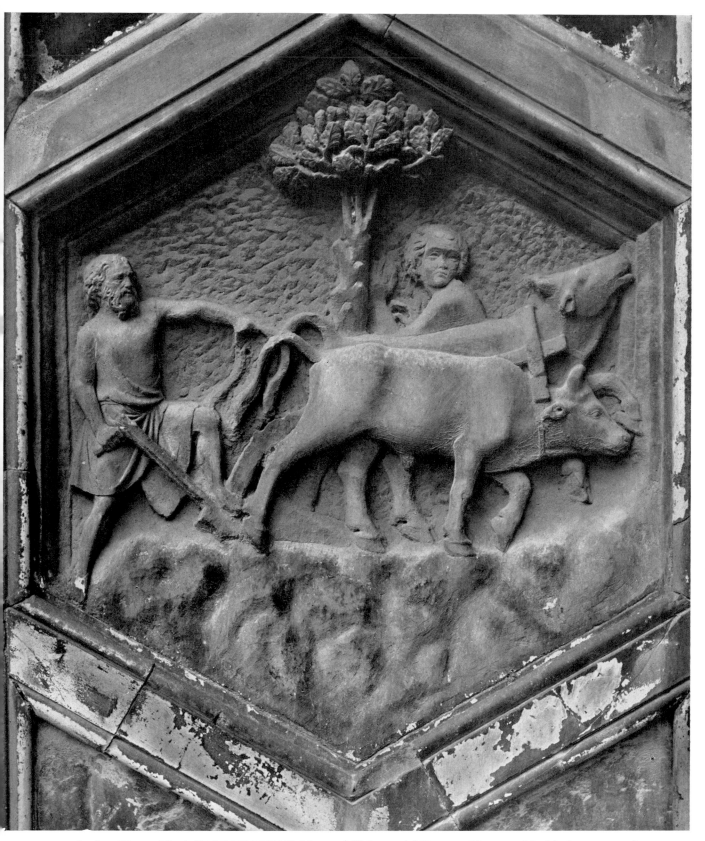

51. Andrea Pisano (?): AGRICULTURE. Museo dell'Opera del Duomo, Florence. Marble (83 × 69 cm.).

52. Nino Pisano: VIRGIN AND CHILD (detail of Figure 41). SS. Giovanni e Paolo, Venice. Marble (H. 123 cm.).

53. Nino Pisano: MADONNA DEL LATTE (detail of Figure 40). Museo Nazionale di S. Matteo, Pisa.
Marble (H. overall 91 cm.).

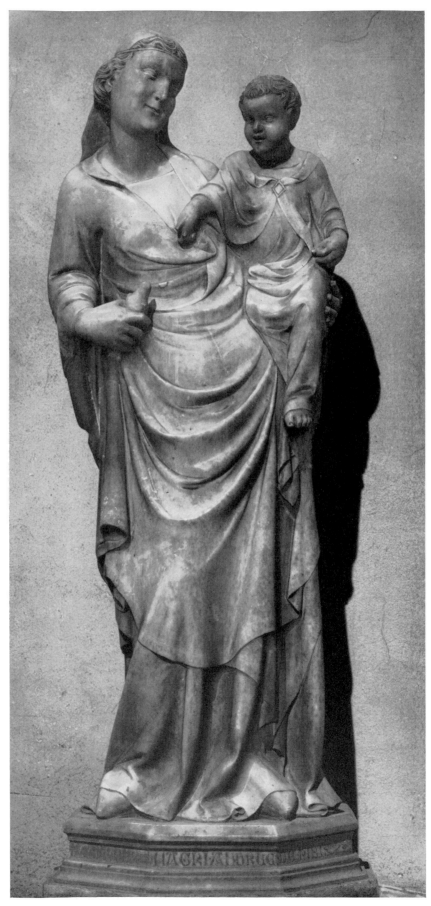

54. Nino Pisano: VIRGIN AND CHILD. S. Maria Novella,
Florence. Marble.

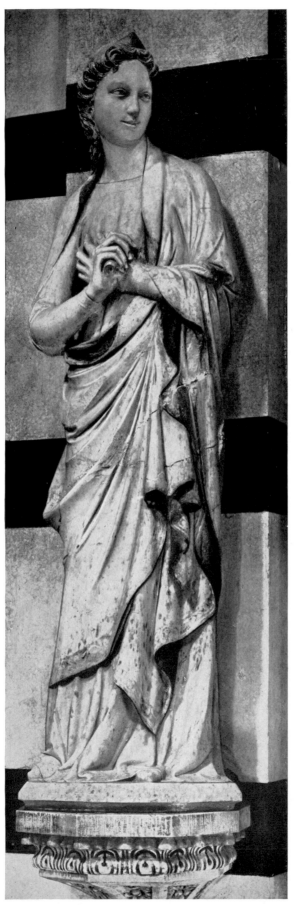

55. Nino Pisano: ANNUNCIATORY ANGEL.
S. Caterina, Pisa. Marble (H. 168 cm.).

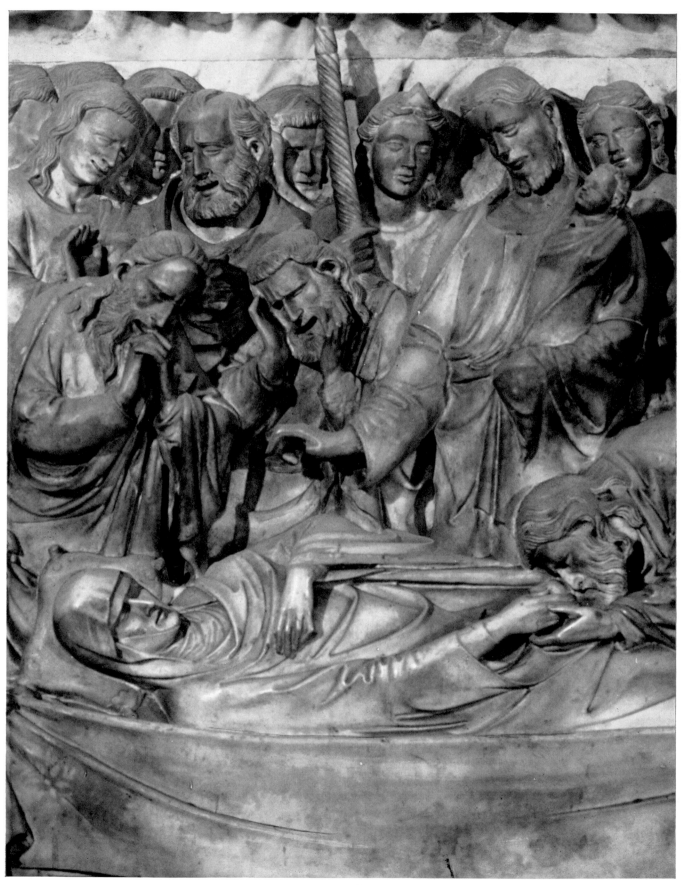

56. Orcagna: THE DORMITION OF THE VIRGIN (detail of Figure 43). Or San Michele, Florence. Marble.

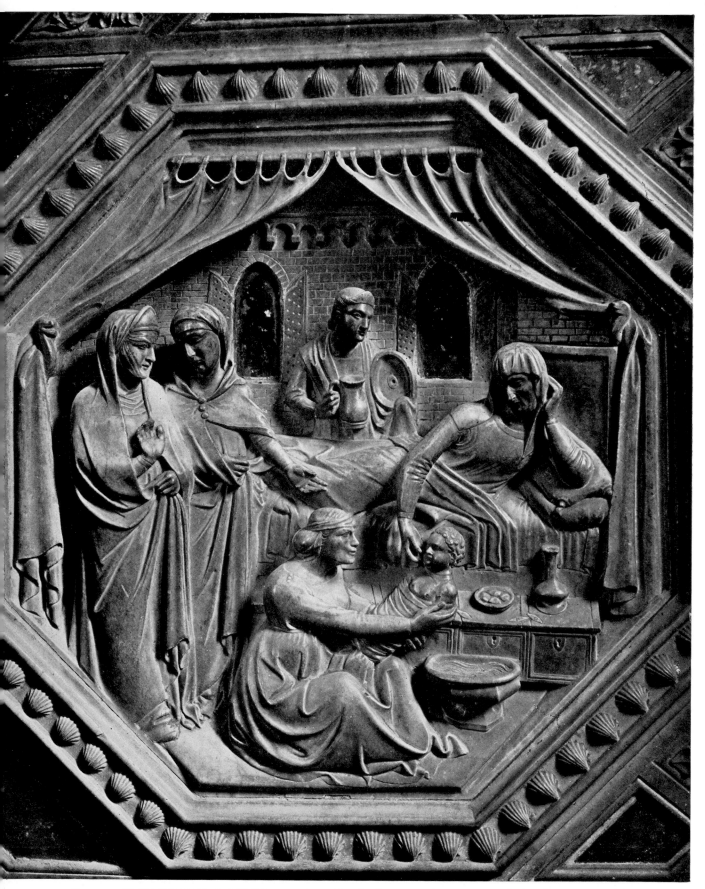

57. Orcagna: THE BIRTH OF THE VIRGIN (detail of Figure 42). Or San Michele, Florence. Marble.

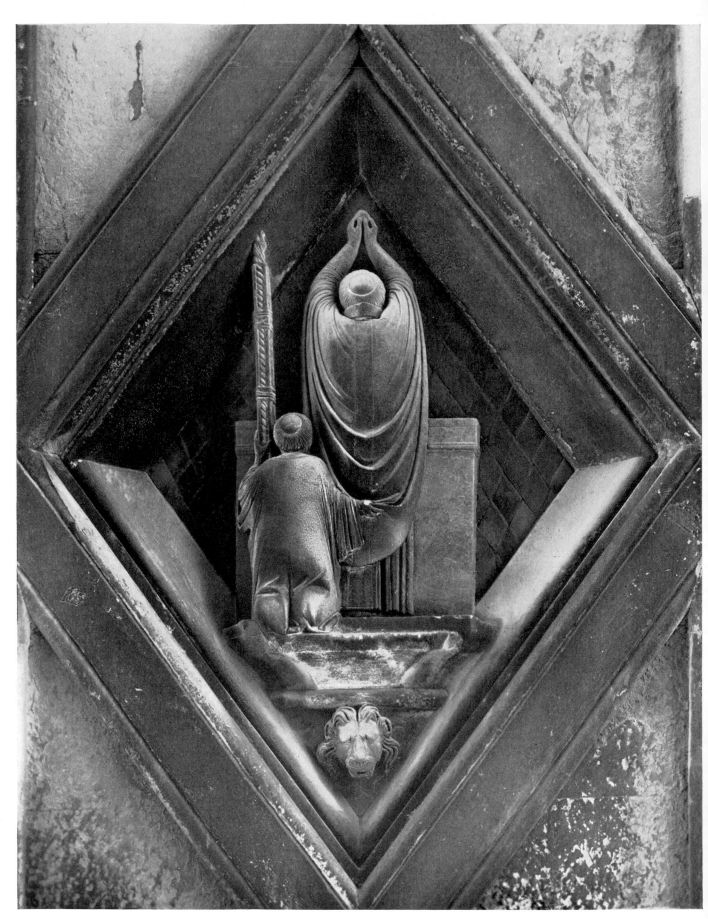

58. Alberto Arnoldi: THE EUCHARIST. Campanile, Florence. Marble (87 × 63·5 cm.).

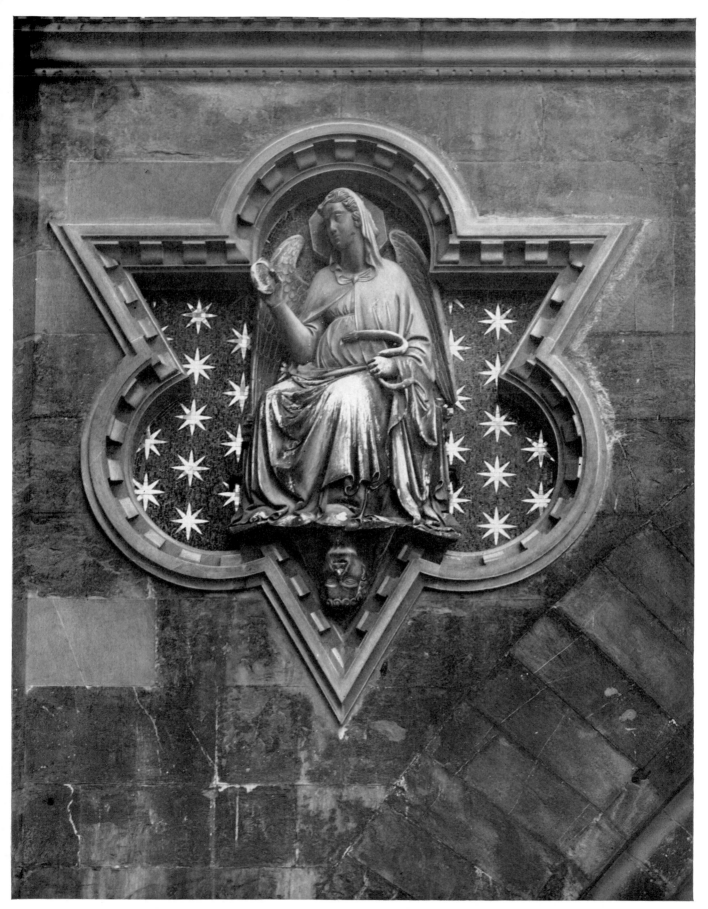

59. Giovanni d'Ambrogio (after Agnolo Gaddi): PRUDENCE. Loggia dei Lanzi, Florence. Marble.

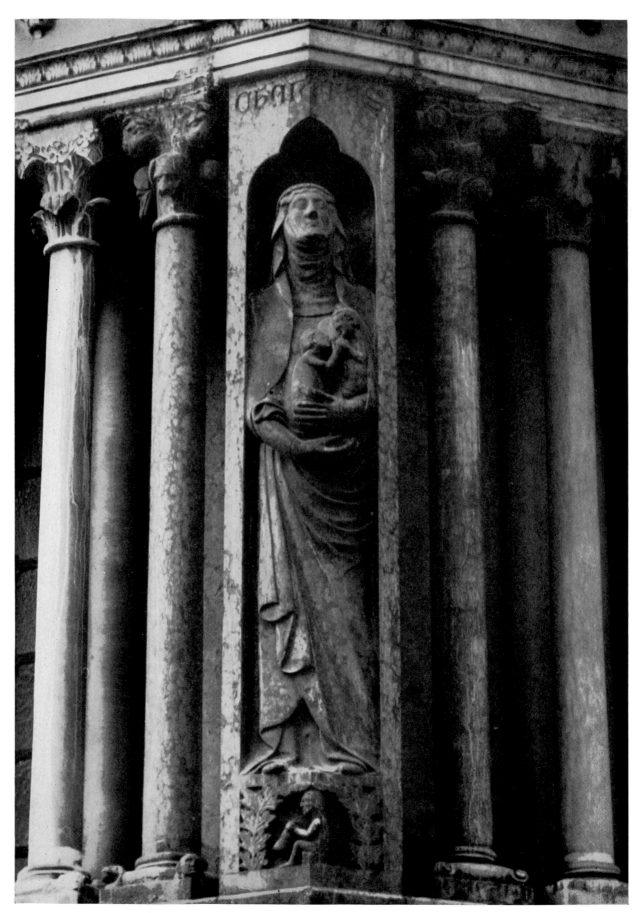

60. Giovanni da Campione: CHARITY (detail of Figure 46). Baptistry, Bergamo. Marble.

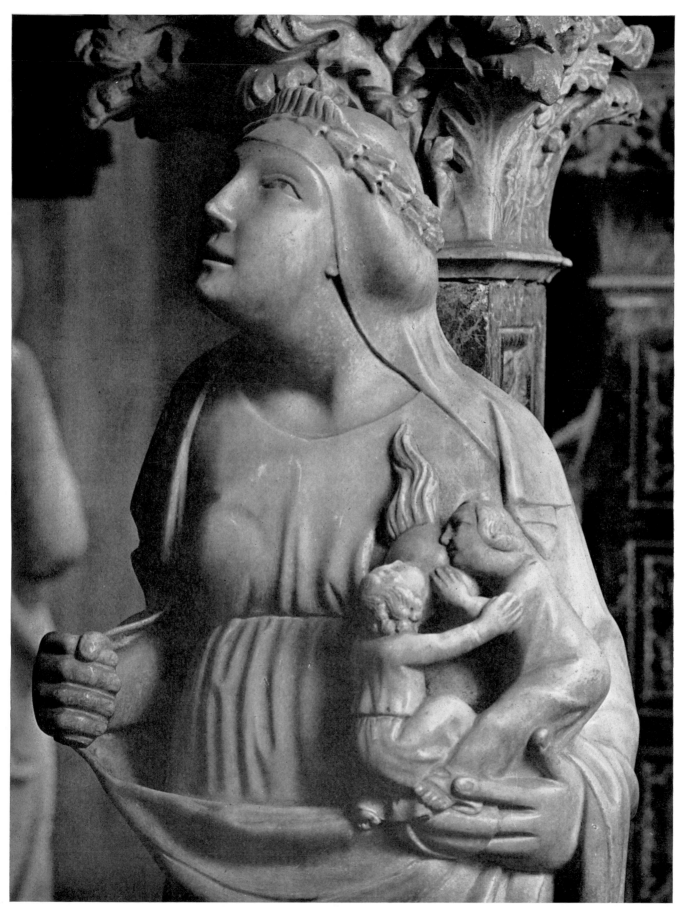

61. Giovanni di Balduccio: CHARITY (detail of Figure 44). S. Eustorgio, Milan. Marble (H. 102 cm.).

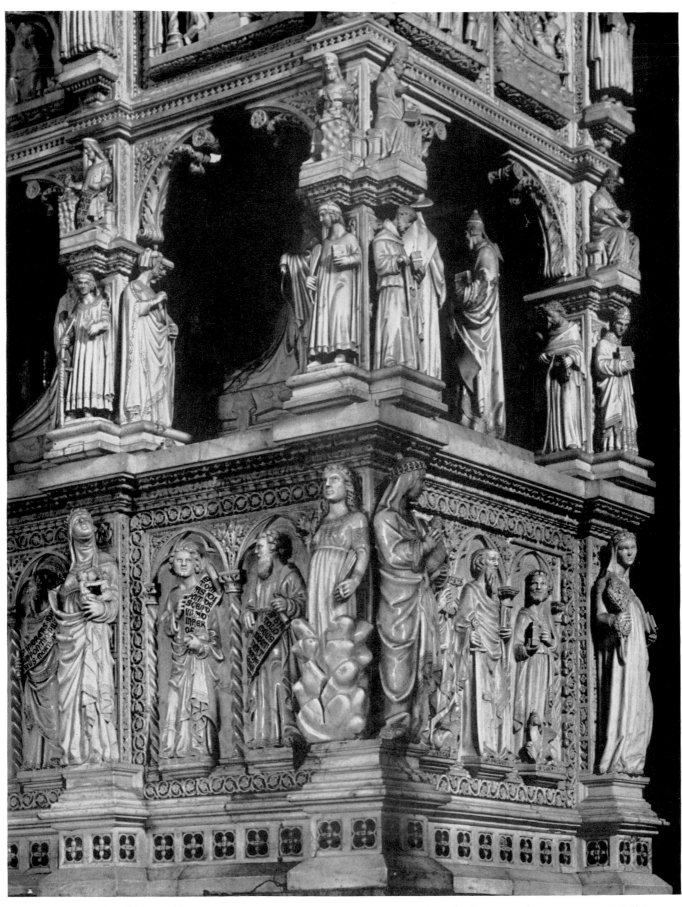

62. Giovanni di Balduccio (?): THE ARCA OF ST. AUGUSTINE (detail of Figure 45). S. Pietro in Ciel d'Oro, Pavia. Marble.

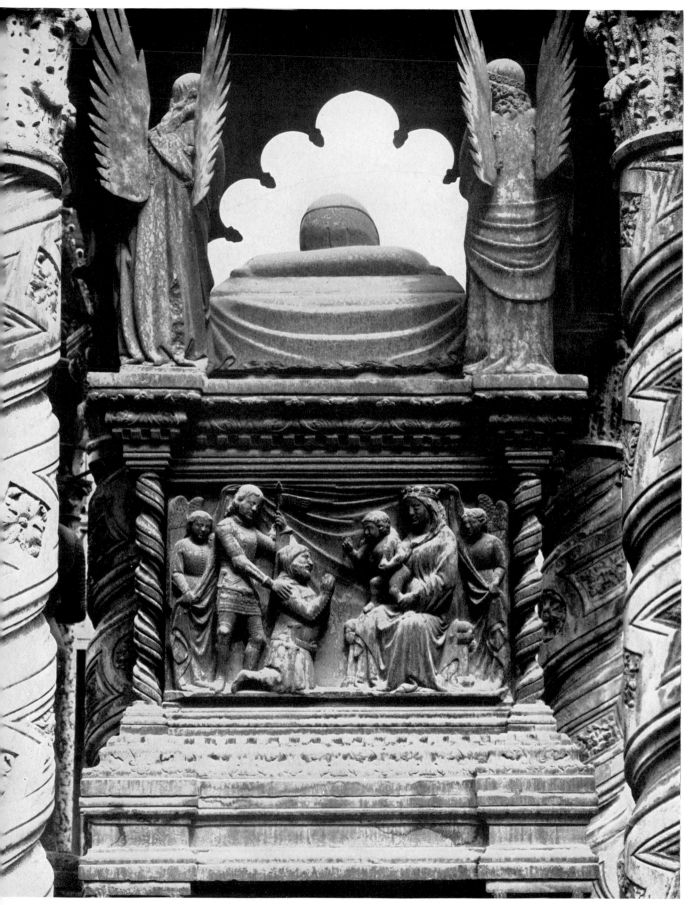

. Bonino da Campione: CANSIGNORIO DELLA SCALA PRESENTED TO THE VIRGIN AND CHILD
(detail of Figure 49). Sagrato di S. Maria Antica, Verona. Marble.

64. Bonino da Campione: BERNABÒ VISCONTI (detail of Figure 52). Museo del Castello Sforzesco, Milan. Marble.

65. Giovannino de' Grassi: CHRIST AND THE WOMAN OF SAMARIA. Duomo, Milan. Marble.

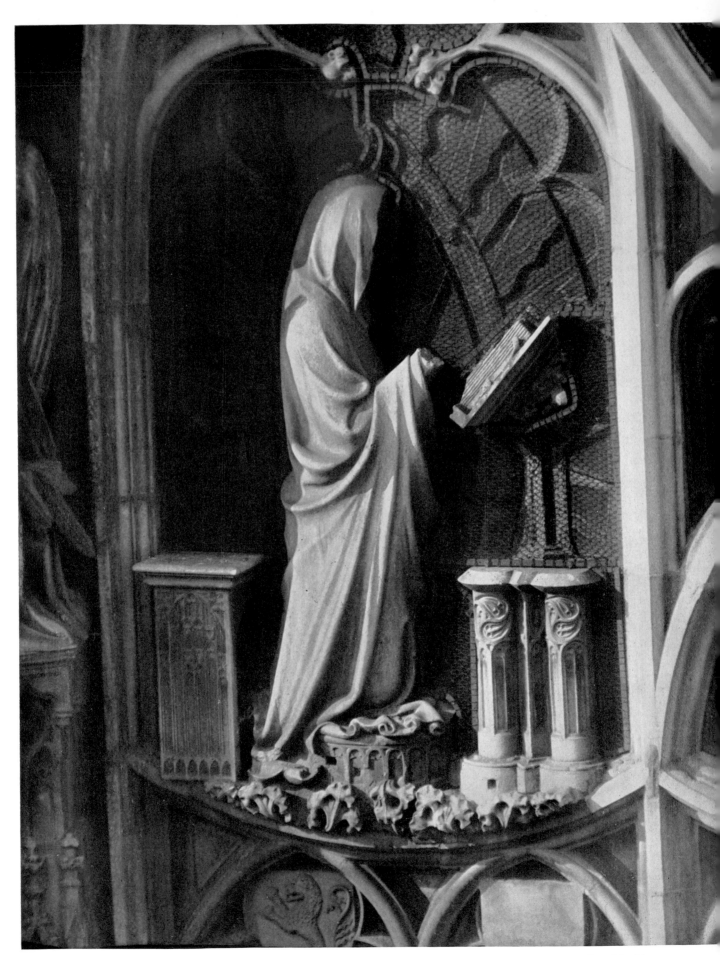

66. Milanese School (after Isacco da Imbonate): VIRGIN ANNUNCIATE. Duomo, Milan. Marble.

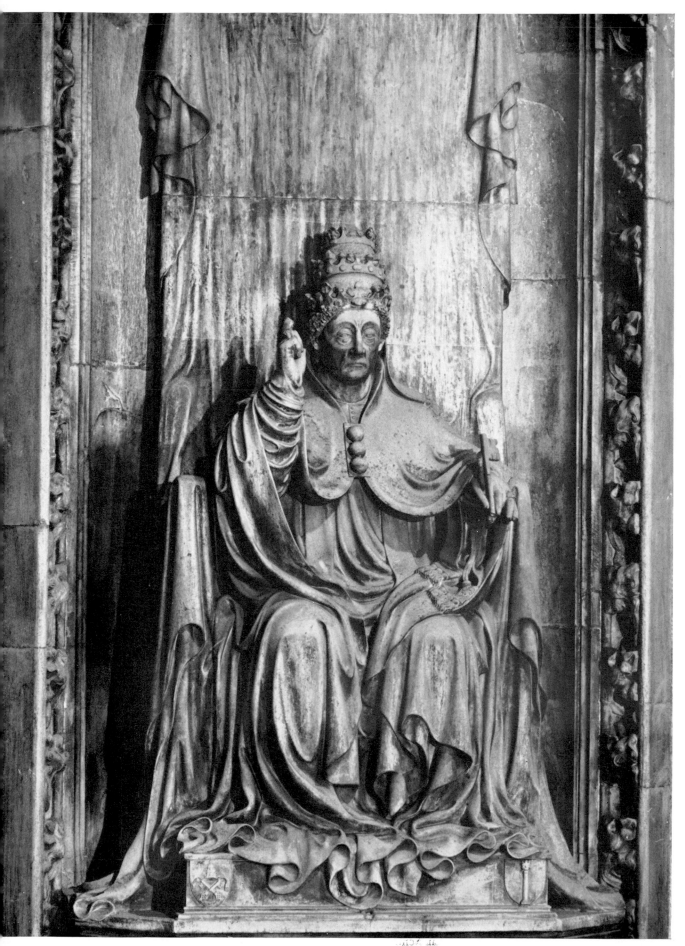

67. Jacopino da Tradate: POPE MARTIN V. Museo del Duomo, Milan. Marble.

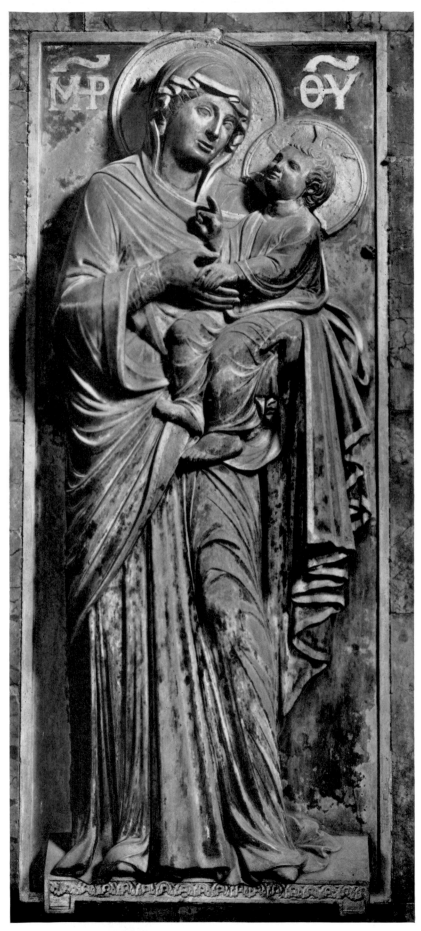

68. Venetian School: MADONNA DELLO SCHIOPPO.
S. Marco, Venice. Marble (173 × 72 cm.).

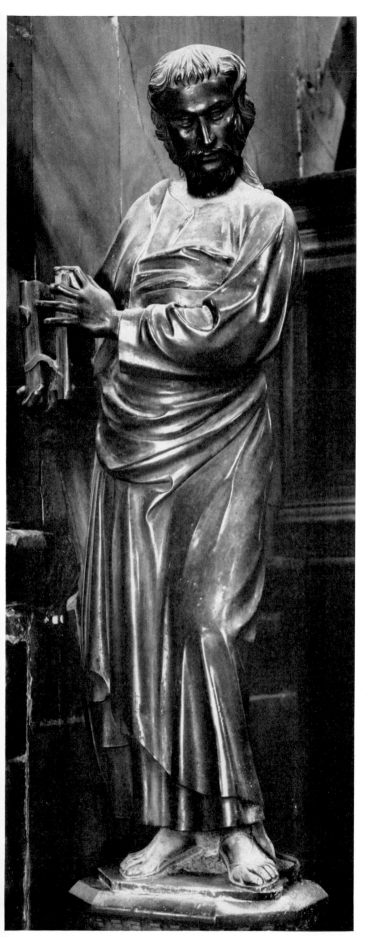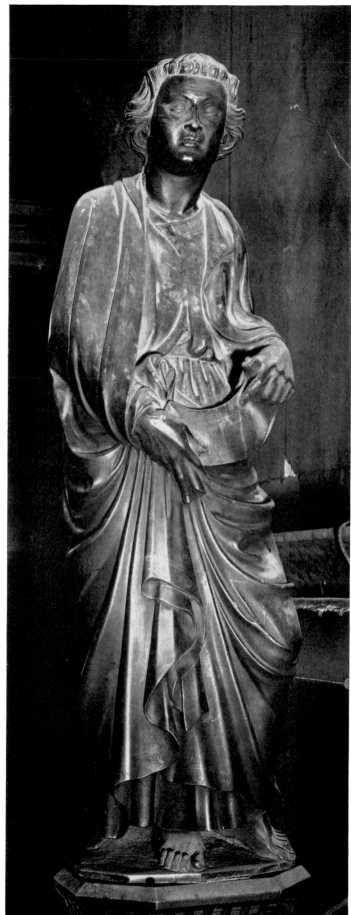

69A-B. Jacobello and Pierpaolo dalle Masegne: SS. MATTHEW AND THOMAS (details of Figure 58). S. Marco, Venice.
Marble (H. 136 cm.).

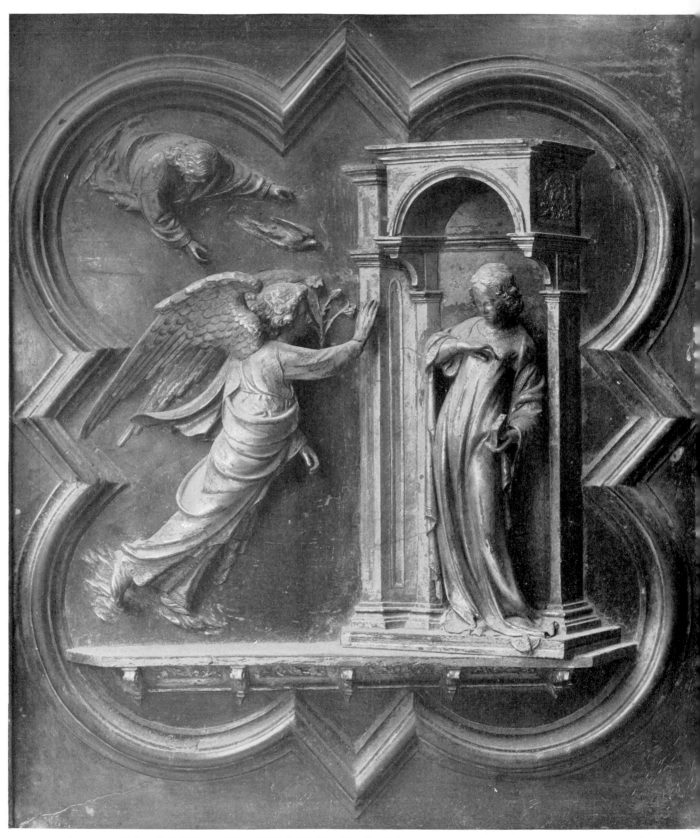

70. Lorenzo Ghiberti: THE ANNUNCIATION (detail of Figure 65). Baptistry, Florence. Bronze, parcel-gilt
(52×45 cm. inside moulding).

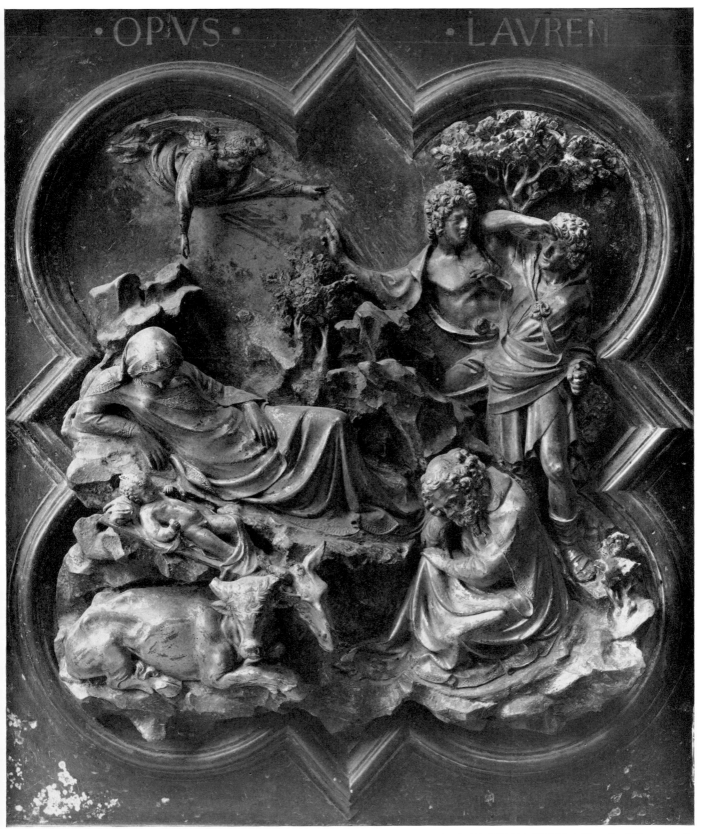

71. Lorenzo Ghiberti: THE NATIVITY AND ANNUNCIATION TO THE SHEPHERDS (detail of Figure 65).
Baptistry, Florence. Bronze, parcel-gilt (52×45 cm. inside moulding).

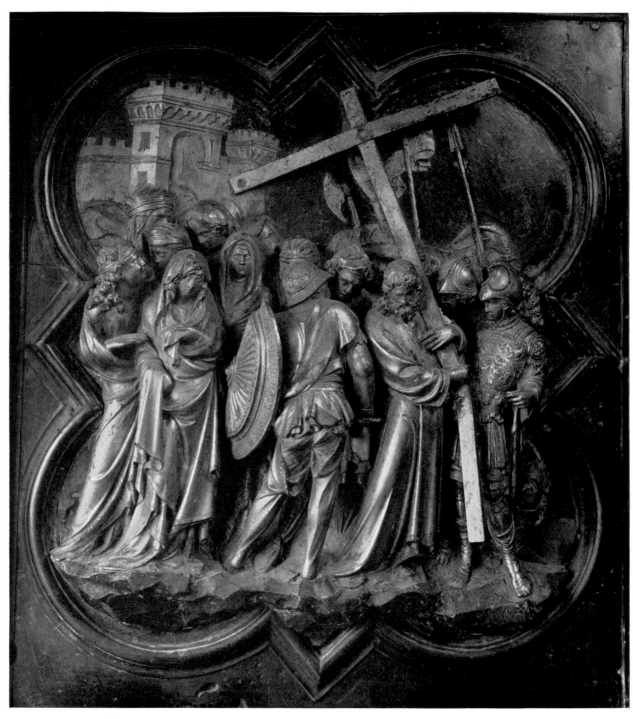

72. Lorenzo Ghiberti: CHRIST CARRYING THE CROSS (detail of Figure 65). Baptistry, Florence.
Bronze, parcel-gilt (52×45 cm. inside moulding).

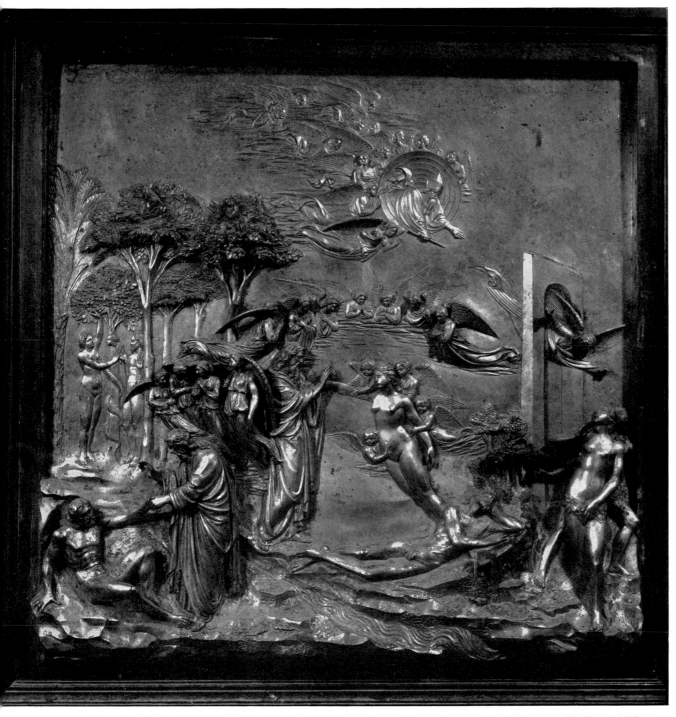

73. Lorenzo Ghiberti: THE CREATION OF ADAM AND EVE, THE FALL AND THE EXPULSION
FROM PARADISE (detail of Figure 66). Baptistry, Florence. Gilt bronze (79×79 cm.).

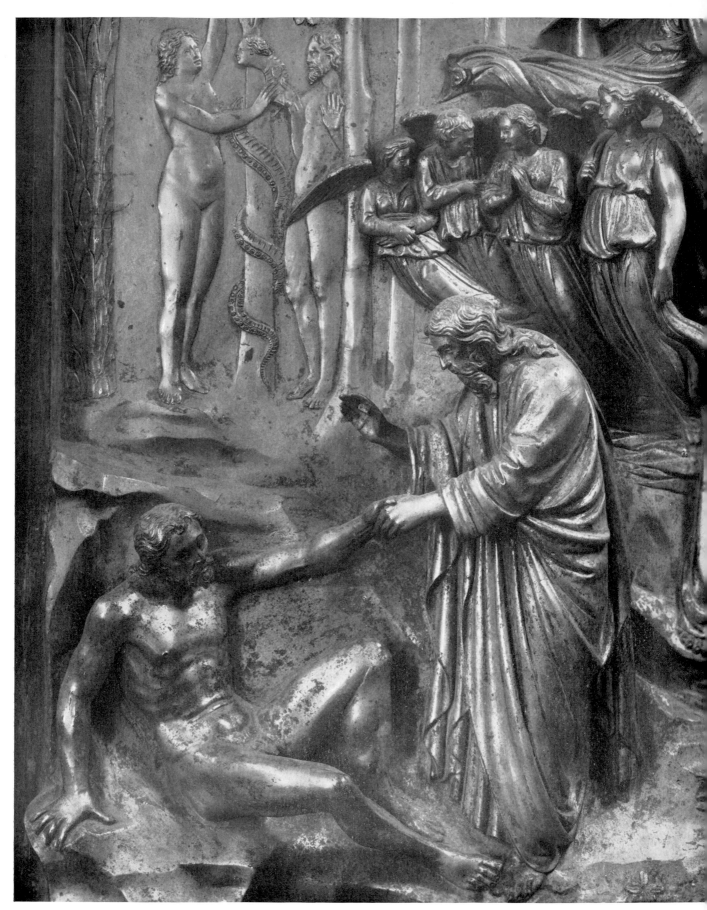

74. Lorenzo Ghiberti: THE CREATION OF ADAM (detail of Plate 73). Baptistry, Florence. Gilt bronze.

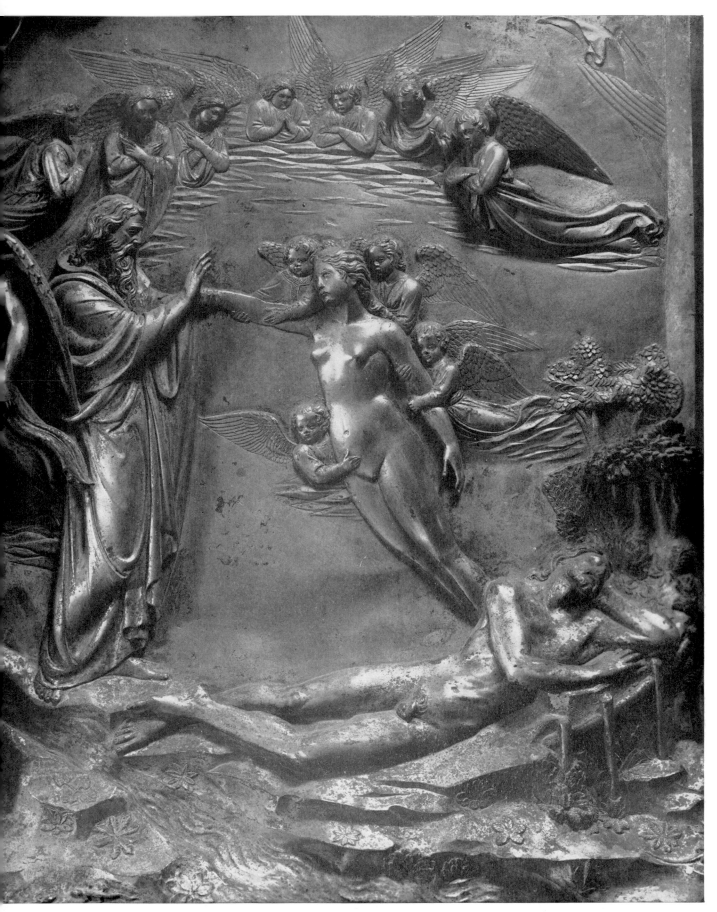

75. Lorenzo Ghiberti: THE CREATION OF EVE (detail of Plate 73). Baptistry, Florence. Gilt bronze.

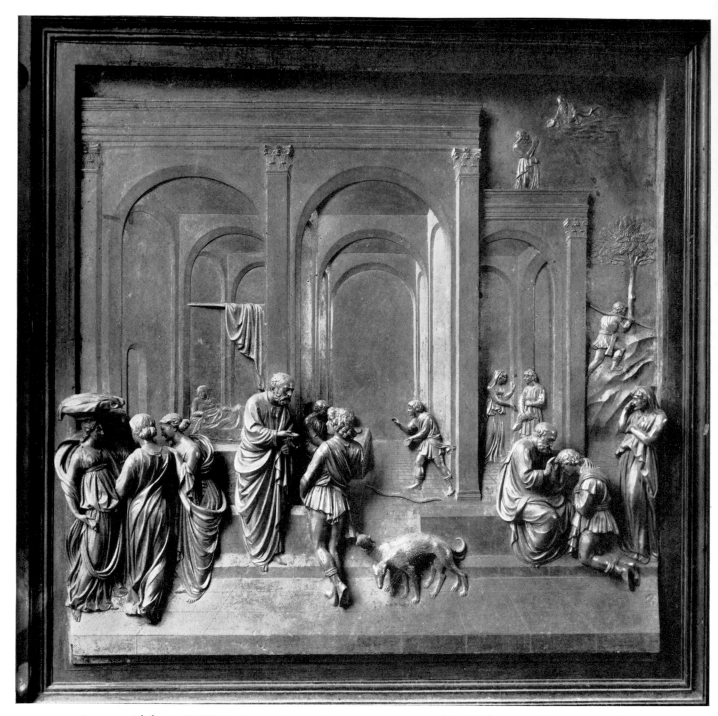

76. Lorenzo Ghiberti: THE STORY OF JACOB AND ESAU (detail of Figure 66). Baptistry, Florence.
Gilt bronze (79 × 79 cm.).

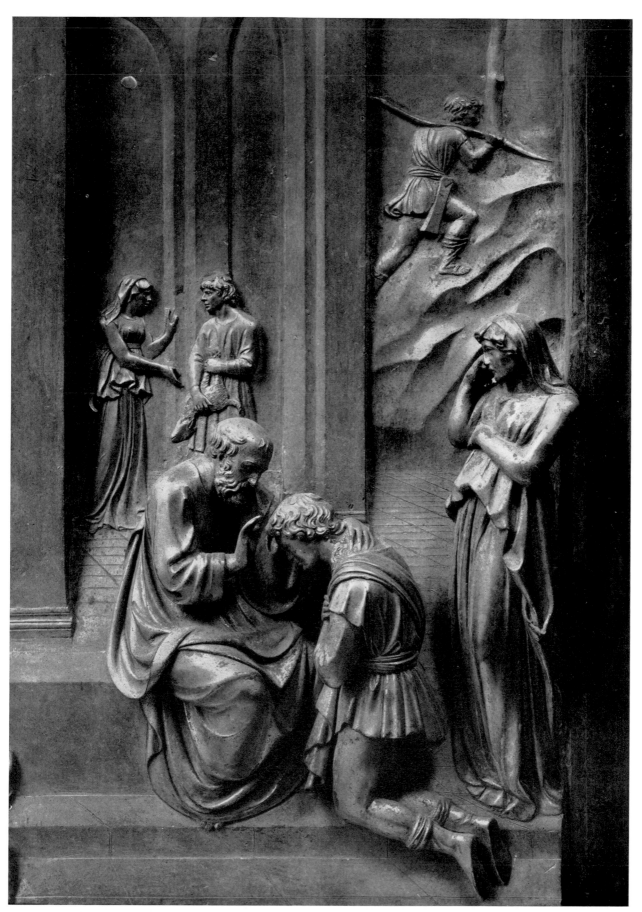

77. Lorenzo Ghiberti: JACOB AND ESAU (detail of Plate 76). Baptistry, Florence. Gilt bronze.

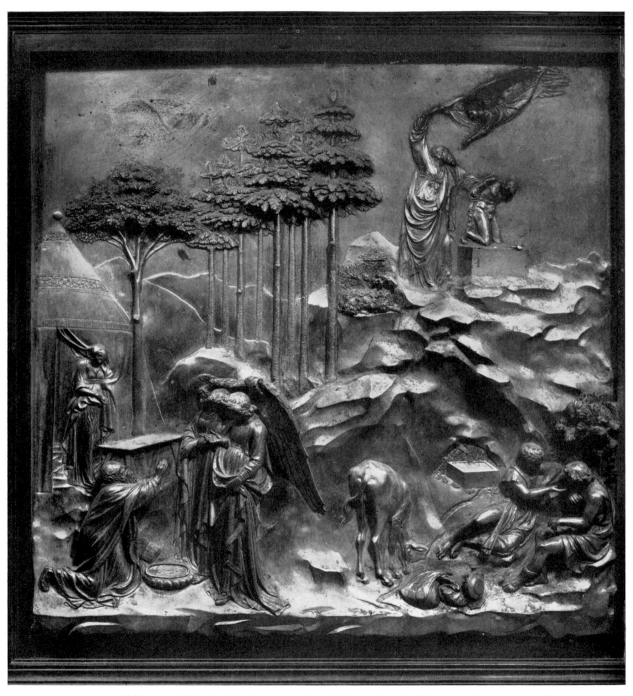

78. Lorenzo Ghiberti: THE STORY OF ABRAHAM (detail of Figure 66). Baptistry, Florence.
Gilt bronze (79 × 79 cm.).

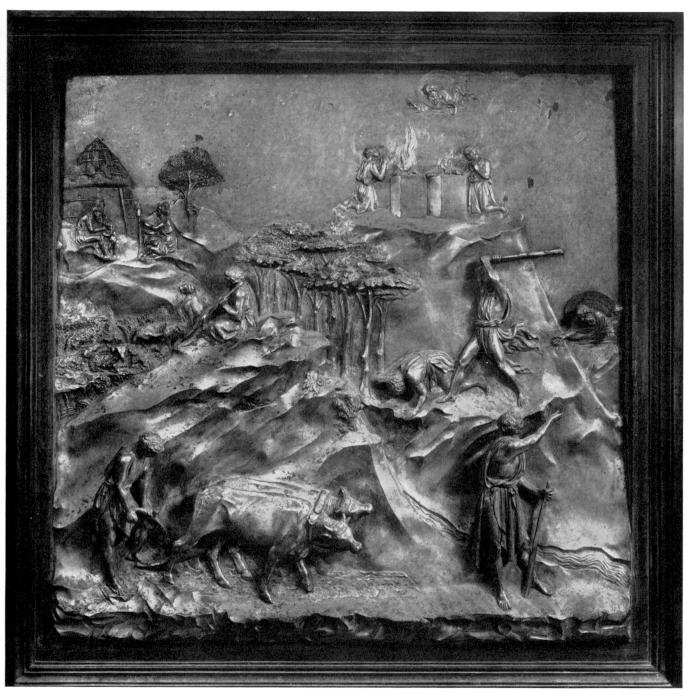

79. Lorenzo Ghiberti: THE STORY OF CAIN AND ABEL (detail of Figure 66). Baptistry, Florence.
Gilt bronze (79 × 79 cm.).

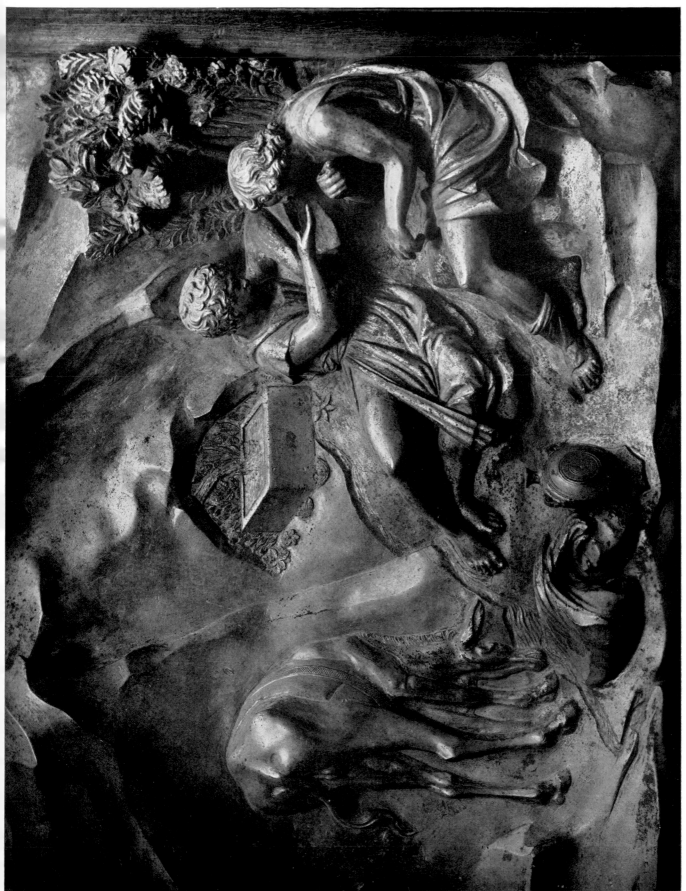

81. Lorenzo Ghiberti: TWO SEATED YOUTHS (detail of Plate 78). Baptistry, Florence. Gilt bronze.

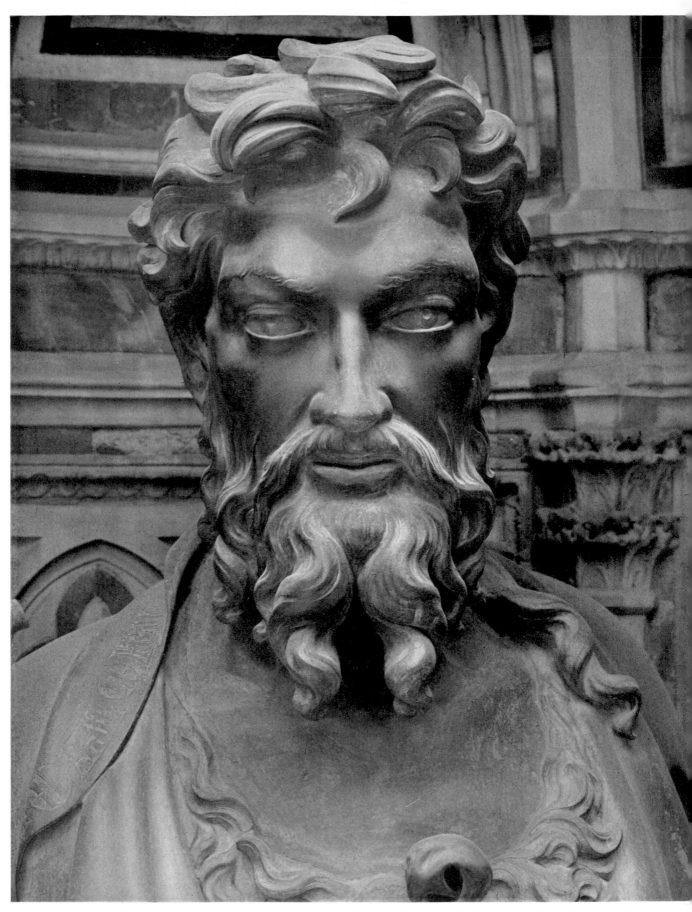

82. Lorenzo Ghiberti: ST. JOHN THE BAPTIST (detail of Figure 67). Or San Michele, Florence. Bronze
(H. overall about 250 cm.).

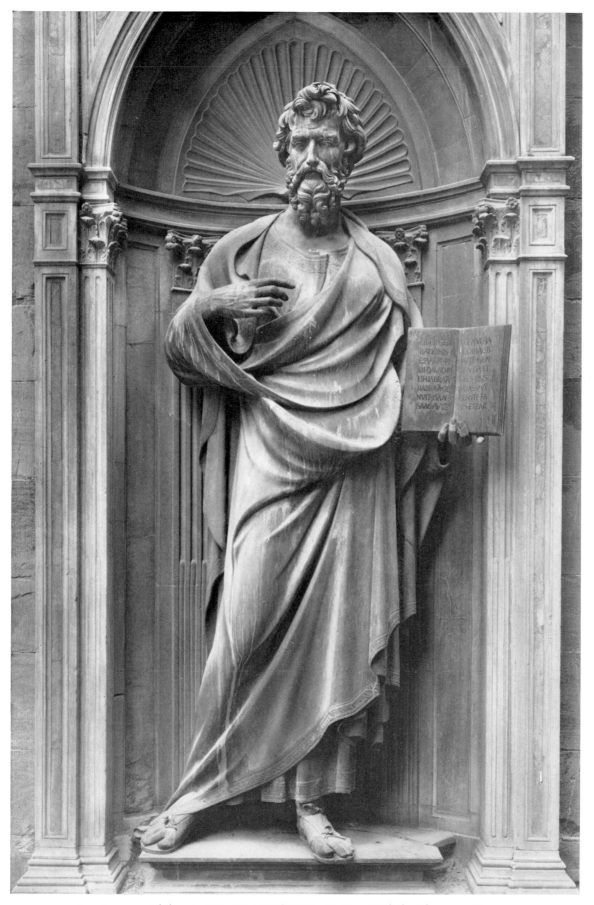

83. Lorenzo Ghiberti: ST. MATTHEW. Or San Michele, Florence. Bronze
(H. about 270 cm.).

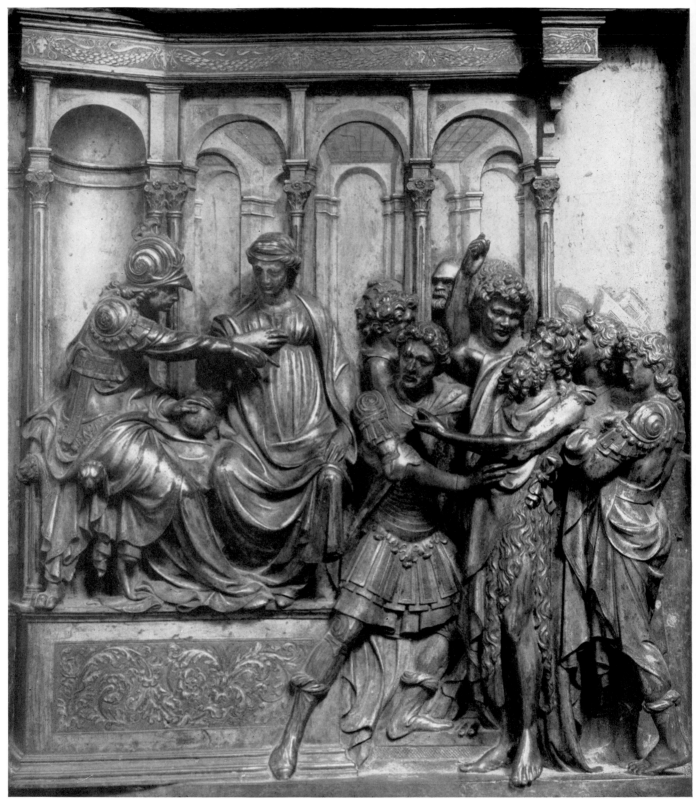

84. Lorenzo Ghiberti and Giuliano di ser Andrea: ST. JOHN THE BAPTIST PREACHING BEFORE HEROD
(detail of Figure 64). Baptistry, Siena. Gilt bronze (62×60 cm.).

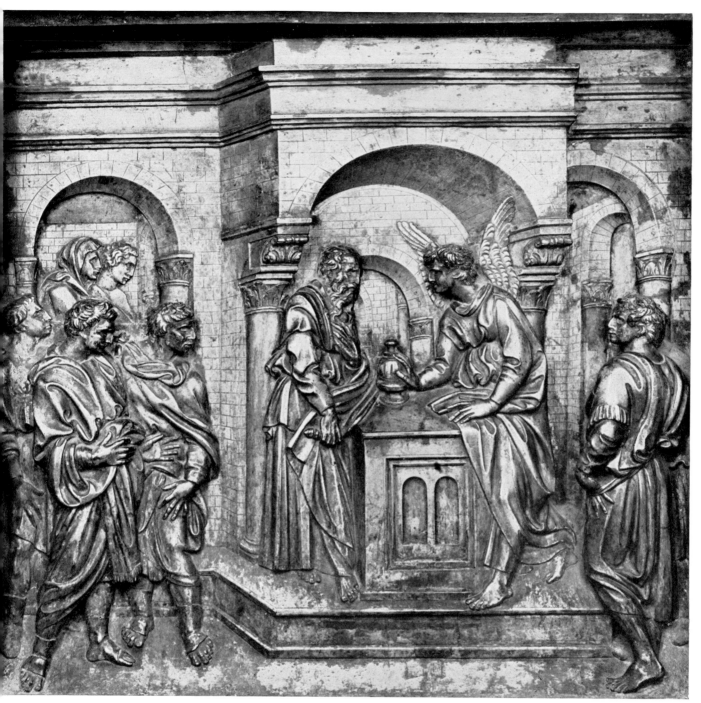

85. Jacopo della Quercia: ZACHARIAS IN THE TEMPLE (detail of Figure 64). Baptistry, Siena.
Gilt bronze (62 × 63 cm.).

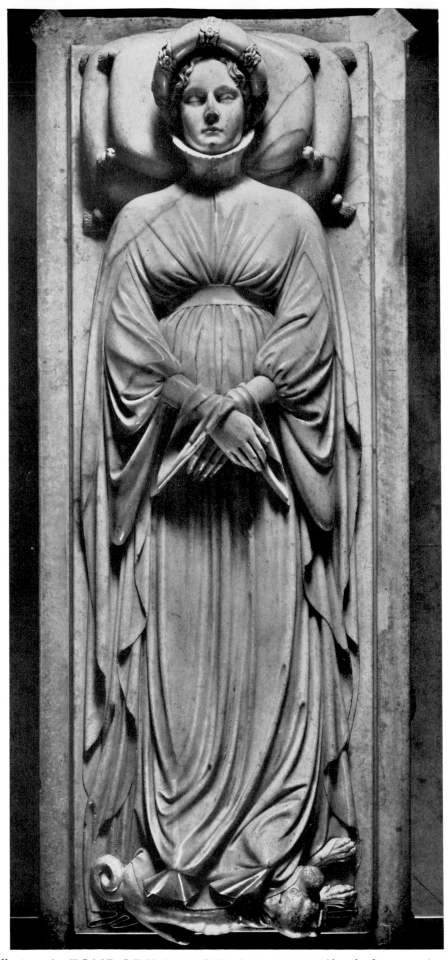

86. Jacopo della Quercia: TOMB OF ILARIA DEL CARRETTO (detail of Figure 69). Duomo, Lucca.
Marble (Sarcophagus L. 234 cm., W. 93 cm.; effigy L. 208 cm.).

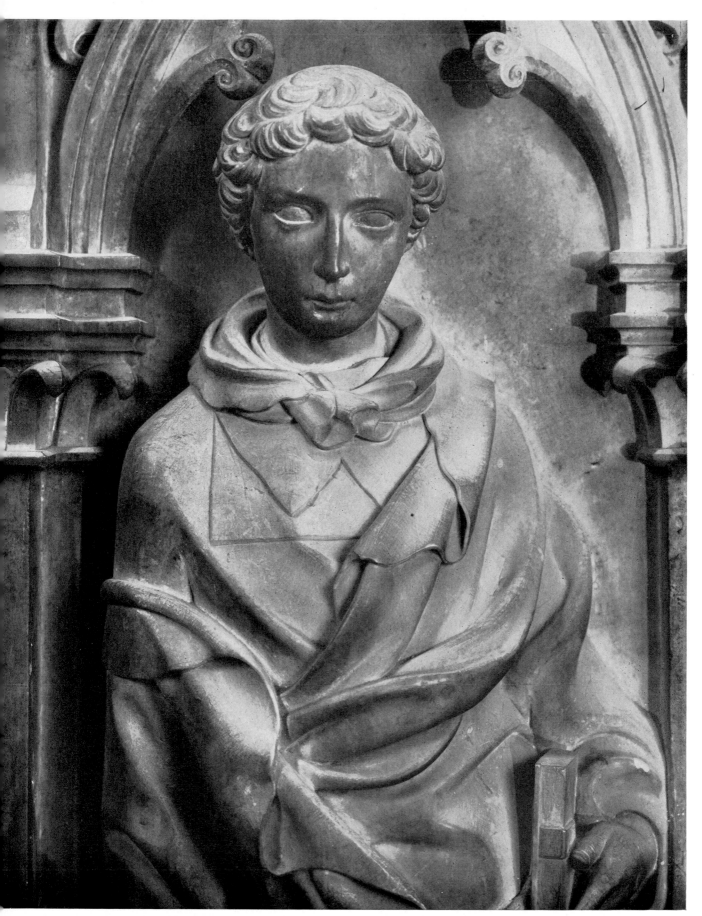

87. Jacopo della Quercia: ST. LAWRENCE (detail of Figure 70). S. Frediano, Lucca. Marble.

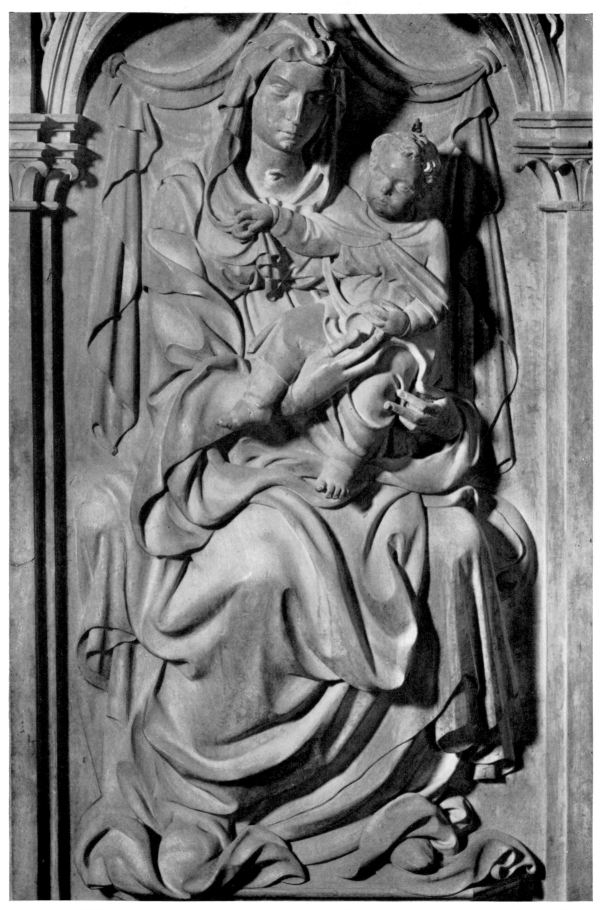

88. Jacopo della Quercia: VIRGIN AND CHILD (detail of Figure 70). S. Frediano, Lucca. Marble.

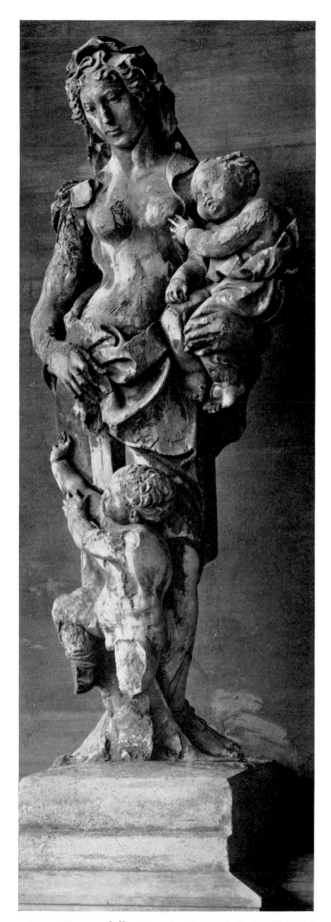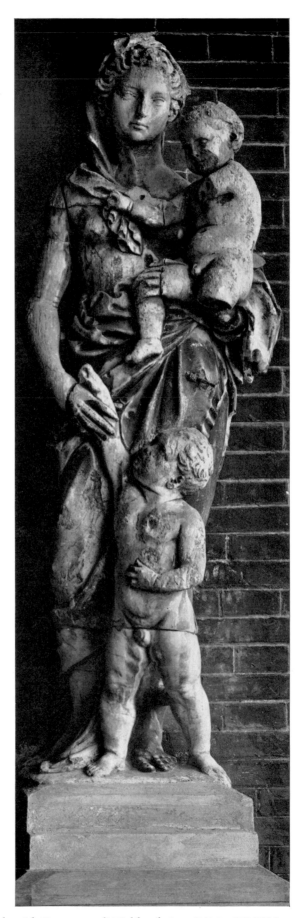

89A-B. Jacopo della Quercia: ACCA LARENTIA and, with Francesco di Valdambrino, REA SILVIA
(details of Figure 71). Palazzo Pubblico, Siena. Marble (H. of each 165 cm.).

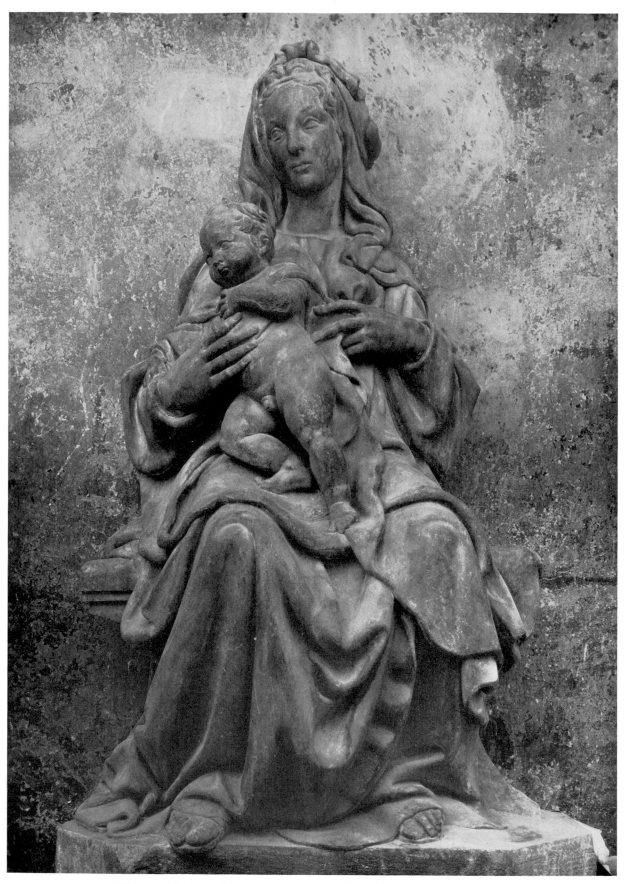

90. Jacopo della Quercia: VIRGIN AND CHILD (detail of Figure 74). S. Petronio, Bologna.
Istrian stone (H. 211 cm.).

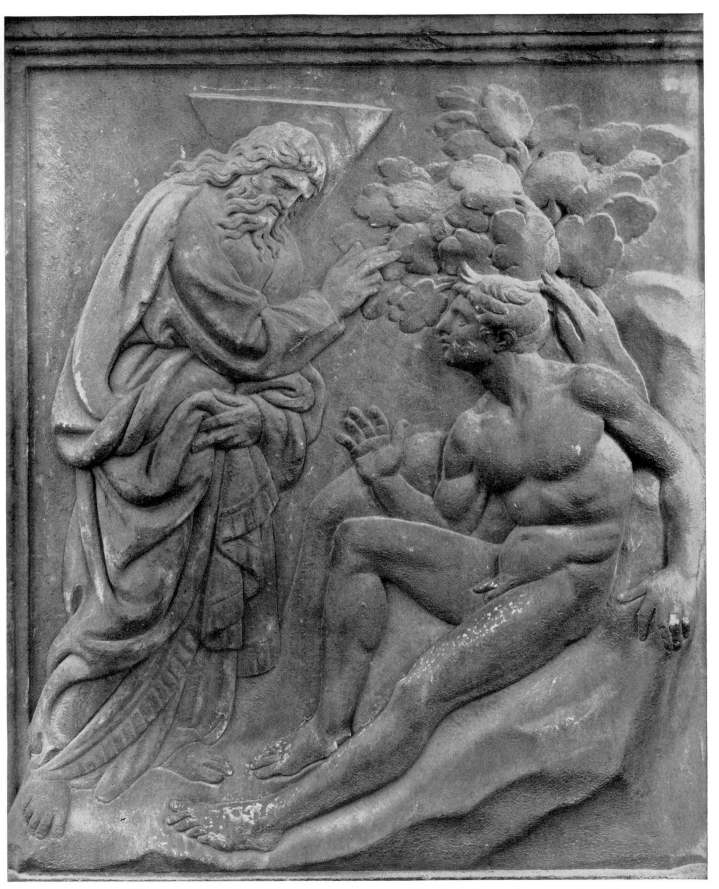

91. Jacopo della Quercia: THE CREATION OF ADAM (detail of Figure 74). S. Petronio, Bologna.
Istrian stone (82×68 cm.).

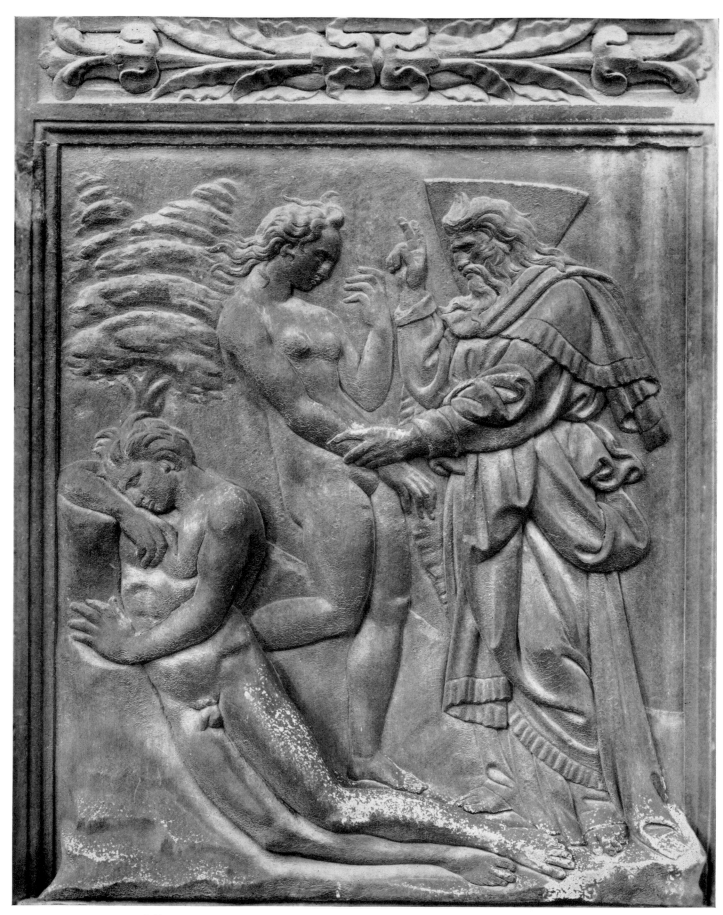

92. Jacopo della Quercia: THE CREATION OF EVE (detail of Figure 74). S. Petronio, Bologna.
Istrian stone (82×68 cm.).

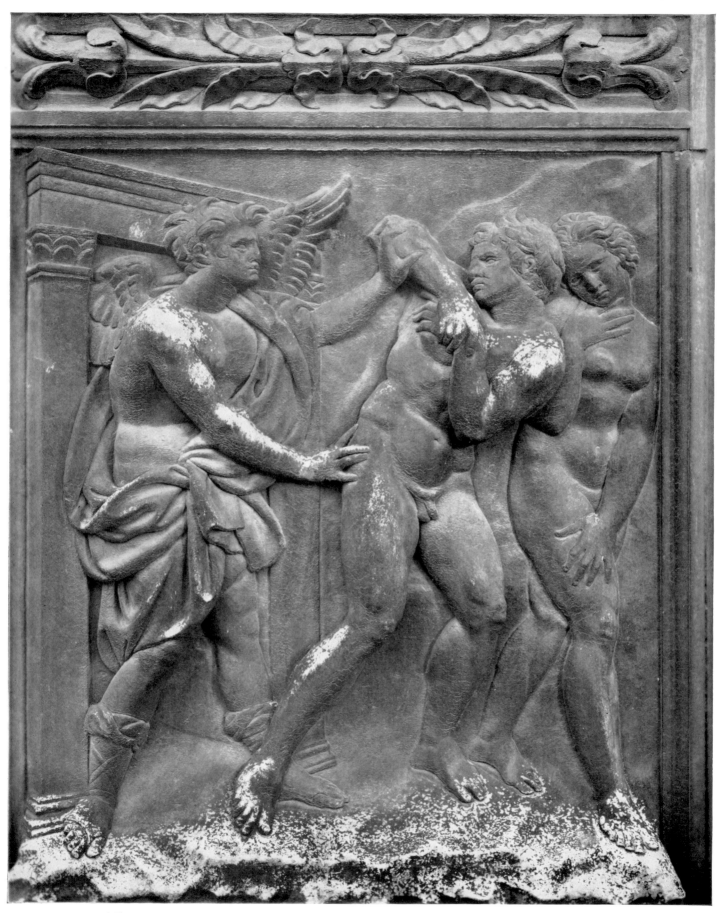

93. Jacopo della Quercia: THE EXPULSION FROM PARADISE (detail of Figure 74). S. Petronio, Bologna.
Istrian stone (82×68 cm.).

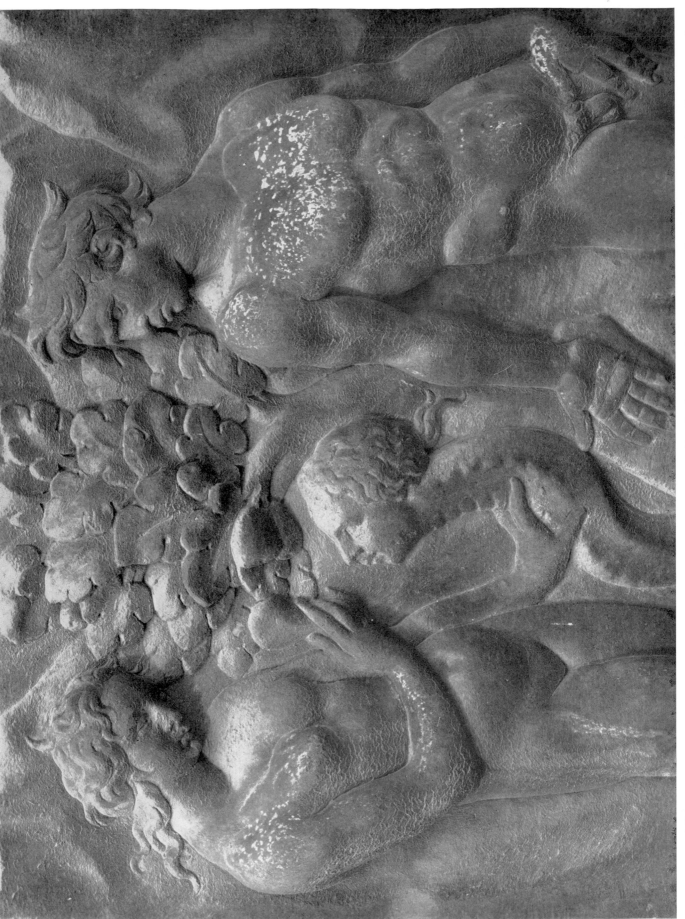

94. Jacopo della Quercia: THE TEMPTATION OF ADAM AND EVE (detail of Figure 71). S. Petronio, Bologna. Istrian stone (overall 83 × 68 cm.)

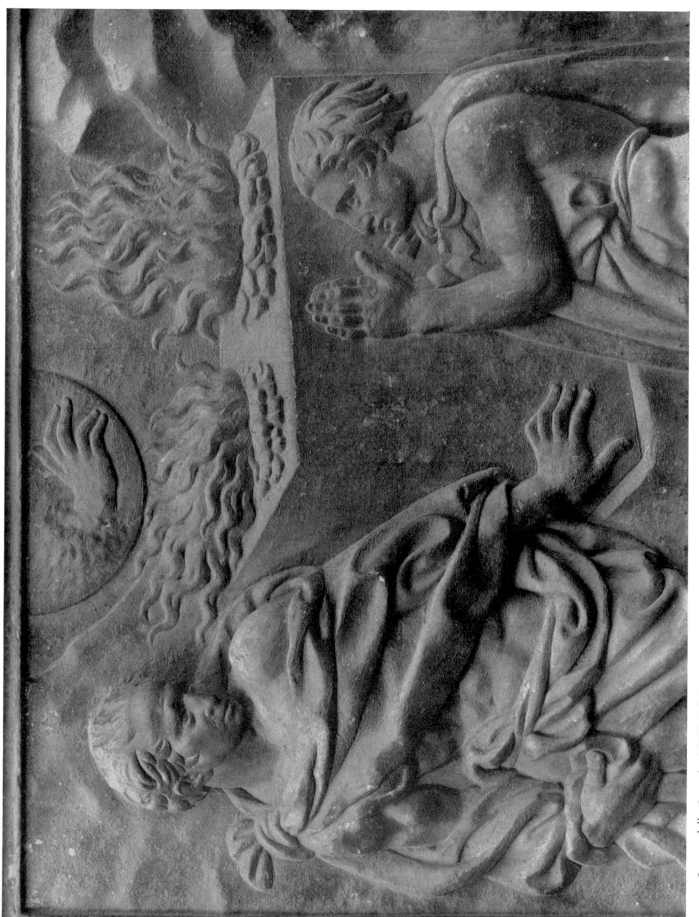

95. Jacopo della Quercia: THE SACRIFICES OF CAIN AND ABEL (detail of Figure 74). S. Petronio, Bologna. Istrian stone (overall 82×68 cm.).

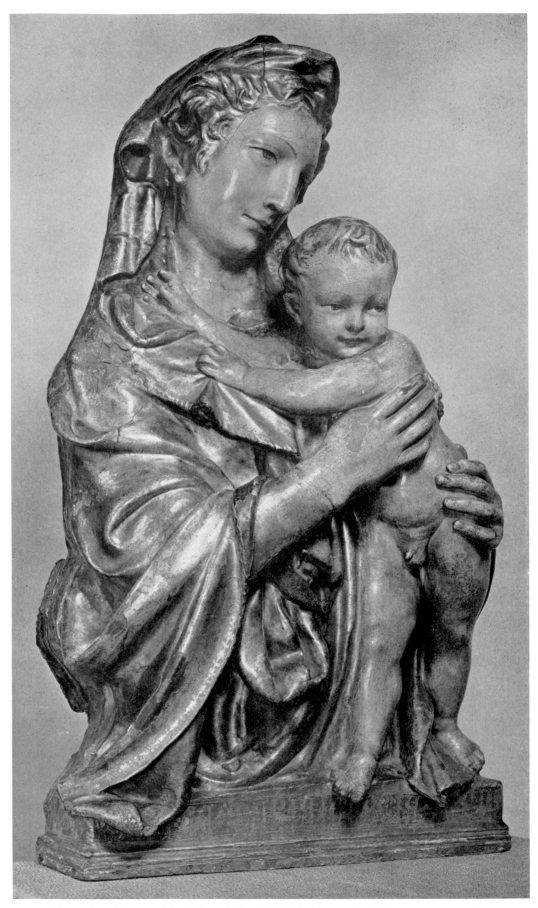

96. Florentine School: VIRGIN AND CHILD. National Gallery of Art, Washington
(Kress Collection). Pigmented terracotta (H. 103 cm.).

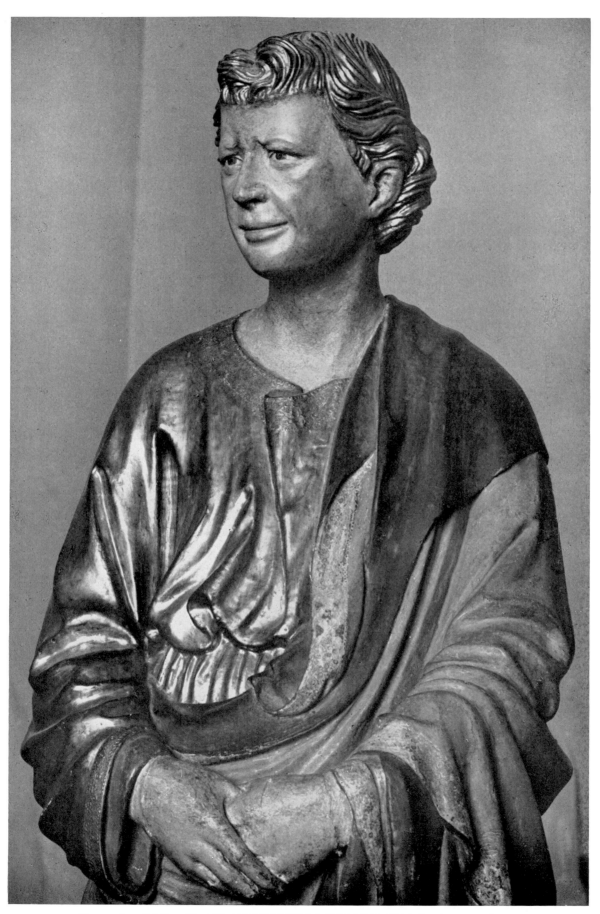

97. Domenico di Niccolò: ST. JOHN THE EVANGELIST. S. Pietro Ovile, Siena.
Pigmented wood (H. overall 166 cm.).

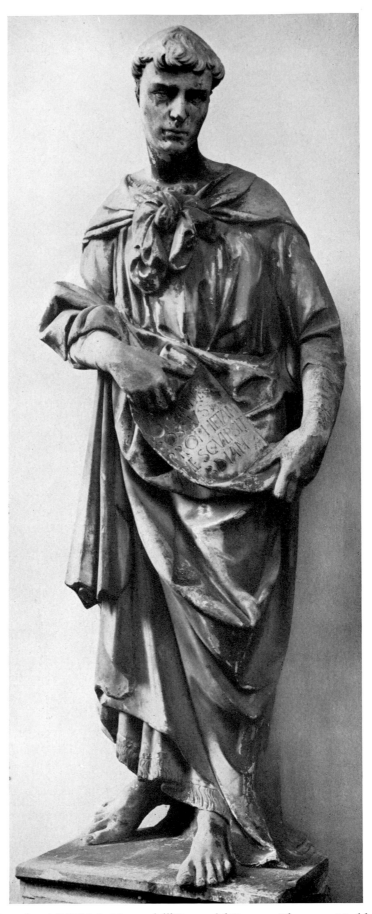

98. Nanni di Bartolo: ABDIAS. Museo dell'Opera del Duomo, Florence. Marble (H. 189 cm.).

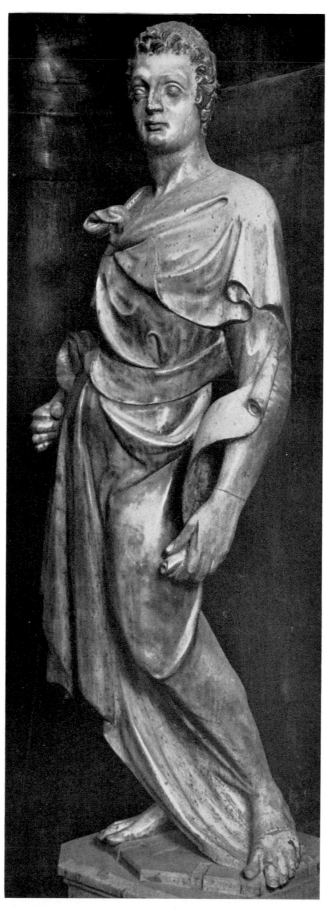

99. Nanni di Banco: ISAIAH. Duomo, Florence. Marble (H. with base 193 cm.).

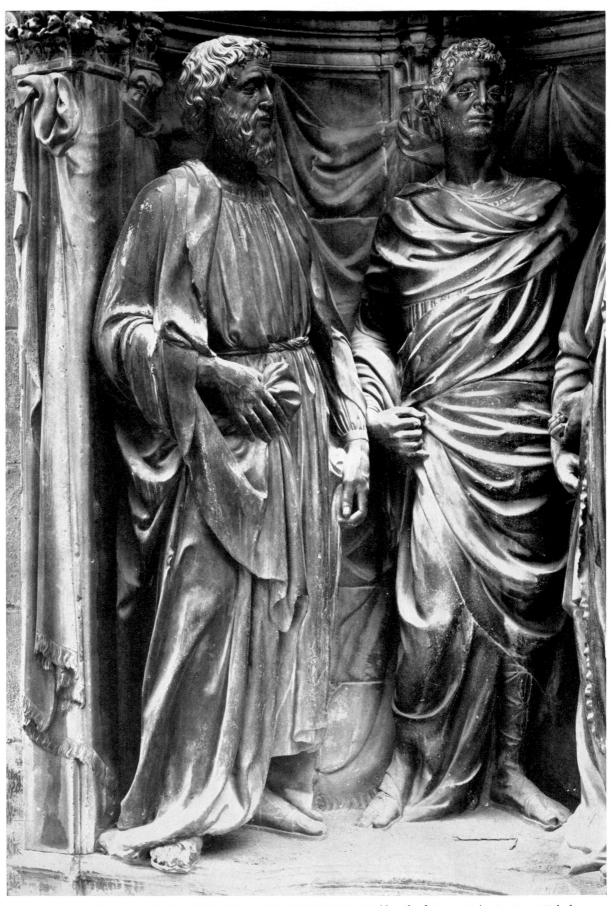

100. Nanni di Banco: QUATTRO SANTI CORONATI (detail of Figure 83). Or San Michele, Florence. Marble.

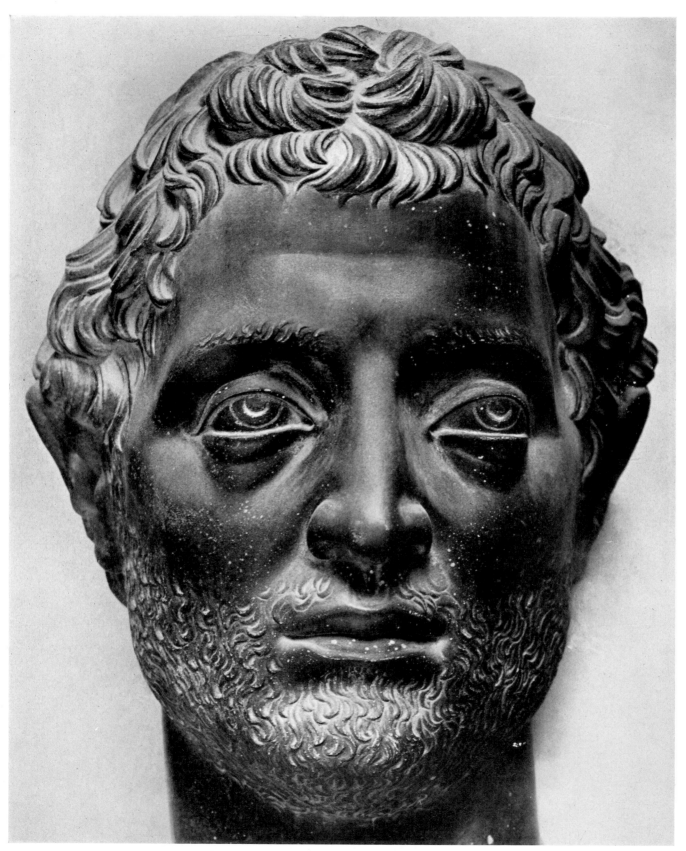

101. Nanni di Banco: HEAD (detail of Plate 100). Or San Michele, Florence. Marble.

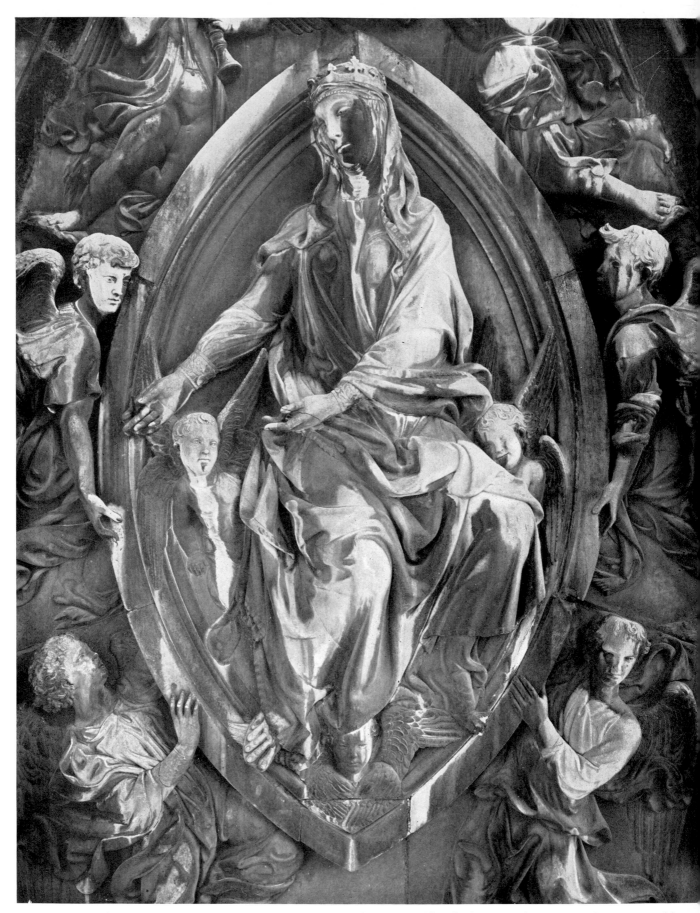

102. Nanni di Banco: THE ASSUMPTION OF THE VIRGIN (detail of Figure 86). Duomo, Florence. Marble.

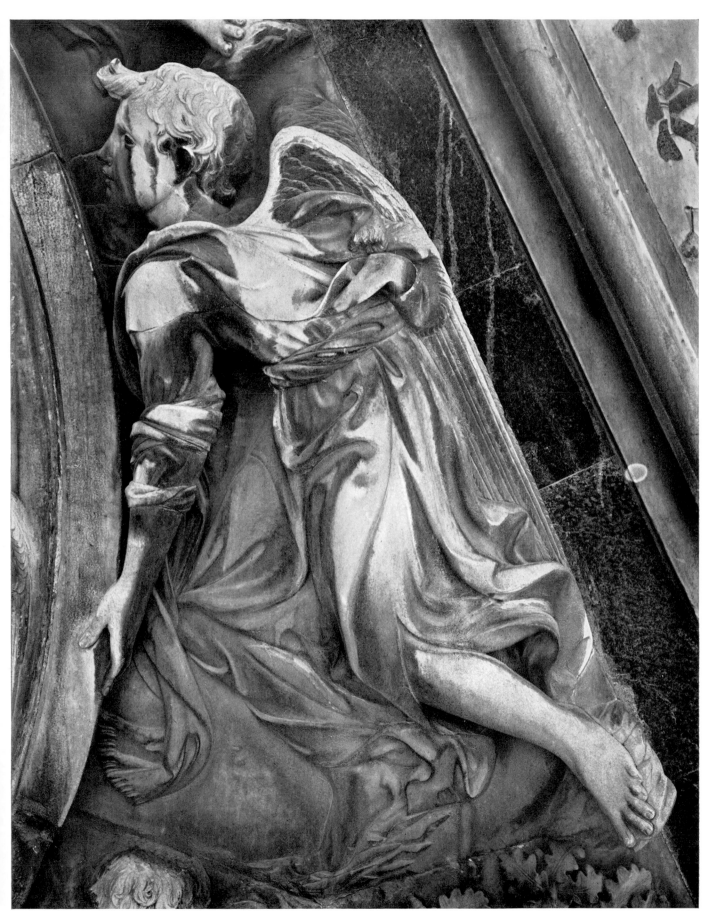

103. Nanni di Banco: ANGEL (detail of Figure 86). Duomo, Florence. Marble.

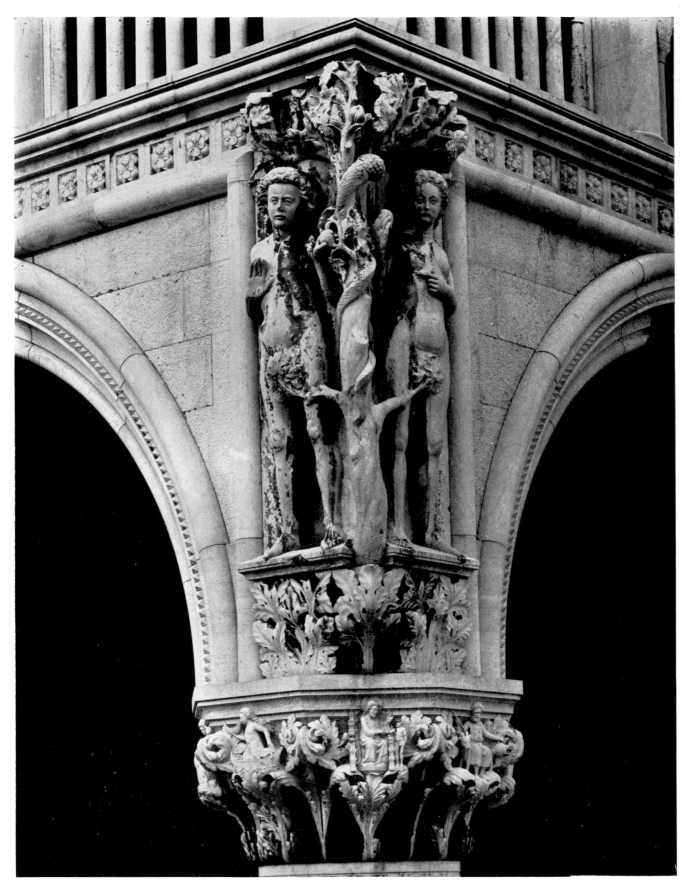

104. Venetian School: THE FALL. Palazzo Ducale, Venice. Istrian stone.

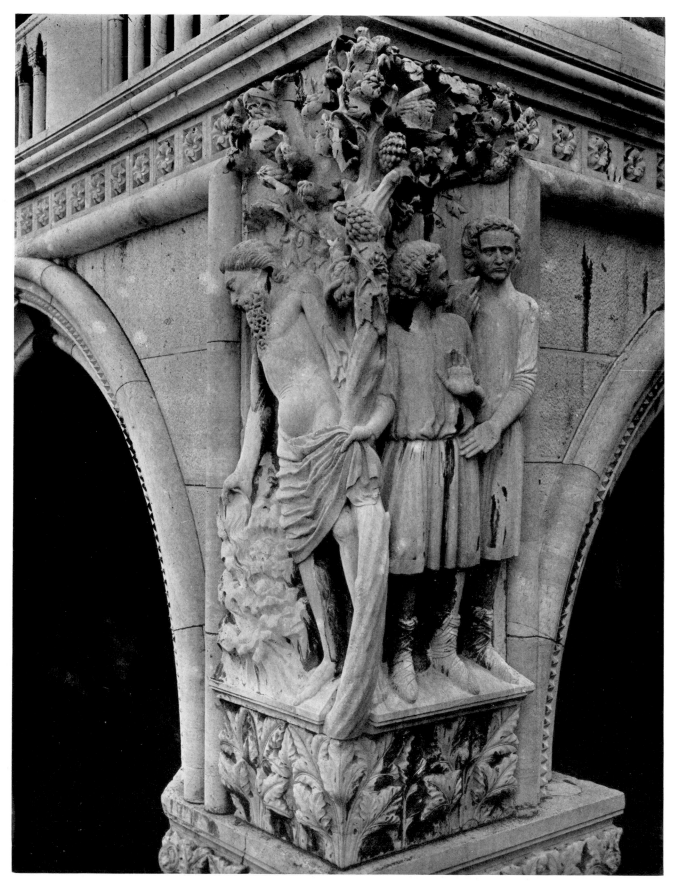

105. Venetian School: THE DRUNKENNESS OF NOAH. Palazzo Ducale, Venice. Istrian stone.

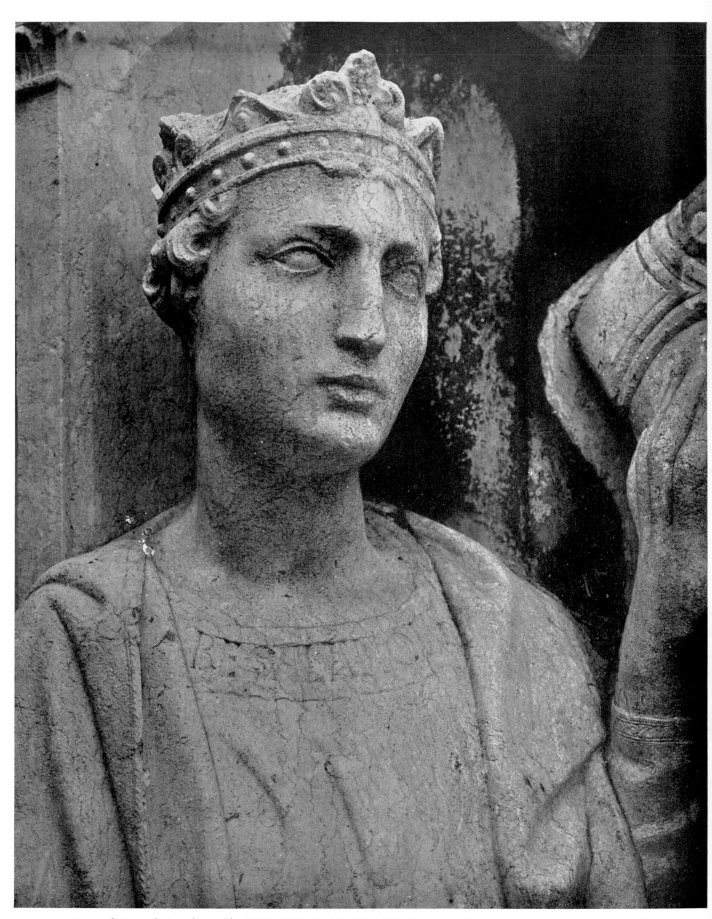

106. Pietro di Niccolò Lamberti (?): THE JUDGMENT OF SOLOMON (detail of Figure 93). Palazzo Ducale, Venice. Istrian stone.

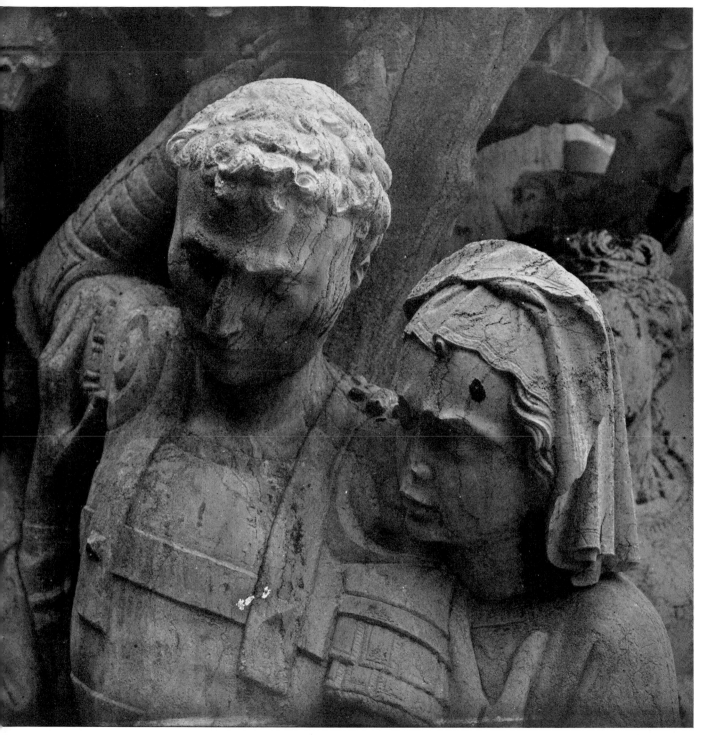

107. Pietro di Niccolò Lamberti (?): THE JUDGMENT OF SOLOMON (detail of Figure 93). Palazzo Ducale, Venice. Istrian stone.

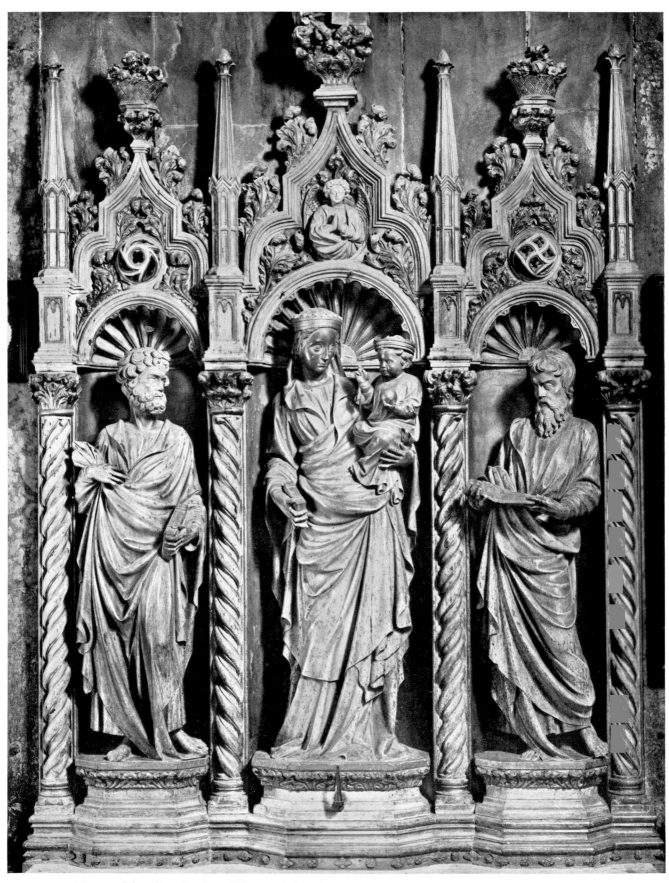

108. Master of the Mascoli Altar: VIRGIN AND CHILD BETWEEN SS. MARK AND JAMES.
S. Marco, Venice. Marble (H. 130 cm.).

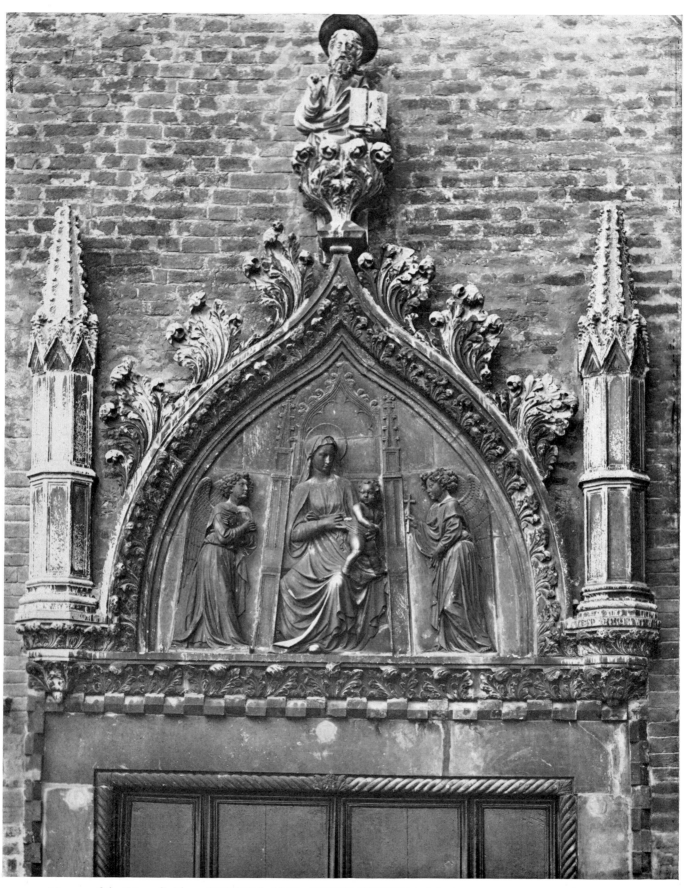

109. Master of the Mascoli Altar: VIRGIN AND CHILD WITH TWO ANGELS. S. Maria dei Frari, Venice.
Istrian stone (149 × 160 cm.).

110. Bartolommeo Buon: JUSTICE (detail of Figure 93). Palazzo Ducale, Venice. Istrian stone.

111. Bartolommeo Buon: PUTTI (detail of Figure 93). Palazzo Ducale, Venice. Istrian Stone.

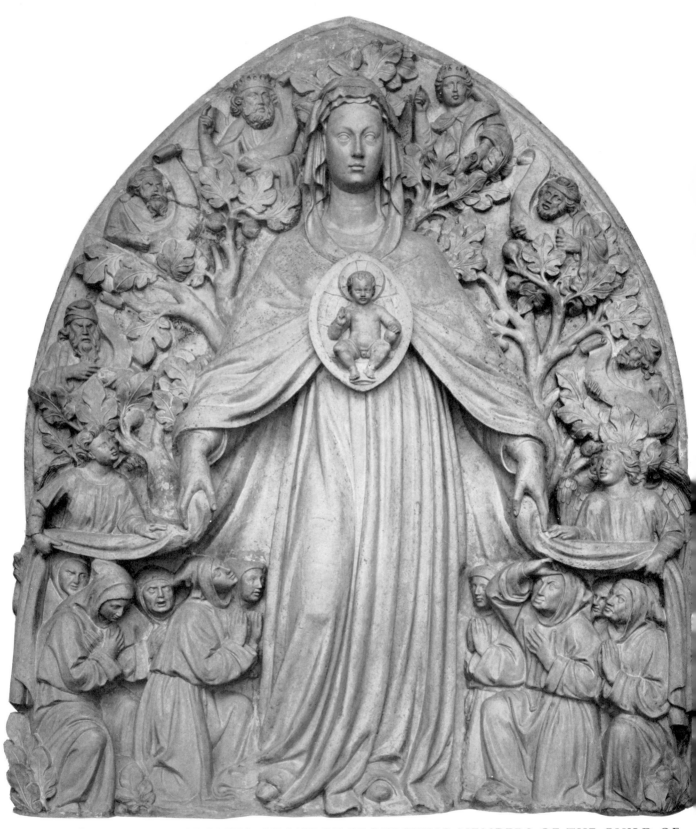

112. Bartolommeo Buon: MADONNA OF MERCY PROTECTING MEMBERS OF THE GUILD OF
THE MISERICORDIA. Victoria and Albert Museum London. Istrian stone (252 × 209 cm.).

NOTES ON THE SCULPTORS
AND ON THE PLATES

NICOLA PISANO
(active 1258–78)

Nicola Pisano is mentioned for the first time in April 1258 in the will of Guidobono Bigarelli, brother of the sculptor Guido da Como, who in 1246 completed the Baptismal Font in the Baptistry at Pisa. In 1259 (1260 Pisan style) he signed his first authenticated work, the pulpit in the Baptistry at Pisa (see Plates 1–5 below). Two reliefs on the Duomo at Lucca, showing (above) the Deposition and (below) the Annunciation, Nativity and Adoration of the Magi, are closely related to the narrative scenes on the Pisa pulpit. They have been variously assumed to precede work on the pulpit (Gnudi, Ragghianti), to be contemporary with the latest work on the pulpit and therefore to have been carved c. 1258–60 (Bottari, Salvini, Kosegarten), to have been executed after the Pisa pulpit and before that at Siena (Swarzenski), to have been produced in 'Nicola's immediate circle' (White) or by his school (Nicco Fasola), and to be derivations from Nicola's work dating from the time of the Pistoia pulpit of Giovanni Pisano (Polzer). There can be relatively little doubt that both reliefs were designed by Nicola Pisano. Their style is more evolved than that of the Pisa pulpit reliefs, and the pronounced Gothic character of the Christ in the Deposition and of the building represented behind the Annunciation is most readily consistent with a dating c. 1260–5. In the present much deteriorated state of the surface it is impossible to judge to what extent the two reliefs are autograph.

In 1265 Nicola concluded a contract for the pulpit in the Duomo at Siena (see Plates 6–10 below), which was completed in 1268. Nicola Pisano's name is also associated with the Arca of St. Dominic in S. Domenico Maggiore at Bologna (see Plate 24 below), which was carved from his design. In July 1273 he undertook to build or reconstruct the Altar of St. James in the Duomo at Pistoia, the final payment for which dates from November of the same year (form unrecorded, probably dismantled in 1787). A holy-water basin, executed by Nicola Pisano in conjunction with his pupil Lapo, may date from this time. In 1278, in association with his son Giovanni, he completed work on the Fontana Maggiore at Perugia (see Plate 11 below), which appears to have been begun in the preceding year. The extent of Nicola Pisano's activity as an architect is conjectural, but there are grounds for supposing that he may have been responsible, about 1270, for the external arcading of the second storey of the Baptistry at Pisa, and for the planning and, in part, the execution, of the busts above the columns and the half-length figures over them. In the latter he was assisted by Giovanni Pisano. A document witnessed by Giovanni Pisano 'quondam magistri Nicholi' on 13 March 1284 proves that Nicola Pisano was dead before this time. In the majority of documents relating to his work Nicola is described as Pisan (e.g. as 'magister Nicholus olim Petri lapidum de Pissis populi sancti Blasii' or more simply as 'magistro Nicholao de Pisis'), but in two documents of 11 May 1266, relating to work on the Siena pulpit and originating from a single notary, he figures respectively as 'magistrum Nicholam Pietri de Apulia' and 'magistro Nichola de Apulia'. Attempts have been made to explain the term 'Apulia' in this context alternatively as a cognomen and as the name of a township in the neighbourhood of Lucca, but these are unpersuasive, and it is generally agreed that the documents may be read at their face value as indicating that the sculptor was born in Southern Italy. This conclusion is based primarily on the figure sculpture on the pulpit in the Baptistry at Pisa, whose style has no precedent in Tuscany and is most readily explicable if it is assumed that the sculptor was trained in Southern Italy among the classicizing sculptors employed by the Emperor Frederick II (d. 1250) at Castel del Monte (begun 1240) and Capua. It has indeed been argued (Bottari, Seymour) that certain of the Capua heads may have been carved by Nicola Pisano. If Nicola Pisano was born as early as 1210–20, this is theoretically possible, but the case is inadmissible on other grounds. It has also been argued that a conjectural early period in Campania was followed, between 1250 and 1255, by a visit to France (Seymour). The full range of Nicola Pisano's debt to the antique and the part which the adoption of classical carving technique played in the formation of his style have not been properly investigated. Since Nicola's son, Giovanni, is known to have been born at Pisa, probably about 1250, he must have been established in Tuscany at least by the middle of the century.

BIBLIOGRAPHY: The best general accounts of Nicola Pisano's work are those of Swarzenski (*Nicola Pisano*, Frankfurt-am-Main, 1926) and Toesca (in *Il Medioevo*, 1927, pp. 863–81). The relevant documents are printed in full in a useful detailed monograph by Nicco Fasola (*Nicola Pisano*, Rome, 1941). A monograph in English by G. H. and E. R. Crichton (*Nicola Pisano and the Revival of Sculpture in Italy*, Cambridge, 1938) is also available. On the dispute over the artist's place of birth see Poggi ('La patria di Nicola Pisano', in *Rivista d'Arte*, 1907, v, pp. 153–61), I. B. Supino (*La Patria di Nicola Pisano*, Bologna, 1916), M. Weinberger ('Nicola Pisano', in *Encyclopedia of World Art*, x, New York, 1965, pp. 319–326) and the monographs cited above. The connection of the sculptor's style with Southern Italy is traced by Bertaux (*L'Art dans l'Italie méridionale*, Paris, 1904, pp. 787 ff.), W. R. Valentiner ('Studies on Nicola Pisano—i', in *Art Quarterly*, xv, 1952, pp. 9–36), and O. Morisani ('Commenti capuani per Nicola Pisano', in *Cronache d'Archeologia e di Storia dell'Arte*, ii, Catania, 1963, pp. 84–120), and, in more tendentious terms, by S. Bottari ('Nicola Pisano e la cultura meridionale', in *Arte antica e moderna*, No. 5, 1959, pp. 43–51, reprinted in *Saggi su Nicola Pisano*, Bologna, 1969), C. Seymour ('Invention and Revival in Nicola Pisano's "Heroic Style",' in *Studies in Western Art. Acts of the XXth International Congress of the History of Art*, i, Princeton, 1963,

pp. 207–26), and W. Krönig ('Toskana und Apulien. Beiträge zum Problemkreis der Herkunft des Nicola Pisano', in *Zeitschrift für Kunstgeschichte*, xvi, 1953, pp. 101–44). Nicola Pisano's relations to French art are discussed, inter alia, by J. White (in *Art and Architecture in Italy, 1250 to 1400*, London, 1966, pp. 40ff.), E. Panofsky (*Renaissance and Renascences in Western Art*, Stockholm, 1960, p. 67), R. D. Wallace (*L'Influence de la France Gothique sur deux des précurseurs de la Renaissance italienne: Nicola et Giovanni Pisano*, Geneva, 1953), R. Freyhan ('The Evolution of the Caritas Figure in the 13th and 14th Centuries', in *Journal of the Warburg and Courtauld Institutes*, xi, 1948, pp. 71ff.), and W. Messerer (*Das Relief im Mittelalter*, Berlin, 1959, p. 123ff.). For the Lucca reliefs see particularly Swarzenski, Nicco Fasola and White, and articles by C. L. Ragghianti ('Approsimazione e Nicola d'Apulia', in *Domus*, April, 1947, pp. 7ff.), S. Bottari ('La Deposizione di Nicola Pisano in S. Martino a Lucca', in *Arte antica e moderna*, 1962, pp. 73–78, reprinted in *Saggi su Nicola Pisano*, Bologna, 1969), R. Salvini ('Nicola Pisano a Lucca', in *Jean Alazard. Souvenirs et Mélanges*, Paris, 1963, pp. 219–33), J. Polzer ('The Lucca Reliefs and Nicola Pisano', in *Art Bulletin*, xlvi, 1964, pp. 211–16), and A. Kosegarten ('Nicola Pisano a Lucca', in *Antichità Viva*, vi, 1967, No. 3, pp. 19–32). The documents relating to the Pistoia commission are well analysed by C. Kennedy ('Niccolò Pisano and the Silver Altar at Pistoia', in *Art Bulletin*, xl, 1958, pp. 255–57). The part played by Nicola Pisano in the sculptures on the Baptistry at Pisa is discussed in an excellent article by A. Kosegarten ('Die Skulpturen der Pisani am Baptisterium von Pisa. Zum Werk von Nicola und Giovanni Pisano', in *Jahrbuch der Berliner Museen*, x, 1968, pp. 14–100). Of the volumes on individual monuments the most penetrating is that of C. Gnudi (*Nicola, Arnolfo, Lapo*, Florence, 1949) dealing with the Arca of St. Dominic at Bologna, which is also discussed by S. Bottari (*L'Arca di S. Domenico in Bologna*, Bologna, 1964, reprinted in *Saggi su Nicola Pisano*, Bologna, 1969). On the Pulpit in the Baptistry at Pisa see, in addition to the books noted above, W. Braunfels ('Zur Gestaltikonographie der Kanzeln des Nicola und Giovanni Pisano', in *Das Münster*, ii, 1948–9, pp. 321–49), M. Weinberger ('Nicola Pisano and the tradition of Tuscan pulpits', in *Gazette des Beaux-Arts*, VIᵉ sér., lv, 1960, pp. 129–46), and S. Bottari ('La parte più antica del pulpito di Pisa', in *Saggi su Nicola Pisano*, Bologna, 1969, pp. 15–21). The Siena pulpit is the subject of a volume by E. Carli (*Il Pulpito di Siena*, Bergamo, 1943). Useful observations are also made on the Siena pulpit by M. Weinberger ('Remarks on the role of French models with the evolution of Gothic Tuscan Sculpture', in *Studies in Western Art. Acts of the XXth International Congress of the History of Art*, i, Princeton, 1963, pp. 198–206), R. Jullian ('Les persistances romanes dans la sculpture gothique italienne', in *Cahiers de Civilisation médiévale*, iii, 1960, pp. 295–305), and on the role played by Lapo in this and other works R. Salvini ('Una possibile fonte medioevale di Leonardo e il suo autore', in *Studien zur toskanischen Kunst, Festschrift für L. H. Heydenreich*, Munich, 1964, pp. 266–74). For a much superior and in part definitive analysis see M.

Seidel ('Die Verkündigungsgruppe der Sieneser Domkanzel', in *Münchner Jahrbuch der bildenden Kunst*, xxi, 1970, pp. 19–72). The material relating to the Perugia fountain is assembled by Nicco Fasola (*La Fontana di Perugia*, Rome, 1951), which should be read in conjunction with explanations of the iconography of the fountain by Braunfels (op. cit.) and K. Hoffmann-Curtius (*Das Programm der Fontana Maggiore in Perugia*, Bonner Beiträge zur Kunstwissenschaft, x, Düsseldorf, 1968) and a note on the constituents of the fountain by F. Santi ('Ancora sui bronzi della Fontana di Perugia', in *Commentari*, ix, 1958, pp. 309–12). The design of the fountain is also discussed by L. Bianchi ('La Fontana di Perugia e il suo architetto', in *Atti del V. Convegno Nazionale di Storia dell' Architettura*, Florence, 1957, pp. 505–38). Some of the postulates behind Nicco Fasola's account are challenged in an original and in large part convincing article by A. Kosegarten ('Nicola und Giovanni Pisano 1268–1278', in *Jahrbuch der Berliner Museen*, xi, 1969, pp. 36–80).

Plates 1–5: PULPIT
Baptistry, Pisa

Inscribed (beneath the relief of the Last Judgment):

ANNO MILLENO BIS CENTUM BISQUE TRICENO
HOC OPUS INSINGNE SCULPSIT NICOLA PISANUS
LAUDETUR DINGNE TAM BENE DOCTA MANUS.

(In the year 1260 Nicola Pisano carved this noble work. May so greatly gifted a hand be praised as it deserves.) The hexagonal pulpit is supported by a central column, resting on a raised base surrounded with grotesque figures and animals, and by six external columns, three with their bases set on lions and three resting on the ground. The foliated Gothic capitals and the naturalistic lions are striking features of this part of the pulpit. Between the lower and upper sections of the pulpit is an archivolt formed of trilobe arches; in the spandrels under the first three scenes are reliefs of paired Prophets and, under the Crucifixion and Last Judgment, of the Evangelists. At the six corners, above the capitals, are statuettes of Charity, Fortitude, Temperance, Prudence, St. John the Baptist and Faith. The upper section of the pulpit consists of five oblong narrative reliefs framed at the angles by clusters of three columns; these reliefs represent (i) the Annunciation, Nativity and Annunciation to the Shepherds (Plate 2), (ii) the Adoration of the Magi (Plate 3), (iii) the Presentation in the Temple, (iv) the Crucifixion, and (v) the Last Judgment. A lectern in the form of an eagle surmounts the angle with the statuette of St. John the Baptist.

The Pisa pulpit is the work of an artist who was at once an architect of genius and a figure sculptor of the first rank. The extent of its originality is apparent in the many unsuccessful attempts that have been made to trace the sources of its architectural form and figure style. Attempts have been made to trace the polygonal form of the pulpit to South Italy (Bertaux, Valentiner, Bottari), to Tuscany (Swarzenski,

Weinberger), and to ambones in Dalmatia (Wallace, citing examples at Split and Trogir) and in North Italy (Nicco Fasola). None of the analogies cited is conclusive, and the design is apparently a synthesis of South Italian and Tuscan elements strongly coloured by French Gothic forms. In the context of Tuscan sculpture the conception of a free-standing pulpit, in which the upper section rested on an archivolt, not on an epistyle or architrave, was an innovation of great significance. Polygonal pulpits exist in Tuscany at Fagna and Borgo San Lorenzo, but the polygonal plan adopted by Nicola Pisano seems to depend directly from polygonal pulpits in South Italy, and the form of the archivolt is developed from a type evolved a century earlier in the pulpit at Moscufo. On the other hand, the predominance of figure sculpture is specifically Tuscan. It has been suggested that before he began work on the pulpit Nicola had been in France. The arguments in favour of this view are part stylistic and part iconographical. Neither the role played by the figure reliefs (Wallace), nor the figures at the base of the central column (Seymour), nor the iconography of the Crucifixion (Panofsky), nor the 'prismatic fold pattern' of the drapery (White) are sufficient proof of such a journey, though Nicola Pisano undoubtedly possessed, from the outset of work on the pulpit, some knowledge of the sculptures at Rheims (best analysis by Kosegarten). Those features of the pulpit which have been construed as evidence for a Northern journey, may well be due to the availability of drawings after Northern Gothic sculptures, of the class of those of the sculptures at Auxerre which were known to Giovanni Pisano (Seidel). The statuettes and the five narrative reliefs make extensive use of antique prototypes. Thus in the first relief the reclining Virgin in the centre is related to Etruscan grave-figures, and the standing Virgin Annunciate seems to have been adapted from a sarcophagus. In the second relief the seated Virgin depends from the Phaedra in a sarcophagus carved with the Legend of Hippolytus in the Campo Santo at Pisa, and a head from this sarcophagus is introduced into the third relief. Nicola Pisano's debt to sarcophagus reliefs is also evident in the handling of space in the first relief (where the subordinate episodes have a spatial reference to the main scene), and in the second in the device of the projecting cornice above the Virgin's head. A number of motifs from the first relief of the Annunciation and Nativity recur, in a less classical form, in the relief of this subject at Lucca.

There is no evidence as to the composition of Nicola's studio at the time the Pisa pulpit was executed, but the carvings themselves reveal certain differences of technique and style from which a productive pattern can be deduced. Thus the Prophets in the first two spandrel reliefs are depicted behind the containing moulding and are carved in shallow relief, while the Prophets in the third spandrel are shown resting against the lower moulding and protrude beyond the frame. The Evangelists in the fourth spandrel are conceived in the same fashion, but are of lower quality, and the Prophets in the fifth, which conform to them in style, are more tactile and expressive. Of the statuettes, the Charity,

Strength, Prudence and St. John the Baptist are by a single hand, which must be identified as Nicola's, while the Temperance is treated more schematically and the Faith is seemingly by the same sculptor as the central support. Substantial differences are also evident in the reliefs. While the first scene corresponds closely in execution with the Last Judgment (the overall effect of which is much impoverished by extensive mutilation of the figures), in the three scenes between, in which the scale of the figures is considerably larger, the articulation of the figures and the handling of space in the Adoration of the Magi is less accomplished than in the Presentation in the Temple and both scenes differ from the Crucifixion, where the figures in the foreground, especially on the right, are treated with greater rigidity. The deep undercutting which is so notable a feature of the first relief, of the Presentation in the Temple and of the Last Judgment is present in the Adoration of the Magi only on the left, in the area of the three horses' heads and is absent from the Crucifixion. For this reason it has been conjectured (Weinberger) that the sequence of execution proceeded from the Adoration of the Magi, through the Crucifixion to the Last Judgment, and that the Nativity and Presentation in the Temple are the latest of the reliefs; and alternatively (Salvini) that the sequence leads from the Adoration of the Magi through the Nativity to the Presentation in the Temple, and that the Crucifixion and Last Judgment are later than the other reliefs. There is some substance in the first hypothesis. Account must, however, also be taken of the intervention of studio assistants in the execution of the carvings. It has, for example, been suggested that the Last Judgment is largely by assistants conjecturally identified with Arnolfo di Cambio (Ragghianti) and with Lapo and the young Giovanni Pisano (Gnudi). In practice it is difficult to distinguish the damaged but highly accomplished nudes of the Last Judgment from, e.g., the Nativity and the statuette of Charity, and there is a strong presumption that the entire relief is by Nicola Pisano. On the other hand the Crucifixion, though designed and worked on by Nicola, appears to be the work of the same more rigid artist who was responsible for the Temperance and the first two spandrel reliefs. These parts of the pulpit are perhaps due to Arnolfo di Cambio.

An effect of polychromy is obtained from the red and green marble employed for the columns and from inlay in the spandrels. Some of the eyes of the figures show black inlay in the pupils, and the background of the Last Judgment seems to have been blue with golden stars. It has been inferred (White) that 'strongly patterned vitreous glazes on a gesso foundation formed the background to the figures' and that 'the reliefs were fully coloured'. There is no means of assessing the extent of pigmentation in the pulpit, but it is likely to have been less than this account suggests.

Since the pulpit was signed in 1260 (Pisan style), it was completed in 1259 (common style). No contract for it survives, but it is likely to have been begun about 1255, and may have formed part (Weinberger) of a programme of decoration in the interior of the Baptistry initiated in the baptismal font of Guido da Como (1246).

Plates 6–10: PULPIT
Duomo, Siena

On 29 September 1265 the contract for a pulpit in the Duomo at Siena was drawn up between Nicola Pisano on the one hand and the Operaio of the Cathedral, Fra Melano, on the other. It was stipulated that work should be carried out by Nicola and by two principal assistants, Arnolfo di Cambio and Lapo, who were to come to Siena early in the following year. Provision was also made for the employment of a junior assistant, Nicola's son Giovanni. In a document of May 1266 instructions were given that Arnolfo should come forthwith to Siena. A fourth assistant, Donato, is mentioned in a payment of July 1267. Work on the pulpit must have been completed by November 1268, when Nicola, on his own behalf and that of his son, Lapo and Arnolfo, signed the final quittance.

In form the Siena pulpit (Fig. 8) is octagonal. As at Pisa, the external columns rest alternately on lions and on a flat base, but the central column is surrounded not with grotesque representations, but with figures of the Liberal Arts, the naturalistic features in the capitals are more pronounced, and the archivolt is heavier and more compact. The triple columns framing the Pisa reliefs are replaced at Siena with figurated supports representing (i) the Virgin Annunciate, (ii) the Writers of the Canonical Epistles, (iii) the Virgin and Child, (iv) three Angels, (v) the Christ of the Apocalypse, (vi) the Symbols of the four Evangelists, (vii) Christ in Judgment, and (viii) three Angels. It has been inferred (Wallace) almost certainly correctly that when the pulpit was reconstructed in the sixteenth century the angle figures were misplaced. The successive reconstructions of the pulpit and its original form are established by M. Seidel, on the basis of a relief of the Annunciatory Angel in the Staatliche Museen, Berlin, and of a capital in the Museo dell'Opera del Duomo, both of which formed part of the pulpit. Within the relief fields the narrative treatment is also more complex than at Pisa. The seven reliefs show: (i) the Visitation, Nativity and Annunciation to the Shepherds, (ii) the Journey of the Magi and the Adoration of the Magi, (iii) the Presentation in the Temple, Herod and the Magi and the Flight into Egypt, (iv) the Massacre of the Innocents (Plate 7), (v) the Crucifixion (Plate 6), (vi) the Elect, and (vii) the Damned. The scale of the figures throughout is smaller than at Pisa, and the influence of classical prototypes is less in evidence; in the foreground of the sixth relief, certain of the figures derive from a sarcophagus now in the Museo dell'Opera del Duomo at Siena. Largely as a result of the elimination of the architectural frame in which the reliefs at Pisa are set, the Siena pulpit is characterized by freer treatment of the relief field. Elsewhere the main style factor is the influence of French Gothic art. This is most striking if we compare the imagery of the Virtues at the angles of the archivolt (Plates 8, 9) with that of the corresponding figures at Pisa. It is also fundamental to certain of the supports above, notably to the Risen Christ and to the angels announcing the Last Judgment. In the narrative reliefs it is manifest in the use of Gothic forms like those employed on the left side of the Crucifixion. The fact that Fra Melano, the Operaio, was a Cistercian from the Abbey of San Galgano, which had been built by French architects and retained close connections with France, may be to some extent accountable for the orientation of the style of the pulpit towards France. The direct sources of the new style cannot be established, though the Virgin and Child has been related (Weinberger) to a group at Rheims and the influence of French ivory carvings has been postulated in the reliefs. French influence on the iconography of the carvings has been well discussed by Braunfels. The columns supporting the pulpit were replaced in 1329.

There is much divergence of opinion as to the allocation of individual sections of the pulpit to members of Nicola's studio. Study of this work and of the contemporary Arca of St. Dominic suggests that the master's assistants were allowed considerable latitude, and though the design of the whole is due to Nicola, in the execution of the parts a personal sense of form is evident. The lower part of the pulpit, with animals and figures of the Liberal Arts, is largely by a single hand plausibly identified by Gnudi as that of Lapo. This sculptor also collaborated with Nicola in the Virtues on the archivolt, perhaps (Weinberger) in the Justice, Temperance and Fortitude. Of the upper supports the Virgin Annunciate, the Risen Christ, the Virgin and Child and the Christ in Judgment appear to have been executed by Nicola, the Writers of the Canonical Epistles are due to Arnolfo di Cambio, while Giovanni Pisano was responsible for the angels to the left of the Massacre of the Innocents and to the right of the Last Judgment. Of the reliefs it is generally agreed that the first, second and third reveal extensive intervention by an assistant variously regarded as an unidentified retardatory member of Nicola's studio (Jullian) and as the young Arnolfo di Cambio (Venturi, Salmi, Bottari). Parts of the third relief have also been mistakenly ascribed (Weinberger) to Giovanni Pisano, who may, however, have intervened in the Massacre of the Innocents alongside Nicola. The Crucifixion (Plate 6) is substantially by Nicola, though Arnolfo's intervention may be detected in the crouching figures on the right hand side.

The pulpit was originally installed 'da lato del Vangelo sotto la cupola tra i due primi piloni' (on the left beneath the cupola between the first two piers). In 1329 the columns on which it rested were replaced by classical granite columns excavated at Ansidonia. The pulpit may have been disassembled at the end of the fourteenth century in connection with the proposed extension of the Cathedral, and was moved to its present position in the early sixteenth century, when the high altar and choir were removed from the area beneath the cupola. The present steps, by Bartolommeo Neroni (Riccio), were added in 1543.

Plate 11: FONTANA MAGGIORE
Perugia

The plan of constructing a fountain in the Piazza Maggiore at Perugia, provided with water from Monte Pacciano three

miles outside the town, dates back at least to 1254. In 1273 it was reported to the Consiglio del Popolo that the sub-terranean aqueduct which was to feed the fountain had been damaged, and four years later it was decided to replace this with a new aqueduct constructed above ground. In 1277 a Venetian, Boninsegna, who was engaged on constructing a fountain at Orvieto, was summoned to Perugia to undertake this work, and later in the year, in August, arrangements were made to choose a site for the new fountain. The fountain, in the form in which it survives today (Figs. 9–11), seems to have been completed in little more than twelve months. A rhymed inscription records the date of completion of the fountain (1278) and the names of the artists and engineers by whom it was designed. The first, mentioned at the beginning of the inscription, is a certain Fra Bevignate and the fourth, mentioned at the end, is Boninsegna. Be-tween are named the sculptors of the monument:

+ ASPICE QVI TRANSIS. JOCUNDUM VIVERE FONTES.
SI BENE PROSPICIAS MIRA VIDERE POTES.
ERCULANE PIE LAURENTII STAE ROGANTES
CONSERVET LATICES QVI SVPER A(S)TRA SEDET.
ET LACVS ET IVRA CLVSINA QVE SINT TIBI CVRA.
VRBS PERVSINA PATER GAVDENTI SIT TIBI FRATER
BENVEGNATE BONVS SAPIENTIS AD OMNIA PRONVS.
HIC OPERIS STRVCTOR FVIT ISTE PER OMNIA DVCTOR.
HIC EST LAVDANDVS BENEDICTVS NOMINE BLANDVS
ORDINE DOTATVS DEDIT HOC ET FINE BEATVS.
+ NOMINA SCVLPTORVM FONTIS SVNT ISTA BONORVM.
(ARTE HONO)RATVS NICOLAVS AD (OMNIA GRA)TVS
EST FLOS SCVLPTORVM GRATISSIMVS ISQVE PROBORVM.
EST GENITOR PRIMVS GENIT(VS) CARISSIMVS IMVS.
CVI SI NON DAMPNES NOMEN DIC ESSE IOHANNES.
ITV (or NATV) PISANI SINT MVLTO TEMPORE SANI.
+ INGENIO CLARVM DVCTOREM SCIMVS AQVARVM
QVI BONINSIGNA VVLGATVR MENTE BENINGNA.
HIC OPVS EXEGIT S(I)DVCTILE QVODQVE PEREGIT.
(VE)NETIIS NAT(VS) PERVSINVS HIC PERIMATVS.
+ FONTES COMPLENTVR SVPER ANNIS MILLE DVCENTIS
(S)EPTVAGI(N)TA (BIS QVAT)T(VOR) ATQVE DABIS.
TERNVS PAPA FVIT NICALVS T(EMP)ORE DICTO
RODVLFVS MAGNVS INDVPERATOR ERAT.

On the bronze basin is an inscription reading:

RVBEVS ME FECIT ANNO DOMINI M.CC.LXX.VII INDICTIONE V
TEMPORE REGIMINIS DOMINI ANSELMI DE ALCATE CAPITANEE
POPVLI. MAGISTRI FVERVNT HVIVS OPERIS FRATER
BEVEGNATE ORDINIS SANCTI BENEDICTI. BONINSEGNA.

Nicco Fasola's interpretation of these records, whereby work on the fountain would have been begun in 1277 and completed in the following year, is challenged by Kosegarten, who argues that work on the sculptures may have been begun in 1276. The part played by Fra Bevignate in the designing of the fountain has been a subject of some con-troversy. As observed by Nicco Fasola, a payment of 26 August 1277 'pro II. cartis, quas habuit frater Bevignate cause designandi fontem' suggests that Bevignate was at least responsible for the general scheme. It has also been inferred

(Cellini) that the fountain was designed by Bevignate before the involvement of Nicola and Giovanni Pisano in the scheme. There is no reason to doubt that Boninsegna was employed solely in a technical capacity. It is difficult to reconcile the architecture of the fountain with the known practice of Nicola Pisano (Bottari), and its form seems to have been related to that of a fountain formerly at Cortona, also constructed with two polygonal basins and dating from the same time (1278) (Hoffmann-Curtius). An attempt to connect the scheme with that of a fountain erected in front of S. Maria Maggiore, Rome, under Honorius III, recorded in a fresco in the Palazzo Venezia, Rome, is fanciful (Cellini).

The fountain at Perugia consists of a twenty-five-sided basin, each face of which is decorated with two upright reliefs; on the angles between them are triple groups of spiral columns evolved from the angle supports of the upper section of the pulpit at Pisa. Within the basin are twenty-four external and thirty-four internal columns supporting a smaller twelve-sided basin above; on this the centre of each face and the angles between the faces are decorated with figurated supports. From the upper basin there rises on a single stem a simple bronze basin, within which is set the main sculptural feature of the fountain, a bronze support consisting of three female figures. Above this there was perhaps another smaller basin, but in the course of successive reconstructions of the fountain this has disappeared. Of the twenty-five double reliefs below, twelve represent the Labours of the Months, four are filled with figures of the Liberal Arts, and the remaining nine show fables, the story of Romulus and Remus, heraldic beasts, and scenes from the Old Testament. The twenty-four figures represented above include abstract personifications (among them Ecclesia Romana and Victoria Magna, the latter perhaps in reference to the defeat of the Ghibellines in 1269), figures representing cities and localities (Roma Caput Mundi, Augusta Perusia, Domina Clusii, or Chiusi, and Domina Laci, or Lake Trasimene), figures from the Old Testament, Saints and living persons (Matteo da Correggio and Ermanno da Sassoferrato, respectively Podestà and Capitano del Popolo at Perugia in the year of the completion of the fountain). The fountain appears to have been restored and incorrectly reconstructed in 1474, and was dismantled and reconstructed afresh in 1948–9. The correct sequence of figures in the upper part is established by J. White ('The Reconstruction of Nicola Pisano's Perugia Fountain', in *Journal of the Warburg and Courtauld Institutes*, xxxiii, 1970, pp. 70–83).

Drastic cleaning of the much weathered marble reliefs on this occasion has weakened the effect of the whole work. The originals of the reliefs of Romulus and Remus and Rea Silvia are now in the Pinacoteca Nazionale dell'Umbria, as is a bronze group of gryphons and lions which previously surmounted the central group. The association of this group with the fountain, though challenged, seems to have been correct, and the central element is in its present form mani-festly incomplete. Six of the animal masks by which water is discharged into the lower basin were replaced in 1834. The programme of the fountain (which in the upper register is

civic in character) presents many difficulties; the standard account by Swarzenski should be read in conjunction with analyses by Braunfels and Hoffmann-Curtius and with a review by J. White (in *Art Bulletin*, lii, 1970, pp. 437–9). Iconographically the reliefs of the Months hark back partly to the antique (e.g. the figure of Flora symbolizing the month of April), partly to Tuscan Romanesque prototypes (e.g. the Byzantinizing reliefs of the Months beside the entrance of the Baptistry at Pisa [Fig. 3]), and partly to French Gothic cycles (e.g. the reliefs representing May). Valid analogies for the style of the carvings are found (Nicco Fasola) at Sens and Notre Dame.

The attribution of individual reliefs and statuettes to Nicola and Giovanni is largely conjectural. Judging from the speed with which the fountain was completed and the quality of much of its sculpture, a number of subsidiary sculptors must have been employed. One relief, that with two eagles, is signed by Giovanni Pisano in the form . . . B(ON?) JOH(ANN)IS SCUL(P)TOR(IS) HVI(VS) OPERIS. Though it is argued by Kosegarten that this inscription refers to the whole sculptural content of the fountain, which would have been devised by Giovanni Pisano and his workshop without the intervention of Nicola, the conventional view that the inscription relates only to the relief where it appears is probably correct. Some of the reliefs are evidently by Nicola (notably those of June and July) and others are evidently by Giovanni (notably those of the Liberal Arts), but between these extremes there are many carvings of uncertain attribution. Among the statuettes the Augusta Perusia is representative of Nicola's, and the Ecclesia Romana of Giovanni's style at this time. The bronze caryatids were cast by the 'cire perdue' method, probably by the bronze founder Rosso (Rubeus) whose name appears on the bronze basin below, and have been given variously to Nicola and Giovanni Pisano (and also, incorrectly, to Arnolfo di Cambio, who did not contribute to the fountain sculptures). In its essentials the scheme (which is of classical origin) looks back to the Pistoia holy-water basin, and there are some grounds for supposing that this great sculpture is, substantially, one of the last works of Nicola Pisano.

Plates 12–13: EXTERNAL SCULPTURE
Baptistry, Pisa

The background of Nicola Pisano's last documented commission, for the Perugia fountain, is supplied by continuing activity on the Baptistry at Pisa, where he seems to have been responsible for the external arcading in the second register, for the Gothic tracery above, and for the planning and in part the execution of the large-scale sculptures which are integrated in the scheme. These sculptures have a dual importance, first as the only surviving testimony to Nicola Pisano's style as a monumental artist, and second as containing a number of early works planned or executed by Giovanni Pisano. The figure sculpture involved in this undertaking (of which the only comprehensive account is that of Kosegarten) comprised small heads in the capitals of the columns of the arcading, sixty large male and female heads set above the capitals (H. 45–50 cm. Twenty-seven heads replaced in the course of restoration in 1854–6, thirty-one in situ and two preserved in the Museo Nazionale di S. Matteo at Pisa), sixty human and animal masks on the keystones of the arches (forty-three in situ and seventeen mid-nineteenth century replacements), a series of gigantic half-length figures set in Gothic tabernacles above (H. 160–180 cm. Twenty-five out of an original total of thirty figures preserved, of which nine are now shown in the interior of the Baptistry), and, at the apex of the tabernacles, three half-length figures of Christ, the Virgin and St. John the Baptist and twenty-seven full-length figures of Saints (H. *c.* 150 cm. Twenty-five figures preserved, of which twenty-four are in the Museo di S. Matteo and one remains in situ on the Baptistry). The Baptistry sculpture presents two inter-related problems of authorship and date. Of the large heads set over the capitals some are strongly classicizing and some recall sculptures at Rheims. It has been asserted (Supino, Swarzenski) that an inscription relating to the reconstruction of the Baptistry in 1278 in the interior ANNI.DNI.MCC.LXX.VIII.EDIFICHATA. FUIT.DE.NOVO provides a *terminus post quem* for the arcaded decoration and therefore for the sculptures. There is no sound reason to suppose that this is so, and the view of the busts above the capitals as late works from the shop of Nicola Pisano, executed between this date and the sculptor's death in 1284, is unlikely to be correct. There is no means of establishing at what date the carving of the heads began, but this may well have been before the commencement of work on the Siena pulpit (Gnudi) and can scarcely have been later than *c.* 1270 (Kosegarten). The claim of A. Venturi (followed by Keller, Nicco Fasola and Toesca) that a number of the heads are due to, and that most of them were planned by, Nicola Pisano is very plausible. The connection of certain of the heads with sculptures at Capua is very marked. Since their publication by Marangoni and their exhibition at eye level first at the Mostra Pisana of 1947 and subsequently in the Baptistry, the gigantic half-length figures have in general been ascribed to Giovanni Pisano and his workshop after the conclusion of work on the fountain at Perugia. There is, however, some substance in the view of Carli that certain of the half-length figures probably date from 1268–77, and in that of Keller that a number of them are due to Nicola Pisano. The figures for which Nicola Pisano's responsibility as designer or part executant can reasonably be postulated are the Virgin and Child originally on the axis of the entrance to the Baptistry, the St. John the Baptist and the adjacent figures of the four Evangelists. All these figures are much weathered, and there is some recutting in the face of the Virgin presumably dating from the nineteenth century. The St. John the Evangelist is the most carefully executed of these figures and the best preserved (Fig. 16). The Deesis group originally set above the Virgin and Child and the Baptist (now in the Museo Nazionale di S. Matteo) has been referred to Byzantine or Italo-Byzantine prototypes (Kosegarten), and the beautiful central Christ seems to represent the last stage in the development of Nicola Pisano. There is evidence that Giovanni

Pisano was employed on the Baptistry in 1284, and the figures of Saints (now in a much deteriorated condition in the Museo di S. Matteo) were probably carved in the period 1277-84 (Bacci) and not, as has also been suggested, between 1284 and 1295, and are thus prior to, and not contemporary with or later than, the statues on the Siena façade.

GIOVANNI PISANO
(b. c. 1248; d. after 1314)

According to the inscriptions on two of his works, Giovanni Pisano was born in Pisa. The earliest reference to his activity occurs in 1265 in the contract for the Siena pulpit of Nicola Pisano; from this a birth-date about 1248 has been deduced. Nothing is known of his activity between the completion of the Siena pulpit (1268) and 1278, when he is mentioned in the inscription on the fountain at Perugia. After the completion of the pulpit he appears to have returned with his father to Pisa, and to have participated in the sculptures above the colonnading on the outside of the Baptistry (see Plate 12 above). From 1284 he was employed at Siena as architect and sculptor in work on the Cathedral (see Plates 14-15 below), of which he is mentioned as Capomaestro for the first time in 1287 and for the last time in 1296. He was engaged, in his capacity as architect, at Massa Marittima in 1287. By 1298 Giovanni Pisano was once more in Pisa, and his last recorded visit to Siena was paid in 1314. In 1300-1 he completed the pulpit in S. Andrea at Pistoia (see Plates 16-19 below), and from 1302 till 1310 he was engaged on the pulpit in the Duomo at Pisa (see Plates 20-22 below). His last work, undertaken in 1312, was the monument of Margaret of Luxemburg in S. Francesco di Castelletto at Genoa, figures from which survive at Genoa in the Palazzo Bianco (see Plate 23 below). Giovanni Pisano's career is punctuated by a series of free-standing Madonnas, of which the most important are full-length figures over the entrance to the Baptistry at Pisa (c. 1295), on the altar of the Arena Chapel at Padua (c. 1305-6) (Fig. 19), and in the Cappella della Cintola of the Duomo at Prato (c. 1312). There is some divergence of view as to the extent to which Giovanni Pisano possessed a first-hand knowledge of French Gothic art; a case can be stated for the view (which is not supported by documentary evidence) that he travelled in France in the bracket 1270-6, and maintained contact with French art after this time. His knowledge of French sculpture may also have been enhanced by drawings of the class of those of Villard de Honnecourt, and by ivory carvings. An ivory Virgin and Child in the treasury of the Cathedral at Pisa (head and right hand of Child and right hand of Virgin restored) may be connected with a document of 1299; this is related compositionally to a Virgin and Child at Notre Dame (c. 1250), and seems to have been made in emulation of French ivory statuettes of the last quarter of the thirteenth century. More important is the direct relationship that can be established between the iconography of the tomb of Margaret of Luxemburg and reliefs at Senlis, Lausanne and elsewhere.

BIBLIOGRAPHY: The standard book on Giovanni Pisano is a small volume by Keller (*Giovanni Pisano*, Vienna, 1942).

Good general accounts of Giovanni Pisano's development are given by A. Venturi (*Giovanni Pisano*, Bologna, 1928), Toesca (in *Il Trecento*, 1951, pp. 219-52), and J. White (*Art and Architecture in Italy, 1250-1400*, London, 1966). Giovanni Pisano's work as an architect is discussed by Paatz (*Werden und Wesen der Trecento-Architektur in Toskana*, Burg, 1937). Among studies of individual monuments may be noted particularly those of Keller on the Siena façade ('Die Bauplastik des Sieneser Doms', in *Kunstgeschichtliches Jahrbuch der Biblioteca Hertziana*, i, 1937, pp. 141-221). M. Seidel ('Die Rankensäulen der Sieneser Domfassade', in *Jahrbuch der Berliner Museen*, xi, 1969, pp. 81-157, throwing much new light on the relationship of Giovanni Pisano both to the antique and to French Gothic sculpture), and A. Kosegarten ('Die Skulpturen der Pisani am Baptisterium von Pisa. Zum Werk von Nicola und Giovanni Pisano', in *Jahrbuch der Berliner Museen*, x, 1968, pp. 14-100; 'Nicola und Giovanni Pisano, 1268-1278', in *Jahrbuch der Berliner Museen*, xi, 1969, pp. 36-80). Generalized accounts of the French sources of Giovanni Pisano's style are given by R. Dan Wallace (*L'influence de la France gothique sur deux des précurseurs de la Renaissance italienne: Nicola et Giovanni Pisano*, Geneva, 1953), W. Messerer (in *Das Relief im Mittelalter*, Berlin, 1959), and M. Weinberger ('Remarks on the Role of French Models within the Evolution of Gothic Tuscan sculpture', in *Studies in Western Art, Acts of the XXth International Congress of the History of Art*, i, Princeton, 1963, pp. 198-206). Also noteworthy are articles by Weinberger ('Giovanni Pisano', in *Burlington Magazine*, lxx, 1937, pp. 54-59) and Carli (in *Sculture del Duomo di Siena*, Turin, 1941; and 'Le statue degli Apostoli per il Duomo di Siena', in *Antichità Viva*, vii, 1968, pp. 3-20). The Pistoia pulpit is the subject of a good and well illustrated volume by M. Seidel (*Giovanni Pisano: il Pulpito di Pistoia*, Forma e Colore 15, Florence, 1965). The iconography of the Pisa pulpit is discussed in the above cited article by Braunfels, by H. von Einem (*Das Stützengeschoss der Pisaner Domkanzel. Gedanken zum Alterswerk des Giovanni Pisano*, Cologne-Opladen, 1962), M. Alpatov ('Sur la chaire de Giovanni Pisano à Pise', in *Arte Lombarda*, x, 1965, pp. 37-50), and G. Jaszai (*Die Pisaner Domkanzel. Neuer Versuch zur Wiederherstellung ihres ursprünglichen Zustandes*. Inaugural Dissertation, Universität zu München, Munich, 1968). For the dispersed carvings deriving from the pulpit see F. Fried ('Zwei Engelgruppen von Giovanni's Domkanzel in Pisa', in *Strygowski Festschrift*, Klagenfurt, 1932, pp. 54ff.), H. Olsen (*Italian Paintings and Sculpture in Denmark*, Copenhagen, 1961, p. 113), and G. Marchini ('Una testa di Giovanni Pisano', in *Studien zur toskanischen Kunst. Festschrift für L. H. Heydenreich*, Munich,

1964, pp. 166–68). The probable participation of Giovanni di Balduccio in the central support of the pulpit is discussed by E. Tolaini ('La prima attività di Giovanni di Balduccio', in *Critica d'Arte*, n.s. 27, 1958, pp. 188–202). The evidence for the present reconstruction of the pulpit is reviewed in an excellent volume by P. Bacci (*La ricostruzione del pergamo del duomo di Pisa*, Milan, 1926). The aesthetic significance of the late style of Giovanni Pisano is examined in periodical contributions by Francovich ('Studi recenti sulla scultura gotica toscana: Giovanni Pisano', in *Le Arti*, iv, 1942, pp. 195–211) and Paccagnini ('Note sullo stile tardo di Giovanni Pisano', in *Belle Arti*, i, 1946–8, pp. 246–59) and, most notably, by Papini ('Promemoria sulla classicità di Giovanni Pisano', in *Miscellanea Supino*, Florence, 1933, pp. 113–23). The progressive reintegration of elements from the tomb of Margaret of Luxemburg may be traced in the writings of H. von Einem ('Das Grabmal der Königin Margarethe in Genua', in *Festschrift H.R. Hahnloser zum 60. Geburtstag*, Basle-Stuttgart, 1961, pp. 125–50; 'Giovanni Pisano und Frankreich', in *Actes du XIXe. Congrès International d'Histoire de l'Art*, Paris, 1959), P. Torriti ('Una statua della Giustizia di Giovanni Pisano per il monumento funebre a Margherita di Brabante in Genova', in *Commentari*, xi, 1960, pp. 231–36), C. Marcenaro ('Per la tomba di Margherita di Brabante', in *Paragone*, No. 133, 1961, pp. 3–17; 'La "Madonna" della tomba di Margherita di Brabante', in *Paragone*, No. 167, 1963, pp. 17–21), and M. Seidel ('Ein neu entdecktes Fragment des Genueser Grabmals der Königin Margarethe von Giovanni Pisano', in *Pantheon*, xxvi, 1968, pp. 335–51). For the ivory statuette of 1299 see Koechlin (*Les Ivoires Gothiques Français*, Paris, i, 1924, pp. 108–9), C. L. Ragghianti ('La Madonna eburnea di Giovanni Pisano', in *Critica d'Arte*, n.s. i, 1954, pp. 385–96), R. Barsotti ('Nuovi studi sulla Madonna eburnea di Giovanni Pisano', in *Critica d'Arte*, n.s. iv, 1957, pp. 47–56), and J. Pope-Hennessy ('New Works by Giovanni Pisano—II', in *Bulletin of the Victoria and Albert Museum*, i, 1965, reprinted in *Essays on Italian Sculpture*, London, 1969, pp. 6–10, publishing a figure of the Crucified Christ ascribed to Giovanni Pisano). A close analogy for the ivory Virgin and Child is provided by a French ivory of the second half of the thirteenth century in S. Maria in Categna, Lugnano di Vazia, Rieti (repr. L. Mortari, *Opere d'arte in Sabina dall'XI al XVII secolo*, Rome, 1957, pp. 67–68). The wooden Crucifixes ascribed to Giovanni Pisano in S. Andrea, Pistoia, the Museo dell'Opera del Duomo, Siena, the Duomo at Prato, and the Staatliche Museen, Berlin-Dahlem, are discussed by E. Carli (*Scultura lignea senese*, Milan-Florence, 1951, and *La scultura lignea italiana*, Milan, 1961), and in greater detail by M. Lisner (*Holzkruzifixe in Florenz und in der Toskana*, Munich, 1970, pp. 16–22).

Plates 14–15: STATUARY
Duomo, Siena

At some date between March 1284, when he is mentioned in Pisa, and September 1285, Giovanni Pisano surrendered his Pisan birthright and became a citizen of Siena, which was the main scene of his activity till 1295, and where he worked intermittently for a further four years. Throughout the whole of this period he seems to have been concerned principally with the building and sculptural decoration of the façade of the Cathedral, of which a *facciata semplice* was in course of construction in 1284. The façade which he designed is the earliest and most richly decorated of the great Italian Gothic façades. In its present form (Fig. 13) only the lower part of the façade is due to Giovanni Pisano. The lowest of the figure sculptures on the façade are six animals (horses, ox, lions, gryphon) set on the level of the base of the lunettes above the entrance. Immediately above these, and approximately level with the upper part of the lunettes, are figures running across the façade and extending, on the same level, round the north and south sides. These until recently comprised: (A) (North Side) (i) Haggai, (ii) Isaiah, (iii) Balaam, (B) (Façade) (i) Plato, (ii) Habakkuk, (iii) Sibyl, (iv) David, (v) Solomon, (vi) modern figure in substitution for Moses (now placed in upper register), (vii) Simeon, (viii) Joshua, (C) (South Side) (i) modern figure, (ii) Mary, sister of Moses, (iii) Aristotle. The figures are now shown in the Museo dell'Opera del Duomo. The statues have been subjected to extensive restoration, and only with the Isaiah, David and Solomon are the lower parts original. Before the figures now in the Museo dell'Opera del Duomo were removed from the façade, many of the statues, as demonstrated by Keller from inscriptions beside the niches, had been interchanged and no longer occupied the positions for which they were designed. Thus it is very probable that the Plato and Habakkuk, now placed together in a double niche on the left of the façade, originally occupied the outer niches to left and right, in association with a figure of Daniel and the Joshua; the Sibyl (Plate 14), however, seems to have been destined for the place it previously occupied in the third niche from the left. This is of practical importance in that the poses of the figures were to some extent determined by their placing on the façade. The iconographical programme of the sculptures is relevant to the cult of the Virgin, to whom the Cathedral was dedicated, and includes representations of the prophets and seers of antiquity who predicted the coming of the Virgin and the birth of Christ. Among these are Plato and Aristotle, with inscriptions relating to the birth of Christ, Balaam, with the inscription *Orietur stella ex Jacob*, and the Sibyl, with the inscription *Et vocabitur Deus et homo*. As is to be expected in works executed over so long a period of time, some measure of stylistic change is apparent within the statuary executed by Giovanni Pisano for the façade, and it is plausibly suggested by Keller that the poles of this development are represented by the figure of the Sibyl, which recalls the statuettes executed by Giovanni Pisano for the fountain at Perugia, and by the statue of Mary, sister of Moses (Plate 15), where the contorted pose is connected with that of the Sibyl on the pulpit at Pistoia (Plate 18). Keller (pp. 180–81) also points out suggestive analogies between the pose and drapery of the Sibyl and that of a Prophet on the inner entrance wall at Rheims. One of the best preserved of the figures is the upper part of the Haggai, which seems to have been removed from the façade

by the middle of the nineteenth century and is now in the Victoria and Albert Museum, London: it originally formed a pair with the Isaiah (Fig. 17) (for this see J. Pope-Hennessy, 'New Works by Giovanni Pisano—I', in *Burlington Magazine*, cv, 1963, reprinted in *Essays in Italian Sculpture*, London, 1969, pp. 1–5). A campaign of restoration of the façade sculptures began in 1836, and a supervisory commission was appointed in 1867. In both figures the influence of the antique is pronounced; the head of the Isaiah has been compared (Keller) to that of an antique faun, and that of the Haggai seems to reflect study of a Hellenistic original.

Plates 16–19: PULPIT
Sant'Andrea, Pistoia

An inscription running round the pulpit beneath the narrative reliefs gives the name of the patron by whom it was commissioned, a certain Arnoldus, and the date of its completion (1301). This reads:

LAUDE DEI TRINI REM CEPTAM COPULO FINI
CURE PRESENTIS SUB PRIMO MILLE TRICENTIS.
PRINCEPS E(ST) OP(ER)IS PLEBAN(US) VEL DATOR ERIS
ARNOLD(US) DICTUS QUI SEMP(ER) SIT BENEDICTUS.
ANDREAS UN(US) VITELLI QUOQ(UE) TIN(US)
NAT(US) VITALI BENE NOT(US) NOMINE TALI
DISPE(N)PSATORES HI DICTI S(UN)T MELIORES
SCULPSIT JOH(ANN)ES QUI RES NO(N) EGIT INANES
NICOLI NAT(US) SENSIA MELIORE BEATUS
QUE(M) GENUIT PISA DOCTU(M) SUP(ER) OMNIA VISA.

(In praise of the triune God I link the beginning with the end of this task in thirteen hundred and one. The originator and donor of the work is the canon Arnoldus, may he be ever blessed. Andrea, (son?) of Vitello, and Tino, son of Vitale, well known under such a name, are the best of treasurers. Giovanni carved it, who performed no empty work. The son of Nicola and blessed with higher skill, Pisa gave him birth, endowed with mastery greater than any seen before.)

If Vasari is correct in stating that Giovanni Pisano worked on the pulpit for four years, this would have been begun in 1297. The pulpit (Fig. 14), like that in the Baptistry at Pisa, is hexagonal, but it differs from this work in the developed Gothic arches of the archivolt, and in the upper section preserves the figurated supports of Nicola Pisano's pulpit at Siena. The supports of the upper section show: (i) a Deacon (Plate 19), (ii) the Apocalyptic Christ, (iii) the Prophet Jeremiah, (iv) the Symbols of the Evangelists, (v) the Writers of the Canonical Epistles, and (vi) four Angels. Between these are reliefs representing: (i) the Annunciation, Nativity and Annunciation to the Shepherds (Plate 16), (ii) the Adoration of the Magi, the Dream of the Magi and the Angel warning the Holy Family to flee, (iii) the Massacre of the Innocents (Plate 17), (iv) the Crucifixion, and (v) the Last Judgment. At the angles of the archivolt are six figures of Sibyls (Plate 18), which are among the most remarkable features of the pulpit. Certain of the narrative reliefs, notably the Crucifixion, incorporate motifs from the narrative reliefs of the Siena pulpit. But the style of the carvings, with their expressive linear rhythms, violently activated figures, deep undercutting and heavy shadows, is strikingly at variance with that practised by Nicola Pisano, and seems to result from experience of French ivory reliefs of the class of the carvings from the Soissons Diptych studio. There is independent evidence, in the Madonna of 1299, of Giovanni Pisano's interest in French ivory carvings at this time. The animation of the narrative reliefs extends to the supports of the upper section and the archivolt, where the sense of movement is enhanced by the elaborate contrapposto of the figures, and to the Prophets in the spandrels, which protrude from their grounds and are no longer portrayed in the shallow relief used in the spandrels of the Pisa and Siena pulpits. The style of the statuettes strongly recalls the later statues on the Siena façade.

The pulpit was originally adjacent to the choir on the right hand (epistle) side. According to G. Dondori (*Della Pietà di Pistoja*, Pistoia, 1666, pp. 27–28), the choir was removed about 1619, and the present siting of the pulpit seems to date from the seventeenth century.

Plates 20–22: PULPIT
Duomo, Pisa

The pulpit contains two inscriptions. The first, running beneath the narrative reliefs, reads:

LAUDO DEUM VERUM PER QUEM SUNT OPTIMA RERUM
QUI DEDIT HAS PURAS HOMINEM FORMARE FIGURAS.
HOC OPUS HIC ANNIS DOMINI SCULPSERE IOHANNIS
ARTE MANUS SOLE QUONDAM NATIQUE NICHOLE
CURSIS UNDENIS TERCENTUM MILLEQUE PLENIS
JAM DOMINANTE PISIS CONCORDIBUS ATQUE DIVISIS
COMITE TUNC DICO MONTISFELTRI FREDERICO
HIC ASSISTENTE NELLO FALCONIS HABENTE
HOC OPUS IN CURA NEC NON OPERE QUOQUE IURA
EST PISIS NATUS UT IOHANNES ISTE DOTATUS
ARTIS SCULPTURE PRE CUNCTIS ORDINE PURE
SCULPENS IN PETRA LIGNO AURO SPLENDIDA TETRA
SCULPERE NESCISSET VEL TURPIA SI VOLUISSET.
PLURES SCULPTORES: REMANENT SIBI LAUDIS HONORES
CLARAS SCULPTURAS FECIT VARIASQUE FIGURAS
QUISQUIS MIRARIS TUNC RECTO JURE PROBARIS
CRISTE MISERERE CUI TALIA DONA FUERE. AMEN.

(I praise the true God, the creator of all excellent things, who has permitted a man to form figures of such purity. In the year of Our Lord thirteen hundred and eleven the hands of Giovanni, son of the late Nicola, by their own art alone, carved this work, while there ruled over the Pisans, united and divided, Count Federigo da Montefeltro, and at his side Nello di Falcone who has exercised control not only of the work but also of the rules on which it is based. He is a Pisan by birth, like that Giovanni who is endowed above all others with command of the pure art of sculpture, sculpting splendid things in stone, wood and gold. He would not know how to carve ugly or base things even if he wished to do so. There

are many sculptors, but to Giovanni remain the honours of praise. He has made noble sculptures and diverse figures. Let any of you who wonders at them test them with the proper rules. Christ have mercy on the man to whom such gifts were given. Amen.)

The second inscription runs along the step beneath the pulpit:

CIRCUIT HIC AMNES MUNDI PARTESQUE IOHANNES
PLURIMA TEMPTANDO GRATIS DISCENDA PARANDO
QUEQUE LABORE GRAVI NUNC CLAMAT NON BENE CAVI
DUM PLUS MONSTRAVI PLUS HOSTITA DAMNA PROBAVI
CORDE SED IGNAVI PENAM FERO MENTE SUAVI
UT SIBI LIVOREM TOLLAM MITIGEMQUE DOLOREM
ET DECUS IMPLOREM VERSIBUS ADDE ROREM
SE PROBAT INDIGNUM REPROBANS DIADEMATE DIGNUM
SIC HUNC QUEM REPROBAT SE REPROBANDO PROBAT.

(Giovanni has encircled all the rivers and parts of the world endeavouring to learn much and preparing everything with heavy labour. He now exclaims: 'I have not taken heed. The more I have achieved the more hostile injuries have I experienced. But I bear this pain with indifference and a calm mind.' That I (the monument) may free him from this envy, mitigate his sorrow and win him recognition, add to these verses the moisture (of your tears). He proves himself unworthy who condemns him who is worthy of the diadem. Thus by condemning himself he honours him whom he condemns.) There is considerable doubt as to the meaning of the two inscriptions. The words 'amnes mundi partesque' have been interpreted metaphorically (Bacci) as references to the four Evangelists and four Cardinal Virtues beneath the pulpit, and literally (Toesca) as alluding to physical journeys on the part of the artist. The personal difficulties mentioned in the second inscription were perhaps the cause of the replacement of Burgundio di Tado in 1307 by Nello di Falcone. The part played by Burgundio di Tado in the pulpit commission is commemorated by an inscription on the side of the Cathedral:

IN NOMINE DOMINI: AMEN
BORGOGNO. DI TADO: FE
CE: FARE: LO PERBIO NVOV
O: LO QVALE E IN DVOMO:
COMINCIOSI: CORENTE: ANI:
DOMINI: MCCCII: FV FINIT
O: IN ANI: DOMINI: CORENT
E: M:CCCXI DEL MESE: D
IICIEMBRE:

(In the name of the Lord. Amen. Burgundio di Tado was responsible for the making of the new pulpit which is in the Cathedral. It was begun in the year 1302 and was finished in the month of December in the year 1311.)

The pulpit was commissioned by the Operaio of the Cathedral, Burgundio di Tado, in 1302 in substitution for the pulpit of Guglielmo now at Cagliari, is mentioned in documents of 1305 and 1307, and was completed in December 1310. Installed at the right forward corner of the choir, it was damaged in the fire of 1599, and July of this year permission

was given for 'il levarsi quel Pulpito'. Dismantled between this date and 1602, its constituents were in part incorporated in a new pulpit and in part dispersed. Some of the details are uncertain (especially in respect of the lower section) and some missing figures have been replaced by copies. Among the fragmentary sculptures which have some claim to originate from the pulpit are two Sibyls and a lectern in the Bode-museum, East Berlin (formerly Kaiser Friedrich Museum, Berlin), three carvings in the Metropolitan Museum, New York, a head of a Saint at Copenhagen, and, more doubtfully, a male head at Volterra. The Duomo pulpit (Fig. 15) is the latest and most elaborate of the series of pulpits which opens with the Baptistry pulpit of Nicola Pisano. The octagonal form of the Siena pulpit is modified by the addition of a protruding section, with two carved faces, on the eighth side, and the upper section thus contains nine narrative reliefs. With the exception of the first and ninth faces, the relief surfaces are curved, and not flat as in the earlier pulpits. In the lower section the figurative elements play an increasingly important part. The central support is formed of three caryatids of the Virtues, above a polygonal base carved with small figures of the Liberal Arts, and the outer supports comprise full-length figures of Ecclesia, flanked by four Cardinal Virtues, Christ with the four Evangelists, St. Michael and Hercules. Beneath the Massacre of the Innocents there may originally have been two similar supports. A wide variety of view has been expressed as to the meaning of the figures in the lower register. According to an interpretation of Von Einem, the inscription on the scroll held by Christ (VERITAS DE TERRA ORTA EST ET IVSTITIA DE COELO PROSPEXIT) should refer to the Christ (who would be a personification of Heavenly Justice) and the female figure (who would represent Truth). The sum of human and theological virtues would be identified respectively with Hercules and with St. Michael, while the Evangelists and the Cardinal Virtues would, as is implied in the inscription, be identified with the rivers of Paradise and continents. The pulpit should thus be regarded as the Templum Justitiae described in Cassiodorus' gloss on Psalm 84. Alternative interpretations are offered by Braunfels and Jaszai. Whether or not they are accepted in detail, the mystical intention behind the structure is in no doubt. Foliated spandrels are introduced into the archivolt, at the angles of which are Sibyls reminiscent of those on the Pistoia pulpit. The narrative reliefs above show: (i) the Annunciation, Visitation and Birth and Naming of the Baptist, (ii) the Nativity and Annunciation to the Shepherds, (iii) the Journey, Adoration and Dream of the Magi, (iv) the Presentation in the Temple, Herod and the Magi, the Angel warning the Holy Family to flee, and the Flight into Egypt, (v) the Massacre of the Innocents, (vi) the Betrayal of Christ, the Mocking of Christ, Christ before Pilate and the Flagellation, (vii) the Crucifixion, (viii) the Elect, and (ix) the Damned. The treatment of the scenes differs from that of the Pistoia pulpit in that a number of them are treated as two superimposed strips of carving between which there is no space relationship. This is the case, e.g., with (v), which shows the Wrath of Herod at the back

and the Massacre proper beneath. There can be little doubt
that this practice was adopted from the antecedent pulpit by
Guglielmo (now at Cagliari) which the new pulpit was
commissioned to replace, where the scenes are segregated in
oblong strips, with, e.g., the Annunciation and Visitation
above the Nativity and the Wrath of Herod over the Massacre
of the Innocents. According to a description prepared by
Canonico Raffaello Roncioni before 1595, the female figure,
identified as 'Pisa (ossia la Chiesa)' was shown 'con una veste
rossa e lungo fino ai piedi, con un manto azzurro, con
corona d'oro in testa' (with a red dress down to her feet, a
blue mantle and a gold crown on her head). If this pig-
mentation was original, other parts of the pulpit must also
have been pigmented. Keller (p. 68) suggests that in places
the grounds of the reliefs may have been filled in with glass
tesserae. The style of the narrative reliefs is, in essentials, that
of the pulpit at Pistoia, but the handling throughout is less
consistent, and Toesca (in *Il Trecento*, 1951, p. 246) notes
extensive studio intervention in scenes (iii), (v), (vi), (viii)
and (ix). Weinberger assigns the intervening supports in the
upper section largely to studio hands. No attempt has,
however, been made to isolate the personalities of the artists
who collaborated on the pulpit, though it is likely that care-
ful analysis would yield results as precise as those obtained
with the Arca of St. Dominic (see Plate 24 below). Both in the
autograph reliefs (notably the Nativity) and in the autograph
caryatids (notably the Ecclesia, Christ and Hercules) the style
is more restrained and classical than at Pistoia. The explana-
tions offered for this change are one and all conjectural. The
beautiful figure of Temperantia depends from a classical
Venus Pudica, and its attribution to Giovanni Pisano has
been disputed; certain features of the St. Michael recall the
early style of Tino di Camaino. It has been claimed that the
relief style of the pulpit is alternatively more concise and
more intense than, and markedly inferior to, that of the
earlier reliefs. An interesting analysis of the classical sources of
the reliefs is given by Papini.

Plate 23: THE MONUMENT OF
MARGARET OF LUXEMBURG
Palazzo Bianco, Genoa

Henry of Luxemburg, crowned as King of Germany in 1309
and as the Emperor Henry VII in June 1312, entered Genoa
on 24 October 1311. There, on 14 December, his Queen,
Margaret of Brabant, died, and was buried in the church of
S. Francesco di Castelletto. Henry VII was resident in Pisa on
his way to Rome between 6 March and 28 April 1312, and
again on his return between 10 March and 8 August 1313.
He died at Buonconvento on 24 August of this year. His
principal commission in Pisa, to Giovanni Pisano for statuary
for the Porta di S. Ranieri of the Cathedral, dates from the
first of these two periods, and it is likely that the tomb for
S. Francesco di Castelletto was commissioned at the same
time. There is a record of Giovanni Pisano's presence in
Genoa on 25 August 1313, and it is possible that the tomb was

finished by this date. There is some doubt as to the placing
of the tomb, which is described in 1739 as 'un arca di marmo
ornata di molte figure che anche al presente si vede sopra la
cappella del medesimo S. Francesco alla parte sinistra del
Sancta Sanctorum' (a marble tomb chest decorated with many
figures which can still today be seen above the chapel of St.
Francis to the left of the high altar); it has been suggested that
this siting was not original, but resulted from re-installation
between 1610 and 1640 (Marcenaro). The church of S.
Francesco di Castelletto was demolished in 1798–1807, and
the tomb was dismantled at this time. The following
sculptures from it survive: (i) Three figures from the scene
of the Resurrection of Margaret of Luxemburg and two frag-
mentary angels opening a baldacchino, recovered in 1874 in
the Villa Brignole and now in the Palazzo Bianco (H. of
figure of the Empress 65·5 cm., H. of attendant angels 67 cm.
and 74 cm., H. of angels with baldacchino 77 cm. and 67·5
cm.). (ii) A figure of Justice (H. 103 cm.), holding a scroll
inscribed DILEXISTI IUSTITIAM ODISTI INIQUITATEM, recovered
in 1960 (Torriti, Marcenaro) and now in the Palazzo Spinola,
Genoa. (iii) The head of a corresponding figure of Tem-
perance (H. 15·5 cm.) in a Swiss private collection (Seidel).
(iv) A headless Virgin and Child (H. 47·5) formerly in the
Museo di S. Agostino, now in the Palazzo Rosso, Genoa,
identified by Valentiner and Marcenaro. The figures of
Justice and the Virgin and Child and the head of Temperance
correspond with these elements in a group of the Virgin and
Child and four Virtues dating from the mid-fourteenth cen-
tury now installed over the entrance to S. Maria Maddalena,
and there is a presumption that the other elements in the
S. Maria Maddalena group were also copies from figures
on the tomb. The tomb of Margaret of Luxemburg is of
special importance by virtue first of the exceptionally high
quality of those parts of it which survive, second of the
fact that it is Giovanni Pisano's only recorded sepulchral
monument, and third that it represents a unique tomb type
of which no other example survives. It is not clear whether
it was conceived as a free-standing tomb (like Tino di
Camaino's tomb of Catherine of Austria in Naples), or as a
tomb which stood forward from the wall; the backs of the
surviving sculptures would be consistent with either pos-
sibility. The scene of the Resurrection of the Empress derives
its iconography from a class of French relief of the Awakening
of the Virgin, which seems to have originated at Senlis, and
spread to Chartres, Laon, Saint Yvod de Braine, Lausanne
and S. Maria in Vezzolano (Piedmont) (for this see E. Mâle,
'Le Portail de Senlis et son influence', in *Revue de l'art ancien
et moderne*, xxix, 1911, pp. 161ff.). The Justice is also strongly
Northern in type, and recalls, e.g., figures at Naumburg
rather than the Justice of the Pisa Cathedral pulpit. The
Resurrection scene may have been contained in a lunette. The
Justice has been explained as a caryatid beneath the
sarcophagus, but since the inscription is in the second person
singular and is addressed to the Empress, it is probable that
this and the three other Cardinal Virtues were grouped round
the effigy. Control of the construction of the monument is
known to have been vested in Giovanni da Bagnara, an

archdeacon of Genoa Cathedral, but the imagery seems to have been dictated by some member of Henry VII's predominantly Northern court, which included Germans (Gottfried of Leiningen and the Emperor's brother Baldwin,

Archbishop of Trier), Frenchmen (Hugo of Vienne), and one Ligurian cardinal, Luca dei Fieschi, whose tomb in Genoa, when he died in 1343, was designed by a belated follower of Giovanni Pisano.

ARNOLFO DI CAMBIO
(b. *c.* 1245; d. *c.* 1310)

Arnolfo di Cambio was born at Colle Val d'Elsa, probably about 1245, and is first mentioned in 1265 as the principal assistant of Nicola Pisano on the Siena pulpit. He appears before this time to have been employed on the Arca of St. Dominic (see Plate 24 below) and on the pulpit in the Baptistry at Pisa (see Plate 1 above). It has also been suggested that about 1260–2 he was responsible for carving two figurated capitals in the Duomo at Siena (Carli, Romanini). Arnolfo's name appears again in the concluding payments for the Siena pulpit in 1267–8, and thereafter he seems to have left Nicola's studio. In 1277 he was at work in Rome in the service of Charles of Anjou, and it has been inferred (Salmi) that he entered the service of Charles of Anjou in Florence in 1272 and subsequently worked in Rome and Naples. To these years belong the monuments of Cardinal Annibaldi in St. John Lateran, Rome (1276) (see Plate 25 below) and of Pope Hadrian V (d. 1276) in S. Francesco, Viterbo (Fig. 23). The latter monument certainly and the former probably depend from a French-influenced tomb type employed by Pietro Oderisio in the monument of Pope Clement IV (d. 1268) at Viterbo. In 1281 he was employed on a fountain at Perugia smaller than and adjacent to that of Nicola Pisano; the small figures from this fountain in the Pinacoteca Nazionale dell'Umbria at Perugia are among the most individual and impressive of Arnolfo's earlier works. From the following year there dates the De Braye monument at Orvieto (see Plates 26–27 below), and this is followed by two Roman ciboria in S. Paolo fuori le Mura (signed HOC OPVS FECIT ARNOLFVS CVM SVO SOCIO PETRO, and completed in 1285 jointly with Pietro Oderisio) and S. Cecilia in Trastevere (1293). Other major Roman commissions of these years are the now dismembered monument of Pope Boniface VIII (recumbent figure and half-length of the Pope in benediction in the Grotte Vaticane, consecrated 1296), the Oratorio del Presepe in S. Maria Maggiore, the Tribunal of Charles of Anjou at the Aracoeli (main statue and fragmentary sculptures preserved in the Palazzo dei Conservatori and the Museo Capitolino), and the bronze statue of St. Peter now in St. Peter's. Arnolfo returned to Florence in 1296, where he designed, and served as Capomaestro of, the Duomo. The principal products of this concluding phase are the sculptures (see Plates 28–29 below) made for the Duomo façade. Arnolfo was still in Florence in 1300, when an appeal for tax exemption was made on his behalf, and died there about 1310. In the history of Italian Gothic art Arnolfo's importance as an architect is even greater than his importance as a sculptor. His architectural and sculptural conceptions appear to have been strongly influenced by the French architects whom he

would have encountered in the course of his work for Charles of Anjou, but in both fields he was the exponent of an individual style of great originality. A mistaken attempt has been made (Frey) to distinguish between Arnolfo di Cambio, an architect presumed to have been trained in the Cistercian workshop at San Galgano, who would have been responsible for the architectural projects, and Arnolfo Fiorentino the sculptor.

BIBLIOGRAPHY: A useful corpus of photographs of Arnolfo's sculptures is offered by Mariani (*Arnolfo di Cambio*, Rome, 1943). The text of this book is, however, superseded by a number of the books and articles listed below. The principal problems arising from Arnolfo's work are discussed in a careful and interesting volume by A. M. Romanini (*Arnolfo di Cambio e lo 'stil novo' del gotico italiano*, Milan, 1969), and an excellent survey of Arnolfo's career as sculptor and architect is given by M. Salmi (in *Enciclopedia Universale dell'Arte*, i, Venice-Rome, 1958, c. 744–51). Fundamental are the researches of Keller ('Der Bildhauer Arnolfo di Cambio und seine Werkstatt', in *Jahrbuch der Preussischen Kunstsammlungen*, lv, 1934, pp. 204–28, lvi, 1935, pp. 22–43). A convincing reconstruction of Arnolfo's early style is given by Gnudi (*Nicola, Arnolfo, Lapo*, Florence, 1948). The attitude of Toesca (in *Il Trecento*, 1951, pp. 202–18) to Arnolfo's origins is unduly negative, as is that of Francovich ('Studi recenti sulla scultura gotica toscana: Arnolfo di Cambio', in *Le Arti*, ii, 1940, p. 236ff.) to the entire œuvre. On the Perugia fountain and its constituent figures see G. Nicco Fasola ('La fontana di Arnolfo', in *Commentari*, ii, 1951, pp. 98–105; *La Fontana di Perugia*, Rome, 1951, pp. 46–51) and F. Santi ('Considerazioni sulla Fontana di Arnolfo a Perugia', in *Commentari*, vi, 1960, pp. 220–30; 'Un altro scriba di Arnolfo per la Fontana perugina del 1281', in *Paragone*, No. 225, 1968, pp. 3–10); and *Galleria Nazionale dell'Umbria. Dipinti, sculture e oggetti d'arte di età romanica e gotica*, Rome, 1969, pp. 142ff.). The Roman sepulchral monuments are discussed by R. U. Montini (*Le tombe dei papi*, Rome, 1957, pp. 224–27, 242–44) and with great perspicacity by A. Kosegarten (in *Jahrbuch der Berliner Museen*, x, 1968, p. 60ff.). The sources for the Tribunal of Charles of Anjou are reviewed by P. Cellini ('L'opera di Arnolfo all'Aracoeli', in *Bollettino d'Arte*, xlvii, 1962, pp. 180–95) and M. Weinberger ('Arnolfo und die Ehrenstatue Karls von Anjou', in *Studien zur Geschichte der europäischen Plastik. Festschrift für Th. Müller*, Munich, 1965, pp. 63–75) and the evidence for the dating and attribution of the bronze statue of St. Peter is analysed by M. Salmi ('Il problema della statua bronzea di S. Pietro nella Basilica

Vaticana', in *Commentari*, xi, 1960, pp. 22–29). In the extensive bibliography of the façade of the Duomo in Florence pride of place belongs, in so far as concerns the sculptures, to the catalogue of the Museo dell'Opera del Duomo in Florence by L. Beccherucci and G. Brunetti cited below. Interest also attaches to the studies of Weinberger ('The first Façade of the Cathedral of Florence', in *Journal of the Warburg and Courtauld Institutes*, iv, 1940–1, pp. 67–79), Paatz (*Werden und Wesen der Trecento-Architektur in Toskana*, Burg, 1937), A. Grote (*Das Dombauamt in Florenz 1285–1370. Studien zur Geschichte der Opera di S. Reparata zu Florenz im vierzehnten Jahrhundert*, Munich, 1961), G. Kiesow ('Zur Baugeschichte des Florentiner Domes', in *Mitteilungen des Kunsthistorischen Institutes in Florenz*, x, 1961, pp. 1–22) and H. Saalman ('Santa Maria del Fiore: 1294–1418', in *Art Bulletin*, xlvi, 1964, pp. 471–500). The relevant documents are published by Poggi (*Il Duomo di Firenze*, Berlin, 1909). For individual sculptures from the façade see Becherucci ('Sculture dell' antica facciata del Duomo di Firenze', in *Dedalo*, viii, 1927–8, pp. 219–37), and Bettini ('Tre sconosciute sculture arnolfiane', in *Rivista d'Arte*, xxvi, 1950, pp. 185–92). Arnolfo's sepulchral monuments are discussed by Bürger (*Geschichte des Florentinischen Grabmals*, Strassburg, 1904, pp. 24–32). Though marred by perverse reasoning, Frey's edition of Vasari's life of Arnolfo (*Le vite de' piu eccellenti pittori scultori e architettori scritte da M. Giorgio Vasari pittore et architetto aretino*, mit kritischem Apparate herausgegeben von Dr. Karl Frey, Munich, 1911, pp. 465–640) remains a primary source for the documentation of the sculptor's work.

Plate 24: THE ARCA OF ST. DOMINIC
San Domenico Maggiore, Bologna

The tomb of St. Dominic (Fig. 18) appears to have been commissioned from Nicola Pisano in 1264. At Pentecost 1265 funds were supplied by the Chapter of the Order for the completion of the monument, and in 1267 the body of the Saint was transferred to the new shrine. Work on the Arca therefore proceeded concurrently with work on the Siena pulpit (see Plates 6–10 above), with which Nicola was mainly concerned at this time. The shrine, which was extended in the fifteenth century and has a superstructure with figures by Niccolò dell'Arca and Michelangelo, was originally a rectangular sarcophagus with a flat top, supported on caryatids. In the centre of the back and front are statuettes (front, the Virgin and Child; back, the Redeemer), and at the corners are figures of the Doctors of the Church. Round the sides run six narrative scenes: (i) St. Dominic invested with the Symbols of his Mission by SS. Peter and Paul, (ii) the Raising of Napoleone Orsini, (iii) The Burning of the Books at Fanjeaux, (iv) St. Dominic and his Brethren fed by Angels, (v) the Story of Reginald, and (vi) the Confirmation of the Dominican Order. The caryatids seem to have comprised two central supports, each with three deacons (one of these is now in the Museo Nazionale, Florence, and the other in the Boston Museum of Fine Arts), and six external supports; two of these, with figures of St. Michael and the Archangel

Gabriel are in the Victoria and Albert Museum, London, and one, with an angel symbolising Faith, is in the Louvre (for these see Pope-Hennessy, 'The Arca of St. Dominic: a Hypothesis', in *Burlington Magazine*, xciii, 1951, pp. 347–51 reprinted in *Essays on Italian Sculpture*, London, 1969, pp. 11–15). Gnudi's analysis is corroborated by S. Bottari (*L'Arca di S. Domenico in Bologna*, Bologna, 1964). In modern criticism (e.g. by Toesca, in *Il Trecento*, 1951, pp. 199–200, and P. Cellini, 'Di fra' Guglielmo e di Arnolfo', in *Bollettino d'Arte*, xl, 1955, pp. 215–29), the Arca is generally ascribed to Fra Guglielmo, a classicising pupil of Nicola Pisano responsible for the design and execution about 1270 of a rectangular pulpit in San Giovanni Fuorcivitas at Pistoia. The traditional view of the Arca as a work of Nicola Pisano is vindicated by Gnudi, who successfully allocates the execution of sections of the monument to the master himself, Arnolfo di Cambio, Lapo, Fra Guglielmo and a so-called Quinto Maestro. Those parts attributable to Arnolfo di Cambio include three of the four caryatids (the two central supports and the Archangel Gabriel) and the Virgin and Child from the centre of the front. Arnolfo also intervened in sections of the first three narrative reliefs and was the dominant figure in reliefs (iv)–(vi). These are Arnolfo di Cambio's earliest known works, but throughout (and particularly in the Virgin and Child and the two central caryatids) the block-like forms which characterize his mature sculptures are already evident.

Plate 25: THE MONUMENT OF CARDINAL ANNIBALDI DELLA MOLARA
San Giovanni in Laterano, Rome

The ascription to Arnolfo of the monument of Cardinal Riccardo Annibaldi della Molara (d. 1275/6), formerly in the church of St. John Lateran, rests on the stylistic connection of the surviving fragments with the parts of the De Braye monument at Orvieto (see Plates 26–27 below) and other authenticated works. From the figurated sculptures of the monument are preserved the effigy of the Cardinal (still in the church) and a frieze of mourning acolytes (now in the cloister of the Lateran). Of the original form of the monument, we know no more than can be ascertained from a drawing in the Grimaldi Codex (reproduced by De Nicola, 'La prima opera di Arnolfo a Roma', in *L'Arte*, x, 1907, p. 97ff.). It perhaps included an arcaded tabernacle like that of the Clement IV monument at Viterbo, and was certainly enclosed by curtains caught up on pillars at the sides. The figure of the Cardinal, represented with eyes closed in death, has an important place in the history of the Italian sepulchral effigy. The frieze of clerics (Fig. 21) was set above and behind the sepulchral effigy, and the bier seems to have rested on an arcaded mosaic base of which part is still preserved. As pointed out by G. Swarzenski ('An early Tuscan Sculpture', in *Bulletin of the Boston Museum of Fine Arts*, xlvi, 1948, pp. 2–11), the six clerics represented on the frieze hold objects used during the Mass and are linked in a narrative illustrating the Office for the Dead. In this respect the imagery recalls that of the central

caryatids of the Arca of St. Dominic. Keller relates the figures to a group of deacons represented on the left of the relief of a Miracle of St. Remigius on the Porte St. Sixte at Rheims, and suggests that Arnolfo may have been familiar with drawings made from this or similar reliefs. An alternative source for the motif has been traced at Bourges (Weinberger). The use of mosaic to intensify the plastic character of the relief is referred by Salmi to Campanian pulpits with which Arnolfo would have become familiar during a conjectural period of activity after 1272 in South Italy in the service of Charles of Anjou, who may himself have been responsible for commissioning the Annibaldi monument.

Plates 26–27: THE MONUMENT OF
CARDINAL DE BRAYE
San Domenico, Orvieto

The monument of Cardinal de Braye (Fig. 25) was removed from its original position in 1680, and was reinstalled in 1934 in the right transept of San Domenico. Its figure sculpture comprises (i) an effigy of the Cardinal, (ii) two angels holding back curtains by which the figure is concealed, (iii) a Virgin and Child above, (iv) a Saint (variously identified as Paul and William, but probably Mark) presenting the Cardinal to the Virgin and Child, (v) a corresponding figure of St. Dominic, and (vi) two headless censing angels not incorporated in the present reconstruction of the monument now in the Museo dell'Opera del Duomo, Orvieto, along with (vii) a large number of non-figurated fragments from the architectural surround (itemised by Romanini). In the centre, set beneath the Virgin and Child, is a tablet with the name of the Cardinal, the name of the artist and the date of the Cardinal's death:

SIT X(RIST)O GRAT(US) HIC GUILLE(L)M(US) TUMULAT(US)
DE BRAYO NAT(US) MARCI TITULO DECORATUS
SIT PER TE MARCE CELI GUILLE(L)M(US) IN ARCE
QUESO NO(STR) PARCE D(EU)S O(MN)IP(O)T(EN)S SIBI PARCE
FRA(N)CIA PLA(N)GE VIRU(M) MORS ISTIU(S) T(IBI) MIRU(M)
DEFECTU(M) PARIET Q(UI)A VIX SIMILIS SIBI FIET
DEFLEAT HUNC MATHESIS LEX ET DECRETA POESIS
NEC NON SINDERESIS HEU M(IHI) Q(UE) THEMESIS
BIS SEX CETENUS BINUS B(IS)Q(UE) VICEN(US)
ANN(US) ERAT X(RISTI) QUA(N)DO MORS AFFUIT ISTI
OBIIT TERCIO K(A)L(ENDAS) MAII
HOC OPUS FECIT ARNOLFUS.

(May William, who is buried here, be well pleasing to Christ. Born de Braye, adorned with the title of Mark, may he through thee, Mark, come to the citadel of heaven. I pray, may the Lord Almighty spare him not sparingly. O France, mourn this man; to thee his death will be a heavy blow, for there will scarcely be another like him. Mourn him, law of learning (or science) and decrees of poetry, and thou too, law of reason,—woe is me—and justice. It was the twelve hundred and (?) eighty-second year of Christ when death came to him. He died on the third day before the kalends of May. Arnolfo made this work.)

Guillaume de Braye was born in France at the Château de Bray and served as Archdeacon of Rheims; he was raised to the Cardinalate by Pope Urban IV in 1262, and died on 29 April 1282 while visiting Pope Martin IV at Orvieto. In its present form his tomb lacks its architectural frame, and must originally have been surmounted by a Gothic tabernacle raised on spiral columns like that of Pope Adrian V at Viterbo. The three upper figures would originally have been set on the back wall of the monument. Conjectural reconstructions of the monument are given by Paniconi (*Monumento al Cardinale Guglielmo de Braye nella chiesa di S. Domenico in Orvieto: rilievo e studio di ricostruzione*, Rome, 1906), L. Fiocca (in *Rassegna d'Arte*, xi, 1911, p. 116ff.), and A. M. Romanini (in *Arnolfo di Cambio e lo 'stil novo' del gotico italiano*, Milan, 1969). This last reconstruction assumes that the monument was somewhat wider than in its present form, and must be viewed with some scepticism on this account. The original depth of the tomb is established by those sections now in S. Domenico, which were intended to stand free of the rear wall. Keller restricts Arnolfo's personal intervention in the execution of the monument to the effigy and the two figures of deacons and regards the three upper figures as the work of studio assistants; this view is unduly exclusive, and the Virgin and Child (in which the right hand of the former and the head of the latter are restored) was certainly carved by Arnolfo. The figures of deacons are carved from relatively thin slabs of marble and form a facing to the more coarsely carved curtains which continue at the sides of the tomb. The introduction of a small number of autograph carvings into a complex which was otherwise entrusted to studio hands is typical of the working procedure of Arnolfo, and stands in contrast to the practice of Giovanni Pisano in the tomb of Margaret of Luxemburg at Genoa or of Tino di Camaino in the Florentine sepulchral monuments. The influence of the Roman environment in which Arnolfo had been employed for at least six years before the execution of the monument is found, first in the extensive use of Cosmatesque inlay which gives the lower part a colouristic character distinct from that of Pisan prototypes, and secondly in the influence of Roman sculpture, most clearly evident in the Virgin and Child, where pose and drapery alike derive from a classical original of a class identified by Salmi in a figure of Abundance in the Capitoline Museum. A tendency towards polychromy is also evident in the red marble facing of one of the cushions beneath the head of the effigy. New features of the monument are the two angels opening or (White) closing the curtains that conceal the effigy. Arnolfo seems to have been responsible for introducing this motif in Italy. The French Gothic sources of the monument are discussed by Panofsky (*Tomb Sculpture*, New York, 1967, p. 76).

Plates 28–29: FAÇADE
Duomo, Florence

Arnolfo di Cambio was recalled to Florence in a consultative capacity in 1294, and was exclusively engaged there after

1296. It is generally assumed that the sculptures carved by him for the façade were produced in a six-year period between this date and his supposed death in 1302. It has, however, also been argued (Becherucci) that he was active in Florence till about 1310, and in this event work on the sculptures may have continued for some fourteen years. After Arnolfo's death work on the façade was suspended until 1357, when it was resumed by the architect Talenti. It can be established from a fresco of 1352 in the Bigallo that Arnolfo's façade was completed to the height of the tympanum over the central doorway. Interpreted in conjunction with this fresco, a drawing by Poccetti of Talenti's façade in the Museo dell'Opera del Duomo at Florence (Fig. 37) constitutes our main evidence for the sculptures with which the façade was decorated. In addition, a literary description of uncertain date made before the dispersal of the sculptures from the façade in 1587 (printed by Richa, *Notizie istoriche delle chiese fiorentine*, vi, 1757, pp. 57ff.), gives useful information on their siting. The principal sculptural elements of the façade were (i) in the lunette over the left entrance, the Nativity, (ii) in niches above the lunette, the Annunciatory Angel and Virgin Annunciate, (iii) to the left of the lunette, the Annunciation to the Shepherds, (iv) to the right of the lunette, the Adoration of the Shepherds, (v) in the lunette above the central doorway, the Virgin and Child with SS. Reparata and Zenobius, (vi) four figures of Prophets in niches above and beside this lunette, (vii) in the lunette above the right entrance, the Dormition of the Virgin, and (viii) in a niche on the upper part of the façade, a figure of Pope Boniface VIII. There survive from (i) a recumbent figure of the Virgin in the Museo dell'Opera del Duomo in Florence (Plate 28A), and two flying angels, from (ii) an Annunciatory Angel in the Fogg Art Museum, Cambridge (formerly Kingsley Porter collection), from (iii) and (iv) fragmentary reliefs in the Palazzo Medici Riccardi and Palazzo Torrigiani and the Museo dell'Opera del Duomo in Florence, from (v) the Virgin and Child (Plate 29) and figures of SS. Reparata and Zenobius, and two small angels moulded to the form of the arch, all in the Museo dell'Opera del Duomo, from (vi) two Prophets formerly in the possession of the Marchese Venturi-Ginori, now in the Museo dell'Opera del Duomo, from (vii) a group of the Virgin and an Apostle (Plate 28B), and two mourning Apostles formerly in the Kaiser Friedrich Museum, Berlin, and a fragment with Christ holding the Virgin's soul in the Museo dell'Opera del Duomo, Florence, and from (viii) a seated figure of Boniface VIII in the Museo dell'Opera del Duomo. A further statue carved for the façade by or in the workshop of Arnolfo is published by Salmi ('Una statua di Arnolfo', in *Commentari*, xvi, 1965, pp. 17–22) and is now in the Casa Buonarroti. The Virgin and Child is described in its original position (Richa) in the following terms: 'sopra la detta porta era fabbricata una vaga e bella cappelletta, nella quale era un' immagine di Nostra Donna di marmo a sedere con Cristo piccolo che con bella grazia le sedeva sopra un ginocchio et ella aveva gli occhi lucenti che parevano veri perche erano di vetro et era messa in mezzo da una statua di San Zanobi e da un'altra di Santa Reparata, e due bellissimi Anglioli, che aprivano un padiglione, che di panno appariva sebbene era di marmo' (above this door there was constructed a beautiful little chapel, in which stood a seated marble figure of Our Lady with the Child Christ, who was seated gracefully on her knee. She had shining eyes which appeared real because they were made of glass, and she was set between statues of San Zanobi and Santa Reparata, and two most beautiful angels, who were opening a tent which looked as though it were made of fabric though it was actually of marble). The use of glass eyes in this figure is unique. In its present form the right hand of the Child is new. Much in the reconstruction of the façade figures must be acknowledged as uncertain and a number of diverse and heterodox views have been expressed both as to the subject and the quality of its constituents. The full literature is reviewed in an exemplary fashion and with impeccable qualitative sense by L. Becherucci (in *Il Museo dell'Opera del Duomo a Firenze*, i, Florence, 1969, pp. 215–28). The central group of the Virgin and Child is richer and more recessive than the corresponding group in the De Braye monument, but the dominance of classical models is still so strong that the head of the S. Reparata, seen frontally, might be regarded as antique.

TINO DI CAMAINO
(b. *c.* 1285; d. 1337)

Tino di Camaino was born at Siena, probably between 1280 and 1285. His first authenticated work, the dismembered Baptismal Font made for the Duomo at Pisa (largely destroyed by fire in 1595, fragments in the Campo Santo and the Museo Nazionale, Pisa), dates from 1311. Before this time he is assumed to have been a member of the studio of Giovanni Pisano, and was perhaps employed on the Cathedral pulpit. Of the two early works with which he has been credited one, the architrave relief over the entrance of the Duomo in Siena (Carli) is a weak sculpture of uncertain authorship, while the other, the Altar of San Ranieri now in the Campo Santo at Pisa (under construction 1306, completed before 1312), is incompatible with the fragments of the Baptismal Font and with the later works but may reflect the style of Tino's father, Camaino di Crescentino (Kosegarten). In 1315 Tino di Camaino was Capomaestro of the Duomo at Pisa, and in the same year he received the commission for the monument of the Emperor Henry VII (d. 1313) of which the sarcophagus and effigy in the Cathedral certainly, and a seated figure of the Emperor with four counsellors and some subsidiary figures in the Campo Santo probably, formed part. Three years later Tino was in Siena, serving in 1319–20 as Capomaestro of the Duomo. At this time he executed the Petroni monument (see Plates 30–31 below). From 1321 till

(?) 1323 Tino di Camaino worked in Florence, executing the Della Torre monument in Santa Croce, the Orso monument in the Duomo (see Plates 32–33 below) and other works, of which the most important was a Baptism of Christ carved for the outside of the Baptistry (fragments in Museo dell' Opera del Duomo). Summoned to Naples in 1323 or 1324 probably by King Robert of Anjou to undertake the monuments of his daughter-in-law, Catherine of Austria (see Plate 34 below), in S. Lorenzo and of his mother, Mary of Hungary, in S. Maria Donna Regina, he remained there till his death in 1337, employed in the service of the Angevin court. In these years he executed the tombs of Charles of Calabria and Mary of Valois (see Plate 35 below) in S. Chiara, and was also active as an architect. Tino di Camaino appears to have been associated with the painter Pietro Lorenzetti, who became guardian of the sculptor's children after Tino's death, and with Giotto, who, from 1329 till 1333, was first court painter at Naples, and of whose studio the sculptor assumed temporary control in 1334–6.

BIBLIOGRAPHY: The standard monograph on Tino di Camaino is that of Valentiner (*Tino di Camaino: a Sienese Sculptor of the fourteenth Century*, Paris, 1935). A shorter volume by Carli (*Tino di Camaino scultore*, Florence, 1934) is of interest, as is a well-edited volume with good colour plates by M. Masciotta (*Tino di Camaino*, I maestri della scultura, No. 20, Milan, 1966). A good account of the sculptor's late style is given by Morisani (*Tino di Camaino a Napoli*, Naples, 1945). Weinberger ('The Master of San Giovanni', in *Burlington Magazine*, lxx, 1937, pp. 24–30) makes an unsuccessful attempt to assign a number of the artist's Florentine works to a hypothetical Master of San Giovanni. This case is answered by Brunetti ('Note sul soggiorno fiorentino di Tino', in *Commentari*, ii, 1952, pp. 97–107) in an article dealing primarily with the lost Baptism of Christ over the entrance to the Baptistry (from which the designation Master of San Giovanni derives). According to a later hypothesis of Valentiner ('Tino di Camaino in Florence', in *Art Quarterly*, xvii, 1954, pp. 117–32) Tino would also have been responsible in 1316–7 for executing life-size groups over the two remaining entrances. For a definitive statement of the evidence relating to this commission see L. Becherucci and G. Brunetti (*Il Museo dell' Opera del Duomo a Firenze*, i, Florence, 1969, pp. 228–30). A mistaken attempt to 'isolare l'arte di Tino nella sua grandezza, liberata dalle inutili fronde di discepoli' is made by R. Causa ('Precisazioni relative alla scultura del '300 a Napoli', in *Sculture lignee nella Campania*, Naples, 1950, pp. 63–73).

Plates 30–31: THE PETRONI MONUMENT
Duomo, Siena

In March 1317 the body of Cardinal Riccardo Petroni (who had died in Genoa three years earlier) was transferred to the Cathedral at Siena. Some payments in the first half of 1318 to Tino di Camaino and to his father Camaino di Crescentino are assumed to refer to the construction of the Cardinal's tomb. The monument was moved at the end of the fifteenth century to make way for the newly constructed Cappella di San Giovanni, was moved once more in 1664 and was again moved in 1726. In 1951 it was reconstituted in its original form (Fig. 26) with the addition of a number of figures which had been displaced, and is now the only intact tomb by Tino di Camaino in Tuscany. The monument rests on a ledge, decorated with coloured marble and supported on four consoles. Four caryatids sustain the sarcophagus, on which are reliefs of the Noli Me Tangere, the Resurrection and Christ and St. Thomas. Above, disclosed by two angels drawing curtains and accompanied by two further angels at the back, the body of the Cardinal rests on its bier, which is decorated with shields and coloured marble in conformity with the ledge below. At the top, beneath a Gothic tabernacle, are statuettes of the Virgin and Child and two Saints. The tent-like structure within which the effigy is placed appears, from a miniature in the Codex Balduini noted by Valentiner, also to have been employed in the monument of the Emperor Henry VII at Pisa, and perhaps derives in both cases from Giovanni Pisano's monument of Margaret of Luxemburg at Genoa, which may also have inspired other features of Tino's wall monuments. Valentiner draws attention to iconographical parallels between the Noli Me Tangere and Christ and St. Thomas on the sarcophagus and the corresponding scenes of Duccio's Maestà (completed 1311) and between the Resurrection and the central predella panel of the S. Croce altar-piece of Ugolino da Siena. Inferior variants of these scenes, more rigid in style and executed in shallower relief, occur on the Della Torre monument in the cloister of S. Croce, Florence.

Plates 32–33: THE ORSO MONUMENT
Duomo, Florence

The monument of Antonio Orso, Bishop of Florence (d. 1320–1), is identified as a work of Tino di Camaino by an inscription on the wall beneath the consoles, which reads:

OPERVM DE SENIS NATUS EX MAGRO CAMAINO IN HOC SITU FLORENTINO: TINUS: SCULPSIT: OE LAT. NUN. P. PATRE GENITIVO DECET INCLINARI UT MAGISTER ILLO VIVO: NOLIT: APPELLARI.

(Tino, son of Master Camaino of Siena, carved this work on every side in this site in Florence. It is fitting that he should so defer to his father as to refuse, during his lifetime, to be called Master.)

The Bishop's body was transferred to the tomb on 18 July 1321. Between 1850, when the tomb was moved, and 1905, when it was reinstalled, many of the components of the monument were lost, and today it consists of the seated figure of the Bishop above a sarcophagus, carved with a single relief showing the Bishop presented by the Virgin to Christ. Supported by three lions, this stands on an arcaded support carved with allegorical representations. After some initial confusion with the dismembered monument of Gastone della Torre, Patriarch of Aquileia, which Tino di Camaino

executed for Santa Croce at this time, it has been established by Valentiner that the following figures also originate from the Orso monument: (i) a Virgin and Child inscribed with the words SEDES SAPIENTIAE in the Museo Nazionale, Florence, (ii) two Angels drawing curtains in the Victoria and Albert Museum, London, (iii) three caryatids, one in the Liebighaus at Frankfurt-am-Main and two in the Fondazione Salvatore Romano, Florence, (iv) an adoring Angel, from the Loeser collection, in the Palazzo Vecchio, Florence, (v) a group showing Antonio Orso kneeling beside an Angel in the Liebighaus at Frankfurt-am-Main, (vi) a standing Saint formerly in the Kaiser Friedrich Museum, Berlin, and (vii) two reliefs of Angels in the Palazzo Torrigiani, Florence (for which see Brunetti, 'Two Reliefs from the Orso Monument', in *Art Quarterly*, xvii, 1954, pp. 135–38). The condition of the component pieces is unequal, and varies between the poles of (i), which is perfectly preserved, and (iii), which are much weathered. The reconstruction of the monument presents considerable difficulty, and that of Valentiner, which shows the seated figure of the Bishop between the two Angels in London, can be accepted only with reserve; it is possible that the two Angels flanked a recumbent effigy, which has now disappeared. The iconography of the monument is unorthodox, and seems to have been devised by Francesco di Barberino, the friend of Dante; the relief on the base shows a three-headed figure, variously interpreted as Death (Toesca) and the Trinity (Valentiner), aiming arrows at two lateral groups of figures. The Virgin and Child was imitated in 1329 in the Carmelite Madonna of Pietro Lorenzetti.

Plate 34: THE MONUMENT OF CATHERINE OF AUSTRIA
San Lorenzo Maggiore, Naples

In Naples Tino di Camaino was responsible for executing the sepulchral monuments of Mary of Hungary in S. Maria Donna Regina (1325), Mary of Anjou in S. Chaira (1329), Charles of Calabria in S. Chiara (1332–3), Mary of Valois in S. Chiara, and Philip of Taranto and John of Durazzo in S. Domenico Maggiore (1335?). The first evidence of his presence in Naples occurs in the will of Mary of Hungary (d. 25 March 1323) enjoining that her monument should be carried out by Tino di Camaino and the Neapolitan architect Gagliardo Primario. But there are reasons for believing that before this time Tino received a commission for the monument of Catherine of Austria, wife of Charles of Calabria (d. 15 January 1323), in S. Lorenzo Maggiore. Work on this monument was in progress in May 1323. The ascription of this monument to Tino di Camaino has been frequently contested, notably by De Rinaldis ('Una tomba napoletana del 1323', in *Dedalo*, viii, 1927–8, pp. 201–19), but is defended by Bertaux and vindicated by Carli (pp. 37–41) and Valentiner. Unlike the Petroni and Orso monuments, the tomb of Catherine of Austria is double-sided, and is enclosed by a Gothic tabernacle with four finials supported on spiral columns. The architecture of the monument is Neapolitan, and is certainly due to an Angevin architect, perhaps Gagliardo Primario. It has been suggested (Morisani) that it was planned and work on it had been begun before Tino di Camaino received the commission for the figure sculpture. One of the arches is filled by a carved lunette showing on one side the Stigmatization of St. Francis and on the other Catherine of Austria presented by a Saint to Christ. The first of the two reliefs is notable for its shallow cutting and for the extensive landscape in which the scene is set. Beneath the tabernacle the sarcophagus rests on two double-sided supports, one with a figure of Hope and the other representing Charity. In these supports the figures are surrounded by foliage, in one case acanthus and in the other oak and laurel. Though the linear treatment of the figures looks back to the caryatids of the Petroni and Orso monuments, the conception of the reliefs has no true precedent in Tino's work, and apparently resulted from the action on his style of the French influences which were dominant in Naples at this time. But the form of the sarcophagus, decorated on one side with medallions of Christ, the Virgin and St. John, and on the other with medallions of SS. Francis, Dominic and Clare, is Tuscan, as are the four saints ranged at the head and feet of the sepulchral effigy. In the latter the crown, robe and cushion are elaborately incised, and were originally covered with gilding and pigmentation.

Plate 35: THE MONUMENT OF MARY OF VALOIS
Santa Chiara, Naples

Mary of Valois, second wife of Charles of Calabria, died in Naples on 15 October 1331. At this time the monument of Charles of Calabria (d. 1328) in S. Chiara was still incomplete, and work on the companion tomb of Mary of Valois (Fig. 28) may not have been begun before the completion of the Charles of Calabria monument in 1333. It is to be inferred that the tomb was still unfinished when Tino di Camaino died in 1337, since a concluding payment was made to his widow in 1339. The tombs of Mary of Hungary in S. Maria Donna Regina and of Charles of Calabria and Mary of Valois in S. Chiara differ from the Catherine of Austria monument in that they are wall monuments built inside Gothic tabernacles which cover but are not structurally related to the tomb. In both of the monuments in S. Chiara the effigy is disclosed by angels and backed by a relief with mourning figures, while above is a group of the Virgin and Child. In design the Mary of Valois tomb is closely associated with that of Charles of Calabria, save that the relief on the sarcophagus of the Charles of Calabria monument is replaced by seated frontal figures which include (centre) Mary of Valois, (extreme left) her son Carlo Martello, and (second from right) her daughter Queen Joanna I. In place of the four heavy caryatids supporting the Charles of Calabria tomb, the monument of Mary of Valois is supported by two simple caryatids representing (left) Charity and (right) Hope. In

point of quality, these figures take their place as the finest sections of the monument, and are rightly regarded by Valentiner as 'among the most beautiful of the later statues of the artist'. Tino's authorship of them is, however, dismissed by Morisani, and they are wrongly ascribed by Causa to Giovanni da Firenze.

GIOVANNI and PACIO DA FIRENZE
(active 1343–5)

The two sculptors, 'magistri Johannes et Pacius de Florentia Marmorarii fratres', are named between 1343 and 1345 in documents relating to the tomb of King Robert of Anjou in S. Chiara, Naples (see Plate 36 below). One of the two sculptors is perhaps identical with a Pacio da Firenze mentioned in a document of 1325, and their activity in Naples is thus likely to have been coterminous with that of Tino di Camaino. Their style, in so far as it can be determined from this and from two attributed works in the same church—the tomb of Louis of Durazzo (d. 1344) and the Scenes from the Legend of St. Catherine of Alexandria (see Plate 37 below) —seems to stem from that of Andrea Pisano, but is also influenced by the Neapolitan monuments of Tino di Camaino.

BIBLIOGRAPHY: The little information available on the two sculptors is assembled by Bertaux ('Magistri Johannes et Petri de Florentia Marmorarii fratres', in *Napoli Nobilissima*, iv, 1895, pp. 134–38, 147–52) and De Rinaldis (*Santa Chiara*, Naples, 1920). For the reliefs with scenes from the legend of St. Catherine of Alexandria see also Fraschetti (in *L'Arte*, i, 1898, p. 245ff.), and for an unjustifiably extensive list of works by the two sculptors, R. Causa ('Precisazioni relative alla scultura del '300 a Napoli', in *Sculture lignee nella Campania*, Naples, 1950, pp. 63–73).

Plate 36: THE MONUMENT OF KING ROBERT OF ANJOU
Santa Chiara, Naples

The partially demolished monument of King Robert of Anjou (d. 10 January 1343) was commissioned by his niece, Queen Joanna I, on 24 February 1343. Supervision of the monument was entrusted to a royal counsellor, Giacomo dei Patti, and its execution was to be undertaken by Giovanni and Pacio da Firenze. It is stipulated in the contract that the monument should be completed by the end of 1343, but on 6 October 1345 it was still unfinished. Payments to the two sculptors are recorded on 20 February and 25 July 1343. From the first of these payments it appears that other local artists were also employed. The tomb (Fig. 32) is set within a Gothic tabernacle analogous to, but more complex than, that of Tino di Camaino's monument of Mary of Hungary in S. Maria Donna Regina. The four supporting pillars are enriched with niches containing statuettes of Prophets and Saints. As in the monument of Mary of Hungary, the scheme provides for a lunette, with figures of Robert of Anjou presented by St. Francis to the Virgin and Child, St. Clare and two angels, and a lower section in which the effigy of the dead King, disclosed by two angels and watched over by the seven Liberal Arts, rests on a sarcophagus. But between the lunette and effigy a new element is introduced in the form of a statue of the King enthroned, inscribed beneath with the words:

CERNITE. ROBERTUM
VIRTUTEM. REPERTUM.

A third representation of the King appears in the centre of the Gothic arcading along the front of the sarcophagus. Also on the sarcophagus, against a background of fleurs-de-lis, are seated figures of (front, left to right) Louis, son of Robert of Anjou, (1301–10), Queen Joanna (1326–82), Queen Sancha, second wife of Robert of Anjou, (d. 1345), Queen Violante, first wife of Robert of Anjou, (d. 1302), Charles of Calabria (d. 1328), and Mary of Valois (d. 1331), second wife of Charles of Calabria and mother of Queen Joanna, (right end) Louis and Charles, sons respectively of Charles of Durazzo and Charles of Calabria, (both died in infancy), and (left end) the two daughters of Charles of Calabria. The execution of the monument is unequal, but the quality of the Virgin and Child above, the sepulchral effigy, the Liberal Arts and the sarcophagus reliefs suggests that the bulk of these were executed by the artists named in the contract for the monument. The angels drawing curtains, the effigy, and the figures on the sarcophagus are conjecturally ascribed by Causa to Pacio da Firenze. The monument was originally heavily pigmented; on the wall behind the lunette were frescoed angels, and the background of the central section was painted in imitation of mosaic. Though the tomb type to which the monument belongs continued in Naples till the early fifteenth century in works like the Minutolo monument in the Cathedral (after 1412) and the monument of King Ladislaus in S. Giovanni a Carbonara (? completed 1428), the tomb of Robert of Anjou is, by any strict qualitative standard, the last of the great Angevin sepulchral monuments.

Plate 37: SCENES FROM THE LEGEND OF ST. CATHERINE OF ALEXANDRIA
Santa Chiara, Naples

The eleven scenes from the legend of St. Catherine of Alexandria, formerly built into the Friars' Choir in the church of S. Chiara and now in large part destroyed, comprised eleven reliefs. Carved from white marble and set on a green marble ground, each scene included below a written description of the event portrayed. The present scene, which is inscribed: QUALITER PATER BEATE CATERINE SUUM CONDEBAT

ULTIMUM TESTAMENTUM and shows the father of St. Catherine dictating his last testament, is the first relief in the cycle. All of the reliefs were considerably damaged in the course of restoration in 1751–4. After an initial ascription to Tino di Camaino (Venturi), the scenes were restored by Bertaux and De Rinaldis to Giovanni and Pacio da Firenze on the strength of analogies with the sculptures of the tomb of King Robert of Anjou. The relief style throughout is strongly influenced by the bronze door of Andrea Pisano (see Plates 46–48 below), though it contains no trace of the Giottesque tendencies which are manifest in Andrea's reliefs. If we except the autograph works of Tino di Camaino, the scenes represent the highest point reached by sculpture in Naples in the fourteenth century. An attempt is made by Fraschetti and Causa to divide the scenes between an anonymous artist (I, II), a hand conjecturally identified as that of Pacio da Firenze (III, IV, V, IX, X, XI), and a hand identified as that of Giovanni da Firenze (VI, VII, VIII in part).

AGOSTINO DI GIOVANNI
(active after 1310; d. before 1347)

Agostino di Giovanni is first heard of in Siena in 1310. In the 1320's he seems to have been active, with Agnolo di Ventura (documented 1312–49), at Volterra, where the two sculptors executed a number of scenes from the lives of SS. Regolo and Ottaviano, now in the Museo dell'Opera del Duomo. Between 1329 and 1332 both sculptors were employed at Arezzo on the Tarlati Monument (see Plate 38 below). In 1337 Agostino was at Orvieto, and after this time he was responsible for the monument of Cino dei Sigibuldi (d. 1337) in the Duomo at Pistoia. Also from the thirties date two lunettes, one formerly over the doorway of the Vescovado at Volterra, and the other from the sepulchral chapel of the Petroni family (1336) now in the cloister of S. Francesco, Siena. It has also been suggested that between 1334 and 1339 he was responsible, with his son Giovanni di Agostino, for the south side of the Duomo at Grosseto. Agostino di Giovanni was resident at Siena in 1340–3. The sculptor's style can be differentiated only in the most tentative way from that of his companion. Agostino di Giovanni is the most notable of a group of Sienese sculptors among whom are to be numbered Goro di Gregorio (known through the Arca di San Cerbone of 1324 at Massa Marittima and the Tabiati Monument of 1333 in the Duomo at Messina) and Gano da Siena (known through the tombs of Tommaso d'Andrea, d. 1303, and Ranieri del Porrina at Casole d'Elsa).

BIBLIOGRAPHY: The available material on Agostino di Giovanni and Agnolo di Ventura was first assembled in a pioneer article by Cohn-Goerke ('Scultori senesi del Trecento', in *Rivista d'Arte*, xx, 1938, pp. 242–89). Good accounts of Agostino di Giovanni's work are supplied by E. Carli (in *Dizionario Biografico degli Italiani*, i, Rome, 1960, pp. 483–84; and *Scultura Italiana. Il Gotico*, Milan, 1967). A more ambitious and not wholly convincing survey is given by A. Garzelli (*Sculture toscane nel Dugento e nel Trecento*, Florence, 1969). A number of the attributions proposed in an interesting article by Valentiner ('Observations on Sienese and Pisan Trecento Sculpture', in *Art Bulletin*, ix, 1926, p. 187ff.) must be treated with reserve. Alone of modern scholars, D. Gioseffi (*Giotto architetto*, Milan, 1963, pp. 62–67) accepts the claim of Vasari that the reliefs on the Tarlati monument at Arezzo depend from designs by Giotto. For Goro di Gregorio and Gano da Siena see Carli (*Goro di Gregorio*, Florence, 1946, and 'Lo scultore Gano da Siena', in *Emporium*, xcv, 1942, pp. 231–47) and M. Monteverdi ('Per una definitiva attribuzione delle statue trecentesche situate sul protiro del Duomo di Cremona', in *Arte Lombarda*, i, 1955, pp. 26–31).

Plate 38: THE TARLATI MONUMENT
Duomo, Arezzo

The tomb of Guido Tarlati, Bishop of Arezzo, in the Cathedral at Arezzo (Fig. 27), is described by Vasari, who records a tradition that its design is the work of Giotto. Payments for work on the monument are recorded to Agostino di Giovanni in 1329 and 1332. It was commissioned after Tarlati's death by his brother, Pier Saccone, and when the latter was expelled from Arezzo in 1341, many of the scenes were mutilated. This mutilation is a tribute to the political importance of the monument, the lower part of which consists of sixteen narrative reliefs celebrating the rule of Tarlati in Arezzo. These open with the consecration of Tarlati as Bishop of Arezzo in 1313 by Pope Clement V, and review Tarlati's appointment as Lord of Arezzo (1321), the building of the walls of Arezzo (1319), and the coronation by Tarlati of Louis of Bavaria in Milan (1327). They include representations of Chiusi, Lucignano and other localities subordinated to Arezzo during Tarlati's rule, and reliefs symbolizing the good government of Tarlati and the evil government of his predecessors. By virtue of the latter the monument takes its place as a civil allegory beside the frescoes of Good and Evil Government of Ambrogio Lorenzetti at Siena. The monument was transferred in 1783 from its original position in the Cappella del Sacramento to a site near the door of the sacristy of the Cathedral. A number of the reliefs seem to have been executed by Agnolo di Ventura. In the central section of the monument is the effigy of the Bishop, disclosed by two angels and accompanied to left and right by lamenting figures. The latter, in view partly of their larger scale, are sculpturally the most interesting feature of the monument, and their flat, linear style presents analogies to the Neapolitan reliefs of Tino di Camaino.

GIOVANNI DI AGOSTINO
(b. *c.* 1311; d. after 1347)

Giovanni di Agostino, the son of Agostino di Giovanni, was associated with his father in 1332–3 in work in the Pieve at Arezzo, and two years later was engaged in constructing a chapel in Arezzo Cathedral. In 1336, and from 1340 till 1345, he was Capomaestro of the Duomo at Siena, and in 1337 he is mentioned as Capomaestro at Orvieto. Giovanni di Agostino's principal works are the Baptismal Font in S. Maria della Pieve at Arezzo (see Plate 39 below), some sculptures in the Tarlati Chapel of the Duomo at Arezzo (associable with the commission of 1335), and a group of works undertaken while Capomaestro of the Cathedral at Siena, notably a Christ enthroned with Angels and a Virgin and Child on the Duomo Nuovo. A small signed relief of the Virgin and Child with two Angels in the Oratory of S. Bernardino, Siena, probably dates from this time. A more refined artist than his father, Giovanni di Agostino is, after Tino di Camaino, the most important Sienese sculptor of the first half of the fourteenth century.

BIBLIOGRAPHY: Giovanni di Agostino's activity is reviewed in a comprehensive article by Cohn-Goerke ('Giovanni d'Agostino', in *Burlington Magazine*, lxxv, 1939, pp. 180–94)

and by A. Garzelli (*Sculture toscane nel Dugento e nel Trecento*, Florence, 1969). Some additional material is published by Carli (*Sculture del Duomo di Siena*, Turin, 1941, and 'Sculture inedite di Giovanni d'Agostino', in *Bollettino d'Arte*, xxxiii, 1948, pp. 129–42).

Plate 39: BAPTISMAL FONT
Santa Maria della Pieve, Arezzo

The hexagonal baptismal font in the Pieve at Arezzo contains three figurated reliefs with scenes from the life of St. John the Baptist. These represent (i) the Angel appearing to St. John the Baptist in the Wilderness (Plate 39), (ii) St. John the Baptist preaching, and (iii) the Baptism of Christ. All three reliefs are related in style to the Tarlati monument reliefs of Agostino di Giovanni and Agnolo di Ventura, but the conception throughout is softer and more lyrical, and looks forward to that of the mature works of Giovanni di Agostino. The date of execution is tentatively referred by Cohn-Goerke to 1332–3, when Giovanni di Agostino was employed in S. Maria della Pieve, and by Garzelli to 1330–2.

LORENZO MAITANI
(b. *c.* 1270; d. 1330)

Maitani is mentioned for the first time in Siena in the Catasto of 1290, and is assumed to have been born about 1270. In the first decade of the fourteenth century he was employed on work on the Duomo at Siena, and in 1310 became 'universalis caput magister' of the Cathedral at Orvieto, whither he had been summoned from Siena about 1308 in connection with the strengthening of the transept and apse of the church. The terms of Maitani's appointment testify to his celebrity as an architect at this time. Until his death in June 1330 he retained his appointment at Orvieto, though his residence there was interrupted by work at Perugia in connection with construction of aqueducts (1317 and 1319–21), at Siena (1322), where he was involved in a consultative capacity on the project for the Duomo Nuovo, at Montefalco (1323) and at Castiglione del Lago (1325). The main architectural monument of Maitani is the façade of Orvieto Cathedral. The reconstruction of Maitani's sculptural activity is largely conjectural, and the only work for which he can be proved from documents to have been responsible is the bronze Symbol of St. John the Evangelist on the Duomo at Orvieto. But there are good, though far from overwhelming, reasons for ascribing to him the works enumerated below.

BIBLIOGRAPHY: The best available photographs (in some cases retouched) of the sculptures ascribed to Maitani are found in Carli's *Le Sculture del Duomo di Orvieto*, Bergamo, 1947. Some of the conclusions in this volume are, however, questionable. In a subsequent volume (*Il Duomo di Orvieto*, Rome, 1965) the same writer's conclusions are somewhat modified. Francovich ('Lorenzo Maitani scultore e i bassorilievi della facciata del duomo di Orvieto', in *Bollettino d'Arte*, vii, 1927–8, pp. 339–72) provides a detailed analysis of the style of the sculptures. Weinberger (review of Carli's volume in *Art Bulletin*, xxxiv, 1952, pp. 60–63) contests the relationship between the façade reliefs postulated by Francovich and dissociates them from Maitani, advancing the theory that they are by the same hand as a wooden Virgin and Child in the Museo dell'Opera at Duomo at Orvieto, presumed to be the work of Ramo di Paganello. Other contributions to the problem of the sculptures, in part of a controversial character are those of Schmarsow ('Das Fassadenproblem am Dom von Orvieto', in *Repertorium für Kunstwissenschaft*, 1926, pp. 119–44), Valentiner ('Observations on Sienese and Pisan Trecento Sculpture', in *Art Bulletin*, ix, 1927, pp. 178–87), and Cellini ('Appunti orvietani: ii, Per Lorenzo Maitani e

Nicola di Nuto', in *Rivista d'Arte*, xxxi, 1939, pp. 229–44). The documents relating to the façade are printed by Fumi (*Il duomo d'Orvieto e i suoi restauri*, Rome, 1891). A claim of Cellini ('Appunti Orvietani, III, Fra Bevignate e le origini del Duomo di Orvieto', in *Paragone*, No. 99, 1958, pp. 3–16) that the architecture of the façade was determined before Maitani's arrival at Orvieto, and that this and sections of the façade reliefs are due to Fra Bevignate is effectively disposed of by R. Bonelli ('Bevignate architetto o amministratore?' in *Critica d'Arte*, No. 28, 1958, pp. 329–32; and *Il Duomo di Orvieto e l'architettura italiana del Duecento-Trecento*, Città di Castello, 1952). Bonelli's conclusions are in substantial agreement with an exemplary analysis of the documents and façade reliefs by J. White ('The Reliefs on the Façade of the Duomo at Orvieto', in *Journal of the Warburg and Courtauld Institutes*, xxii, 1959, pp. 254–302). On the iconography of the second pier of the façade see A. Nava ('L'Albero di Jesse nella cattedrale di Orvieto e la pittura bizantina', in *Rivista del R. Istituto d'Archaeologia e Storia dell'Arte*, v, 1936) and A. Watson ('The Imagery of the Tree of Jesse on the West Front of Orvieto Cathedral', in *Fritz Saxl. A volume of memorial essays*, London, 1957); and on peripheral aspects of the Orvieto sculptures A. Kosegarten ('Einige Sienesische Darstellungen der Muttergottes aus dem frühen Trecento', in *Jahrbuch der Berliner Museen*, n.f. viii, 1966, pp. 96–118; and 'Ein Relief aus der Orvietaner Dombauhütte in London', in *Kunstgeschichtliche Studien für K. Bauch*, Munich, 1967). An attempt is made by A. Garzelli (*Sculture toscane nel Dugento e nel Trecento*, Florence, 1969, p. 205ff.) to ascribe to Maitani the monument of Pope Benedict XI in S. Domenico, Perugia, and the portal of the Palazzo dei Priori at Perugia (begun 1319).

Plates 40–45: RELIEFS AND LUNETTE
Duomo, Orvieto

The foundation stone of the Duomo at Orvieto was laid by Pope Nicholas IV on 15 October 1290. In May 1293 the Sienese sculptor Ramo di Paganello was associated with work on the Cathedral, and in October 1295 Fra Bevignate (whose name occurs again in connection with the Fontana Maggiore at Perugia) was confirmed as Operaio 'sicut fuit antea'. In the first decade of the fourteenth century doubts were expressed as to the structural solidity of the building, and to allay these Maitani, about 1308, was summoned from Siena. The present façade of the building (Fig. 30), of which the lower section is Maitani's, is generally supposed to date from after Maitani's appointment as Capomaestro in 1310, though the view has been advanced by Schmarsow, Cellini, Carli and Weinberger that some of the sculptures on it were completed before this time. The principal sculptural decoration of the façade comprises (i) a lunette over the central doorway (Fig. 31), in which six bronze angels draw back a curtain to reveal a marble group of the Virgin and Child, (ii) four bronze Symbols of the Evangelists, set on the level of the lunette and flanking the outer doorways, and (iii) four

carved pilasters below (Figs. 33–36). The Symbol of St. John was cast under the supervision of Lorenzo Maitani. Since the four Symbols of the Evangelists and the lunette are almost certainly by a single artist, it is highly probable that Maitani was responsible for all these works. A number of other artists are mentioned in connection with the lunette, among them Niccolò di Nuto (to whom Valentiner ascribes all of the sculptures on the façade), but these seem to have played a secondary role. The marble reliefs which flank the lateral doorways show (A) Genesis scenes, running from the Creation of the World (bottom left corner) to the Descendants of Cain (top right corner), (B) the Tree of Jesse and the Prophecies of the Redemption, (C) the Narrative of the Redemption, prefaced by reliefs of Prophets (below) and running from the Annunciation (third from bottom left) to the Noli Me Tangere (top right corner), and (D) the Last Judgment and Paradise. The two inner reliefs (B and C) differ in style from those outside (A and D). It is argued with considerable force by Francovich that A and D are so closely related to the Symbols of the Evangelists and the lunette as almost certainly to have been designed by Maitani; and there is a consensus of opinion in favour of this view. There is no general agreement on B and C, which are assumed by Carli and Weinberger to precede A and D and to have formed the models from which Maitani's reliefs derive. The case in favour of this thesis, and of an ascription to Ramo di Paganello is not a strong one, and probability favours the contention of Francovich that all four reliefs were produced under the supervision of a single artist. Incontrovertible arguments for this conclusion are presented by White, who infers, from the uniformly unfinished state of the reliefs on all four piers, that work on them proceeded simultaneously as part of a single sculptural campaign, and that their state results from an unexpected cessation of work for causes which can no longer be ascertained. In (A) the three lowest registers are completed, and the figures above are unfinished; (B) is in the same condition; in (C) the first four registers and part of the fifth have been completed; and in (D) the completed area extends only to the two lowest registers. Francovich distributes the reliefs between Maitani (who was almost certainly responsible for the lower sections of A and D) and four assistants (of whom the most notable is the sculptor responsible for the Annunciation, Visitation and other scenes in the lower part of C). This thesis is of doubtful validity, and it is demonstrated by White that a number of sculptors worked on details of each relief, and that, e.g., the two flying angels in the relief of the Creation of Eve (Plate 44) are the work of either three or four hands. The scene of the Visitation recalls the corresponding scene on the Pisa pulpit of Giovanni Pisano. No date can be established for the reliefs, other than that these were executed between 1310 and 1330, when on Maitani's death control of the work was assumed by his sons, Nicola and Vitale, and by Meo da Orvieto. The role played by sculpture on Maitani's façade at Orvieto is strikingly different from that played by the sculpture on Giovanni Pisano's façade at Siena. In detail the treatment of the human figure in (B) and (C) owes an appreciable debt to Giovanni Pisano's pulpit reliefs.

ANDREA PISANO
(b. *c.* 1290; d. 1348?)

Andrea da Pontedera, known as Andrea Pisano, was the son of a notary, Ser Ugolino Nini, and appears to have been born at Pontedera about 1290–5. The name of his father occurs in connection with the Opera del Duomo at Pisa in 1285, 1302 and 1320. Nothing is known of his activity before 1330, when he began work on the bronze door of the Baptistry at Florence (see Plates 46–48 below), but he is presumed to have been trained as a goldsmith, either in Pisa, Pistoia, or Florence. In 1334, two years before completing the bronze door (1336), he was engaged to prepare a seal for the Arte dei Baldrigai. Prior to 1330 Andrea Pisano may have been in contact with the studio of Maitani at Orvieto, but there is no documentary evidence of this. In 1340 he was Capomaestro of the Opera del Duomo in Florence, and in May 1347 Capomaestro at Orvieto. If, as is sometimes supposed, he left Florence in 1343, he may have been active in Pisa between this date and 1347. The last documentary reference to his activity dates from 26 April 1348, and he is presumed to have died before 19 July of the following year, when he had already been succeeded as Capomaestro at Orvieto by his son, Nino Pisano. It is, however, stated by Vasari that Andrea Pisano was buried in Florence, and a case has been advanced (Becherucci) for supposing that in 1348 he left Orvieto and returned to Florence, resuming work on the sculptures for the Campanile and dying there about 1350. At Orvieto Andrea's only documented work is a marble Maesta formerly over the Porta di Postierla of the Cathedral, installed in 1348, from which the Virgin and Child and two headless angels are in the Museo dell'Opera del Duomo at Orvieto. Though now widely accepted, the attribution of this figure to Andrea Pisano presents considerable difficulty, and probability favours the earlier theory that it was carved in the workshop of Andrea by his son, Nino Pisano. The name of Andrea Pisano is associated almost exclusively with two monuments, the bronze door of the Baptistry and the reliefs and statues on the Campanile at Florence (see Plates 46–48 and 49–51 below).

BIBLIOGRAPHY: A well-illustrated volume by I. Toesca (*Andrea e Nino Pisani*, Florence, 1950) touches on some of the main problems presented by the artist's style, but is unduly restrictive and, in the field of attribution, theoretical. It should be read in conjunction with reviews by E. Castelnuovo (in *Paragone*, No. 29, 1952, pp. 62–64) and M. Weinberger (in *Art Bulletin*, xxxv, 1953, pp. 243–48), and with the literature listed below. General accounts of Andrea Pisano's career and style are given by J. Lanyi (in Thieme *Künstlerlexikon*), J. Pope-Hennessy (in *Enciclopedia Universale dell'Arte*, i, Rome-Venice, 1959, c. 383–87), and E. Castelnuovo (in *Dizionario Biografico degli Italiani*, iii, Rome, 1961, pp. 115–21). Of fundamental importance for the study of the bronze door are Falk's *Studien zu Andrea Pisano* (Hamburg, 1940), and an article in English (Falk and Lanyi, 'The Genesis of Andrea Pisano's Bronze Doors', in *Art Bulletin*, xxv, 1943, pp. 132–53) covering part of the same ground as this book. Further suggestions are contained in M. Wundram ('Stileinheit und künstlerische Entwicklung in der Bronzetür Andrea Pisanos', in *Kunstchronik*, xxi, 1968, pp. 373–77). Valentiner ('Andrea Pisano as a Marble Sculptor', in *Art Quarterly*, 1947, pp. 163–84) offers some acute observations on the Campanile statuary, for which the fundamental source is a first-rate analysis by L. Becherucci (in *Il Museo dell'Opera del Duomo a Firenze*, i, Florence, 1969, pp. 232–39). Some interesting observations on the Campanile reliefs and other material are offered by M. Wundram ('Toskanische Plastik von 1250–1400', in *Zeitschrift für Kunstgeschichte*, xxi, 1958, p. 263ff.). For the activity of Andrea Pisano at Pisa after 1343 see L. Becherucci ('La bottega pisana di Andrea da Pontedera', in *Mitteilungen des Kunsthistorischen Institutes in Florenz*, ix, 1965, pp. 226–62).

Plates 46–48: BRONZE DOOR
Baptistry, Florence

The proposal to supply the Baptistry at Florence with bronze doors is heard of for the first time in 1322. Provision seems to have been made initially for wooden doors covered in gilded metal and not for doors of solid bronze. These are referred to in a document of 19 November 1322 (for which see L. Becherucci and G. Brunetti, *Il Museo dell'Opera del Duomo a Firenze*, i, Florence, 1969, p. 21) recording that 'le porte di S. Giovanni si cuoprino di rame dorate o di metallo. Maestro Tino Camaini da Siena si conduca a lavorare nell'Opera di S. Giovanni nei lavori da farsi quasi come parra a consoli e offiziali' (the doors of S. Giovanni be covered with gilded copper or metal. Master Tino di Camaino of Siena agrees to work in the Opera of S. Giovanni on making them as shall appear fit to the Consoli and officers). This proposal was not proceeded with. Seven years later, in 1329, it was once more agreed that bronze doors should be provided for the Baptistry, and a representative of the Arte di Calimala was instructed to travel first to Pisa, to study and make drawings of the bronze doors of the Cathedral, and then to Venice, to search for a master to undertake the work. In the middle of January 1330 we hear of the preparation of wooden doors (perhaps wooden models for the frames), and from later in the same month dates our first reference to Andrea Pisano as 'maestro delle porte'. By 2 April the entire door was modelled in wax; in view of the short time interval this document probably refers to the framing of the door and not to the narrative reliefs. In 1331 mention is made of two goldsmiths assisting Andrea Pisano, Lippo Dini and Piero di Donato, and in April 1332 we encounter the name of a Venetian, Maestro Lionardo d'Avanzo, employed to cast the door. The first wing was finished by the end of 1332, and the second was gilded

between July and December 1333. In August 1335 Andrea Pisano was instructed to remedy certain flaws in the casting or alignment of the doors, in June 1336 they were weighed, and shortly after they were put in place in the south doorway of the Baptistry. The casting and setting up of the door was an event of great importance, and is mentioned in a number of chronicles, notably the *Chronica* of Giovanni Villani (ed. Giunti, 1587, Lib. X, c. 178, p. 641), who writes: 'Nel detto anno 1330, si cominciarono a far le porte di metallo di S. Giovanni molto belle, e di maravigliosa opera, e costo; e furono formate in terra e poi pulite, e dorate le figure per un maestro Andrea pisano, gittate furono a fuoco di fornelle per maestri Veneziani; e noi autore per l'arte di mercatanti di Calimala guardiani dell'opera di S. Giovanni fui ufficiale a far fare il detto lavorio.' ('In this year 1330, work was begun on the metal doors of San Giovanni. These are very beautiful and of marvellous workmanship and value; and they were moulded in clay and then polished, and the figures gilded by a master named Andrea Pisano. They were cast in fire of furnaces by Venetian masters; and we the author, on behalf of the Guild of Merchants of the Calimala, guardians of the Opera of San Giovanni, were the official who commissioned the said work'). The bronze door (Fig. 39) is dated 1330 and inscribed with the name of the sculptor:

ANDREAS : UGOLINI : NINI : DE : PISIS : ME : FECIT

A : D : M : CCC : XXX.

The door was cast not, like the caryatids of the Fontana Maggiore at Perugia and the bronze doors of Ghiberti, by the *cire perdue* method, but on another system. The reliefs were cast separately and later inserted in the frame. The gold, of which there is documentary evidence, was uncovered in the course of cleaning in 1945–6; all of the figures are gilded, and much of the colouristic interest of the reliefs derives from the contrast between the raised gilt surfaces and the flat bronze ground. The reference in the document of 1329 to the bronze doors at Pisa is no doubt to the Porta Regia of the Cathedral, completed by Bonanno in 1180 and destroyed in the fire of 1595. A basis for comparison is, however, offered by the Porta di San Ranieri, also by Bonanno, and it is clear that this materially influenced the form of Andrea Pisano's door. Each wing of the Bonanno doorway contains ten rectangular narrative reliefs arranged in pairs with, at top and bottom, oblong reliefs equal in width to two of the narrative reliefs above. In Andrea Pisano's scheme the oblong reliefs have been eliminated, and each wing contains fourteen rectangular relief fields. In the framing, at the corners of the relief fields, are gilded lions' heads, to a total of twenty-four on each wing, which replace the rosettes decorating the frames of the reliefs of Bonanno. These heads, and the gilded studs which intervene between them, give the scheme a unity over and above that imposed by the homogeneity of the relief style. In each wing the ten upper reliefs show scenes from the Life of St. John Baptist and the four lower reliefs figures of Virtues. The narrative reliefs read downwards from the top across each wing, beginning in the upper left corner of the left wing with the Annunciation to Zacharias,

and concluding in the third field from the bottom on the right of the right wing with the Burial of the Baptist. These scenes, in which the figures are accompanied by a summarily indicated architectural or naturalistic setting and stand on a projecting stage, reveal Andrea Pisano as a narrative artist of the utmost concentration and expressiveness. A contrast is drawn by M. Wundram ('Stileinheit und künstlerische Entwicklung in der Bronzetür Andrea Pisanos', in *Kunstchronik*, xxi, 1968, pp. 375–77) between the spatial construction and figurative character of the reliefs on the right and left wings of the door, those on the right wing being conjecturally earlier than those on the left. It is also suggested by Wundram that the most archaic of the scenes, that with the Birth of the Baptist, may have originated as a trial relief and thus antedates the remainder of the series. The iconography of a number of the scenes is influenced by that of the mosaic scenes from the Life of St. John Baptist within the Baptistry, and the compositions of the Naming of the Baptist and the Banquet of Herod incorporate features from Giotto's frescoes in the Peruzzi Chapel in Santa Croce. Within each rectangle the scene or figure is contained in a quadrilobe medallion and the decorative effect of the two wings is produced, in large part, by the opposition between these Gothic forms and the rectangles in which they are set. It has been argued (M. Weinberger, in *Art Bulletin*, xxxv, 1953, pp. 243–48) that the primary source of the relief style is the French Gothic box relief as it appears about the middle of the thirteenth century on the transept façade of Notre Dame, and conversely (M. Wundram, 'Studien zur künstlerischen Herkunft Andrea Pisanos', in *Mitteilungen des Kunsthistorischen Institutes in Florenz*, viii, 1959, pp. 199–222) that Andrea Pisano was trained in the workshop of a Tuscan goldsmith, perhaps that of Andrea di Jacopo d'Ognabene at Pistoia and that the supposed French influences are less important than his contacts with Sienese sculpture and painting. The part played by French influences in determining the style of the bronze door is not open to serious doubt, but Andrea Pisano's debt is likely to have been to French Gothic metalwork rather than to monumental sculpture. Over and above those scenes whose iconography can be related to works by Giotto, Giotto's style demonstrably exercised a profound influence on the spatial concepts and figurative language of Andrea Pisano's reliefs.

Plate 49: STATUARY
Museo dell'Opera del Duomo, Florence

After the death of Giotto in 1337, his scheme for the upper part of the Campanile (Fig. 38) was modified by Andrea Pisano, notably by the addition, above the two cycles of reliefs, of niches, four on each face, designed to contain statuary. In a relatively short space of time eight niches, those on the West and South faces, appear to have been filled with statues. The statues of the West face were subsequently (1464) moved to niches on the North face. The eight statues are now in the Museo dell'Opera del Duomo. These represent (i) Solomon, (ii) David, (iii) the Eritrean Sibyl, (iv) the Tiburtine Sibyl, (v)–(viii) four Prophets. The name of Andrea

Pisano comes into question only for the execution of figures (i)–(iv), and even with these there is no consensus of opinion as to authorship. The two poles of criticism are represented by Valentiner, who ascribes all four figures to Andrea, and I. Toesca, who denies Andrea's authorship of any of the statues. This wide diversity of view is due at root to the lack of any authenticated sculptures by Andrea on a comparable scale, since the only marble sculptures which conform exactly to the style of the bronze door and for which Andrea's name is generally accepted on this account, two statuettes of Christ and S. Reparata in the Museo dell'Opera del Duomo, are higher in quality, better preserved, and smaller in size. The heads of the Solomon and David are, however, intimately related to that of Herod in the Banquet of Herod on the bronze door. Of the Prophets (v)–(viii) one is close to Andrea, one less close, and two are by an independent hand. Three of the figures are, however, credited to Andrea Pisano by L. Becherucci (*Il Museo dell'Opera del Duomo a Firenze*, i, Florence, 1969, pp. 241–45), by whom it is argued, possibly correctly, that the decoration of the Campanile was not prosecuted horizontally, but that the entire south face (including the related reliefs and the figures of Prophets) was treated as a unity, and that the statues may therefore have been produced after Andrea's conjectured return to Florence from Orvieto in 1348. The question of whether or not any of the figures are autograph works by Andrea is to some extent an academic one, since there can be no reasonable doubt that all eight statues were carved from Andrea's designs, and their main interest rests in the new conception of the relation between figure and niche embodied in them; as they are now shown in the Museo dell'Opera del Duomo, deprived of their architectural frames, they lose much of their interest and character. While the basis of attribution remains conjectural, Valentiner's assessment of the aesthetic quality of the figures is more convincing than that of I. Toesca, and there is a probability that the Giottesque Sibyls and the Solomon and David were carved by Andrea Pisano.

Plates 50–51: RELIEFS
Museo dell'Opera del Duomo, Florence

In 1334 the painter Giotto was appointed principal architect of the Duomo in Florence, and between this date and his death in 1337 he designed and supervised the building of the lower part of the Campanile (Fig. 38) beside the Cathedral. Work on the Campanile was continued after Giotto's death by Andrea Pisano, and was completed two decades later by Francesco Talenti. The scheme designed by Giotto for the lower section of the Campanile provided for two rows of reliefs, those below contained in hexagonal, and those above in rhomboid frames. The programme of the reliefs as they were eventually executed comprises (above) representations of the seven Planets, seven Virtues, seven Sacraments, and seven Liberal Arts, and (below) representations of scenes from Genesis, and of practitioners of the arts, sciences and works of man. The reliefs in the bottom register (which suffered serious deterioration in the nineteenth century and are now shown in the Museo dell'Opera del Duomo, being replaced with copies on the Campanile), were arranged in the following sequence: West Front, Creation of Adam, Creation of Eve, the Labours of Adam and Eve, Jabal, Jubal, Tubalcain and Noah; South Front, Gionitus, Building, Medicine, Hunting, Spinning, Legislation and Daedalus; East Front, Navigation, Hercules and Cacus, Agriculture, Art of the Theatre and Architecture; North Front, Phidias (Sculpture) and Apelles (Painting). The best iconographical analyses are those of Schlosser and Becherucci. The reliefs illustrate a scholastic programme, divided into the categories of Necessitas, Virtus and Sapientia. The reliefs on the North Front were later completed by Luca della Robbia. Unlike the bronze door, the reliefs are not documented, and there is considerable divergence of view as to their attribution. There is a persistent tradition that some at least of the lower reliefs were carved by Giotto. The earliest reference to these occurs in the *Centiloquio* of Antonio Pucci (Canto lxxix, l. 81ff.):

> Nell'anno, a' di diciennove di luglio
> De la chiesa maggiore il campanile
> Fondato fu, rompendo ogni cespuglio,
> Per mastro Giotto, dipintor sottile,
> Il qual condusse tanto il lavorio
> Ch'e primi intagli fe' con bello stile.

(In this year, on 19 July, the Campanile of the Cathedral was founded by Master Giotto, the subtle painter, who carried the work so far that he made the first reliefs with beautiful style.)

Ghiberti in the *Commentari* (ed. Schlosser, p. 37) also records that Giotto 'fu dignissimo in tutta l'arte, ancora nella arte statuaria. Le prime storie sono nello edificio il quale da lui fu edificato, del campanile di Sancta Reparata, furono di sua mano scolpite et disegnate' (was most worthy in everything pertaining to art, even in the art of sculpture. The first narrative reliefs which are in the building he constructed, the campanile of Santa Reparata, were carved and designed by his hand). In a later passage (ed. cit., p. 43) Ghiberti credits Andrea Pisano with the reliefs above. It is generally agreed from analysis of the style of the reliefs, first that Andrea Pisano did not intervene personally in the upper series, though some of these must have been executed while he was Capomaestro, and secondly that the bulk of the twenty-one reliefs below are due not to Giotto but to Andrea Pisano. The three Genesis scenes, with the Creation of Adam, the Creation of Eve and the Labours of Adam and Eve, are wholly homogeneous and there can be no reasonable doubt that Andrea Pisano was responsible for the design and execution of these scenes. Others of the reliefs are less Gothic in style, and, as noted in Toesca's excellent analysis (in *Il Trecento*, 1951, pp. 313–20), for these Giotto may have prepared, or intervened in, the designs. Thus the seated figure of the Sculptor is characteristic of Andrea Pisano's style as we encounter it in the bronze door, whereas the seated figure of Tubalcain the Smith may well have been devised by Giotto. In the case of the reliefs of Jabel, Jubal, Rowing and Ploughing, Giotto may also have supplied cartoons. It must, however, be emphasized that the reliefs

are not decorative adjuncts to the structure of the Campanile, but, with their complex and elevated programme, form an integral part of Giotto's architectural conception. There is indeed evidence (Gnudi, in *L'Europe Gothique, XIIe.–XIVe. siècle*, Paris, 1968, pp. 79–80) that one of the reliefs on the West Front, the Tubalcain, was inserted into the surrounding marble at the time of the construction of this part of the Campanile, and thus indubitably dates from the lifetime of Giotto, and specifically from 1334–7. The quality of the reliefs is very variable, and it has been inferred that they may have been undertaken by Andrea Pisano in two campaigns, one terminating in 1343 and the other begun in 1348. This is conjectural. The proportions of the figures in the Genesis scenes are somewhat different from and more attenuated than those in the other carvings, and may, though this is by no means certain, reflect the idiom of the façade reliefs at Orvieto. In the present state of the carvings it is difficult to determine which should be regarded as autograph, but from a figurative standpoint some of them (e.g. the Noah, Gionitus, and Art of Building) are manifestly of lower quality than the rest. If the reliefs were begun concurrently with the construction of the Campanile in 1334, and constituted a major civic commission, it is highly unlikely that Giotto's was not, in a broad sense, the designing mind, and the gravity of intention which is so marked a feature of the reliefs now that they can be studied at close quarters in the Museo dell'Opera del Duomo, would be inexplicable if this were not the case. Many of the reliefs show traces of priming, and it is probable that the backgrounds were originally covered in blue paint.

NINO PISANO
(b. *c.* 1315; d. 1368?)

Nino Pisano, son of Andrea, is assumed to have been born about 1315. He is mentioned for the first time in October 1349 at Orvieto, in a document which suggests that he had been Capomaestro of the Duomo since 19 July of this year. Two payments of November 1349 also refer to work at Orvieto. Before March 1353 Nino Pisano had been succeeded as Capomaestro by Matteo di Ugolino. In 1357 and 1358 he was active at Pisa as a silversmith, engaged, in the latter year, on an antependium for the Cathedral. On 5 December 1368 payment was made to Nino's son, Andrea, for a monument to Giovanni d'Agnello (lost), and the sculptor's death must have occurred before this time. None of the documents referring to Nino Pisano can be related to a surviving work, and the basis for the reconstruction of his style is afforded by two signed Madonnas in S. Maria Novella, Florence (see Plate 54 below) and on the Cornaro monument in SS. Giovanni e Paolo, Venice (see Plate 52 below) and a figure of an Episcopal Saint in S. Francesco at Oristano (Sardinia). There is no unanimity of view as to Nino Pisano's chronology or as to the authorship of certain unsigned works. The most important of the disputed attributions are those of the tomb of Simone Saltarelli (d. 1342) in S. Caterina at Pisa (probably commissioned from Andrea Pisano and executed in the workshop of this sculptor), a Virgin and Child in the Museo dell'Opera del Duomo at Orvieto (executed in the workshop of Andrea Pisano, perhaps by Nino), and a Virgin and Child with SS. John Baptist and Peter formerly on the altar of S. Maria della Spina, now in the Museo Nazionale, Pisa (by Nino), all of which have received alternative attributions to Andrea Pisano. Other works associable with Nino Pisano and his workshop are a figure of St. Margaret in S. Margherita at Montefiascone, a seated figure of the Redeemer at a lunette over the entrance to the Cappella del Corporale in the Duomo at Orvieto, an unfinished figure of Fortitude in the Museo dell'Opera del Duomo at Orvieto, and the Scherlatti (d. 1363) monument in the Campo Santo at Pisa.

BIBLIOGRAPHY: The principal works ascribed to Nino Pisano are illustrated by I. Toesca (*Andrea e Nino Pisani*, Florence, 1950). An analysis of Nino's style is provided in a suggestive but unduly restrictive and in part mistaken article by Weinberger ('Nino Pisano', in *Art Bulletin*, xix, 1937, pp. 58–91); this is supplemented by a review by Weinberger of I. Toesca's monograph (in *Art Bulletin*, xxxv, 1953, pp. 243–48). For the attribution to Andrea Pisano of the works at Orvieto and in S. Maria della Spina and S. Caterina at Pisa see Lanyi ('L'ultima opera di Andrea Pisano', in *L'Arte*, n.s., iv, 1933, pp. 204–27), Valentiner ('Andrea Pisano as a Marble Sculptor', in *Art Quarterly*, x, 1947, pp. 163–87), Cellini ('Appunti orvietani per Andrea e Nino Pisano', in *Rivista d'Arte*, 1933, pp. 1–15) and Becherucci ('An Exhibition of Pisan Trecento Sculpture', in *Burlington Magazine*, lxxxix, 1947, pp. 68–70; and 'La bottega pisana di Andrea da Pontedera', in *Mitteilungen des Kunsthistorischen Institutes in Florenz*, ix, 1965, pp. 226–62). A number of valid attributions to the workshop of Nino Pisano are made by A. Kosegarten ('Aus dem Umkreis Nino Pisanos', in *Pantheon*, xxv, 1967, pp. 235–49). For the Annunciation in S. Caterina at Pisa see also M. Wundram ('Toskanische Plastik von 1250–1400', in *Zeitschrift für Kunstgeschichte*, xxi, 1958, p. 266), and for Nino Pisano's relations with France M. Weinberger ('Remarks on the Role of French Models within the Evolution of Gothic Tuscan Sculpture', in *Studies in Western Art. Acts of the XXth International Congress of the History of Art*, i, Princeton, 1963, pp. 198–206). The signed statue of an Episcopal Saint in S. Francesco at Oristano is discussed by C. Maltese (*Arte in Sardegna dal V al XVIII*, Rome, 1962, pp. 221f.). The celebrated Madonna in the Santuario dell'Annunziata at Trapani is republished as a work of Nino Pisano by S. Bottari ('Una scultura di Nino Pisano a Trapani', in *Studi in onore di M. Marangoni*, Florence, 1957, pp. 164–66). A seated figure of the Saviour holding a Chalice in the lunette over the entrance to the Cappella del Corporale in the Duomo at Orvieto is given

by Kosegarten (loc. cit.) to the workshop of Nino and by Carli (*Il Duomo di Orvieto*, Rome, 1965, pp. 66f.) to Nino Pisano. For the wooden Annunciation groups by or from the circle of Nino Pisano see especially E. Carli (*La Scultura lignea italiana*, Milan, 1960, pp. 55ff.) and J. Pope-Hennessy and R. Lightbown (*Catalogue of Italian Sculpture in the Victoria and Albert Museum*, i, London, 1964, pp. 38–40).

Plate 52: THE CORNARO MONUMENT
Santi Giovanni e Paolo, Venice

The monument of Marco Cornaro in SS. Giovanni e Paolo in Venice (Fig. 41) consists of a recumbent effigy below, and separated from it, above, an arcaded tabernacle with statues of the Virgin and Child, SS. Peter and Paul and two Angels. The entire monument was associated with the studio of the Dalle Masegne until Venturi (*Storia*, iv, 1906, pp. 498–505) ascribed the five statues to Nino Pisano. The correctness of this attribution was later confirmed by an inscription on the octagonal base of the central figure. The recumbent effigy and the architecture of the upper section are Venetian, and offer an argument in favour of the view that the five figures were carved by Nino Pisano at Pisa, and not in Venice. The two angels reveal the intervention of a studio hand. The smooth, linear style of the Cornaro Madonna is closely related to that of the signed Madonna by Nino Pisano in S. Maria Novella in Florence (see Plate 54 below), and its scheme is associated by Weinberger with that of a silver-gilt statuette of the Madonna presented to Saint Denis in 1339 by Jeanne d'Evreux, now in the Louvre. Since Marco Cornaro was elected Doge in 1365 and died in 1367, it has been assumed that the five statues were executed after 1365. It cannot, however, be presumed that the statues in the arcading above it were necessarily commissioned for the tomb and not (at a somewhat earlier date) for an altar or other complex. The view that the five figures by Nino Pisano predate the commissioning of the tomb is endorsed by Becherucci and contested by Weinberger (1953). The statuary carved in the workshop of the Dalle Masegne for the Venier monument in the same church (Fig. 59) is closely based on that of the Cornaro monument.

Plate 53: MADONNA DEL LATTE
Museo Nazionale di San Matteo, Pisa

The Madonna del Latte (Fig. 40) is described by Vasari (*Vite*, ed. Milanesi, i, 1906, p. 494): 'Andato poi a Pisa, fece (Nino) nella Spina una Nostra Donna, di marmo dal mezzo in su, che allatta Gesù Cristo fanciuletto, involto di certi panni sottili; alla quale Madonna fu fatto fare da messer Iacopo Corbini un ornamento di marmo, l'anno 1522' (then, going to Pisa, Nino made in the Spina a half-length figure of Our Lady, suckling the infant Christ, wrapped in subtle draperies. A marble surround for this Madonna was commissioned by messer Jacopo Corbini in the year 1522). Since the time of Vasari this figure and the statues of the Virgin

and Child and SS. Peter and John Baptist on the altar of the Oratory have been generally accepted as works of Nino Pisano. The ascription to Nino of the Madonna del Latte is, however, rejected by Weinberger, who casts a number of unwarranted aspersions on its quality, and by Becherucci and Valentiner, who assign it, along with the Virgin and Child on the altar, to Andrea Pisano. This latter attribution is consequential on Lanyi's ascription to Andrea Pisano of a Virgin and Child with two Angels in the Museo dell'Opera del Duomo at Orvieto, previously given to Nino Pisano. The Orvieto Madonna was certainly carved about 1347–9, in the workshop of Andrea Pisano, either by Andrea or Nino Pisano, probably the latter. It can be argued that the Orvieto Madonna was carved at Pisa between 1343 and 1347 or at Orvieto about 1347–9; it finds a point of reference in two works almost certainly executed in the earlier date bracket, the Virgin and Child over the Saltarelli monument in the Campo Santo at Pisa and the standing Virgin and Child with two Saints from S. Maria della Spina. All three sculptures are likely to have been commissioned from Andrea Pisano and executed in his workshop, probably by Nino. The Madonna del Latte is associated explicitly by Gnudi (*L'Europe Gothique. XIIe.–XIVe. siècle*, Paris, 1968, No. 131, pp. 78–79), with a dating between 1343 and 1347, and implicitly by Becherucci (1965) with these works. The probability, however, is that it dates from a considerably later time, since stylistically it is inseparable from the Annunciation in S. Caterina (see Plate 55 below), which in the time of Vasari bore Nino's name and the apocryphal date 1370. There is a strong case for regarding it as one of Nino's last works.

Plate 54: VIRGIN AND CHILD
Santa Maria Novella, Florence

The signed Madonna by Nino Pisano in S. Maria Novella is listed by Vasari as the sculptor's earliest work (*Vite*, ed. Milanesi, i, 1906, p. 494): 'D'Andrea rimase Nino suo figliuolo, che attese alla scultura; ed in Santa Maria Novella di Firenze fu la sua prima opera, perche vi finì di marmo una Nostra Donna stata cominciata dal padre, la quale e dentro alla porta del fianco, al lato alla cappella de' Minerbetti' (Andrea was followed by his son Nino, who occupied himself with sculpture. His first work was undertaken for Santa Maria Novella in Florence, for there he completed the marble Virgin and Child begun by his father, which stands inside the lateral doorway, beside the Minerbetti chapel). The figure is now in the right transept of the church over the Aldobrandino Cavalcanti monument, whither it was moved in 1869. I. Toesca (p. 76) tentatively connects the commissioning of the figure with a record of the death in 1348 of a certain Fra Ugolino de' Minerbetti, who was buried near the Minerbetti altar in S. Maria Novella. This dating is accepted by Becherucci, on the basis of style not of a hypothetical connection with the death of Fra Ugolino de' Minerbetti, but is rejected by Weinberger, who assigns it to the end of the artist's career.

Plate 55: THE ANNUNCIATION
Santa Caterina, Pisa

The marble figures of the Annunciatory Angel and Virgin Annunciate in S. Caterina at Pisa are described by Vasari at the end of his life of Andrea Pisano (*Vite*, ed. Milanesi, i, 1906, pp. 494–95): 'Fece ancora Nino, per un altare di Santa Caterina pur di Pisa, due statue di marmo; cioè una Nostra Donna ed un Angelo che l'annunzia; lavorate, siccome l'altre cose sue, con tanta diligenza, che si può dire ch'elle siano le migliori che fussino fatte in que' tempi. Sotto questa Madonna Annunziata, intagliò Nino nella base queste parole: A di primo Febbraio 1370; e sotto l'Angelo: Queste figure fece Nino figliuolo d'Andrea Pisano' (then Nino made, for an altar in Santa Caterina at Pisa, two marble statues, namely a figure of Our Lady and an Annunciatory Angel, worked, like all his other sculptures, with such diligence that one can say they are the best that were made in those times. Beneath the Virgin Annunciate Nino carved on the base the words: 'The first day of February 1370,' and beneath the Angel: 'Nino son of Andrea Pisano made these figures'.) It was pointed out by Morrona (*Pisa illustrata*, Pisa, 1797, ii, p. 224)

that the inscription must be apocryphal, and by Milanesi (loc. cit.) that if the inscription on the first figure were correct, the group would have been executed two years after Nino's death. Both figures are denied to Nino by Weinberger. A direct attribution to Nino Pisano is defended by Wundram. In style the group is inseparable from the Madonna del Latte (see Plate 53 above). The Annunciation is regarded by Toesca (in *Il Trecento*, 1951, p. 328) as a late work, but is assigned by I. Toesca to the sixth decade of the century since it does not conform to the style of the supposedly later Cornaro Madonna (see Plate 52 above). The evidential value of the inscription recorded by Vasari on the base of the Annunciatory Angel is, however, greater than that of the conjectural date assigned to the Cornaro Madonna, and the date 1370 may well refer to the installation of the figure not to its execution. If this were so, it would be one of Nino's last works, executed about 1365–8. The figures retain much of their original polychromy (gold on the edging of the robes, blue inside the cloaks, colour in the eyes and on the cheeks). Features of the statues are reproduced in a number of wooden Annunciation groups, of which the most distinguished is in the Museo Nazionale at Pisa.

ANDREA ORCAGNA
(active 1343–68)

Andrea di Cione, known as Orcagna, was active in Florence in the middle of the fourteenth century as painter, sculptor and architect. Born in or after 1308, he matriculated in the Arte dei Medici, Speziali e Merciai in 1343 or 1344, and was admitted to the Guild of Stonemasons in 1352. His only authenticated painting, the altar-piece of the Strozzi Chapel in S. Maria Novella, Florence, was commissioned in 1354 and is dated 1357. In 1355 Orcagna became Capomaestro of Or San Michele. The tabernacle in Or San Michele (see Plates 56–57) below dates from after this time. In 1357 he prepared a design for the pillars of the Duomo; this was rejected in favour of a design by Talenti. In 1358 Orcagna became Capomaestro of the Duomo at Orvieto, and in 1359–60 was engaged there, in conjunction with his brother Matteo di Cione, on supervising the mosaic decoration of the façade and on structural work. In 1364–6 he was again associated with the Duomo at Florence. In August 1368 an altar-piece of St. Matthew for the Arte del Cambio (now in the Uffizi, Florence) was completed by Jacopo di Cione on account of his brother's illness, and Orcagna is assumed to have died in this year. Orcagna's development as a painter is comparatively clear, but little is known of his work as a sculptor, though in addition to the tabernacle in Or San Michele he may have designed the marble Tabernacle of the Corporal at Orvieto and a statue of St. Paul on S. Paolo at Pistoia (Toesca). In painting Orcagna's activity was closely bound up with that of his brothers Nardo and Jacopo di Cione, and in the Or San Michele tabernacle he was possibly assisted by his brother

Matteo, whom Ghiberti records as 'scultore non molto perfetto'.

BIBLIOGRAPHY: A fully documented account of Orcagna's career is provided by R. Offner (*A Critical and Historical Corpus of Florentine Painting*, Section IV, i, New York, 1962, pp. 7–24). The available material on Orcagna as a sculptor is assembled by Steinweg (*Andrea Orcagna: quellengeschichtliche und stilkritische Untersuchung*, Strasbourg, 1929). Venturi (*Storia*, iv, 1906, pp. 638–63) gives a notable account of the Tabernacle. The relation between Orcagna's paintings and sculptures is discussed by H. Gronau (*Andrea Orcagna und Nardo di Cione: eine stilgeschichtliche Untersuchung*, Berlin, 1937, pp. 20–23). Some interesting suggestions are advanced in two articles by Valentiner ('Orcagna and the Black Death of 1348', in *Art Quarterly*, xii, 1949, pp. 48–68, 113–28). Doubt is thrown on Matteo di Cione's alleged participation in the Tabernacle and on his supposed responsibility for other sculptures by M. Wundram ('Antonio di Banco', in *Mitteilungen des Kunsthistorischen Institutes in Florenz*, x, 1961–63, pp. 23–32), who also ('Toskanische Plastik von 1250–1400', in *Zeitschrift für Kunstgeschichte*, xxi, 1958, pp. 243–70) contests a number of Valentiner's ascriptions to Orcagna. Orcagna's part in the construction of the Cathedral in Florence is discussed by H. Saalman ('Santa Maria del Fiore, 1294–1418', in *Art Bulletin*, xlvi, 1964, pp. 471–500). For the historical background of Orcagna's work see Meiss (*Painting in Florence and Siena after the Black Death*, Princeton, 1951).

Plates 56–57: TABERNACLE
Or San Michele, Florence

The tabernacle (Fig. 42) is described by Ghiberti (*Commentari*, ed. Schlosser, i, p. 39): 'Fu l'Orcagna nobilissimo maestro perito singularissimamente nell'uno genere et nell'altro. Fece il tabernacolo di marmo d'Orto San Michele, e cosa excellentissima et singulare cosa, fatto con grandissima diligentia, esso fu grandissimo architettore et condusse di sua mano tutte le storie di detto lauorio, eui scarpellato di sua mano la sua propria effigie marauigliosamente fatta, fu di prezo di 86 migliaia di f(iorini)' (Orcagna was a most noble master, extraordinarily skilled in both arts. He made the marble tabernacle in Or San Michele, and a most excellent and singular thing it is, made with the utmost diligence. He was an outstanding architect, and executed with his own hand all the narrative scenes in this work, and there he also carved his own likeness marvellously rendered. The price of the work was eighty-six thousand florins). Beneath the sarcophagus of the Burial of the Virgin on the back of the tabernacle is the inscription: ANDREAS CIONIS PICTOR FLORENTIN ORATORII ARCHIMAGISTER EXTITIT HVI MCCCLIX. According to Vasari (*Vite*, ed. Milanesi, i, 1906, pp. 605–06), the tabernacle was commissioned by the Compagnia di Or San Michele with money collected after the Black Death of 1348 as a shrine for the Virgin and Child enthroned with Angels painted by Daddi about 1346, which is still housed within it. Work on the tabernacle was certainly begun by 1355, and perhaps as early as 1352. The balustrade surrounding the tabernacle was added in 1366. The tabernacle, which has strictly speaking the character of an altar or ciborium, is an ornamental structure of great complexity. Supported on four octagonal piers, it is open at the front and sides and closed at the back. The arches of the open sides are decorated with tracery and statuettes of Saints, and surmounted in front by a triangular gable flanked by ornate pinnacles. Behind the gable is a cupola. Round the sides and front of the base of the tabernacle run octagonal reliefs with scenes from the life of the Virgin interspersed with hexagonal reliefs of the Virtues. At the back is a large relief (Fig. 43), running the whole height of the tabernacle, showing (below) the Burial of the Virgin, and (above) the Assumption of the Virgin (or the Virgin dropping her Girdle to St. Thomas). The tabernacle is heavily encrusted with coloured inlay, and the effect in the original is one of brilliant polychromy. There is a striking disparity in quality between the various carvings on the tabernacle. In some cases, as with the statuettes above, this is attributable to the intervention of inferior studio hands. In others it probably reflects the development of the sculptor's style; thus Steinweg distinguishes, probably correctly, between the early pictorial relief of the Adoration of the Magi, and the more sculptural Annunciation of the Death of the Virgin. Vasari records a tradition that Orcagna was a pupil of Andrea Pisano, and the narrative reliefs of the tabernacle certainly do not confute the view that his style depends ultimately from that of the carvings on the Campanile, though the forms throughout are heavier and the narrative technique and space structure are more pedantic than Andrea Pisano's. The finest of the reliefs is that on the back, where the Burial of the Virgin is treated with a new pathetic emphasis, and the Assumption reveals the open composition and full forms that look forward to the Assumption of Nanni di Banco on the Porta della Mandorla and back to Orcagna's masterpiece, the Strozzi altarpiece.

ALBERTO ARNOLDI
(active 1351–64)

Alberto Arnoldi, mentioned in a story by Sacchetti (Novella CXXXVI) as 'grande maestro di intagli', is one of the principal sculptors active in Florence in the middle of the fourteenth century. His name occurs in documents for the first time in 1351 in connection with work on the windows of the Campanile. In 1357–8, when joint Capomaestro of the Cathedral with Talenti, he received a commission to complete the tabernacle over the central doorway, and in 1361 he executed a lunette of the Virgin and Child (documented) on the outside of the Bigallo. Between 1359 and 1364 Arnoldi was employed on a Virgin and Child with two Angels for the altar of the Bigallo. It has been suggested that Arnoldi was of Lombard origin, and Sacchetti (Novella CXXIX) states that after leaving Florence he entered the service of Galeazzo Visconti, Duke of Milan. If Valentiner's ascription to Arnoldi of the Vieri di Bassignana monument (Museo del Castello Sforzesco, Milan) is correct, the sculptor was active as late as 1377–9.

BIBLIOGRAPHY: A survey of the style of Arnoldi is offered by Becherucci ('I rilievi dei Sacramenti nel campanile del duomo di Firenze', in *L'Arte*, xxx, 1927, pp. 214–23), to whom the attribution to the sculptor of the reliefs discussed below is due. For a full discussion of the problems arising from them see Becherucci in L. Becherucci and G. Brunetti (*Il Museo dell'Opera del Duomo a Firenze*, i, Florence, 1969, pp. 239–40). An article by Valentiner ('Orcagna and the Black Death of 1348', in *Art Quarterly*, xii, 1949, pp. 48–59) proposes a number of further attributions.

Plate 58: RELIEFS
Museo dell'Opera del Duomo, Florence

The most distinguished of the reliefs in the upper cycle formerly on the Campanile in Florence (see Plates 50–51 above) are representations of the seven Sacraments. In each the Sacrament is depicted by means of two or more figures

carved in deep relief and set on a platform recalling that employed on the bronze door of Andrea Pisano. In the triangular spaces beneath the platform are allegorical heads relating to the Sacrament portrayed, in the case of the Eucharist a lion's head and in that of the Extreme Unction the head of an eagle, explained by Venturi (*Storia*, iv, 1906, p. 540) as symbols respectively of the Church and of the soul winging its way to heaven. The backgrounds are inlaid with blue glazed majolica. The attribution to Arnoldi of these simple and subtle scenes is warranted by analogies with the documented lunette on the Bigallo. The reliefs are variously assigned to the second half of the thirteen forties and to a date *c.* 1351, and certainly precede Arnoldi's documented works. The style depends from that of Andrea Pisano (to whom the reliefs are traditionally ascribed by Ghiberti and other sources), but in the hands of Arnoldi the treatment of the figures assumes a personal inflexion, and is throughout less monumental than in the reliefs of Andrea Pisano below.

GIOVANNI D'AMBROGIO
(active 1366–1418)

Giovanni d'Ambrogio's name occurs for the first time in 1366. It has been conjectured (Brunetti) that a figure of a Prophet from the Campanile, now in the Museo dell'Opera del Duomo, is his earliest work. Nothing is known of his work, however, before the commission for the Loggia dei Lanzi (see Plate 59 below), where he was responsible for the reliefs of Prudence and Justice. In 1391 he was employed on the Porta della Mandorla of the Cathedral, where he seems to have been responsible, between this date and 1397, for a mensola with a naked putto, for part of the architrave, and for reliefs of Hercules and other subjects (Fig 87). In 1395–6 he executed a figure of St. Barnabas for the façade of the Cathedral (plausibly identified by Brunetti with a headless figure now in the Museo dell'Opera del Duomo, Florence). He has also been tentatively credited (Wundram), possibly correctly, with the Annunciation group from the Porta della Mandorla, also in the Opera del Duomo. He served as Capomaestro of the Duomo between 1404 and 1407, and is last mentioned in 1418. Though present knowledge of Giovanni d'Ambrogio is in part conjectural, those works which can be given to him with reasonable confidence (e.g. the Angel with a Rebeck from the façade of the Cathedral in the Opera del Duomo) suggest that he should be regarded as one of the most distinguished Florentine sculptors of his time.

BIBLIOGRAPHY: The first systematic attempt to reintegrate the work of Giovanni d'Ambrogio is due to G. Brunetti ('Giovanni d'Ambrogio', in *Rivista d'Arte*, xiv, 1932, pp. 1–22). This is amplified by L. Becherucci and G. Brunetti (*Il Museo dell'Opera del Duomo a Firenze*, i, Florence, 1969, pp. 22–24, 249–51, 256–58). For Giovanni d'Ambrogio's part in the sculptures of the Loggia dei Lanzi see particularly M. Wundram ('Jacopo di Piero Guidi, in *Mitteilungen des Kunsthistorischen Institutes in Florenz*, xiii, 1967–8, pp. 195–222), and for his share in the Porta della Mandorla M. Wundram ('Niccolo di Pietro Lamberti und die Florentiner Plastik um 1400', in *Jahrbuch der Berliner Museen*, n.f. iv, 1962, pp. 78–115) and C. Seymour ('The Younger Masters of the first Campaign of the Porta della Mandorla, 1391–1397', in *Art Bulletin*, xli, 1959, pp. 1–17). The case for regarding Giovanni d'Ambrogio as the author of the Annunciation group is presented by M. Wundram ('Der Meister der Verkündigung in der Domopera zu Florenz', in *Beiträge zur Kunstgeschichte, Festgabe für H. R. Rosemann*, Munich-Berlin, 1960, pp. 109–25). The sculptures for the façade of the Cathedral are also discussed by H. Keller ('Ein Engel von der Florentiner Domfassade im Frankfurter Liebighaus', in *Festschrift für H. von Einem*, Berlin, 1965, pp. 117–22). For the documentation of the work discussed below see Frey (*Die Loggia dei Lanzi*, Berlin, 1885, pp. 33–36).

Plate 59: VIRTUES
Loggia dei Lanzi, Florence

In 1373–4 provision was made for the building of the present Loggia dei Lanzi in the Piazza della Signoria. Vasari records an incorrect tradition that the Loggia was designed by Orcagna. The sculptural decoration of the Loggia is limited to seven reliefs of the Virtues set in the spandrels of the arches, which were likewise ascribed by Vasari to Orcagna. The history of the reliefs (of which the best account is that of Wundram) goes back to June 1383, when a drawing for one of the figures was supplied by Agnolo Gaddi. The first payment for the reliefs, to Jacopo di Piero Guidi, dates from 12 October of the same year, when two of the carvings were commissioned from Giovanni d'Ambrogio. Payments for the Faith and Hope of Jacopo di Piero Guidi were made respectively in November 1384 and October 1385. Two further reliefs, the Strength and Temperance, were commissioned from Giovanni Fetti in March 1385, and were transferred a year later to Jacopo di Piero Guidi, who was also responsible for the Charity (completed July 1391). Agnolo Gaddi's design for the relief of Prudence was finished by 27 March 1386, and work on the carving was completed by Giovanni d'Ambrogio (who was also responsible for the relief of Justice) at the end of this year or the beginning of 1387. The figures were subsequently pigmented by the painter Lorenzo di Bicci and set on a coloured ground. In addition to the designs which he prepared for these reliefs, Agnolo Gaddi prepared drawings, in 1387 and 1390, for three statues for the façade of the Duomo executed by Piero di Giovanni Tedesco. The tendency towards pictorial sculpture manifest in these commissions and in the Loggia dei Lanzi reliefs constitutes a Florentine parallel for the pictorial sculpture with which Milan Cathedral was decorated in the same term of years (see Plates 65–67 below).

GIOVANNI DA CAMPIONE
(active 1340–60)

In the middle of the fourteenth century indigenous sculpture in Lombardy is dominated by the figures of the Campionesi, notably of Giovanni and Bonino da Campione. Giovanni da Campione is known to have been active from 1340 till 1360, and worked principally at Bergamo on the Baptistry (inscribed M.CCC.XL. JOHANNES) and on Santa Maria Maggiore, where he is thought to have executed the equestrian figure of St. Alexander over the main entrance (1353) and part of the sculptured decoration of the lateral doorway (1360). There is, however, some doubt as to his personal responsibility for these sculptures, since he is referred to in the accounts of S. Maria Maggiore between 1361 and 1363 as the master in charge of the 'refectio operis ecclesie', and in an earlier document of 1348, relating to the building of SS. Nazaro e Celso at Bellano as 'magister di muro e di legnamine', not as a sculptor. The figures of Virtues on the outside of the Baptistry (see Plate 60 below) have been given alternatively to Giovanni da Campione and to his father Ugo da Campione, by whom no authenticated work is known.

BIBLIOGRAPHY: A reasoned account of the activity of the Campionesi is given by Baroni (*Scultura Gotica Lombarda*, Milan, 1944), whose volume supersedes the earlier but still fundamental study of Meyer (*Lombardische Denkmäler des Vierzehnten Jahrhunderts*, Stuttgart, 1893). For a later and more ample survey by Baroni see *Storia di Milano*, v, Milan, 1955, pp. 737–54, 783–91. A useful account of Giovanni da Campione as an architect is supplied by A. M. Romanini (*L'architettura gotica in Lombardia*, Milan, 1964, pp. 292–95). The sculptural style of the Campionesi is also discussed by R. Jullian (*Les persistances romanes dans la sculpture gothique italienne*, in *Cahiers de Civilisation Médiévale*, iii, 1960, pp. 295–305).

Plate 60: VIRTUES
Baptistry, Bergamo

The eight large reliefs of Virtues on the angles of the Baptistry at Bergamo (Fig. 46) must have been executed about 1340, if, as assumed by Baroni, they are to be connected with the inscription M.CCC.XL. JOHANNES on the Baptistry. A figure of St. John Baptist over the altar of the Baptistry and, possibly, some reliefs with scenes from the Life of Christ, also in the Baptistry, are by the same hand. The Virtues are conjecturally associated by Toesca (in *Il Trecento*, 1951, pp. 383–85) with Ugo da Campione, of whom we know only that he was the father of the sculptor Giovanni da Campione and that he died before 1360, and by Baroni more plausibly with Giovanni da Campione. They and the reliefs inside the Baptistry are due to a number of hands working within a single studio. The Virtues reveal the superficial influence of the caryatids on Giovanni di Balduccio's Arca of St. Peter Martyr, but in other respects than iconography their hieratic style, with its rigid, heavy forms, is impervious to Tuscan influence.

GIOVANNI DI BALDUCCIO
(active 1317–49)

Giovanni di Balduccio is thought to have been born about 1300, and in 1317–18 was active in the Opera del Duomo at Pisa, where Tino di Camaino was then working. If, as has been suggested, his hand is to be traced in the base of the central support of the Pisa pulpit of Giovanni Pisano and in subsidiary sections of the tomb of Margaret of Luxemburg, he would have been born at a considerably earlier date. His earliest datable work, the tomb of Guarniero degli Antelminelli in S. Francesco at Sarzana, belongs to the years 1327–8, but before this time (probably in the bracket 1320–5) he was responsible for the high altar of S. Domenico Maggiore, Bologna, of which a number of fragments survive at Bologna and elsewhere. From the late twenties date a pulpit with reliefs of the Annunciation in S. Maria at San Casciano Val di Pesa, and the Baroncelli monument in S. Croce in Florence. At about this time Giovanni di Balduccio was also employed on the statuary of S. Maria della Spina at Pisa. About 1334 he was summoned to Milan, perhaps in connection with the monument of Beatrice d'Este in S. Francesco Grande or with a Visconti monument formerly in S. Tecla, and there he remained active for a decade and a half, at the head of a large studio, engaged on the Arca of St. Peter Martyr in S. Eustorgio (1335–9) (see Plate 61 below), the tomb of Azzo Visconti (d. 1339) in S. Gottardo, from which a Virgin and Child in the Museo del Castello Sforzesco appears to have originated, the doorway of S. Maria di Brera (1347), the monument of Lanfranco Settala in S. Marco and other works. The sculptor's name occurs for the last time in 1349, when he refused an offer of appointment as Capomaestro of the Duomo at Pisa, but if he was responsible for designing the Arca of St. Augustine at Pavia (see Plate 62 below), he must have been active in Milan till about 1360.

BIBLIOGRAPHY: A review of the material on Giovanni di Balduccio, with special reference to his Milanese activity, is given by Baroni (*Scultura Gotica Lombarda*, 1944, pp. 63–93; and 'La scultura gotica', in *Storia di Milano*, v, Milan, 1955, pp. 758–83). From a scattered bibliography mention should be made of articles by Valentiner ('Giovanni di Balducci a Firenze', in *L'Arte*, n.s. vi, 1935, pp. 3–29, and 'Notes on Giovanni Balducci and Trecento Sculpture in Northern Italy', in *Art Quarterly*, x, 1947, pp. 40–60), Carli ('Sculture

pisane di Giovanni di Balduccio', in *Emporium*, xcvii, 1943, p. 143ff.; and *Scultura Italiana. Il Gotico*, Milan, 1967, p. 46f.) and Gnudi ('Un altro frammento dell'altare bolognese di Giovanni di Balduccio', in *Belle Arti*, i, 1946–8, 3–4, pp. 165–81; and 'Ancora per l'altare bolognese di Giovanni di Balduccio', in *Critica d'Arte*, viii, 1949, pp. 73–75). An attempt to ascribe to Giovanni di Balduccio the central support of Giovanni Pisano's pulpit in Pisa Cathedral and a number of decorative heads on the Campo Santo at Pisa is made by E. Tolaini ('Alcune sculture della facciata del Campo Santo di Pisa', in *Studi in onore di M. Marangoni*, Florence, 1957, pp. 155–63; and 'La prima attività di Giovanni di Balduccio', in *Critica d'Arte*, n.s. xxvii, 1958, pp. 188–202). For Giovanni di Balduccio as an architect at S. Maria di Brera and elsewhere in Milan see A. M. Romanini ('L'architettura lombarda nel secolo XIV', in *Storia di Milano*, v, Milan, 1955, pp. 673–92). The Settala monument in S. Marco, Milan, is discussed by D. Celada ('Le sette arche marmoree della basilica di S. Marco in Milano', in *Arte figurativa*, vi, 1958, pp. 44–49), and the Virgin from the Azzone Visconti monument by A. d'Auria ('Le sculture della Villa Tittoni di Desio passate al Castello Sforzesco di Milano', in *Arte antica e moderna*, 1963, pp. 124–38). An historical analysis of the Arca of St. Peter Martyr is supplied by P. Venturino Alice ('La tomba di S. Pietro Martire e la Cappella Portinari in S. Eustorgio di Milano', in *Memorie Domenicane*, lxix, 1952, pp. 3–34). It is claimed by G. Brunetti ('Osservazioni sulla Porta dei Canonici', in *Mitteilungen des Kunsthistorischen Institutes in Florenz*, viii, 1957, pp. 1–12) that the marble relief of the Man of Sorrows on the Porta dei Canonici of the Duomo in Florence is a late work of Giovanni di Balduccio, executed in the late thirteen sixties after his return from Lombardy.

Plate 61: THE ARCA OF ST. PETER MARTYR
San Eustorgio, Milan

The monument (Fig. 44) carries the inscription: MAGISTER IOHANNES BALDVCII DE PISIS.SCULPSIT HANC ARCHAM.ANNO DOMINI MCCCXXXVIIII. In the *Atti Capitolari* of 1335, it is noted that 'i padri del convento di Milano avendo intrapreso di fare ad onore di san Pietro Martire un sepolcro che fosse in tutto simile a quello del padre san Domenico, si esortano i religiosi a cercare elemosine' (the fathers of the convent in Milan, having undertaken to erect in honour of St. Peter Martyr a tomb similar in every respect to that of our father St. Dominic, exhort the religious to raise alms). It is presumed that work on the monument was begun in this year. The lower section of the monument consists of eight caryatids of (front, left to right) Justice, Temperance, Fortitude and Prudence, and (back, left to right) Obedience, Hope, Faith and Charity, standing on platforms flanked by animals. Round the sarcophagus run eight scenes from the life of St. Peter Martyr, divided from each other by statuettes of Saints, placed immediately above the caryatids beneath. The eight reliefs show (front, left to right) the Death of St. Peter

Martyr, the Canonization of St. Peter Martyr, and St. Peter Martyr saving a Ship at Sea, (back, left to right) a Miracle of St. Peter Martyr, St. Peter Martyr preaching, St. Peter Martyr restoring Speech to a dumb Man, and (ends) the Martyrdom of St. Peter Martyr and the Body of St. Peter Martyr deposited in the Convent at Milan. Above, round the edges of the sarcophagus, are representatives of eight of the nine orders of Angels, and from the sloping lid, itself carved with reliefs, rises a tabernacle containing figures of the Virgin and Child with SS. Dominic and Peter Martyr. This complex programme seems to have been based on that of the Arca of St. Dominic in S. Domenico Maggiore at Bologna (see Plate 24 above), as was the form of the lower part of the monument, which differs from its prototype in the division of the longer sides of the sarcophagus into three parts and in a corresponding adjustment in the number and spacing of the caryatids below. New features are the upper statuettes and the sloping lid surmounted by a tabernacle. The architecture of the latter recalls that of the tabernacle on the façade of S. Maria della Spina. In form the Arca is almost completely devoid of Lombard elements, but in the execution Giovanni di Balduccio undoubtedly made use of Lombard sculptors, particularly on the lid and in certain of the reliefs. The hand of one of these, responsible for the much simplified Burial and Canonization reliefs, is identified by Baroni in the Settala monument. The finest of the components of the monument, for which Giovanni di Balduccio must himself have been responsible, are the eight caryatids and the figures beneath the tabernacle.

Plate 62: THE ARCA OF ST. AUGUSTINE
San Pietro in Ciel d'Oro, Pavia

The body of St. Augustine, Bishop of Hippo, was brought to Pavia by Liutprand in 722–5 and interred in the church of S. Pietro in Ciel d'Oro, where it remained an object of veneration throughout the Middle Ages. The decision to construct a new shrine to contain the body seems to have been taken about 1350. A record of 1578 (quoted by Maiocchi, *L'Arca di Sant' Agostino in S. Pietro in Ciel d'Oro*, 1900, pp. 11–12) states that work on the Arca was begun in December 1362, but this is doubtful. On the cornice of the base of the monument is the date ANNO MCCCLXII, and it is likely that by this time at least the lower part of the shrine was complete. The will of Gian Galeazzo Visconti (1397) makes provision for the completion of the monument and for the installation of the body of the Saint in its new shrine, but so late a date can hardly be ascribed to any part of the monument as it exists today. The shrine (Fig. 45) was moved from the Sacristy and set up on the altar on which it now stands in 1738–9. The form of the Arca of St. Augustine depends from that of the Arca of St. Peter Martyr in S. Eustorgio in Milan (see Plate 61 above), but the idiom in which it is conceived is characteristically Lombard. The Arca consists of three main sections. The first (below) is a solid base ornamented along the front and back with three double reliefs of Saints, separated from each other by caryatids of the Virtues derived

G

from the caryatids in S. Eustorgio. The second (centre) is a colonnade with three rounded arches on the longer sides supported by piers enriched with statuettes of Saints; within is the Saint's effigy, attended by angels holding the pall or winding-sheet, and, at the head and feet, by Saints. The third (above) contains rectangular reliefs and triangular gables with scenes from the Life of St. Augustine, interspersed with and surmounted by further statuettes. The sarcophagus of the Arca of St. Peter Martyr seems to have formed the point of departure for this part of the monument. The elaboration of the monument may be judged from the fact that it comprises ninety-five statuettes and fifty reliefs. It was suggested initially by Maiocchi that the Arca of St. Augustine was a work

of Giovanni di Balduccio, and this view is sustained by Valentiner. But the aesthetic preconceptions embodied in the Arca differ materially from those of the shrine of St. Peter Martyr. The execution is due to at least two main sculptors, of whom one is correctly identified by Meyer (*Lombardische Denkmäler des Vierzehnten Jahrhunderts*, Stuttgart, 1893, pp. 36–41) with the author of an altar in S. Eustorgio, Milan, carved with reliefs illustrating the Journey and Adoration of the Magi. Structurally, however, the Arca of St. Augustine is a work of great distinction, and neither the altar in S. Eustorgio nor the Aliprandi monument in S. Marco, Milan, by the same hand, suggest that this artist could have been responsible for its design.

BONINO DA CAMPIONE
(active after 1349; d. 1397)

The most distinguished of the Campionesi, Bonino da Campione was active from after 1349 (year of the death of Lambertino Balduino, for whose tomb in the Duomo Vecchio at Brescia he was responsible). Other early works are the monuments of Stefano and Valentina Visconti and Protaso Caimi in S. Eustorgio, Milan, and the sarcophagus of Folchino de' Schizzi (d. 1357) in the Duomo at Cremona. Before 1363 he carved the great equestrian figure of Bernabò Visconti, now in the Museo del Castello Sforzesco (see Plate 63 below). In 1374 he completed the monument of Cansignorio della Scala at Verona (see Plate 64 below). To a later phase, in the thirteen eighties, belong the reliefs of the sarcophagus of the Bernabò Visconti monument and a Crucifixion in S. Nazaro, Milan. In 1388 he acted as adviser on the structure of Milan Cathedral. He died in 1397.

BIBLIOGRAPHY: The best accounts of the activity of Bonino da Campione are those of C. Baroni (*Scultura Gotica Lombarda*, Milan, 1944; 'La Scultura Gotica', in *Storia di Milano*, v, Milan, 1955, pp. 728–812). See also F. Russoli in *Arte Lombarda dai Visconti agli Sforza*, Milan, 1958, p. 12f. The Monument of Cansignorio della Scala and the related Scaliger monuments are discussed by F. De Maffei (*Le arche scaligere di Verona*, Verona, 1955) and L. Magagnato (*Arte e civiltà del Medioevo Veronese*, Turin, 1962).

Plate 63: MONUMENT OF CANSIGNORIO
DELLA SCALA
Sagrato di Santa Maria Antica, Verona

The immediate source of the class of equestrian monument to which the statue of Bernabò Visconti belongs seems to have been Verona, where it has precedents in the monuments of Can Grande della Scala (d. 1324) over the doorway of S. Maria Antica and of Mastino II della Scala (before 1351) (Figs. 50–51). But the ultimate source of these figures is German, and is to be sought in the middle of the thirteenth century in the Kaiserdenkmal at Magdeburg and the Horse-

man at Bamberg. The most notable of the Scaliger monuments is that constructed by Bonino da Campione during the lifetime of Cansignorio della Scala (d. 1375). The monument (Fig. 49) is inscribed with the distich:

UT FIERET PVLCV POLLES NITIDVQVE SEPVLCRVM
VERE BONINVS ERAT SCVLPTOR GASPARQVE REOLTOR

(That this tomb should be beautiful, mighty and handsome, Bonino was the sculptor and Gaspare the realtor). A second inscription reads:

HOC.OPVS, FECIT.ET.SCVLPSIT.BONINVS.DE.CAMPIGLIONO. MEDIOLANENSI. DIOCESIS.

(Bonino da Campione of the diocese of Milan designed and carved this work).

There is some doubt as to the precise date of the tomb, which is variously thought to have been begun about 1370 and completed in 1374, or (De Maffei, on the evidence of Torello Saraina, *Historia e fatti dei Veronesi*, 1542) to have been begun in 1374 and completed in 1375/6. Raised on pillars, it contains in the centre an arcaded tabernacle within which rest the funeral effigy and the sarcophagus of Cansignorio. At the head of the sarcophagus stand two angels, who recall the supporting figures in the Arca of St. Augustine (see Plate 62 above), and on the sides are reliefs with six scenes from the Life of Christ with, at the head and feet, Cansignorio della Scala presented to the Virgin by St. George and the Coronation of the Virgin. Above, in the Gothic superstructure, are seated figures of the Virtues and niches with angels holding the stemma of the Della Scala. On the apex of the monument rests the mounted figure of Cansignorio. At the corners of the grille surrounding the monument are tabernacles raised on pillars containing figures of the warrior Saints George, Martin, Quirinus, Alvise, Valentine and Sigismund. In the monument of Cansignorio della Scala the sculptural features of the monument are subordinated to the ornate architectural frame, and the mounted figure above is less fine than the corresponding figure of Bernabò Visconti, from which it appears to be a workshop derivative. Extensive

studio intervention must be presumed through the whole tomb, but the effigy, the candle-bearing angels and three of the scenes on the sarcophagus (the Miracle of the Loaves and Fishes, the Healing of a Man possessed of the Devil, and the Temptation of Christ) have been rightly claimed (De Maffei) as autograph. The complexity and size of the tomb have conspired to make it the most impressive Gothic sepulchral monument in Northern Italy.

Plate 64: MONUMENT OF BERNABÒ
VISCONTI
Museo del Castello Sforzesco, Milan

Bernabò and Galeazzo II Visconti succeeded their uncle, Giovanni Visconti, Archbishop and Lord of Milan, on the latter's death in 1354, establishing their courts respectively at Milan and Pavia. The monument of Bernabò (d. 1385) (Fig. 52), now in the Museo del Castello Sforzesco, was made for the church of S. Giovanni in Conca, Milan, where it originally occupied a position 'in superficie altaris maioris'. A description in the anonymous *Lamento per la morte di Bernabo Visconti*, quoted by Baroni, proves that the monument was originally covered with gold and silver. The figure is also described in the *Chronicon* of Pietro Azario: 'Imago sua intexta in marmore albo, tam magna et tam grossa quantum ipse erat et armatus super unum destrerium magnum et grossum quantum est unus maximus destrerius. Et dictae imagines dicti domini Bernabovis et dicti equi sunt una lapis integra, tam magna et grossa et alta quantum ipse et equus erant, et est mirabilis et pulchra opera.' (His image is worked in white marble, as large and wide as he was in life, and seated in armour on a charger as large and wide as the greatest charger is. And the aforesaid likenesses of the lord Bernabò and of the horse are carved from a single stone, as large and wide and high as he and the horse were, and it is a wonderful and beautiful work.) Since the *Chronicon*, as noted by Baroni, was concluded in 1363, the equestrian statue was presumably completed by this year. The sarcophagus beneath, executed in or shortly before 1385, is carved with reliefs of (front) Bernabò Visconti presented by St. George to the Crucified Christ with attendant Saints, (back) the Pietà with the Virgin, St. John, St. Barnabas and other Saints, and (ends) the Coronation of the Virgin, and the Evangelists and Fathers of the Church. Meyer correctly distinguishes between the equestrian statue, which, on the analogy of the signed monument of Cansignorio della Scala at Verona (see Plate 63 above), must have been executed by Bonino da Campione, and the sarcophagus, which is of lower quality and was evidently carved in the master's studio.

GIOVANNINO DE' GRASSI
(active 1389–98)

Giovannino de' Grassi is mentioned for the first time in the accounts of the Fabbrica of the Duomo at Milan in 1389, and two years later is described as 'ingegnere della fabbrica'. The only sculpture that can be ascribed to him with confidence is a relief of Christ and the Woman of Samaria above the lavabo in the South Sacristy of the Cathedral (begun in 1391 and painted and gilded by the artist in 1396). Other payments date from 1393 and 1395. In 1396 Giovannino de' Grassi was at Pavia, in the company of Giacomo da Campione and Marco da Carone, in connection with plans for the Certosa. In the same year he executed a painting for the high altar of the Cathedral at Milan and prepared drawings of capitals for the Cathedral. Giovannino de' Grassi died at Milan on 3 July 1398. A painter and designer rather than a sculptor, his Christ and the Woman of Samaria carries to its logical conclusion the pictorial tendency inherent in Lombard Gothic style.

BIBLIOGRAPHY: The facts of Giovannino de' Grassi's brief career are recapitulated by Weigelt (in Thieme-Becker, *Künstlerlexikon*, xiv, 1921, pp. 534–6). For the artist's sculptural activity see Nebbia (*La scultura nel Duomo di Milano*, Milan, 1908) and Baroni (*Scultura Gotica Lombarda*, Milan, 1944), and for his work in other mediums Toesca (*La pittura e la miniatura nella Lombardia*, Milan, 1912, pp. 294–323). Giovannino de' Grassi's share in the construction and decoration of the Duomo in Milan is also discussed by F. Russoli (in *Arte Lombarda dai Visconti agli Sforza*, Milan, 1958), A. M. Romanini (*L'architettura gotica in Lombardia*, Milan, 1964, pp. 360ff.), M. L. Gatti Perrer ('Appunti per l'attribuzione di un disegno della Raccolta Ferrari: Giovannino de' Grassi e il Duomo di Milano,' in *Arte Lombarda*, x, 1965, pp. 49–64), and A. Cadei ('Giovannino de' Grassi nel Taccuino di Bergamo,' in *Critica d'Arte*, xvi, 1970, pp. 17–36), who gives a careful analysis of the relief discussed below.

Plate 65: CHRIST AND THE WOMAN OF
SAMARIA
Duomo, Milan

The relief of Christ and the Woman of Samaria, situated over the lavabo of the south sacristy of the Cathedral, was begun a month after the appointment of Giovannino de' Grassi as engineer of the fabric of the Duomo of Milan in July 1391. It remained unfinished until 1396, when it was gilded and pigmented by the artist; some traces of colour remain. Though the documents refer only to the relief above, there can be little doubt that Giovannino de' Grassi was responsible for the design of the entire lavabo. The scheme of the upper part, where two winged putti, seated on sprays of foliage, support a crown, on which there rests a platform serving as base for the irregular medallion containing the scene above, is of special elegance, as are the foreshortened figures set in the stylized landscape of International Gothic convention.

MILANESE SCHEMA

MILANESE SCHOOL

Plate 66: THE ANNUNCIATION
Duomo, Milan

In 1390 designs were submitted by a French architect designated by the Italian name of Niccolò de Bonaventuris and by Giacomo da Campione for the central window of the apse of Milan Cathedral. The project of Niccolò de Bonaventuris was accepted, but was subsequently modified. In December 1401 an alternative scheme for the window prepared by Filippino da Modena was under consideration by Gian Galeazzo Visconti, and in March 1402 this was approved, and arrangements were made for the preparation of drawings for the figure sculpture of the window by a painter, Filippolo da Melegnano. At the end of May 1402 the designs for the sculpture were once more modified, and instructions were given that the figures of the Virgin Annunciate and Annunciatory Angel should be executed 'eis modo et forma quibus designabuntur et ordinabuntur per magistrum Isaach de Imbonate optimum pictorum Mediolani' (in that manner and form in which they will be designed and determined by master Isacco da Imbonate excellent painter of Milan). Final approval for the two figures was given on 22 July, when it was enjoined that the cartoons should be drawn or painted and duplicated 'per magistros Ysaach de Imbonate, ad id alias ellectum et Paulinum de Montorfano', and that a start should then be made on the two carvings. Nothing is known of Isacco da Imbonate or Paolo da Montorfano, from whose cartoons the figures were carved, nor is the sculptor named in documents. It is argued by C. Gilli Pirina ('Franceschino Zavattari, Stefano da Pandino, Maffiolo da Cremona, "magistri a vitriatis" e la vetrata della "raza" del Duomo milanese', in *Arte antica e moderna*, No. 33, 1966, pp. 25–45) that the Virgin Annunciate was designed by Isacco da Imbonate and the Angel by Paolo da Montorfano, and that the two figures were carved by different sculptors. This latter conclusion is probably correct. The hands by which they were executed are clearly distinct from, and in some respects superior to, those of Peter Monich, who executed two seraphim for the window, Niccolò da Venezia, who carved one of the censing angels, and Matteo Raverti, who was responsible for a second censing angel. The sculpture of the window is representative of the system of decoration employed in the Cathedral, first in its collaborative character, and second in the subordination of the sculptural elements to an overall pictorial design.

JACOPINO DA TRADATE
(active 1401–40)

The name of Jacopino da Tradate occurs in the accounts of the Fabbrica of the Duomo at Milan between 1401 and 1425, in association with Matteo Raverti, Niccolò da Venezia, and Walter and Peter Monich, with the latter of whom he collaborated in 1404. A Gigante which he carved on the outside of the Cathedral in 1404 has been tentatively identified. His best known work is the statue of Pope Martin V on the south wall of the choir (see Plate 67 below). Jacopino da Tradate was later (1440) employed by Giovanni Francesco Gonzaga at Mantua.

BIBLIOGRAPHY: Jacopino da Tradate's activity at Milan is discussed by Nebbia (*La scultura nel Duomo di Milano*, Milan, 1908) and C. Baroni ('La scultura del primo Quattrocento', in *Storia di Milano*, vi, Milan, 1955, pp. 732–38). For further attributions see F. Russoli (in *Arte lombarda dai Visconti agli Sforza*, Milan, 1958, p. 48), R. Longhi ('Qualche aggiunta antologica al "Gotico internazionale" in Italia', in *Paragone*, No. 155, 1962, pp. 75–80), and P. Diraghi ('Schedula per Beltramino de Zottis da Roli', in *Il Duomo di Milano*, *Congresso internazionale*, *Atti*, i, Milan, 1969, pp. 106–10). For the Martin V statue see Hager (*Die Ehrenstatuen der Päpste*, Leipzig, 1929, pp. 32–34).

Plate 67:
POPE MARTIN V
Duomo, Milan

The high altar of Milan Cathedral was dedicated by Pope Martin V on his return from the Council of Constance in October 1418, and in the following year, in commemoration of this event, a seated figure of the Pope, almost twice life size, was commissioned by Filippo Maria Visconti from Jacopino da Tradate. The figure was completed in 1421. The Pope is shown frontally, seated above a step resting on a foliated console. The effect of the design is enhanced by the rectangular curtain behind, and by a rectangular frame. On the step of the throne are the arms of Colonna and of the Holy See. The metal decoration of the tiara, executed in 1424 by Alvino Frota, has disappeared. This distinguished figure is sometimes supposed to have been influenced by Niccolò di Pietro Lamberti's St. Mark on the Duomo at Florence, but the connection between the two figures is not a close one, and Jacopino da Tradate's statue, with its flowing drapery, was conceived within the idiom of North Italian Gothic style under strong German or Bohemian influence.

VENETIAN SCHOLL

Plate 68:

MADONNA DELLO SCHIOPPO

St. Mark's, Venice

The Madonna dello Schioppo in St. Mark's (of which the best analysis is supplied by O. Demus, *The Church of San Marco in Venice*, Washington, 1960, pp. 187–90) is not precisely datable. Perhaps produced as late as the second decade of the fourteenth century, it reflects the influence of Palaeologan sculpture of the class of the Virgin Aniketos in the Zen Chapel of St. Mark's, for which an origin in Constantinople or Epirus has been postulated and which seems to date from the third quarter of the thirteenth century. Both in its iconography (which is adapted from the conventional Byzantine Hodegetria) and in its Byzantinizing style it is influenced, albeit superficially, by Gothic forms. The deep cutting (whereby it is invested with the character of a statue rather than of a relief), the play of movement in the drapery, and the human relationship between the Virgin and the Child distinguish it from archaizing works of the type of the dated S. Donato at Murano (1310) and the Virgin and Child with SS. Peter and Paul on S. Polo.

JACOBELLO and PIERPAOLO
(d. *c.* 1409) (d. ? 1403)
DALLE MASEGNE

Nothing is known of the origins of the brothers Dalle Masegne, who appear to have been trained in Venice, perhaps (Roli) in the following of Andriolo de Sanctis. Two marble statues of SS. John the Baptist and Anthony of Padua in the sacristy of S. Stefano, Venice, have been identified (Wolters) as works of Jacobello dalle Masegne of *c.* 1380. The two brothers were at work in Emilia by 1383, when they executed the monument of Giovanni da Legnano in S. Domenico, Bologna (now in the Museo Civico). In Venice their style was influenced by the Cornaro monument of Nino Pisano, and it has been suggested (Bettini) that they may have come into direct contact with Nino. A knowledge of Nino's work is implied by the altar for S. Francesco, Bologna (begun 1388, completed 1392), in which the predominant figure is that of Pierpaolo dalle Masegne. From 1391 till 1394 work was in progress on the iconostasis of St. Mark's in Venice (see Plate 69 below), where the principal figure was Jacobello. Subsequently the Dalle Masegne seem to have worked at Mantua (contract for façade of Cathedral 1395, sculpture for the façade 1401), and in 1398 Pierpaolo was involved in the construction of S. Petronio at Bologna. On 26 July 1399, the two brothers contracted to undertake work for the Cathedral in Milan, though from the autumn of this year Jacobello is known to have been active principally at Pavia, where he undertook work for Gian Galeazzo Visconti. The two brothers appear to have separated at this time. In 1400 Pierpaolo was employed at Mantua and on the south window of the Palazzo Ducale at Venice. Among Pierpaolo's last works must be numbered the Virgin and Child with SS. Peter and Paul above the monument of Antonio Venier (d. 1400) in SS. Giovanni e Paolo, Venice. Pierpaolo dalle Masegne seems to have died in 1403, and Jacobello was still living six years later. Both sculptors were exponents of a naturalistic Gothic style, which was of great importance in the history of Italian sculpture, and which, especially in the iconostasis statuary, has something in common with German Gothic sculpture of the middle of the fourteenth century.

BIBLIOGRAPHY: General accounts of the work of the Dalle Masegne are given by Venturi (*Storia*, iv, pp. 797–824), Planiscig ('Geschichte der Venezianischen Skulptur im XIV Jahrhundert', in *Jahrbuch der Kunsthistorischen Sammlungen des Kaiserhauses*, 1916, pp. 176–98) and Toesca (in *Il Trecento*, 1951, pp. 420–27). Krautheimer ('Zur Venezianischen Trecentoplastik', in *Marburger Jahrbuch für Kunstwissenschaft*, v, 1929, pp. 193–212) sets this in the wider context of European Gothic style. For the Bologna altar see Supino (*La pala d'altare di Jacobello e Pier Paolo dalle Masegne nella chiesa di S. Francesco a Bologna*, Bologna, 1915) and R. Roli (*La pala marmorea di San Francesco in Bologna*, Bologna, 1964). For the early statues in S. Stefano in Venice see W. Wolters ('Über zwei Figuren des Jacobello dalle Masegne in S. Stefano zu Venedig', in *Zeitschrift für Kunstgeschichte*, xxviii, 1965, pp. 113–20), and for the Mantuan commissions A. M. Romanini ('L'architettura lombarda nel secolo XIV', in *Storia di Milano*, v, Milan, 1955, pp. 636–726) and E. Marani ('Nuovi documenti mantovani su Jacomello e Pietropaolo dalle Masegne', in *Accademia Virgiliana di Mantova, Atti e memorie*, n.s. xxxii, 1960, pp. 71–102). For the further literature of the Dalle Masegne as sculptors see S. Bettini ('L'ultima e più bella opera di Pierpaolo dalle Masegne', in *Dedalo*, xii, 1932, p. 347) and C. Gnudi ('Jacobello e Pierpaolo dalle Masegne', in *Critica d'Arte*, ii, 1937, pp. 26–38, and 'Nuovi appunti sui fratelli Dalle Masegne', in *Proporzioni*, iii, 1950, pp. 48–55). The Milanese activity of the Dalle Masegne is discussed by Mariacher ('Orme veneziane nella scultura lombarda: i fratelli Dalle Masegne a Milano', in *Ateneo Veneto*, cxxxvi, 1945, pp. 25–27), C. Bocciarelli ('Di una probabile opera di Jacobello dalle Masegne a Milano', in *Arte Lombarda*, iii, 1958, pp. 71–76), C. Ferrari da Passano and E. Brivio ('Contributo allo

studio del tiburio del Duomo di Milano', in *Arte Lombarda*, xii, 1967, pp. 3–36) and J. Gitlin-Bernstein (in *Il Duomo di Milano, Congresso Internazionale, Atti*, v, Milan, 1969, pp. 95–105).

Plates 69A–B: ICONOSTASIS
St. Mark's, Venice

The iconostasis (Fig. 58) separating the choir of St. Mark's from the body of the church is inscribed on the architrave:

MCCCLXXXXIIII. HOC OPUS FACTUM FUIT TEMPORE EXCELSI DOMINI ANTHONII VENERIO DEI GRATIA DUCIS VENETORUM AC NOBILIUM VIRORUM DOMINORUM PETRI CORNARIO ET MICHAELIS STENO HONORABILIUM PROCURATORUM PREFECTAE ECCLESIAE BENEDICTAE BEATISSIMAE MARCI EVENGELISTAE/JACHOBELUS ET PETRUS PAULUS FRATRES DE VENETIIS FECIT HOC OPUS. MCCCLXXXXIIII. (This work was made in the time of the excellent lord Antonio Venier, by the grace of God Doge of Venice, and of the noblemen the lords Pietro Cornaro and Michele Steno, honourable procurators of the blessed and most holy church of the Evangelist St. Mark. The brothers Jacobello and Pietro Paolo of Venice made this work.) A payment to the two brothers in connection with the icono-

stasis was made in December 1395 (Ongania, *La Basilica di S. Marco*, Venice, 1881–4, Doc. 840). In the centre of the iconostasis is a silver Crucifix signed by Jacopo di Marco Benato and dated 1394, and at the sides are marble figures of the Virgin, St. John the Evangelist and the Apostles. The figure sculpture of the iconostasis differs in certain respects from that of the Bologna altar, and this has given rise to the suggestions (i) (Toesca) that the former is due predominantly to Jacobello and the latter to Pierpaolo dalle Masegne, and (ii) (Krautheimer) that the Bologna altar, though begun earlier, was completed later than the iconostasis. The second of these theories cannot be sustained, since it is known (Roli) that on 19 June 1391 Jacobello dalle Masegne was preparing to leave Bologna for Venice, presumably in connection with the commission for the iconostasis, and was absent from Bologna when the altar in S. Francesco was completed in September of the following year. An effective contrast is drawn (Gnudi) between the fluent Gothic style of Pierpaolo dalle Masegne in the Virgin Annunciate of the Bologna altar and the Virgin of Jacobello on the iconostasis. Parallels for the style tendency represented by the statues on the iconostasis are noted by Krautheimer at Vienna (Singer Portal), Prague and elsewhere.

LORENZO GHIBERTI
(b. 1378; d. 1455)

Lorenzo Ghiberti was born in Florence in 1378, and trained as a goldsmith in the workshop of his stepfather, Bartolo di Michele. According to the autobiography contained in his *Commentari* (see bibliography below) he left Florence in 1400 to avoid the plague, and in 1401, when the competition for the second bronze door of the Baptistry was announced, was employed as a painter at the court of Malatesta il Senatore, Lord of Pesaro. Returning to Florence, he was successful in preparing the prize-winning relief of the Sacrifice of Isaac (now in the Museo Nazionale, Florence), and was awarded the commission for the door (see Plates 70–72 below). During the years in which work on the door and on its successor, the Porta del Paradiso (see Plates 73–81), was in progress, Ghiberti's workshop became the principal training-ground for the new generation of Florentine Renaissance artists. Though a second contract of 1407 for the first door forbade the sculptor to work on other commissions, this provision seems not to have been complied with, and before the completion of the door he had accepted commissions for the bronze statues of the Baptist and St. Matthew on Or San Michele (see Plates 82, 83 below) and for two reliefs for the Baptismal Font at Siena (1417) (see Plate 84 below). The latter, representing the Baptism of Christ and St. John the Baptist before Herod, were delivered in 1427. Other works by Ghiberti are the tomb slabs of Fra Leonardo Dati (d. 1423) in S. Maria Novella and of Lodovico degli Obizzi (d. 1424) and Bartolommeo Valori (d. 1427) in S. Croce, the Arca of the three Martyrs (1426–28), now in the Museo Nazionale, a tabernacle for Fra Angelico's Linaiuoli triptych (1432), the

Arca di San Zanobio for the Duomo in Florence (commissioned 1432, contract cancelled 1437, recommissioned 1439, completed 1442) and the bronze door of a tabernacle by Bernardo Rossellino in S. Maria Nuova (1450). None of Ghiberti's work in precious metals, of which the most important examples were a morse and mitre made for Pope Martin V in 1419 and a mitre for Pope Eugenius IV contracted for about 1439, survives. From an early stage in his career he was responsible for the cartoons of a number of stained glass windows for the Duomo, of which the earliest, an Assumption on the façade, dates from 1404, and the latest, three windows for the cupola, date from 1443. He also enjoyed a reputation as an architect, preparing a design for the cupola of the Cathedral (rejected 1436) and for the choir (rejected 1438). He made two journeys to Rome (before 1416 and late 1420s). Ghiberti died on 1 December 1455. In the history of Florentine sculpture in the first half of the fifteenth century Ghiberti has an importance second only to that of Donatello. But he remained a Gothic artist, though his late work contains strong Renaissance elements. In the *Commentari* Ghiberti expresses special admiration for a German goldsmith named Gusmin, who worked for the Duc d'Anjou, and his early reliefs reveal close familiarity with Parisian goldsmiths' work of the last quarter of the fourteenth century. On the bronze doors the handling is more closely related to metalwork than sculpture, but in the large figures on Or San Michele Ghiberti emerges as a sculptor on a monumental scale. Though associated mainly with work in bronze, Ghiberti exercised great influence in Florence on painting and

work in other mediums, and this influence radiates as far as Venice (which he visited in 1424) and the Abruzzi (where it is reflected in the work of Niccolò da Guardiagrele). The *Commentari*, perhaps written in 1447–8, is one of the main source books on Florentine art, and testifies to the interest in antiquity which formed one of the firmest strands in the complex tissue of the sculptor's style.

BIBLIOGRAPHY: The fundamental work on Ghiberti is an exhaustive volume by Krautheimer (*Lorenzo Ghiberti*, Princeton, 1956). This remarkable book contains a meticulous analysis of the documentary background for study of Ghiberti's work, of the character and sources of his style and of his writings. It supersedes all earlier monographs devoted to the artist, among them a short monograph by Planiscig (*Lorenzo Ghiberti*, Florence, 1949). The ambitious and often profound *Leben und Meinungen des Florentinischen Bildners Lorenzo Ghiberti* of Schlosser (Basel, 1941) analyses Ghiberti's place in the culture of the early Renaissance. To Schlosser is also due the standard edition of the *Commentari* (*Lorenzo Ghibertis Denkwürdigkeiten*, 2 vols., Berlin, 1912). The history of Ghiberti's collections is discussed by T. Krautheimer-Hess ('More Ghibertiana', in *Art Bulletin*, xlvi, 1964, pp. 307–21). The *Zibaldone* of Buonaccorso Ghiberti and its relevance to Lorenzo Ghiberti are discussed in a suggestive thesis summary by G. Scaglia ('Studies in the "Zibaldone" of Buonaccorso Ghiberti', in *Marsyas*, x, 1960–61, p. 71). Of articles dealing with specific aspects of Ghiberti's work the most valuable are those of Krautheimer on the origins of the artist's style ('Ghiberti and Masetro Gusmin', in *Art Bulletin*, xxix, 1947, pp. 25–35) and on the chronology of the first bronze door ('Ghibertiana', in *Burlington Magazine*, lxxi, 1937, pp. 68–80), of Poggi on technical aspects of the two bronze doors ('La ripulitura delle porte del Battistero fiorentino', in *Bollettino d'Arte*, xxxiii, 1948, pp. 244–57), of Schmarsow on the iconography of the first bronze door ('Ghibertis Kompositionsgesetze an der Nordtür des Florentiner Baptisteriums', in *Abhandlungen der Sächsischen Gesellschaft der Wissenschaft*, xviii, 1899), of Brockhaus on the Porta del Paradiso (in *Forschungen über Florentiner Kunstgeschichte*, Leipzig, 1902), and of Doren on the St. Matthew on Or San Michele ('Das Aktenbuch für Ghibertis Matthäusstatue an Or San Michele zu Florenz', in *Italienische Forschungen*, i, Berlin, 1906, pp. 1–58). An unconvincing attempt is made by Marchini ('Ghiberti ante litteram', in *Bollettino d'Arte*, 1965, pp. 181–92) to identify as early works of Ghiberti executed in the Marches a bronze relief of the Assumption of the Virgin in S. Maria dei Servi at S. Angelo in Vado, a wooden figure of the Virgin Annunciate in S. Filippo at S. Angelo in Vado, and a terracotta relief of the Virgin and Child in the Galleria Nazionale delle Marche, Urbino. On the treatment of space in Ghiberti's reliefs see especially J. White (*The Birth and Rebirth of Pictorial Space*, London, 1956) and on the architectural forms in the reliefs of the Porta del Paradiso, H. Saalman ('Filippo Brunelleschi: Capital Studies', in *Art Bulletin*, xl, 1958, pp. 113–37). The documentation of the Porta del Paradiso is extended by M. C. Mendes Aterasio ('Documenti

inediti riguardanti la "Porta del Paradiso" e Tommaso di Lorenzo Ghiberti', in *Commentari*, xiv, 1963, pp. 92–103). The articles devoted to the sculptor by Bode deal mainly with terracotta and stucco reliefs ascribed to Ghiberti, and are now of little interest.

Plates 70–72: BRONZE DOOR
Baptistry, Florence

In 1401 the Arte di Calimala determined to commission a second bronze door to accompany that completed for the Baptistry by Andrea Pisano sixty-four years earlier. With this in view a competition was held at which seven competitors were required to submit trial reliefs. The story of this competition is told in the *Commentari* of Ghiberti (p. 46): 'Fu a ciascuno dato quattro tauole d'ottone. La dimostratione uollono i detti operai e gouernatori di detto tempio ciascuno facesse una istoria di detta porta la quale storia elessono fusse la imolatione di Ysaach et ciascuno dei conbattitori facesse una medesima istoria. Condussonsi dette pruoue in uno anno e quello uinceua doueua essere dato la uictoria. Furono e combattitori questi: Filippo di Ser Brunellesco, Symone da Colle, Nicholo d'Areco, Jacopo della Quercia da Siena, Francesco di Valdombrina, Nicholo Lamberti; fummo sei a ffare detta pruoua la quale pruoua era dimostratione di gran parte dell'arte statuaria. Mi fu condeceduto la palma della uictoria da tutti i periti et da tutti quelli si pruouorono mecho. Uniuersalmente mi fu conceduta la gloria sança alcuna exceptione. . . I guidicatori furono 34 tra della citta et delle altre terre circunstanti: da tutti fu dato il mio fauore la soscriptione della uictoria, e consoli et operai et tutto il corpo dell'arte mercatoria la quale a in gouerno il tempio di sancto Giouanni Batista. Mi fu conceduto et determinato facessi detta porta d'ottone pel detto tempio. El quale condussi con grande diligentia. Et questa e la prima opera: monto collo adornamento d'intorno circa a uentidue migliaia di fiorini.' (Each of us was furnished with four sheets of bronze. The wardens and officials of the church demanded that each artist should make one narrative relief for the proposed door. The scene selected was the Sacrifice of Isaac, and this was to be treated by all of the competitors. The trial reliefs were to be submitted within a year, and whoever triumphed was to be awarded the victory. The competitors were the following: Filippo di Ser Brunellesco, Simone da Colle, Niccolò d'Arezzo (Niccolò di Luca Spinelli), Jacopo della Quercia from Siena, Francesco di Valdambrino, Niccolò Lamberti. We were six who entered the competition, and the trial was a test of a great part of the sculptor's art. The palm of victory was conceded to me by all the experts, as well as by all my fellow competitors . . . There were thirty-four judges, some drawn from the city and some from neighbouring localities; all of them testified in my favour, consuls and operai and the entire body of the Merchants' Guild which has the church of St. John the Baptist under its control, and it was decided that I should make the bronze door for the church. I worked at it with great diligence. This is my first work; with the decoration round the door it cost twenty-two thousand

florins.) Of the trial reliefs of the Sacrifice of Isaac only those of Brunelleschi and Ghiberti survive, both in the Museo Nazionale, Florence. The shape and size of the two trial reliefs, as of the reliefs of the door as finally executed, were adapted from the bronze door of Andrea Pisano. On 23 November 1403 the contract for the door was allotted to Ghiberti and his father Bartolo di Michele, both described as goldsmiths. It was stipulated that three finished reliefs should be delivered annually in the period after 1 December of the same year, and that 'Lor.ᶻᵒ debba lavorare in sui Compassi di sua mano le figure, alberi e simili cose' (that on the reliefs Lorenzo should work with his own hands the figures, trees and similar things). Though Ghiberti's studio is known by 1405 to have comprised eleven members, work seems to have proceeded slowly, and was accelerated only after 1407, when a document of 1 June establishes that the delivery rate of three reliefs a year had not been met. In this document Ghiberti's salary is fixed at 200 florins a year, he is prohibited from undertaking other works without permission from the Consoli, and is enjoined to undertake personal responsibility for the execution both of the wax and bronze reliefs 'e massimamente in su quelle parti che sono di piu perfezione come Capelli, ignudi, e simili' (and especially on those parts where the highest degree of finish is required, such as hair, naked figure and the like). It is also laid down that 'deva ogni giorno che si lavora lavorare di suo mano tutto il di come fa chi sta a provisione e scioperandosi lo sciopero gli debba essere messo a conto e scritto in un libro fatto a posto' (that on every working day he must work with his own hands all the day like any manual worker). The frame of the door was probably cast (Krautheimer) between 1415 and 1420. The door was ultimately set in position (in the entrance to the Baptistry opposite the Cathedral, now occupied by the Porta del Paradiso, and not in the north entrance, where it now stands) on Easter Sunday (19 April) 1424. It is signed, above the reliefs of the Nativity and Adoration of the Magi, in the form: OPUS.LAUREN/TII.FLORENTINI. The names of the many painters and sculptors trained in or employed by Ghiberti's workshop during the years in which work on the commission was in progress (Bartolo di Michele, his stepfather; Giuliano di ser Andrea, who was also employed on the Siena reliefs; Maso di Cristofano, probably identical with the painter Masolino; Donatello; Michelozzo; Ciuffagni; Paolo Uccello; and others) have little relevance to the style of the reliefs on the door. The procedure employed by Ghiberti in preparing the door is described by Vasari (Vite, ed. Milanesi, 1906, ii, pp. 227–28): 'Cominciando, dunque, Lorenzo l'opera di quella porta per quella che e dirimpetto all'opera di San Giovanni, fece per una parte di quella un telaio grande di legno quanto aveva a esser appunto, scorniciato, e con gli ornamenti delle teste in su le quadrature intorno allo spartimento de' vani delle storie, e con quei fregi che andavano intorno. Dopo fatta e secca la forma con ogni diligenza; in una stanza che aveva compero dirimpetto a Santa Maria Nuova, dove e oggi lo spedale de' tessitori, che si chiamava l'Aia, fece una fornace grandissima, la quale mi ricordo aver veduto, e getto il metallo di detto telaio. Ma, come volle la

sorte, non venne bene: perche conoscendo il disordine, senza perdersi d'animo o sgomentarsi, fatta l'altra forma con prestezza, senza che niuno lo sapesse, lo rigetto e venne benissimo. Onde cosi ando seguitando tutta l'opera, gettando ciascuna storia da per se, e rimettendole, nette ch'erano, al luogo suo. E lo spartimento dell'istorie fu simile a quello che aveva gia fatto Andrea Pisano nella prima porta.' (Accordingly Lorenzo began work on the door opposite the Opera of San Giovanni, he made for one wing of it a large wooden frame of the exact size required, with a moulding, and with ornamental heads on the squares surrounding the spaces for the narrative scenes, and with the friezes which were intended to surround it. After the mould had been made and dried with all care, he set up a huge furnace in some premises he had bought opposite Santa Maria Nuova, where the hospital of the silk-weavers now is, which was called l'Aia, and there he cast the metal frame. But, as fate would have it, it was not successful. Realizing that this was so, without losing heart or becoming discouraged, he made another mould with all possible speed, without informing anyone, and cast it successfully. He carried through the whole work in this way, casting each scene separately, and setting it, when it had been cleaned, in its appointed place. The disposition of the narrative scenes was like that followed by Andrea Pisano in the first door.) As in the door of Andrea Pisano each wing contains fourteen reliefs (Fig. 65), of which the four below show single figures (in this case the Evangelists and Fathers of the Church) and the ten above illustrate narrative scenes. The narrative scenes run across both wings from left to right, but they read from the bottom up and not (like Andrea Pisano's scenes from the Life of St. John the Baptist) from the top down. The first of the reliefs, the Annunciation, thus occupies the third space from the bottom on the left hand side, and the last, the Pentecost, fills the upper right corner of the right wing. The gilding of the door, which is applied to the raised surfaces only, and not to the ground, had become obfuscated by dirt by the middle of the eighteenth century, and was recovered only as a result of cleaning in 1946–8. Before this time neither the subtle chiselling of the figures nor the colouristic character of the whole door could be discerned, and accounts of this work and of the Porta del Paradiso written prior to 1948 should be read with this fact in mind. A total of 34,000 libbre of bronze were required for the casting of the door and the surrounding border, and of these 5,564 libbre were procured before 1415. The development of style within the reliefs has been discussed on two occasions by Krautheimer, who, in his final resolution, divides the scenes into four main groups: (A) characterized by crowded compositions analogous to that of the trial relief (Annunciation, Nativity, Adoration of the Magi and Baptism of Christ); (B) characterized by shallow compositions unified by the architectural background (Agony in the Garden, Christ among the Doctors, Temptation of Christ, Transfiguration and Crucifixion); (C) characterized by transitional features (Raising of Lazarus, Expulsion from Temple, Entry into Jerusalem, Christ before Pilate, Christ calming the Storm, and Resurrection) and (D) characterized

by more classical feeling, by more carefully balanced compositions and by functionally articulated movements (Arrest of Christ, Christ carrying the Cross, Flagellation, and Pentecost). The reference of the reliefs in group (A) is to the trial relief, and it is possible that these date from before 1407, though this cannot be conclusively demonstrated. Working from motifs adopted by Giovanni Turini on the Siena Font in 1416–19 and by Giuliano Fiorentino in reliefs at Valencia executed after 1417, when this sculptor left Florence, it can be shown that the compositions in groups (B) and (C) were evolved before 1417. It is argued by Krautheimer that all the quatrefoils were probably modelled and cast by 1419. Points of reference for (B) and (C) are provided by the St. John the Baptist on Or San Michele, and for (D) by the St. Matthew. The heads on the frame seem to date from a late stage in the preparation of the door. The differences between the Annunciation, with its strong reminiscences of International Gothic paintings from the circle of Lorenzo Monaco and of Northern metalwork, and the more realistic and more highly organized Christ carrying the Cross thus afford a measure of the development of Ghiberti's artistic personality in the first half of his career. Of the many local repairs on the door the most disturbing is that of the base of the cross in Christ carrying the Cross, which has been wrongly reattached. The reliefs were cast as single units, but, as noted by Krautheimer, certain figures were cast separately; these include such protuberant figures as the young king on the left of the Adoration of the Magi, the St. John in the Baptism, a youth in the foreground of the Expulsion, three figures in the Transfiguration, the Christ in the Crucifixion and the three principal figures of the Flagellation. While there is no reason to doubt Ghiberti's responsibility for the designs of all the reliefs, certain of them (e.g. the Last Supper, Christ calming the Storm and the Resurrection) are chased in a less precise and expressive fashion, and reveal the intervention of studio hands.

Plates 73–81: THE PORTA DEL PARADISO
Baptistry, Florence

The third and last of the bronze doors of the Baptistry (Fig. 66) was commissioned from Ghiberti by the Arte di Calimala on 2 January 1425, less than a year after the second door was set in place. This door was originally, like its predecessor, to have consisted of twenty-eight reliefs, twenty of them with narrative scenes from the Old Testament and eight with figures of Prophets. A programme for the reliefs was drawn up by the humanist Leonardo Bruni; according to this the scenes of the Creation of Heaven and Earth, the Creation of Adam and Eve, the Fall and the Expulsion from Paradise (later unified in a single scene) were to be represented in four separate reliefs. Bruni's advice seems, however, to have been disregarded, and the artist appears instead to have adopted a scheme proposed by Ambrogio Traversari. The documents relating to the door are published by Krautheimer. By 4 April 1436 ten narrative scenes and twenty sections of the frieze of the door had already been cast and were in course of cleaning

by Ghiberti, his son, and the sculptor Michelozzo di Bartolommeo. On 4 July 1439 we learn from a payment to Ghiberti's son Vittorio that the scenes of Cain and Abel and Jacob and Esau were completed, that that of the Story of Moses was almost ready, and that those with the Story of Joseph and the Story of Solomon were respectively half and a quarter finished. In 1440 bronze was procured from Bruges for the casting of the door. On 24 June 1443 four of the ten narrative reliefs were still incomplete, and these seem to have been finished only in 1447. The wax models for the heads round the door were in course of preparation in 1448, and in January 1451 it was stipulated that the door should be completed in twenty months. The door was finished on 13 April 1452 and gilded by 16 June of the same year. Each wing of the door as it was finally executed contains five not fourteen scenes, and it has been suggested (Schlosser, Schottmüller, Planiscig) that the apparent contradiction in the documents according to which ten scenes had been completed by 1436 and a smaller number by 1439, may be connected with this change of plan. If this were so, the ten narrative scenes completed by 1436 would have been rejected when the form of the door was reconsidered, and all of the narrative reliefs incorporated in the present door would date from after 1437. It has, however, been proved conclusively by Krautheimer that this explanation is untenable, and that the ten narrative scenes incorporated in the door are identical with those recorded in 1436. The back of each wing of the door is divided in such a way as to be consistent with a project for six oblong or twelve upright reliefs, and the date of its casting (probably 1429) provides a terminus post quem for the modelling of the narrative scenes. The ten narrative reliefs represent (left wing, top to bottom) (i) the Creation of Adam, Creation of Eve, Fall and Expulsion from Paradise, (ii) the Story of Noah, (iii) Esau and Jacob, (iv) the Story of Moses, and (v) David and Goliath, (right, wing top to bottom) (i) Cain and Abel, (ii) the Story of Abraham, (iii) the Story of Joseph, (iv) the Story of Joshua, and (v) Solomon and the Queen of Sheba. The five reliefs in each wing are framed to right and left by narrow borders containing small figures of Prophets and Sibyls in niches separated by male heads protruding from circular apertures; among the latter is the sculptor's self-portrait. Above and below are reclining figures of (above) Adam and Eve and (below) Noah and Puarphara. Outside the doorway runs a border with naturalistic foliage, animals and birds. The representation of the ark as a four-sided pyramid derives, according to Wind, from Origen. A meticulous analysis of the iconography by Krautheimer reveals references to St. Ambrose and other patristic sources, and demonstrates that the concluding scene of the Meeting of Solomon and the Queen of Sheba refers to the projected reconciliation of the Greek and Latin churches, with which Traversari was closely identified. The conception of Ghiberti's second bronze door differs radically from that of his first. In the ten large rectangular scenes, with their richly figured borders, the sculptor emancipates himself completely from the trecento scheme perpetuated in the first door. Hand in hand with this change goes a development

in the use of gilding, which is here applied not to the raised surface only but to the entire scene. Within each field a new importance attaches to the creation of a space illusion, sometimes, as in the Story of Adam and Eve, within the idiom of International Gothic landscape, sometimes, as in the Esau and Jacob, by the extended use of linear perspective. As first noted by Krautheimer, the latter relief makes use of an orthodox legitimate construction of the type described by Alberti in the *Della Pittura*. This expedient is also probably responsible for the correct diminution of the figures in the three preceding scenes. While the treatment of space is less scientific and more empirical than in the contemporary reliefs of Donatello, it fulfils its primary function of enabling a number of scenes to be represented in one field on varying, often widely diverse, planes, and at the same time (as in the paintings of Uccello) contributes to the decorative character of the compositions. So far as concerns the chronological sequence of the ten reliefs, it is concluded by Krautheimer, in part on the basis of internal evidence and in part from analogies with the reliefs of the Arca di San Zenobio, that the first scene to be modelled was the Creation, and that the confused scenes of David and Goliath and the Story of Joshua and the unified narrative of the Meeting of Solomon and the Queen of Sheba represent the last stage in Ghiberti's development as a relief artist. The treatment of the relief surface is more pictorial than in the first door, the chiselling of the heads and figures is, as a whole, less delicate and less precise, and the psychology of individual groups is less penetrating and intense. But despite their ambivalent style the panels of the Porta del Paradiso (so called on account of a comment ascribed by Vasari to Michelangelo) reveal a lyrical imagination, a poetic fantasy and a formal inventiveness which place them among the most significant achievements of early Renaissance art.

Plate 82: SAINT JOHN THE BAPTIST
Or San Michele, Florence

In 1336 it was decreed that a loggia, palace and oratory should be constructed at Or San Michele to replace a loggia destroyed by fire in 1304. Three years later it was decided that the Florentine Guilds should be required to construct tabernacles containing figures of their patron Saints on each of the twelve pillars of the new loggia. In 1406 the demand was renewed, and the Guilds to whom niches had been allotted were required to fill them, on pain of forfeiture, within ten years. Prior to 1406 four figures appear to have been executed, a Virgin and Child by Niccolò di Pietro Lamberti for the Arte dei Medici e degli Speciali, still at Or San Michele (1399), a St. Luke by the same sculptor for the Arte dei Giudici e dei Notai, now in the Museo Nazionale, a St. Stephen for the Arte della Lana, and a St. John the Evangelist for the Arte della Seta, also in the Museo Nazionale. After 1406 work on the statues was accelerated, and the figures executed after this time by Nanni di Banco, Donatello, Ciuffagni and Ghiberti together form one of the great monuments of Florentine sculpture. These figures comprise

(i) the St. Philip of Nanni di Banco (Arte dei Calzolai), (ii) the Quattro Santi Coronati of Nanni di Banco (Arte dei Maestri di Pietra e Legname) (Fig. 83), (iii) the St. Eligius of Nanni di Banco (Arte dei Maniscalchi) (Fig. 84), (iv) the St. Mark of Donatello (Arte dei Linaiuoli), (v) the St. Louis of Toulouse of Donatello (Parte Guelfa), (vi) the St. George of Donatello (Arte dei Corazzai), (vii) the St. James of Niccolò di Pietro Lamberti (Arte dei Viaii), (viii) the St. Peter (Arte dei Macellari), (ix) the St. John the Baptist of Ghiberti (Arte di Calimala) (Fig. 67), (x) the St. Matthew of Ghiberti (Arte del Cambio) (Plate 83), and (xi) the St. Stephen of Ghiberti (Arte della Lana) (Fig. 68). The paucity of documents relating to Or San Michele leaves considerable doubt as to the date of many of these figures (available evidence summarized by Paatz). The latest of the statues, the St. Stephen, substituted for an earlier figure, dates from 1427–8. Special importance attaches to the tabernacles in which the figures were set; that containing the St. John the Baptist seems to have been designed by an unknown architect, possibly Giuliano d'Arrigo (Pesello), who is mentioned in payments for the tabernacle (Paatz) and may also have been responsible for the design of a mosaic (lost) in the pediment. All of the figures are in marble save those by Ghiberti and Donatello's St. Louis; Ghiberti's Baptist was the first of the statues to be cast in bronze. The date of the figure can be established from the Strozzi index to the Libri Grandi of the Calimala (best analysis in Krautheimer), which show that it was 'being worked on' in 1413, was installed in its niche in 1416, and was parcel gilt in the following year. A transcription from a missing account book (zibaldone) of Ghiberti made by Baldinucci (*Notizie dei Professori del Disegno*, 1786, iii, p. 11), which contains a passage, dated 1 December 1414, opening with the words: 'Hereunder I will keep a record of whatsoever I shall spend on the cast of the figure of St. John the Baptist.' It can therefore be inferred that the statue was planned in 1412–13, was cast in the last month of 1414 or in 1415, and was worked up in 1415–16. The hazardous and experimental character of so large a casting is emphasized by the stipulation of the Arte di Calimala that the casting should be undertaken at the sculptor's risk, and that his expenses should not be recoverable in the event of its proving unsuccessful. The figure is cast in a single piece. On the hem of the cloak, in isolated letters, is the signature OPUS LAUR(E)NTII (mistranscribed by Schlosser, Planiscig, and in the first edition of this book as LAVRENTIVS GHIBERTVS MCCCCXIV). The whole visible surface of the statue is highly chased. It has been convincingly suggested (Krautheimer) that the sum of 530 florins paid to Ghiberti represents his remuneration in excess of the expenses incurred in connection with the statue. As we would expect in a statue executed while Ghiberti was at work on the first of his bronze doors, the drapery has the same predominantly decorative character as the reliefs of the Evangelists. But the relation of the figure to its niche marks a notable advance on that of Nanni di Banco, and the full forms and noble head attest a genius for monumental sculpture which was to find full expression in the St. Matthew (see Plate 83 below). The lettering on the scroll held by the

Baptist is well analysed by M. Meiss ('Toward a more comprehensive Renaissance Palaeography', in *Art Bulletin*, xlii, 1960, pp. 97–112), who stresses its importance as one of the first examples of humanist script in monumental art.

Plate 83: SAINT MATTHEW
Or San Michele, Florence

The statue of St. Matthew was commissioned from Ghiberti by the Arte del Cambio on 26 August 1419. This work is more amply documented than the St. John the Baptist. It is stipulated in the contract that the St. Matthew should be at least as high as the St. John the Baptist, should be cast in a single piece (though the sculptor might cast the head separately if he wished), should weigh not more than two thousand five hundred libbre, and should be completed within three years from the following July, that is by 1423. Ghiberti's remuneration for the statue, exclusive of the expenses incurred in connection with it, is assessed in an entry of 17 December 1422, as 650 florins. The statue is inscribed on the edge of the robe OPVS VNIVERSITATIS CANSORVM FLORENTIAE A.D. MCCCCXX; this date refers to the completion of the model and not to the completion of the cast. The bronze for the figure was obtained from Venice, but, on 16 July 1421, Ghiberti reported to the Guild that the casting had failed in part. It was agreed, at Ghiberti's instance, to have certain parts recast. On 30 January 1422 it was reported that this work had been satisfactorily completed, and a sum of 200 florins was allotted for the cleaning and chasing of the cast and for the installation of the statue. In December 1422 it was necessary to recast the base of the statue. On 2 May 1422 two stonemasons, Jacopo di Corso and Giovanni di Niccolò, were employed to execute Ghiberti's design for the niche, which was finished in December, and the figure was installed in its place in the following year. The figure seems to have been cast with the assistance of the sculptor Michelozzo, who was employed as a *conpagno* of Ghiberti in or before 1421, left Ghiberti's studio in 1424, and on a tax return of 1427 enters a sum due to him from the Arte del Cambio in connection with the statue of St. Matthew. The differences between the St. John the Baptist and St. Matthew are a measure of Ghiberti's emergence as a Renaissance artist. The design of the niche, with its interior pilasters, the bold pose of the figure moving forward from its base, the classicizing drapery beneath which the forms are visible, the rhetorical gesture of the right hand and the grave, classical countenance mark a notable departure from the style of the earlier statue. Whereas in the St. John the Baptist gilding seems to have been confined to the edge of the cloak, in the St. Matthew the whole surface appears to have been gilt.

Plate 84: ST. JOHN THE BAPTIST
PREACHING BEFORE HEROD
Baptistry, Siena

See Plate 85 below.

JACOPO DELLA QUERCIA
(b. *c.* 1374; d. 1438)

Jacopo della Quercia, the greatest Sienese sculptor, was the son of a goldsmith and woodcarver, Piero di Angelo, who was employed for a time at Lucca and whose unskilled and provincial style is perpetuated in a wooden Annunciation group in S. Maria at Benabbio. Vasari describes an equestrian figure executed by Quercia for the funeral of the condottiere Giovanni d'Azzo Ubaldini (d. 1390). If the sculptor in fact undertook this work, he may have been born as early as 1370–1. In 1401 Quercia was one of the competitors in the contest for the first bronze door of the Baptistry in Florence (see Plates 70–72 above). The earliest surviving work by Quercia is a relief of St. Agnellus in the sacristy of the Duomo at Lucca, which formed part of the sarcophagus carved for the altar of this Saint and dates from 1392. Traditionally and wrongly ascribed to Antonio Pardini, the 'magister operis' of the Duomo at Lucca, whose style is known from reliefs in the Cathedral and at Pietrasanta, it has been convincingly ascribed (Kosegarten) to Quercia, on the basis of resemblances to the somewhat later tomb of Ilaria del Carretto and a Madonna at Ferrara (see below). Two other hypotheses as to the style of Quercia's early work have also been advanced. According to one of these (Carli), he would have been responsible, about 1397–8, for a marble Virgin and Child above the Piccolomini Altar in Siena Cathedral. According to the other (Brunetti), he would have executed, in Florence, a marble Annunciation group now in the Museo dell' Opera del Duomo and would have worked on certain parts of the Porta della Mandorla of the Cathedral. While contacts appear to have existed between Quercia and the contemporary Florentine sculptors working on the Porta della Mandorla, this second attribution is unacceptable. A convincing reconstruction of the work of the Master of the Opera del Duomo Annunciation is supplied by Wundram ('Der Meister der Verkündigung in der Domopera zu Florence', in *Beiträge zur Kunstgeschichte, eine Festgabe für H. R. Rosemann*, Berlin, 1960, pp. 109–25). There are good reasons to believe that, at a still earlier stage, Quercia came in contact in Bologna with works by the Dalle Masegne and by Emilian followers such as the authors of the tomb-slab of Andrea Manfredi (d. 1396) in S. Maria dei Servi, and of the monument of Carlo, Riccardo and Roberto Saliceto from S. Martino, now in the Museo Civico (1403). In 1403 Quercia was commissioned by the executors of Virgilio Silvestri da Rovigo to execute a marble Virgin and Child for the Cathedral at Ferrara. The requisite marble was procured from Carrara by 1406, and the figure was carved between January and September of this

year; it is identical with a statue in the Museo dell'Opera del Duomo at Ferrara, which carries an inscription of more recent date with Quercia's name and the year 1408. This work is followed by the tomb of Ilaria del Carretto in the Duomo at Lucca (see Plate 86 below). At Lucca he executed the tomb slabs of the Trenta family and the Trenta altar in S. Frediano (see Plates 87, 88 below). His first important work in Siena, the Fonte Gaia, was commissioned in 1409 and carved between 1414 and 1419 (see Plate 89 below). Between 1417 and 1431 he participated in work on the Baptismal Font in S. Giovanni, Siena (see Plate 85 below), and from 1425 until his death in 1438 he was responsible for the design and execution of the central doorway of S. Petronio, Bologna (see Plates 90–95 below). During its earlier phase work on the S. Petronio doorway was interrupted by the claims of the Siena Font, and during its later phase by the decoration of the Cappella Casini in Siena Cathedral (after 1430; the right half of a lunette with Cardinal Casini presented by St. Anthony the Abbot to the Virgin and Child survives in the Ojetti collection) and by the Vari-Bentivoglio monument in S. Giacomo Maggiore, Bologna (carved after 1433 for the Vari family of Ferrara, confiscated after the artist's death by the authorities of the Opera del Duomo at Bologna, and acquired in 1443 by Annibale Bentivoglio). A wooden Annunciatory Angel and Virgin Annunciate in the Collegiata at San Gimignano (Fig. 76) date from 1421. Quercia's development presents problems of great difficulty, and the relief style of the Fonte Gaia marks a radical departure in the Tuscan sculpture of its time. This style is carried further in the Trenta monument and the Baptismal Font and reaches its climax on the Bologna façade. There is evidence that Quercia was in contact with North Italy, but the course of his development can hardly be explained unless we assume him to have been familiar with Transalpine sculpture from the circle of Claus Sluter at Dijon.

BIBLIOGRAPHY: The literature of Quercia is weaker than that of Ghiberti, and none of the existing monographs is on the level demanded by the sculptor's work. A large and amply illustrated volume by Supino (*Jacopo della Quercia*, Bologna, 1926) has been in part invalidated by the rich fund of new documents published by Lazzarreschi ('La dimora a Lucca di Jacopo della Quercia e di Giovanni da Imola', in *Bollettino Senese di Storia Patria*, xxxii, 1925, pp. 63–97) and Bacci (*Jacopo della Quercia: nuovi documenti e commenti*, Siena, 1929). A short monograph by Biagi (*Jacopo della Quercia*, Florence, 1946) gives an accurate survey of Quercia's work; some of the critical problems ignored in this book are discussed by Nicco (*Jacopo della Quercia*, Florence, 1934). O. Morisani's *Tutta la scultura di Jacopo della Quercia* (Milan, 1962) provides a useful body of small illustrations with sometimes tendentious annotation. An elaborate article by Lanyi ('Quercia Studien', in *Jahrbuch für Kunstwissenschaft*, 1930, pp. 25–63), vindicating Quercia's authorship of the Madonna at Ferrara, is of interest for its method rather than for its results. The documents relating to the Ferrara commission are published by N. Rondelli ('Jacopo della Quercia a

Ferrara, 1403–1408', in *Bollettino Senese di Storia Patria*, lxxi, 1964, pp. 131–42). The attribution to Quercia of the Madonna and Child in the Duomo at Siena is due to Carli (in *Critica d'Arte*, xxvii, 1949, pp. 71–24), and that of the Annunciation in the Museo dell'Opera del Duomo at Florence to Brunetti ('Jacopo della Quercia a Firenze', in *Belle Arti*, 1951, pp. 3–17; 'Jacopo della Quercia and the Porta della Mandorla', in *Art Quarterly*, 1952, pp. 119–31). The Bolognese background of Quercia's early work is discussed, inaccurately, by Bettini ('Un'opera sconosciuta di Andrea da Fiesole', in *L'Arte*, n.s. ii, 1931, pp. 506–12) and more precisely by Gnudi ('Intorno ad Andrea di Fiesole', in *Critica d'Arte*, iii, 1938, pp. 23–29). A Madonna of Humility in the National Gallery of Art, Washington, published by Seymour and Swarzenski ('A Madonna of Humility and Quercia's early Style', in *Gazette des Beaux-Arts*, lxxxviii, 1946, pp. 129–52) is perhaps by Domenico di Niccolò dei Cori. On the development of the Fonte Gaia project see Krautheimer (in *Bulletin of the Metropolitan Museum of Art*, 1952, pp. 265–74) and a useful volume by A. C. Hanson (*Jacopo della Quercia's Fonte Gaia*, Oxford, 1965). Additional light is thrown on Quercia's work for Lucca Cathedral by H. Klotz ('Jacopo della Quercias Zyklus der "Vier Temperamente" am Dom zu Lucca', in *Jahrbuch der Berliner Museen*, ix, 1967, pp. 81–99). The material relating to the Bologna façade is discussed by J. H. Beck ('Jacopo della Quercia's Design for the Porta Magna of San Petronio in Bologna', in *Journal of the Society of Architectural Historians*, xxiv, 1965, pp. 115–26) and less importantly by A. M. Matteucci (*La Porta Magna di S. Petronio in Bologna*, Bologna, 1966) and C. Gnudi ('La Madonna di Jacopo della Quercia in S. Petronio a Bologna', in *Atti e memorie della Deputazione di Storia Patria per le Provincie di Romagna*, n.s. iv, 1953, pp. 5–12). The documentation of the Vari-Bentivoglio monument is published by Matteucci (*Il tempio di San Giacomo Maggiore in Bologna. Studi sulla storia e le opere d'arte*, Bologna, 1967, pp. 73–82). On the wooden sculptures of Quercia see E. Carli (*Scultura lignea senese*, Milan-Florence, 1951, pp. 69–73; *La scultura lignea italiana*, Milan, 1960, pp. 82–87), P. Sanpaolesi ('Una figura lignea inedita di Jacopo della Quercia', in *Bollettino d'Arte*, 1958, pp. 112–16), and C. L. Ragghianti ('Novità per Jacopo della Quercia', in *Critica d'Arte*, xii, 1965, pp. 35–47). A figure in the Staatliche Museen, Berlin-Dahlem, is mistakenly given to Quercia by Wundram ('Die sienesische Annunziata in Berlin. Ein Frühwerk des Jacopo della Quercia', in *Jahrbuch der Berliner Museen*, vi, 1964, pp. 38–52).

Plate 85: BAPTISMAL FONT
San Giovanni, Siena

The Baptismal Font in Siena (Fig. 64) consists of two parts, a hexagonal basin raised on two steps and a central tabernacle surmounted by a figure of St. John the Baptist. The long history of the Font opens in May 1416, when the commission for the marble basin was entrusted to three sculptors, Sano di Matteo, Nanni di Jacopo da Lucca and Giacomo di Corso da Firenze. In July of this year Ghiberti was summoned to

Siena in connection with the Font, and in December the Sienese sculptor Giovanni Turini visited him in Florence. In January 1417 Ghiberti again came to Siena, later despatching a specimen bronze cast from Florence for inspection by the Operaio. In March a representative from Siena again visited Ghiberti, and in April a model of the Font was prepared. It is clear from the documents relating to this phase of the construction of the Font that the decision to decorate the hexagonal basin with gilt bronze narrative reliefs was due in large part to Ghiberti. In April two of these reliefs were commissioned from the Sienese goldsmiths and sculptors Turino di Sano and Giovanni Turini (the Birth of St. John and St. John preaching) and two from Jacopo della Quercia (Zacharias in the Temple and the Presentation of the Baptist's Head to Herod). In May Ghiberti, who again visited Siena, received the commission for the two remaining reliefs (the Baptism of Christ and St. John preaching before Herod). In 1423 the commission for one of the two reliefs allocated to Quercia (the Presentation of the Baptist's Head to Herod) was transferred to Donatello, and in 1425, as a result of the unsatisfactory progress of the work, Quercia, Donatello and Ghiberti were required to make restitution of certain sums advanced to them. The two reliefs by Turino di Sano and Giovanni Turini were ultimately delivered in May 1427, that by Donatello in October 1427, and those by Ghiberti (of which the second (Plate 84) was executed in part by Ghiberti's assistant, Giuliano di ser Andrea) in November of the same year. Payments for Quercia's Zacharias in the Temple run from April 1428 to August 1430, and this relief was thus begun after that by Donatello (by which it is strongly influenced) was received in Siena. It is, however, argued by Krautheimer (*Lorenzo Ghiberti*, Princeton, 1956, p. 117n.) that Quercia's relief was modelled in 1419. This inference, based on the supposed appearance of a motif from the Annunciation to Zacharias in Giovanni Turini's and Turino di Sano's *Preaching of the Baptist*, is unconvincing. At the corners of the basin are six niches containing gilt bronze statuettes of Virtues, of which the Hope and Faith are by Donatello (1427–9), the Strength is by the goldsmith Goro di ser Neroccio (1428–31) and the Charity, Justice and Prudence are by Giovanni Turini (1429–31). The six narrative reliefs are heterogeneous in style, and range between the poles of the Birth of St. John the Baptist (with its empirical space construction and figures adapted from Ghiberti's first bronze door) and the Presentation of the Baptist's Head (with its strong dramatic content and developed perspective scheme). The space construction of Quercia's Zacharias in the Temple is less scientific and less assured than that of Donatello's relief, and the heavy Romanesque architecture distinguishes it from Ghiberti's St. John preaching before Herod. The symbolic opposition of Romanesque to Gothic architecture (as emblematic respectively of the Old and the New Law) is not uncommon in Flemish fifteenth-century painting, and tends to confirm that Quercia must have been familiar with Northern art. With the exception of the tabernacle door (by Giovanni Turini) and five small putti on the corners (three by Giovanni Turini and two by Donatello; the sixth, also by

Donatello, formerly in Berlin), the upper section of the Font is carved in marble. Work on this part of the structure began after June 1427, when Quercia was commissioned to complete the Font. In this he was assisted by a Sienese, Pietro del Minella, and the Florentine Pagno di Lapo Portigiani. There is no documentary proof that the tabernacle was designed by Quercia, but Quercia was certainly responsible for its main sculptural features, five Prophets in niches between pilasters and a statuette of St. John the Baptist, and seems to have played the same dominant role in this part of the monument as Ghiberti in the basin beneath. The prophets appear to have been executed in 1428–30. The niches flanked by pilasters, in which they are set, recall those beneath the Coscia monument of Donatello in the Baptistry in Florence (on which Pagno di Lapo Portigiani also worked), but the figures themselves, though influenced by Donatello, seem also to postulate some knowledge of Burgundian sculptures.

Plate 86: TOMB OF ILARIA DEL CARRETTO
Duomo, Lucca

One of the most celebrated of all Italian monuments, the tomb of Ilaria del Carretto (Fig. 69) is described in Vasari's life of Jacopo della Quercia (*Vite*, ed. Milanesi, 1906, ii, pp. 111–12): 'Partito dunque da Siena, si condusse per mezzo d'alcuni amici a Lucca, e quivi a Paulo Guinigi, che n'era signore, fece per la moglie, che poco inanzi era morta, nella chiesa di San Martino una sepoltura; nel basamento della quale condusse alcuni putti di marmo che reggono un festone tanto pulitamente, che parevano di carne; e nella cassa posta sopra il detto basamento fece con infinita diligenza l'immagine della moglie d'esso Paulo Guinigi, che dentro vi fu sepolta; e a' piedi di essa fece nel medesimo sasso un cane di tondo rilievo, per la fede da lei portata al marito. La qual cassa, partito o piuttosto cacciato che fu Paulo l'anno 1429 di Lucca, e che la citta rimase libera, fu levata di quel luogo, el, per l'odio che alla memoria del Guinigio portavano i Lucchesi, quasi del tutto rovinata. Pure la reverenza che portarono alla bellezza della figura e di tanti ornamenti, li rattenne, e fu cagione per poco appresso la cassa e la figura furono con diligenza all'entrata della porta della sagrestia collocate, dove al presente sono.' (Leaving Siena, he [Quercia] betook himself by means of certain friends to Lucca, where he made a tomb in the church of San Martino for the wife of the lord of Lucca, Paolo Guinigi; she had died shortly before. On the base of this tomb he executed some marble putti carrying a garland in so polished a fashion that they seemed made of flesh; and on the sarcophagus placed above this base he made with infinite diligence the likeness of the wife of Paolo Guinigi, who was buried within it; and at her feet he placed a dog in full relief carved from the same stone, as an emblem of the faith she bore her husband. When Paolo departed, or more properly was expelled from Lucca in 1429 and the city was freed, the tomb was removed from the place in which it was set, and, because of the hatred which the Lucchese bore towards Guinigi, was almost completely ruined. But the reverence which was felt for the beauty of the

figure, and of so many of the ornaments, restrained them, and was the reason why not long afterwards the sarcophagus and figure were carefully set up at the entrance to the sacristy, where they now are.) Both the identification of the monument as that of Ilaria del Carretto and its ascription to Jacopo della Quercia have been contested. Maria Ilaria, daughter of the Marchese Carlo del Carretto, became the second wife of Paolo Guinigi in February 1403, and died in December 1405. The identity of the tomb as that of Ilaria (rather than of Paolo Guinigi's first wife, Maria Caterina degli Antelminelli) is established by the coat-of-arms recovered in 1911 and now at the head of the sarcophagus, which is quartered with the device of the Guinigi and (beneath repainting now removed) with that of Ilaria del Carretto. Paolo Guinigi married for the third time in April 1407, and it is widely accepted that the monument was in all probability executed in the course of the year 1406. The Guinigi account books for the year 1406 do not survive. It is argued by Kosegarten, probably correctly, that the remarriage of Paolo Guinigi does not constitute a *terminus ante quem* for the tomb, and that if Quercia was in Ferrara till 1408, the monument must have been carved after this time. It has also been suggested (Lanyi following Milanesi) that the monument was executed in 1413, when Quercia is known to have been in Lucca, but this is improbable. Though there is no firm evidence of the presence of Quercia in Lucca in 1406, it is known that his father, Piero di Angelo, was employed in 1401 by Paolo Guinigi. It is claimed by Bacci that the putti on the north side of the sarcophagus were executed by Francesco da Valdambrino, who appears to have been in Lucca at this time. These are certainly by a different hand from those on the south side, but have no explicit connection with Francesco da Valdambrino. After its reassembly, the monument was removed on at least two occasions, and there is no certainty as to its original form, which may have included a tabernacle or other superstructure. It has been conjectured, implausibly, that it was set below the level of the pavement of the church (Morisani), and (Del Bravo) that it was placed in a niche which would have rendered one side of the sarcophagus invisible, one of the lateral reliefs and the reliefs at the two ends being later additions. As it exists today, it consists of two parts. The first of these is a sarcophagus surrounded by winged putti bearing garlands. As noted by Bacci, a number of fragmentary Roman sarcophagi in the Campo Santo at Pisa (Papini, *Catalogo delle cose d'arte e di antichità d'Italia: Pisa*, ii, 1932, Nos. 84–86) offer close analogies to, and perhaps served as the basis of, this part of the tomb. A Roman sarcophagus was employed in the tomb of Giovanni di Parghia degli Antelminelli of Lucca in the Campo Santo. The monumental effigy finds precedents in the Lombard tomb of Bianca of Savoy (1387) in the Museo del Castello Sforzesco (Vigezzi, *La Scultura in Milano*, i, 1934, No. 384, pp. 124–25), and a parallel (Kosegarten) in the Catherine of Alençon monument in the Louvre (*c.* 1410–12), and is Northern (perhaps French) in type. The awkward relation of the effigy to the sarcophagus has not been satisfactorily explained, and it is likely that they were originally separated by a missing element. The

arguments against the view that they represent pieces of two different tombs, the upper section originating from the tomb of Paolo Guinigi's first wife, Maria degli Antelminelli, and the lower section from that of Ilaria del Carretto, are marshalled by Kosegarten. The Northern character of the monument can be adequately explained through Guinigi's extensive contacts with Burgundy and France, which appear also to have been reflected in his library and collection (for these see E. Lazzareschi, 'Il Tesoro di Paolo Guinigi', in *Bollettino storico lucchese*, iii, 1931, pp. 73–79).

Plates 87–88: THE TRENTA ALTAR
San Frediano, Lucca

The Trenta altar (Fig. 70) was begun after 1416, when the donor, Lorenzo Trenta, secured permission to replace the existing altar in the chapel in which it stands, and was completed in 1422. The latter date appears beneath the Virgin and Child in the centre of the altar in an inscription which reads: HOC OPVS FECIT IACOBVS MAGISTRI PETRI DE SENIS. 1422. The sculptor had been employed in the chapel as early as 1413, and in 1416 carved the tomb slabs of Lorenzo Trenta and of his wife and their descendants for the Cappella di S. Caterina near S. Frediano, later moved to the Trenta chapel in the latter church. An attempt has been made (Krautheimer, in *La Diana*, iii, 1928, pp. 278–79) to assign the upper part of the altar and the predella to different stages in Quercia's development (lateral saints, 1413; Madonna, 1416; predella 1422). This is questionable, and both parts of the altar probably represent the artist's style in the period after the commencement of the Fonte Gaia and before the commencement of the upper section of the Baptismal Font. Quercia is known to have been in Lucca in May 1422. It has also been claimed (Del Bravo) that the altar was designed and blocked out as early as 1412, and that the tomb slabs were designed at the same time. The form of the altar is that of a pentaptych with five niches containing figures of (centre) the Virgin and Child flanked by (left to right) SS. Ursula, Lawrence, Jerome and Richard. Beneath is a predella showing (left to right) the Massacre of the Virgins, the Martyrdom of St. Lawrence, Christ in the Tomb with the Virgin and St. John, St. Jerome and the Lion, and a Miracle of St. Richard. Above the four lateral niches are half-length figures of Evangelists (probably executed by Giovanni da Imola); the central niche may originally have been surmounted by a half-length Redeemer (now lost) and the pilasters at the sides by an Annunciatory Angel and Virgin Annunciate, but there is no firm evidence of this. The structure of the altar, and notably the form of the canopies of the five niches, with their receding surfaces, is derived from the altar of Tommaso Pisano in S. Francesco at Pisa, perhaps modified by contact with the advanced Gothic style of the Dalle Masegne as it is exemplified in the altar in S. Francesco at Bologna (1388). Lorenzo Trenta, a Lucchese silk-merchant trading in Bruges and Paris, was certainly familiar with Northern art, and features of the tomb-slabs are strongly Northern in character. It is suggested by Meiss (*French Painting in the Time of Jean de Berry: the*

Boucicaut Master, London, 1968, pp. 68, 100–1) that the relief of the Martyrdom of St. Lawrence was inspired by a representation of this scene in a Missal illuminated by the Boucicaut Master for Lorenzo Trenta about 1415, which is now in the Biblioteca Governativa, Lucca. Of special importance is the fact that the five figures are conceived as deep reliefs, and not as statues or statuettes, unified in a single linear pattern with the architectural forms. Both Del Bravo and Nicco Fasola ('Jacopo della Quercia', in *Enciclopedia Universale dell'Arte*, iv, 1960, c. 248) over-emphasize the share of Giovanni da Imola in the main altar reliefs. In the dramatic scenes beneath use is made not, as in the Zacharias in the Temple on the Baptismal Font, of a form of perspective representation, but of the spatial conventions of International Gothic art. The scenes are carved in relatively low relief, and mark a point of transition between the Genesis reliefs on the Fonte Gaia and the reliefs of the Bologna door.

Plate 89: THE FONTE GAIA
Palazzo Pubblico, Siena

Until 1858 the Fonte Gaia, of which the sections are now preserved in a fragmentary state in the loggia of the Palazzo Pubblico at Siena (Fig. 71), occupied its destined place in the Piazza del Campo. Rectangular in form, it consisted of an open basin into which water was discharged from low jets set at the back and sides. Its main sculptural features comprised at the back five large niches with rounded tops carved with seated figures in deep relief, and at the sides two sloping wings, adjusted to the level of the Campo, each containing three niches diminishing in size. The reliefs showed (left to right) the Creation of Adam, Wisdom, Hope, Fortitude, Prudence, the Virgin and Child flanked by two Angels (Fig. 73), Justice, Charity, Temperance, Faith and the Expulsion from Paradise (Fig. 72). On the forward corners of the fountain were figures of (left) Acca Larentia and (right) Rea Silvia, the foster-mother and mother of the legendary founders of Siena, Romulus and Remus. The fountain, which occupied a central position in the city analogous to that of the Fontana Maggiore at Perugia, replaced an earlier fountain constructed between 1334 and 1343, which is known to have included steps (presumably leading down into the basin) and was decorated with a figure of the Virgin and Child (Hanson). A replacement for this work was commissioned from Jacopo della Quercia prior to 15 December 1408. In a document of 22 January 1409 the price is given as 2000 florins. From a later statement by the sculptor it is known that in 1408 he made a drawing of the fountain on the wall of a room in the Palazzo Pubblico. The contract of 1409 also refers to the existence of a drawing by the sculptor 'in quadam carta edina'; this has sometimes been identified with a sheet in the Victoria and Albert Museum, London, of which another section is in the Metropolitan Museum, New York. Though claimed by Lanyi and Krautheimer as a drawing by Quercia for the fountain, these sheets are more probably derivatives from one of Quercia's designs. C. Seymour ('"Fatto di sua mano". Another Look at the Fonte Gaia Drawing Fragments in London and New York', in

Festschrift U. Middeldorf, Berlin, 1968, pp. 93–105) regards the sheets as identical with the drawing of 1409, but ascribes them to Martino di Bartolommeo. If the testimony of the two sheets is to be believed, the wings were originally to have comprised two niches containing seated figures and omitting the two Genesis scenes, and the niches themselves were to have been narrower than those ultimately constructed, perhaps with pointed tops. The scheme of the fountain is known to have been modified once more in January 1415, and the two narrative scenes were probably added at this time. Reference is made to the purchase of marble for the fountain in January 1414, and effective work on the sculptures may be localized between this date and October 1419 when the concluding payment was made. The reliefs are thus roughly contemporary with the figure of an Apostle in the Duomo at Lucca and immediately precede the Trenta altar (see Plates 87–88 above), and are at least six years later than the Ferrara Madonna; this interval does something to explain the change in style manifest in the later work. Of the two free-standing figures, one, the Rea Silvia, was gravely damaged by a fall in 1743, and was reinstalled by Giuseppe Mazzuoli, to whom the lower section is due. The right arm has been claimed as a replacement of the same date, but is possibly original (Hanson). This statue has been given (Bacci) to Francesco di Valdambrino on the strength of a statement in the *Cronaca Senese* of Antonio di Martino da Siena under the year 1419 (known through a copy of 1490) that this sculptor 'fece una di detta fighura'. Though not confirmed by any document, this record seems to have some validity, and is corroborated by the carving of the head and drapery. The model is, however, clearly by the same artist as the companion figure. It is assumed by Hanson that the Rea Silvia was executed in 1416–18, before the Acca Larentia. The Acca Larentia, despite its weathered state, preserves much of Quercia's handling, and derives from a classical prototype of the class of a Roman Venus at Madrid (Garcia y Bellido, *Esculturas Romanas de España y Portugal*, Madrid, 1949, No. 147). Some impression of the reliefs can be formed from the least damaged figures, the Wisdom and the Virgin and Child, and it is clear, from the handling of detail on the inner sides, that they were originally as highly worked as the Ilaria del Carretto and the Ferrara Madonna would lead us to anticipate. The more legible of the two narrative scenes is the Expulsion; the exceptionally deep relief employed in this and the companion scene may be compared with that of the two narrative reliefs by Nanni di Banco on Or San Michele. The evidence from copies for the original appearance of the reliefs is reviewed by A. Bertini ('Calchi della Fonte Gaia', in *Critica d'Arte*, xv, 1968, pp. 35–54).

Plates 90–95: DOORWAY
San Petronio, Bologna

The contract for Quercia's masterpiece, the central doorway of San Petronio in Bologna (Fig. 74), was signed on 28 March 1425. The text (known through a sixteenth-century copy transcribed by Supino, of which the best

analysis is that of Breck) refers to a pre-existing drawing prepared by Quercia, and specifies the dimensions agreed on for the architectural features of the door. As originally planned the door was to include fourteen narrative reliefs on the lateral pilasters, three Nativity scenes running across the architrave, twenty-eight busts of prophets, a lunette with the Virgin and Child and S. Petronio and a standing figure of Pope Martin V with a kneeling portrait of Lodovico Alemanno, Papal Legate and Governor of Bologna, who was responsible for the commission, two life-size lions, statues of SS. Peter and Paul above the pilasters, a relief of Christ in glory supported by angels, and a Christ on the Cross rising from the foliated decoration at the apex of the scheme. There is some reason to think that the initial scheme was modified as work proceeded on the door; thus there are five narrative reliefs, not seven, in each of the pilasters, and five reliefs, not three, in the architrave above the door. As demonstrated by Breck, the change in the number of narrative reliefs from seven to five did not affect the total height of the pilasters, since the individual scenes prescribed in the contract measured 76×68 cm., while the actual scenes measure 82×68 cm. The stone for these reliefs was ordered in 1429, and it can therefore be inferred that the reduction in the number of pilaster reliefs and the increase in the number of architrave reliefs was agreed before this time. It is suggested by Breck that the content of the lunette was changed after 1428, when following a rebellion in Bologna the city was placed under a papal interdict, and that the figures of Martin V and Lodovico Alemanno were omitted from the scheme at this time. It has also been proved that a drawing of 1522 by Peruzzi, which shows the present number of pilaster and architrave reliefs, is based on a lost drawing by Quercia of 1428–31. This drawing constitutes the only firm evidence for the form of the upper part above the lunette, which had not been constructed at Quercia's death. A document published by Breck ('An important new document for Jacopo della Quercia in Bologna', in *Arte antica e moderna*, 1962, pp. 206–7) proves that the statue of St. Petronius was installed in the lunette on 21 November 1434. Work on the doorway seems to have progressed spasmodically. In 1426 and 1427 Quercia visited Verona to secure red marble for the door, and in 1429 he was in Venice engaged in procuring Istrian stone. These visits were repeated in 1432 and 1433. At the end of 1428 and the beginning of 1429 he was in Siena, where he was engaged on the Baptismal Font (see Plate 85 above), and in 1435 he was appointed Operaio of the Duomo at Siena. On 20 October 1438 Quercia died, leaving the doorway incomplete. The figure sculpture concluded by Quercia before his death comprised ten Old Testament reliefs, five reliefs from the New Testament, the eighteen half-length Prophets set beside

the doorway, and the Virgin and Child and San Petronio above. In 1510 it was decided to dismantle the portal, move it forward some fifty centimetres towards the piazza, and complete it. At this time a figure of St. Ambrose by Domenico Aimo da Varignana was substituted for the projected figures of Martin V and Lodovico Alemanno, and the lunette was completed with a frieze of fifteen Prophets carved in imitation of Quercia's reliefs. A suggestion of Morisani and Matteucci that the St. Ambrose was begun by Quercia and completed by Domenico Aimo da Varignana is refuted by Breck ('A Document regarding Domenico da Varignana', in *Mitteilungen des Kunsthistorischen Institutes in Florenz*, xi, 1964, pp. 193–94; and in *Art Bulletin*, l, 1968, pp. 384–85). This is the form of the door as it stands today. The reliefs show (left pilaster, top to bottom) the Creation of Adam, the Creation of Eve, the Fall, the Expulsion from Paradise, and the Labours of Adam and Eve, (right pilaster, top to bottom) the Sacrifices of Cain and Abel, the Murder of Abel, the Release from the Ark, the Drunkenness of Noah and the Sacrifice of Isaac, (architrave, left to right) the Nativity, the Adoration of the Magi, the Presentation in the Temple, the Massacre of the Innocents and the Flight into Egypt. The choice of scenes (e.g. the two reliefs devoted to the story of Cain and Abel and the substitution of the Release from the Ark for the more usual Building of the Ark) is unusual, and suggests that the selection was determined by an Emilian Romanesque tradition represented by the façade of the Duomo at Modena, where three scenes from the story of Cain and Abel are included and the Release from the Ark is also shown. It is likely that the archivolt and figurated architrave of the Porta dei Principi at Modena influenced the form of the upper part of Quercia's doorway. There is no indication of the order in which the reliefs were executed. The quality of those in the architrave is somewhat lower than that of the pilaster reliefs. The magnificent scenes from Genesis are autograph carvings by Quercia, but the two concluding reliefs on the right-hand pilaster are less distinguished than those which precede them, and one of these, the Sacrifice of Isaac, perhaps retains features of Quercia's lost trial relief of 1402. The Virgin and Child in the lunette, with its diagonal pose, is the most elaborate of Quercia's free-standing statues. The gaze and gesture of the Child were no doubt directed to the figure of Lodovico Alemanno, intended to be set on the left side of the lunette. With the exception of one relief, the Murder of Abel, which seems to have been carved from a defective slab of stone, and certain protruding surfaces, the reliefs, though dirty and polluted, are well preserved, as are the adjacent strips of foliage, which are exceptionally free in handling and must be in part autograph. A surface preparation has been applied in modern times to the figures in the lunette.

FLORENTINE SCHOOL

Plate 96: VIRGIN AND CHILD
National Gallery of Art, Washington

The Virgin and Child in Washington (No. A.147. Terra-

cotta. H.: 103 cm. Coll.: E. Simon, Berlin; Clarence Mackay, Long Island; S. H. Kress Collection) belongs to a class of pigmented terracotta and stucco Madonnas produced in Florence in the second quarter of the fifteenth century.

Existing in a single version, it was given by Bode ('Lorenzo Ghiberti as leader of the clay-modellers of the early half of the Quattrocento', in *Florentine Sculptors of the Renaissance*, 2nd ed., 1928, pp. 61–70) to Ghiberti, to whom it is still officially ascribed, was connected by Krautheimer ('Terracotta Madonnas', in *Parnassus*, viii, December, 1936, pp. 5–8) with Jacopo della Quercia, to whom it is also given by C. L. Ragghianti ('Novità per Jacopo della Quercia', in *Critica d'Arte*, xii, 1968, pp. 35–47), and is ascribed by Planiscig ('Die Bildhauer Venedigs in der ersten Hälfte des Quattrocento', in *Jahrbuch der Kunsthistorischen Sammlungen in Wien*, n.f. iv, 1930, p. 82) to Nanni di Bartolo (see below, page 216). Half-length Madonnas of this class enjoyed great popularity through the middle of the fifteenth century. The connection of the present relief with Quercia is not a close one, and it is probably, but not certainly, by the same hand as two half-length Madonnas in Berlin (Nos. 1562/Sch. 20 and 138/Sch. 19), also given to Nanni di Bartolo by Planiscig, who notes a connection between the Child of the present group and the two putti holding back the curtain of the Brenzoni monument in S. Fermo at Verona (Fig. 90). The ascription to Nanni di Bartolo is inconclusive.

No half-length Madonnas can be directly associated with Ghiberti, though many of them reflect aspects of his style and one of them, formerly in the Kaiser Friedrich Museum, Berlin (No. 7181), is set on a base cast from the reclining female figure above the left wing of Ghiberti's Porta del Paradiso. A number of other works are associable with the hand responsible for the prototype of this composition.

A third group of works in terracotta and stucco is by an anonymous artist influenced by Ghiberti but practising a notably individual style. The principal works of this sculptor are a Virgin and Child in glazed terracotta formerly in the Palazzo Davanzati, Florence, the front of a chest with three glazed terracotta reliefs of Genesis scenes in the Victoria and Albert Museum, London, a relief from a companion chest with the Creation of Eve in the Museo dell'Opera del Duomo, Florence (all ascribed to Ghiberti by Bode, 'Ghibertis Versuche seine Tonbildwerke zu glasieren', in *Jahrbuch der Preussischen Kunstsammlungen*, xlii, 1921, pp. 51–54), and half-length Madonnas in the Memorial Art Museum, Rochester (Fig. 77), and the collection of Mrs. Edsel Ford, Detroit. This artist, who is perhaps to be identified with Ghiberti's son, Vittorio Ghiberti (b. 1418), is characterized by the use of glaze in certain of his works, by the employment of gilding (e.g. on the London Genesis scenes and on the hair of the Virgin and Child in Detroit), and by the elegance

and refinement of his designs. None of his surviving works can be dated before the second quarter of the fifteenth century.

A fourth group comprises reliefs, e.g. a Virgin and Child formerly in Berlin (No. 7177), and Madonnas in the Museo Bardini and the Museo di Santo Spirito, Florence, which seem to derive from compositions by Quercia. These are correctly ascribed by C. del Bravo (*Scultura senese del Quattrocento*, Florence, 1970, p. 72) to Antonio Federighi.

A fifth group of works in terracotta is attributable to the presumed Michele da Firenze, who appears, on the strength of a payment of 1436 (Fiocco, 'Michele da Firenze', in *Dedalo*, xii, 1932, pp. 542–43) to have been responsible for the most important example of terracotta decoration in the first half of the fifteenth century, the Pellegrini Chapel in S. Anastasia at Verona (Fig. 78). The scheme of this decoration comprises twenty-four reliefs with scenes from the Life of Christ, set between twisted pillars, and accompanied by Gothic niches containing statuettes of Saints and a kneeling figure of the donor of the Chapel. The iconography of certain of the reliefs provides corroboratory evidence that the sculptor of the Chapel was a Florentine; thus the central figures of the Nativity presuppose knowledge of Arnolfo di Cambio's Nativity on the façade of the Duomo in Florence, the Adoration of the Magi is based in reverse on the relief of this subject on Ghiberti's first bronze door, and a Nativity on the Istituto dei Buoni Fanciulli at Verona, which certainly originates in the same workshop, depends from the Nativity on the first door. The idiom of the Pellegrini Chapel is not, however, purely Florentine, and the architecture includes decorative features which have led Venturi and other students to regard the reliefs as North Italian. It is clear that the sculptor, if a Florentine, reflected aspects of local style in north-east Italy. Associated with the Pellegrini Chapel are a number of other monuments, of which the most important are a terracotta altar in the Cathedral at Modena (1442) and the tomb of Francesco Rosselli in S. Francesco at Arezzo (1431). In 1441 Michele da Firenze executed an altar for the church of Belfiore at Ferrara, and the Modena altar reveals the influence of Emilian prototypes from the circle of the Dalle Masegne and Jacopo della Quercia. Though a contrary case is advanced by Balogh (in *Az Orszagos Magyar*, ix, 1940, p. 50), who regards the Rosselli monument and the sculptures related to it as Aretine, and the Pellegrini Chapel as Lombard-Veronese, it is very probable that the reliefs at Arzzeo, Verona and Modena represent three different phases in the activity of a single artist.

DOMENICO DI NICCOLÒ
(b. c. 1363; d. before 1453)

A contemporary and associate of Francesco di Valdambrino, Domenico di Niccolò was a member of the supervisory

commission for the Fonte Gaia in Siena (see Plate 89 above) and between 1415 and 1428 was engaged on intarsias for the

choir of the chapel in the Palazzo Pubblico, which earned him the appellation 'dei Cori'. In 1413 he became Capo-maestro of the Duomo in Siena, for which he executed pavement designs and other works.

BIBLIOGRAPHY: The identification of the two figures listed below is due to Bacci (*Jacopo della Quercia: nuovi documenti e commenti*, Siena, 1929, pp. 52–59). The skeleton supplied by Bacci is filled out by Carli with a number of well-founded supplementary attributions and a catalogue of Domenico di Niccolò's works (*Scultura lignea senese*, Milan-Florence, 1951; *La scultura lignea italiana*, Milan, 1960), and is further amplified by C. del Bravo (*Scultura senese del Quattrocento*, Florence, 1970). On Francesco di Valdambrino, a more prolific but less important artist, see Bacci (*Francesco di Valdambrino*, Siena, 1936), Ragghianti ('Su Francesco di Valdambrino', in *Critica d'Arte*, iii, 1938, pp. 136–43), and C. del Bravo ('Schede sulla scultura senese del Quattrocento', in *Antichità Viva*, viii, 1969, pp. 15–21; and *Scultura Senese del Quattro-cento*, Florence, 1970).

Plate 97: THE VIRGIN AND ST. JOHN THE EVANGELIST
San Pietro Ovile, Siena

The two figures originally flanked a Crucifix in the Cappella del Crocifisso of the Duomo at Siena. Payments to Domenico di Niccolò in connection with work on the figures are recorded in 1414 and 1415, when the two statues were pigmented by the painter Martino di Bartolommeo. The concluding payment dates from 1416. After successive re-paintings the figures were whitewashed, and between 1676 and 1682 were removed from the Cappella del Crocifisso. The original paint was recovered as a result of restoration undertaken between 1938, when the figures were exhibited in their repainted state (*Commune di Siena: Catalogo della Mostra di Sculture d'Arte Senese del XVo. Secolo*, 1938, Nos. 22, 23), and 1944 (*Capolavori dell'arte senese* a cura di Enzo Carli, p. 108, Nos. 89, 90). The interest of the figures is concentrated in the deeply expressive carving of the heads and in this, as well as in the linear rhythms of the drapery, they reveal (Del Bravo) the influence of Ghiberti.

NANNI DI BARTOLO
(active 1419–51)

Nanni di Bartolo called Rosso is first mentioned in Florence in 1419, when he received a commission for an unidentified figure for the façade of the Duomo. In 1421 he completed a statue of Joshua, begun by Ciuffagni and destined for the Campanile, and in the same year he was engaged with Donatello on the group of Abraham and Isaac, also destined for the Campanile and now in the Museo dell'Opera del Duomo. In 1422 he executed independently a statue of Abdias for the Campanile (see Plate 98 below), and this work, now in the Museo dell'Opera del Duomo, is the main source for our knowledge of his early style. An entry in the accounts of the Opera del Duomo for 11 February 1424 records that by this time Nanni di Bartolo had left Florence for Venice. Of cardinal importance for the reconstruction of Nanni di Bartolo's style after he left Florence are the signed doorway of S. Nicola at Tolentino (datable 1432–5) (Fig. 85) and the Brenzoni monument in S. Fermo Maggiore at Verona (Fig. 90). The latter, which represents the Resurrection, is inscribed: QVEM GENVIT RVSSI FLORENTIA TVSCA IOHANNIS: ISTVD SCVLPSIT OPVS INGENIOSA MANVS. The figure of the Prophet at the apex of the monument conforms to that of the Abdias on the Campanile, the sleeping soldiers in the foreground are consistent with the Tolentino doorway, and the two naked putti holding back the curtains are generically Donatellesque. But the Christ and angels on the sarcophagus, and the two standing angels in front, fall in the context of International Gothic style, and there is a strong case for believing that a North Italian sculptor was responsible for these parts of the work. Nanni di Bartolo is perhaps identical with a sculptor Rosso who collaborated with Giovanni and Bartolommeo Buon on a well-head for the Ca' d'Oro in

Venice and on other works. Many of the ascriptions to Nanni di Bartolo of works in Venice and North Italy are untenable (e.g. that of the monument of the Beato Pacifico in the Frari), but the possibility that he was responsible for the Judgment of Solomon on the Palazzo Ducale (see Plates 106–7 below) cannot be ruled out. Nanni di Bartolo is supposed to have been active at Carrara as late as 1451.

BIBLIOGRAPHY: For the documentation of Nanni di Bartolo's works in Florence see Poggi (*Il Duomo di Firenze*, Berlin, 1909) and Semper ('Regesten zur Geschichte des Giovanni Bartolo, genannt il Rosso', in *Donatello: seine Zeit und seine Schule*, Vienna, 1875). A good general survey of Nanni di Bartolo's development is given by Planiscig ('Die Bildhauer Venedigs in der ersten Hälfte des Quattrocento', in *Jahrbuch der Kunsthistorischen Sammlungen in Wien*, n.f. iv, 1930, pp. 76–88). The attribution to Nanni di Bartolo of a number of half-length Madonnas (see Plate 96 above) proposed in this article is, however, questionable. For the Abdias and for the part played by Nanni di Bartolo in the Campanile statuary see Lanyi ('Le statue quattrocentesche dei Profeti nel Campanile e nell'antica facciata di Santa Maria del Fiore', in *Rivista d'Arte*, xvii, 1935, pp. 120–59). Some further attributions are advanced by M. Wundram ('Donatello und Ciuffagni', in *Zeitschrift für Kunstgeschichte*, xxii, 1959, pp. 85–101), C. del Bravo ('Proposte e appunti per Nanni di Bartolo', in *Paragone*, No. 137, 1961, pp. 26–32, ascribing to Nanni di Bartolo four figures of Apostles on the façade of the Madonna dell'Orto, Venice, and four doccioni on the north side of St. Mark's, and giving an admirable summary of the sculptor's style), and L. Becherucci and G. Brunetti (*Il*

Museo dell'Opera del Duomo a Firenze, i, Florence, 1969, pp. 258f., 264f.).

Plate 98: ABDIAS
Museo dell'Opera del Duomo, Florence

The construction of the Campanile in Florence was completed about 1359, but no steps appear to have been taken to fill the eight vacant niches in the second storey until 1415, when a statue of Joshua was commissioned from Ciuffagni. Thereafter provision was made for the filling of all the niches with statues (in completion of the scheme initiated by Andrea Pisano, see Plate 49 above). The artist most closely identified with these figures was Donatello, who was intermittently associated with the project for almost twenty years and whose Habakkuk (completed 1436) was the last statue put in place. In the early phases of the project Nanni di Bartolo was also closely associated with work on the Campanile statues,

collaborating with Donatello on the Abraham and Isaac and on Ciuffagni's Joshua. The Abdias, executed independently by Rosso for a niche on the side of the Campanile facing the Duomo, is inscribed on the scroll held by the prophet: IOHANNES ROSSUS PROPHETAM ME SCULPSIT ABDIAM, and seems, from payments published by Poggi (*Il Duomo di Firenze*, Berlin, 1909, pp. lix–lx), to have been carved in 1422. It is, however, argued by G. Brunetti ('I profeti sulla porta del Campanile di Santa Maria del Fiore', in *Festschrift U. Middeldorf*, Berlin, 1968, pp. 106–11; and 'Riadattamenti e spostamenti di statue fiorentine nel primo Quattrocento', in *Donatello e il suo tempo*, Florence, 1968, pp. 277–82) that the statue was originally carved for a niche on the extreme left of the façade of the Cathedral, and was, at some later time, transferred thence to the Campanile. While of limited interest in the history of Florentine sculpture, the Abdias is of importance as illustrating the style which, two years after its completion, Rosso carried with him to North Italy.

NANNI DI BANCO
(b. *c.* 1374; d. 1421)

The date of Nanni di Banco's birth is uncertain, and has been set as early as 1374 and as late as 1390. As has been argued by Wundram and other scholars, the most likely birth-date is in the mid-1370s. His father, Antonio di Banco, matriculated in the Arte dei Maestri di Pietra e Legname in 1372, and is mentioned in documents between 1394 and 1409 in connection with the Porta della Mandorla of the Duomo in Florence, of which he became Capomaestro in 1414. In the surviving documents he is mentioned in connection with constructional work, and there is no conclusive evidence that he was a sculptor (Wundram). He seems to have died in the following year. Nanni di Banco matriculated in February 1405, and was engaged with his father in work on the Cathedral in 1406 and 1407. In 1407–8 he executed one of two Prophets for the Porta della Mandorla, of which the companion figure was by Donatello, and in January 1408, he received, in conjunction with his father, the commission for a marble figure of Isaiah (see Plate 99 below), of which the companion figure of David was commissioned a month later from Donatello. In December 1408 he received the commission for a seated figure of St. Luke for the façade of the Cathedral (now in the Museo dell'Opera del Duomo). Concurrently with, or immediately after, this work, he was engaged on the statues of St. Eligius (Fig. 84), St. Philip, and the Quattro Santi Coronati (see Plates 100–1 below) for Or San Michele, and after 1414 on the Assumption of the Virgin above the Porta della Mandorla (see Plates 102–3 below). In 1419 he collaborated with Brunelleschi and Donatello on a model for the cupola of the Duomo. Nanni di Banco died on 12 February 1421.

BIBLIOGRAPHY: A brief survey of the sculptor's work is supplied by Planiscig (*Nanni di Banco*, Florence, 1946). The admirably illustrated volume by Vaccarino (*Nanni*, Florence,

1951) is marred by its polemical tone and by lack of critical perspective, but corrects and supplements that of Planiscig in a number of respects and reproduces the extant documents relating to the artist. Of single articles the most valuable is that of Lanyi ('Il profeta Isaia di Nanni di Banco', in *Rivista d'Arte*, xvii, 1935, pp. 137–78). The most substantial recent contribution to the study of Nanni di Banco is a volume by M. Wundram (*Donatello und Nanni di Banco*, Berlin, 1969), who wrongly rejects the ascription to Nanni di Banco of the Isaiah (see Plate 99 below) but gives excellent analyses of the Quattro Santi Coronati (see Plates 100–1 below) and of the Assumption of the Virgin (see Plates 102–3 below). On the Porta della Mandorla see also M. Wundram ('Niccolò di Pietro Lamberti und die Florentiner Plastik um 1400', in *Jahrbuch der Berliner Museen*, iv, 1962, pp. 78–115; and 'Jacopo della Quercia und das Relief der Gürtelspende über der Porta della Mandorla', in *Zeitschrift für Kunstgeschichte*, xxviii, 1965, pp. 121–39), C. Seymour ('The Younger Masters of the First Campaign of the Porta della Mandorla', in *Art Bulletin*, xli, 1959, pp. 1–17; and *Sculpture in Italy 1400–1500*, London, 1966), and M. Phillips ('A new Interpretation of the Early Style of Nanni di Banco', in *Marsyas*, xi, 1962–64, pp. 63–66). Disagreement on the identification and attribution of the so-called Prophets above the Porta della Mandorla has given rise to a number of articles; the contribution of Planiscig to this rather academic controversy ('I profeti della Porta della Mandorla del Duomo fiorentino', in *Rivista d'Arte*, xxiv, 1942, pp. 125–42) should be read in conjunction with the relevant pages of Vaccarino's book and with the subsequent analysis by H. W. Janson (*The Sculpture of Donatello*, Princeton, 1957, ii, pp. 219–22). The documents relating to the Evangelist for the Cathedral and to the relief on the Porta della Mandorla are printed by Poggi (*Il Duomo di Firenze*, Berlin, 1909). The problem of the Isaiah is also

discussed by G. Brunetti ('Riadattamenti e spostamenti di statue fiorentine del Primo Quattrocento', in *Donatello e il suo tempo*, Florence, 1968, pp. 277–82), A. Kosegarten ('Das Grabrelief des S. Aniello Abbate im Dom von Lucca', in *Mitteilungen des Kunsthistorischen Institutes in Florenz*, xiii, 1968, p. 250) and M. Lisner ('Gedanken vor frühen Standbildern des Donatello', in *Kunstgeschichtliche Studien für K. Bauch*, Munich, 1967, pp. 77–92). For Nanni di Banco's father, Antonio di Banco, see M. Wundram ('Antonio di Banco', in *Mitteilungen des Kunsthistorischen Institutes in Florenz*, x, 1961, pp. 23–32). Good colour reproductions of Nanni di Banco's sculptures are supplied by L. Bellosi (*Nanni di Banco*, I Maestri della Scultura, No. 64, Milan, 1966).

Plate 99: ISAIAH
Duomo, Florence

On 24 January 1408 the Operai of the Duomo in Florence commissioned from Antonio di Banco and his son Giovanni 'unam figuram nominis Isaie profete marmi longitudinis brachiorum trium et quarti unius,' to be placed on the exterior of the recently completed northern tribune of the Cathedral. A month later a companion figure of David (now in the Museo Nazionale, Florence) was commissioned from Donatello. The concluding payment for the Isaiah is dated 15 December 1408; though made to Antonio di Banco, it expressly states that the figure was 'facte per Iohannem eius filium in totum' (wholly made by Giovanni his son), and the figure is thus Nanni di Banco's earliest fully authenticated work. It appears to have been placed immediately in its destined position, but was removed in July 1409 and was subsequently placed on the façade of the Cathedral, where it remained till 1587, when it was placed in the interior. The identification of the figure as Nanni di Banco's Isaiah is due to Lanyi. The case is contested by Wundram, who denies that the figure is that commissioned from Nanni di Banco in 1408 and wrongly ascribes it to Donatello. An unconvincing attempt to identify classical sources for the pose in the Giustiniani Sarcophagus in the Kunsthistorisches Museum, Vienna, and for the head in a bust of Constantine in the Capitoline Museum, Rome, is made by Phillips. Vaccarino discusses the supposed defects of the figure, and attributes these tentatively to the use of an irregular block of marble. These defects are apparent only if we compare the figure with the more solid and more classical St. Luke, and are inherent in the ambivalent style, part Gothic, part classicistic, in which the statue is conceived.

Plates 100–1: QUATTRO SANTI CORONATI
Or San Michele, Florence

Of the statues of guild patrons on Or San Michele (see Plates 82–83 above) three were executed by Nanni di Banco. These represent St. Philip (Arte dei Calzolai), St. Eligius (Arte dei Maniscalchi) (Fig. 84) and the Quattro Santi Coronati (Arte dei Maestri di Pietra e Legname) (Fig. 83). None of these figures is dated, and their traditional attribution to Nanni di Banco is not confirmed by documents, though it is amply justified by arguments from style. The statue of St. Philip is variously dated 1405 (Schlosser), 1409–11 (Vaccarino) and c. 1415 (Planiscig), while that of St. Eligius is usually assigned to the years 1413–14. The four figures of the Quattro Santi Coronati may have been begun as early as 1408 (Schlosser and Vaccarino), but more probably were executed after 1413 (Planiscig). Strong arguments in favour of the latter or of a still later dating are advanced by Wundram. It has, however also been suggested (Brunetti) that the second figure from the left was carved as a Prophet, a pendant to the Isaiah. If this highly conjectural theory were accepted, it would be considerably earlier than the companion figures. The group is regarded by Seymour as Nanni di Banco's 'first work finished on Or San Michele'. The figures represented are Claudius, Castor, Symphorian and Nicostratus, four Christian sculptors who refused to execute a commission from the Emperor Diocletian for a statue of Aesculapius, and were put to death about the year 300. The legend of these sculptors was later confused with that of four Christian soldiers, who refused an order to worship in the temple of Aesculapius, and were venerated as the Quattro Santi Coronati. Beneath the niche containing the figures is a relief, also by Nanni di Banco, showing the four sculptors at work. Above is a half-length figure of Christ blessing. The Quattro Santi Coronati offer the only case at Or San Michele of a niche containing more than one figure (though the niche destined for Donatello's St. Louis of Toulouse was later filled by the two figures of Verrocchio's Christ and St. Thomas), and the presence of four life-size figures grouped together gives the work a unique place in the Florentine sculpture of its time. The disposition of the figures in their niche seems to depend from Roman grave altars, where four figures are sometimes disposed in half-length in a closely similar way. The pose of the figure in the left background recalls the Isaiah, and the head of that in the right background the St. Luke. In the scene beneath, the deep cutting is in marked contrast to the rilievo stiacciato of the carving beneath Donatello's St. George, and represents an intermediate phase between the reliefs of Andrea Pisano on the Campanile and the St. Peter predella of Luca della Robbia. For its iconography see particularly H. von Einem ('Bemerkungen zur Bildhauerdarstellung des Nanni di Banco', in *Festschrift für H. Sedelmayr*, Munich, 1962, pp. 68–79).

Plates 102–3:
THE ASSUMPTION OF THE VIRGIN
Duomo, Florence

The Porta della Mandorla (Fig. 86), the principal doorway on the north side of the Duomo in Florence, was begun in 1391. The lower part of the doorway was executed between this year and 1397 by a group of artists, of whom the most notable was Niccolò di Pietro Lamberti. Between 1404 and 1409 the lunette above the doorway was constructed by the

Capomaestro Giovanni d'Ambrogio, Niccolò di Pietro Lamberti, Antonio di Banco and Nanni di Banco. In this were set the two figures of an Annunciation group, carved before 1409 and installed in 1414, now in the Opera del Duomo, variously ascribed to Nanni di Banco, Giovanni d'Ambrogio and Jacopo della Quercia. For this group, which is a work of great distinction and is perhaps by the second of these artists, see the judicious analysis by Becherucci and Brunetti (*Il Museo dell'Opera del Duomo a Firenze*, Florence, 1969, pp. 255–58). The reliefs of the right and left sides of the archivolt are by different hands; an attempt by Wundram to give the right side of the archivolt to Niccolò di Pietro Lamberti and the left side to Nanni di Banco is possibly correct, though the contrary case (Seymour) has also been advanced. In 1414 the uppermost section ('unum frontem super januam dicte cathedralis ecclesie Sancte Marie del Fiore') containing a relief of the Assumption was commissioned from Nanni di Banco. A number of payments refer to the progress of the work between 1415 and the death of Nanni di Banco in February 1421. Though the relief is referred to after the artist's death as 'ipsa ystoria imperfecta derelicta', it must have been substantially completed at this time, since six figures were finished by October 1418. It is, however, argued by Wundram that the greater part of the relief was carved between 1417/18 and 1420, and that its style is in part ascribable to the influence of the Fonte Gaia carvings of Jacopo della Quercia. The scene represented is the Tuscan variant of the conventional Assumption iconography, in which the Virgin is represented dropping her girdle to St. Thomas the apostle, who kneels in the lower left corner of the composition. In the lower right corner is a bear cub. In these features, and in the oval mandorla sustained by three music-making angels on each side, the composition recalls the Assumption of Orcagna in Or San Michele (Fig. 43). The treatment throughout is less classical than that of the Quattro Santi Coronati or of the St. Luke, and the seated figure of the Virgin in particular is primarily Gothic in style. Particularly striking are the free poses and heavy wind-blown drapery of the seven angels, and it is not to be wondered at that Vasari should have ascribed the relief to Quercia, since in this respect it offers a parallel to the development which took place, in the same period of time, in Quercia's work. The relevant sentences from Vasari's account (*Vite*, ed. Milanesi, 1906, ii, p. 115) read: 'Dove egli fece in una mandorla la Madonna, la quale da un coro d'Angeli e portata, sonando eglino e cantando, in cielo, con le piu belle movenze e con le piu belle attitudini, vedendosi che hanno moto e fierezza nel volare, che fussino insino allora state fatte mai. Similmente la Madonna e vestita con tanta grazia ed onesta, che non si puo immaginare meglio, essendo il girare delle pieghe molto bello e morbido, e vedendosi ne' lembi de' panni che vanno accompagnando l'ignudo di quella figura, che scuopre coprendo ogni svoltare di membra.' (Here he (Jacopo della Quercia) represented a Madonna in a mandorla carried to heaven by a choir of angels, who are playing and singing, displaying the most beautiful movements and attitudes, for there is vigour and decision in their flight, such as had never been seen before. In like manner the Madonna is clothed so gracefully and simply that nothing better could be desired, for the folds of the drapery are soft and beautiful, the clothes following the lines of the figure, and while covering the limbs disclose every turn.)

VENETIAN SCHOOL

Plates 104–5: THE FALL, THE DRUNKENNESS OF NOAH

The exposed corners of the Palazzo Ducale (Fig. 92) are decorated with sculptures showing (on the angle facing towards the Porta della Carta) the Judgment of Solomon, (on the angle facing towards the Piazzetta) the Fall, and (on the angle facing towards the Ponte della Paglia) the Drunkenness of Noah. There is no firm evidence of the date of these groups, which do not perform a structural function like the capitals of the colonnade below, and the earlier of them, the Fall and the Drunkenness of Noah, which are uniform in style, have been dated as early as the last decade of the fourteenth and as late as the second decade of the fifteenth century. Attention was first drawn by Meyer (*Oberitalienische Frührenaissance: Bauten und Bildwerke der Lombardei*, i, Berlin, 1897, p. 59ff.) to resemblances between the earlier of the angle reliefs and the so-called Giganti executed by Matteo Raverti and other sculptors for the Duomo at Milan, and Venturi (*Storia*, vi, 1908, pp. 27–32) ascribes these reliefs, and the celebrated relief of Venice in the spandrels of the colonnade, to a Lombard artist under Northern influence. Mariacher ('Matteo Raverti nell'arte veneziana del primo quattrocento', in *Rivista d'Arte*, xxi, 1939, pp. 23–40) accepts Raverti's authorship of one of the doccioni (water-spouts) on the façade of St. Mark's and connects his name with a number of the earlier capitals of the external colonnade of the Palazzo Ducale, but rejects the ascription to Raverti of the angle reliefs. A tentative attribution of the Drunkenness of Noah to Raverti is accepted by M. Clonini Visani ('Proposta per Matteo Raverti', in *Arte Veneta*, xvi, 1962, pp. 31–41). While the reliefs show points of affinity with the figures at Milan, their more naturalistic treatment renders it unlikely that they are by a Lombard sculptor, and, as noted by Baroni (*Scultura Gotica Lombarda*, Milan, 1944, pp. 53–54), they find a precedent in the Genesis carvings at the apex of the monument of Mastino II della Scala at Verona (*c.* 1350). The author of the angle reliefs was also responsible for a number of related capitals beneath (among them that with the Creation of Adam and the so-called Capitello d'Amore). A conjectural attribution to Giovanni Buon, proposed by Planiscig, is very plausible.

NICCOLÒ DI PIETRO and PIETRO DI NICCOLÒ
(b. c. 1370; d. 1451)　　　　　　(b. c. 1393; d. 1435)
LAMBERTI

Though Niccolò di Pietro Lamberti and his son Pietro di Niccolò were of Florentine origin, they played a more important part in the development of Venetian than of Florentine sculpture. Niccolò di Pietro seems to have been born about 1370 and was at work in 1393 on the Porta della Mandorla of the Duomo in Florence. In 1415 he received the commission for a statue of St. Mark for the Cathedral, and in 1416 is mentioned for the first time in Venice. He is mentioned once more in Venice in 1424, and was later active in Bologna, where he is documented on four occasions between 1428 and 1439. Niccolò di Pietro died in 1451. In Venice Niccolò di Pietro played a leading part in the sculpture of the upper story of the façade of St. Mark's (Fig. 91). This is elucidated by Fiocco, who ascribes to him the central pinnacle of St. Mark in Glory, the pinnacles of Temperance, Charity, Faith and Fortitude, and, in the intervening tabernacles, statues of Saints and of the Fathers of the Church. When he arrived in Venice, Niccolò di Pietro Lamberti seems to have been accompanied by his son Pietro di Niccolò, who was born about 1393 and was employed in Or San Michele in 1410. In 1423, in conjunction with a sculptor from Fiesole, Giovanni di Martino, Pietro di Niccolò executed the monument of the Doge Tommaso Mocenigo in SS. Giovanni e Paolo, Venice (Fig. 89), and between 1429 and 1431 was at work on the Fulgosio monument in the Santo at Padua, where he collaborated with a certain Giovanni di Bartolommeo da Firenze. In 1430 he was in Verona and in 1434–5 was employed in Venice on the Ca' d'Oro. Pietro di Niccolò Lamberti seems to have died in this year. The limits of Pietro di Niccolò's personality are less clear than those of his father's, and in Venice he is credited by Fiocco with a heterogeneous list of works, of which the most convincing are parts of the lunettes executed by his father on St. Mark's and the fine doccioni on the side of the Basilica towards San Basso. The last of the capitals of the colonnade of the Palazzo Ducale on the corner towards the Porta della Carta is stated at one time to have borne the inscription DVO SOTI FLOREN-TINI, and on this account the capital, with a representation of Justice, and the related capitals in this wing of the building, which were executed after 1424, have been ascribed to Pietro di Niccolò and Giovanni di Martino da Fiesole.

BIBLIOGRAPHY: The little available information on Pietro di Niccolò Lamberti's activity in North Italy is summarized, with mutually exclusive results, by Fiocco ('I Lamberti a Venezia—ii, Pietro di Niccolò Lamberti', in *Dedalo*, viii, 1927–8, pp. 343–76) and Planiscig ('Die Bildhauer Venedigs in der ersten Hälfte des Quattrocento', in *Jahrbuch der Kunsthistorischen Sammlungen in Wien*, n.f. iv, 1930, pp. 47–III). For Niccolò di Pietro Lamberti in Venice see Fiocco ('I Lamberti a Venezia—i, Niccolò di Pietro Lamberti', in *Dedalo*, viii, 1927–8, pp. 287–314). A responsible account of the careers of both artists is supplied by L. Becherucci and G. Brunetti (*Il Museo dell'Opera del Duomo a Firenze*, i, Florence, 1969, pp. 23ff. and 254ff.). For Niccolò di Pietro Lamberti in Florence see particularly G. Brunetti ('Osservazioni sulla Porta dei Canonici', in *Mitteilungen des Kunsthistorischen Institutes in Florenz*, viii, 1957, pp. I–12), C. Seymour ('The younger Masters of the First Campaign of the Porta della Mandorla, 1391–1397', in *Art Bulletin*, xli, 1959, pp. I–17) and especially M. Wundram ('Niccolò di Pietro Lamberti und die Florentinische Plastik um 1400', in *Jahrbuch der Berliner Museen*, iv, 1962, pp. 78–115; 'Albizzo di Piero. Studien zur Bauplastik von Or San Michele in Florenz', in *Das Werk des Künstlers, Studien zur Ikonographie und Formgeschichte H. Schrade zum 60. Geburtstag dargebracht*, Stuttgart, 1960, pp. 161–67; and 'Der Heilige Jacobus an Or San Michele in Florenz', in *Festschrift K. Oettinger*, Erlangen, 1967, pp. 193–207).

Plates 106–7:
THE JUDGMENT OF SOLOMON
Palazzo Ducale, Venice

The latest of the three angle reliefs of the Palazzo Ducale faces towards the Basilica of St. Mark's and surmounts the so-called Justitia capital. That part of the Ducal Palace on the Piazzetta between the relief of Venice and the Porta della Carta (Fig. 93) was rebuilt under the Doge Francesco Foscari after 1424, and the Judgment of Solomon must date between this year and the commencement of the Porta della Carta in 1438. There is no general agreement on the authorship of the relief, which was traditionally ascribed to the Buon studio (this attribution has been sustained in recent times by Planiscig) and is given by Venturi (*Storia*, vi, 1908, p. 216) to Nanni di Bartolo (see Plate 98 above) and by Fiocco and other students to Pietro di Niccolò Lamberti. It has also been ascribed by Gnudi (see A. M. Matteucci, *La Porta Magna di S. Petronio in Bologna*, Bologna, 1966, p. 68n.) to Jacopo della Quercia. The handling of the Judgment of Solomon has been alternatively associated with (Fiocco) and distinguished from (Planiscig) that of the Justitia capital beneath. Unlike the two earlier angle reliefs, this reveals strong Florentine influence, and probably results from some form of collaboration between Giovanni and Bartolommeo Buon and a Florentine artist. The attribution to Pietro di Niccolò Lamberti is supposititious (though the executioner shows certain similarities to the doccioni on St. Mark's), and there is no evidence that he was capable of rising to the level of this unusually distinguished work. Comparison with the authenticated works of Nanni di Bartolo suggests that an ascription to this artist is not untenable.

THE MASTER OF THE MASCOLI ALTAR

The sculptor known as the Master of the Mascoli Altar derives his name from a marble altar-piece and antependium in the Mascoli chapel in St. Mark's, Venice (see Plate 108 below). The style of the altar marks a transitional stage between that of the Dalle Masegne and Bartolommeo Buon, and on this account the sculptor, who is clearly of Venetian origin, has been tentatively identified (initially by Selvatico, *Sulla architettura e sulla scultura in Venezia*, p. 138, and subsequently by some modern students) with Giovanni Buon, the father of Bartolommeo. Though there are certain differences between the Madonna on the one hand and the two Saints on the other, and between those figures and the antependium, the whole work originates from a single studio and appears substantially to have been carved by a single hand. Other works attributable to the sculptor are the tympanum of the doorway of the Cappella Cornaro in S. Maria dei Frari, Venice (see Plate 109 below), two reliefs of angels in S. Stefano, and a relief with the Dandolo arms in the via Cavour at Udine (1429–30).

BIBLIOGRAPHY: The reintegration of the œuvre of the Master of the Mascoli Altar is due to Planiscig (*Venezianische Bildhauer der Renaissance*, Vienna, 1921, pp. 14–20, and 'Die Bildhauer Venedigs in der ersten Hälfte des Quattrocento', in *Jahrbuch der Kunsthistorischen Sammlungen in Wien*, n.f. iv, 1930, pp. 113–20). The works of the Master of the Mascoli Chapel are ascribed by Venturi (*Storia*, vi, 1908, p. 987) to Giovanni and Bartolommeo Buon, and his personality is merged by Fiocco ('I Lamberti a Venezia—ii, Pietro di Niccolò Lamberti', in *Dedalo*, viii, 1927–8, pp. 352–3) in those of Bartolommeo Buon on the one hand and Pietro di Niccolò Lamberti on the other. Fiocco's attempt to associate the lunette of the Cornaro Chapel with Pietro di Niccolò Lamberti is contested by A. Sartori ('Il reliquiario della lingua di S. Antonio di Giuliano da Firenze', in *Rivista d'Arte*, xxxiv, 1959, pp. 123–49).

Plate 108: THE MASCOLI ALTAR
St. Mark's, Venice

The altar of the Mascoli Chapel in St. Mark's is decorated (i) with an altar-piece showing the Virgin and Child with SS. Mark and James beneath foliated tabernacles, and (ii) with an antependium showing two angels censing a Cross. The Mascoli Chapel was dedicated in 1430, and both altar-piece and antependium were presumably in position by this time. The best account of the style of the altar is supplied by Paoletti (*L'architettura e la scultura del rinascimento a Venezia*, Venice, 1893, p. 50), who distinguishes between the three upper figures and the work of Bartolommeo Buon. The figure sculpture contains a synthesis of elements deriving in part from Nino Pisano (the Virgin and Child) and in part from the iconostasis figures of the Dalle Masegne (St. James); the St. Mark suggests that the sculptor may also have been acquainted with Florentine Renaissance sculptures. In point of execution the altar is perhaps the most distinguished Venetian sculpture of its time, and reaches a level of proficiency far higher than that of contemporary works from the Buon studio.

Plate 109: VIRGIN AND CHILD ENTHRONED WITH TWO ANGELS
Santa Maria dei Frari, Venice

A document published by Paoletti (*L'architettura e la scultura del rinascimento a Venezia*, Venice, 1893, p. 50) shows that the construction of a chapel in the Frari endowed under the will of Francesco Cornaro was begun after October 1422, and the present relief, which surmounts the door giving access to the chapel from the outside of the church, must date from after this time. An attempt of Fiocco to ascribe the relief to the year 1417 is incorrect, as is an attribution of Venturi (*Storia*, vi, 1908, p. 987) to Bartolommeo Buon. The types and handling of the lateral angels are closely connected with those of the Mascoli antependium (see above). The depiction of space plays a more important part in the Frari tympanum than in reliefs from the Buon studio; the device used for depiction of the receding arms of the throne and the placing of the angels in a forward plane are particularly notable. With its light and elegant design, its developed linear drapery its implied contrapposto in the central group and its heavy frame of naturalistic foliage above, the relief is one of the most individual and attractive examples of Venetian Gothic sculpture.

BARTOLOMMEO BUON
(b. *c.* 1374; d. 1467?)

In the late fourteenth and first half of the fifteenth centuries the principal personalities in native Venetian sculpture are those of Giovanni Buon and his son Bartolommeo. Giovanni Buon is mentioned for the first time in 1382 and was probably born about 1355. In 1392 Giovanni, with Bartolommeo as his assistant, was employed on the façade of S. Maria dell' Orto. There is no further reference to the Buons till 1422, when father and son, with two assistants, were at work on the Ca' d'Oro, in conjunction with the Milanese sculptor and architect, Matteo Raverti, who had been entrusted with this work in 1421. From 1427 dates a documented well-head by Bartolommeo Buon and a certain Rosso (perhaps identical with Nanni di Bartolo, q.v.) in the Ca' d'Oro, and in 1430 a contract was placed for the frieze on the façade which was to

be executed from a design by Giovanni. Work on the exterior and interior of the Ca' d'Oro continued till 1434. To the late thirties belong the tympanum lunette over the entrance to the Scuola di San Marco (1437) and the Porta della Carta (see Plates 110, 111 below). Giovanni Buon died in or before 1443, and was succeeded as head of the workshop by Bartolommeo. Between 1442 and 1450 Bartolommeo Buon was employed on work for the Chiesa della Carità, in 1445 he executed a Madonna for the Palazzo Pubblico at Udine, and in 1463 he was engaged in the Palazzo Ducale. Like the author of the angle reliefs before him, Buon was strongly influenced by South German sculpture. His death occurred between 1464 and 1467. Nothing is known of the early activity of the Buon studio prior to 1422, and the ascription to it of the reliefs illustrated on Plates 104, 105 above is conjectural.

BIBLIOGRAPHY: A comprehensive account of the activity of the Buon studio is given by Planiscig ('Die Bildhauer Venedigs in der ersten Hälfte des Quattrocento', in *Jahrbuch der Kunsthistorischen Sammlungen in Wien*, n.f. iv, 1930, pp. 47–111). For less detailed treatment see also Planiscig (*Venezianische Bildhauer der Renaissance*, Vienna, 1921, pp. 3–30). Planiscig's conclusions should be read in conjunction with articles by G. Fogolari ('Gli scultori toscani a Venezia nel Quattrocento e Bartolomeo Buon, Veneziano', in *L'Arte*, xxxiii, 1930, pp. 427–64, and 'Ancora di Bartolomeo Bon, scultore veneziano', in *L'Arte*, xxxv, 1932, pp. 27–45) and G. Fiocco (review of Fogolari's article in *Rivista d'Arte*, xii, 1930, pp. 566–84). The bulk of the available documentary material is published by Paoletti (*L'architettura e la scultura del rinascimento a Venezia*, Venice, 1893).

Plates 110–11:
THE PORTA DELLA CARTA
Palazzo Ducale, Venice

Unlike the angle reliefs of the Palazzo Ducale, the Porta della Carta (Fig. 93), situated between the Palazzo Ducale and the Basilica of St. Mark's, is fully documented. The contract commissioning the doorway from Giovanni and Bartolommeo Buon is dated 10 October 1438, and stipulates that the work should be completed within eighteen months. A drawing for the doorway had already been prepared and approved at this time, and the contract refers to a number of details in the work as it was subsequently executed, among them the Lion of St. Mark over the entrance ('sam Marche in forma di liom . . . segondo la forma di un disegno che per nuj e fato et a vuj in le vostre mani avemo consignado') and the figure of Justice above ('una figura del nostro marmoro in figura de Justizia secondo la continensia del dito disegno'). By 1441 the figure of Justice was in place at the top of the structure, and by 1442 the doorway, with the exception of

certain details specified, was complete. The figurative elements of the structure comprise (i) in the frame above the entrance, the Doge, Francesco Foscari (replacement of lost original) kneeling before the Lion of St. Mark, (ii) in the tympanum above the window, half-length of St. Mark in a circular medallion sustained by three angels, framed by putti and foliage, (iii) at the apex, a seated figure of Justice, (iv) in the left lateral support, from top to bottom, two putti with the Foscari arms, Charity and Temperance, and (v) in the right lateral support, from top to bottom, two putti with the Foscari arms, Prudence and Fortitude. As noted by Planiscig the two lower Virtues, Temperance and Fortitude, are later additions to the doorway by Antonio Bregno. The figure of Justice (hands broken and replaced), the putti and foliage below and the putti supporting the Foscari arms are probably due to Bartolommeo Buon. Along with the lunette of the Scuola di San Marco in Venice and a lunette from the Scuola della Misericordia, now in the Victoria and Albert Museum (see Plate 112 below), the Porta della Carta is the most important and extended of the surviving works of the Buon studio.

Plate 112: VIRGIN AND CHILD WITH KNEELING MEMBERS OF THE GUILD OF THE MISERICORDIA
Victoria and Albert Museum, London

On 6 August 1441, at a meeting of the Guild of the Misericordia in Venice, it was agreed to reconstruct the façade of the Scuola della Misericordia, and between 1441 and 1445 this work was undertaken under the direction of Bartolommeo Buon. The present relief was originally set above the principal doorway of the Scuola Vecchia della Misericordia, where it is described by Sansovino (*Venetia citta nobilissima e singolare*, Venice, 1580, c. 101v.), and is not identical with a figure of the Virgin and Child erected 'sopra la porta delle case de corte nuve' in 1451. In 1612 the Scuola was handed over to the Tessitori di Seta, and the relief was transferred with other sculptures to the adjacent Abbazia della Misericordia, where it is mentioned by Martinioni (edition of Sansovino's *Venetia*, Venice, 1663, p. 286). It was removed from its new site and reinstalled between 1828 and 1840 inside the church, from which it was later sold. The relief (like the relief executed by Bernardo Rossellino for the Misericordia at Arezzo and the altarpiece executed by Piero della Francesca for the Misericordia at Borgo San Sepolcro) represents the Madonna of Mercy, but with the addition of the motif of the Child in a mandorla on the Virgin's breast as we find it in an altar-piece by Simone da Cusighe in the Accademia at Venice, a fourteenth-century relief above the lateral doorway of the Scuola della Misericordia and a Veneto-Byzantine mid-thirteenth century relief of the Madonna Orans at Santa Maria Mater Domini.

ACKNOWLEDGEMENTS

A number of illustrations in this book are reproduced from photographs supplied by scholars at whose instance they were made. In this connection a special debt is due to the generosity of Professor Constantino Baroni (Plates 61–63, 65 and 66), Professor Enzo Carli (Plates 14, 24, 31 and 97) and Dottoressa G. Nicco Fasola (Plate 11). Dottoressa Giulia Brunetti, Dr Giovanni Mariacher, Professor Ottavio Morisani and Mr Charles Seymour kindly co-operated in the measuring of certain of the sculptures reproduced. The translation of the inscriptions incorporated in the notes to Plates 1–5, 11, 16–19, 20–21, 26–27 and 32–33 were prepared in collaboration with Dr Elisabeth Rosenbaum.

The Publishers thank the following Museums and Collections for the supply of illustration material: *Bologna*, A. Villani & Figli: Plates 92–93. *Carrara*, Bessi: Plate 13. *Copenhagen*, National Museum: Fig. 12. *Florence*, Scala: Plate 47. *Florence*, Soprintendenza alle Gallerie: Figs. 8, 14, 65, 66, 87; Plates 1–5, 7–10, 16–19, 32, 48, 49, 87. *London*, Thames and Hudson: Plate 23. *London*, Victoria and Albert Museum: Plate 112. *Milan*, Nimatallah: Plate 67. *Naples*, Soprintendenza alle Gallerie: Plate 34. *Perugia*, Benvenuti: Figs. 9–11. *Pisa*, Orsoloni: Plate 12. *Pisa*, Soprintendenza alle Gallerie: Figs. 2, 16; Plates 33, 53. *Rochester*, Memorial Art Gallery: Fig. 77. *Siena*, Grassi: Fig. 76; Plates 15, 31, 85, 97. *Venice*, O. Böhm: Fig. 93; Plates 52, 69, 104–107, 110, 111. *Washington*, National Gallery of Art: Plate 96.
All other photographs from Phaidon Archive.

FIGURES

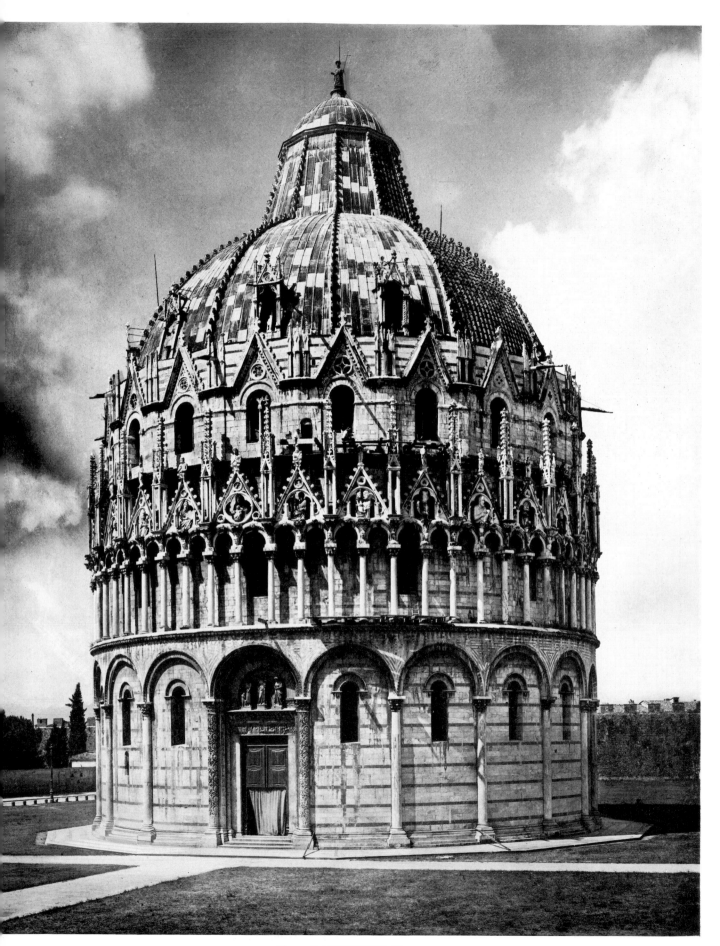

Fig. 1. BAPTISTRY. Pisa.

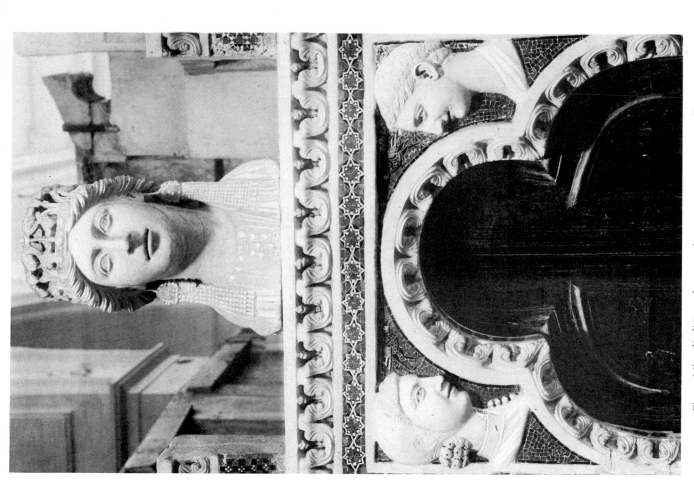

Fig. 5. Niccolò di Bartolommeo da Foggia: PULPIT. Ravello.

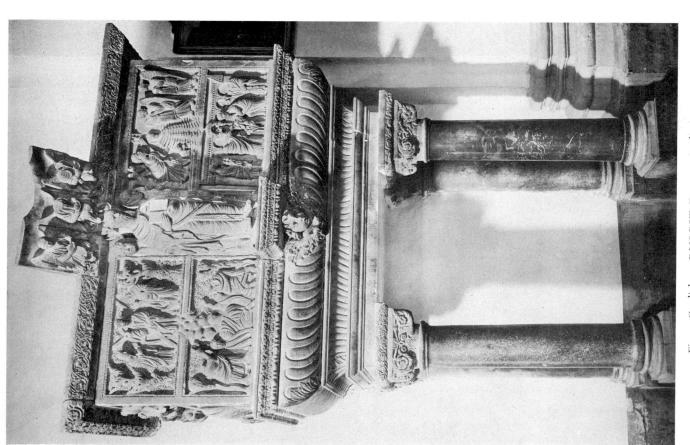

Fig. 4. Guglielmo: PULPIT. Duomo, Cagliari.

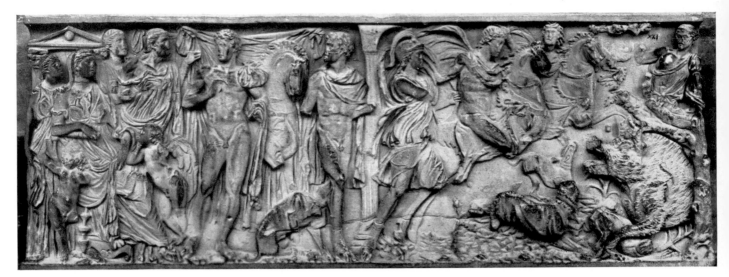

Fig. 6. THE PHAEDRA SARCOPHAGUS. Campo Santo, Pisa.

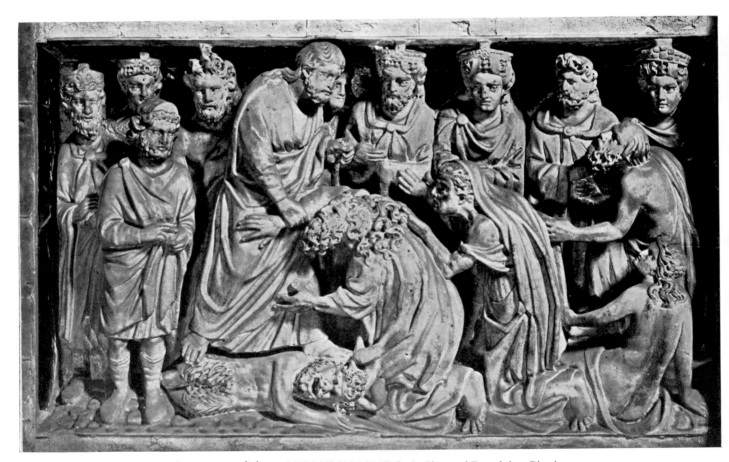

Fig. 7. Fra Guglielmo: CHRIST IN LIMBO. S. Giovanni Fuorcivitas, Pistoia.

Fig. 8. Nicola Pisano: PULPIT. Duomo, Siena ▶

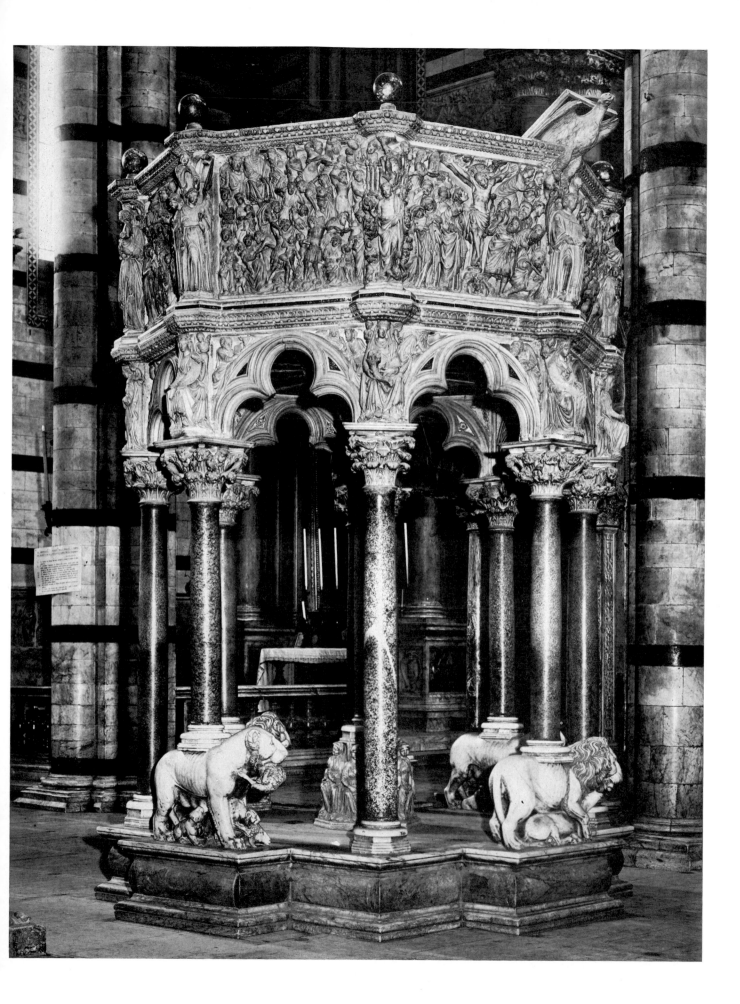

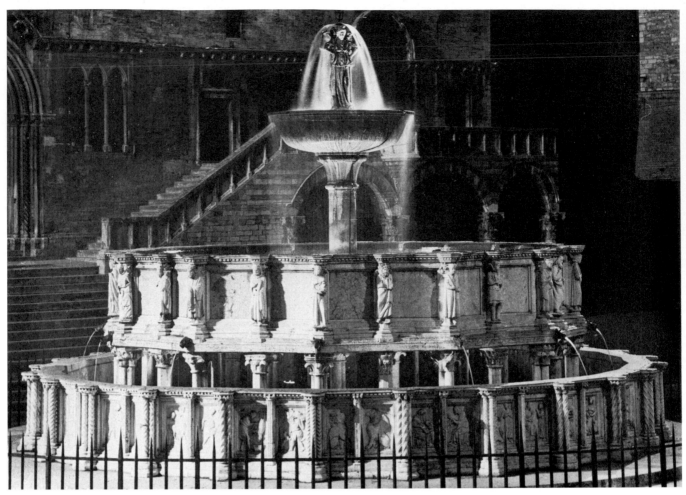

Fig. 9. Nicola Pisano: FONTANA MAGGIORE. Perugia.

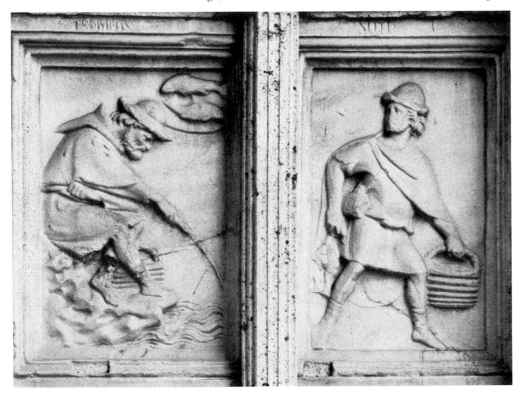

Figs. 10–11. Nicola Pisano: THE MONTH OF FEBRUARY. Relief from the
Fontana Maggiore, Perugia.

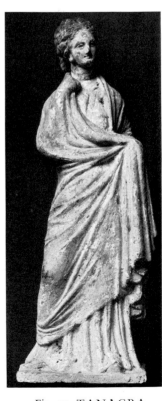

Fig. 12. TANAGRA
FIGURE. National Museum,
Copenhagen.

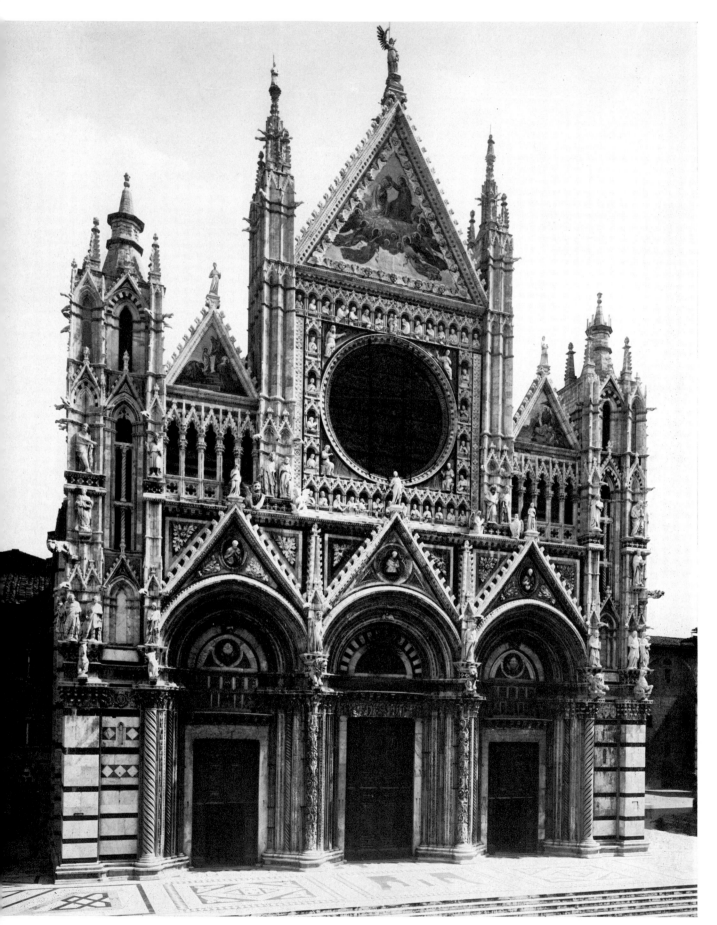

Fig. 13. CATHEDRAL FAÇADE. Siena.

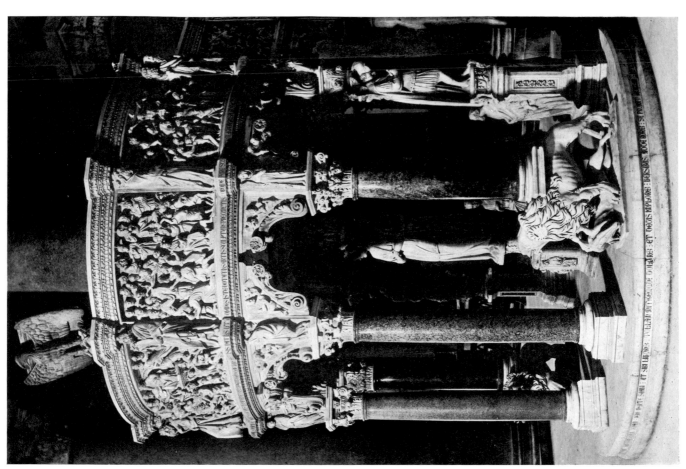

Fig. 15. Giovanni Pisano: PULPIT: Duomo, Pisa

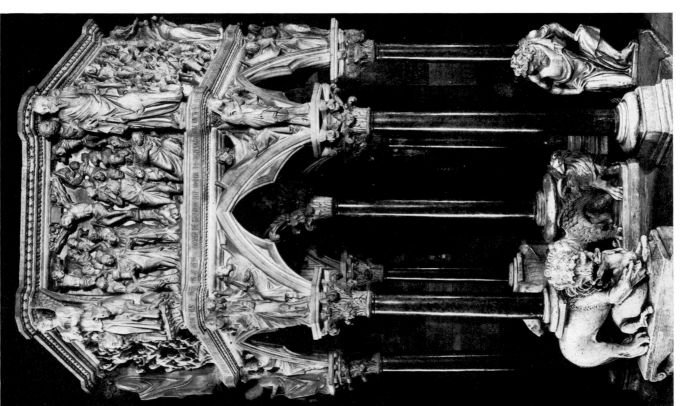

Fig. 14. Giovanni Pisano: PULPIT: S. Andrea, Pistoia

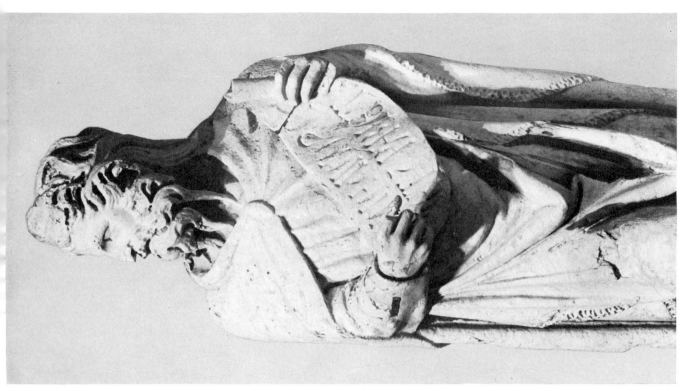

Fig. 17 Giovanni Pisano: THE PROPHET ISAIAH. Museo dell'Opera del Duomo, Siena.

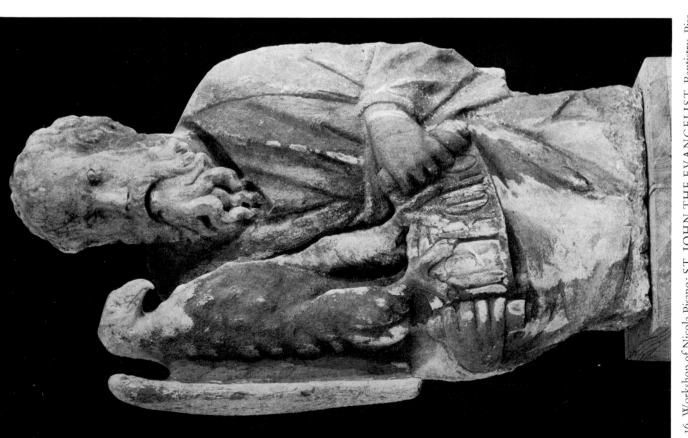

Fig. 16. Workshop of Nicola Pisano: ST. JOHN THE EVANGELIST. Baptistry, Pisa.

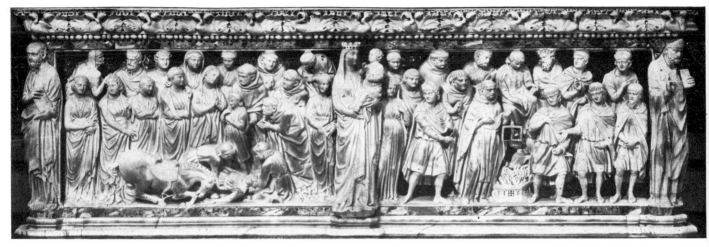

Fig. 18. Workshop of Nicola Pisano: RELIEF FROM THE ARCA OF ST. DOMINIC. S. Domenico Maggiore, Bologna.

Fig. 19. Giovanni Pisano: VIRGIN AND CHILD WITH TWO ANGELS. Arena Chapel, Padua.

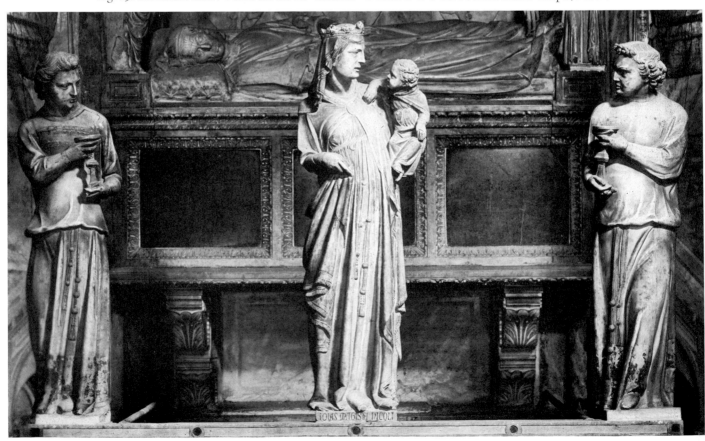

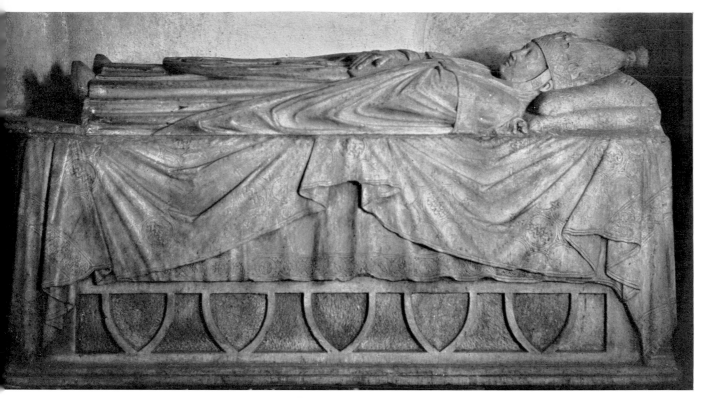

Fig. 20. Arnolfo di Cambio: MONUMENT OF POPE BONIFACE VIII. Grotte Vaticane, Rome.

Fig. 21. Arnolfo di Cambio: RELIEF FROM THE ANNIBALDI MONUMENT. S. Giovanni in Laterano, Rome.

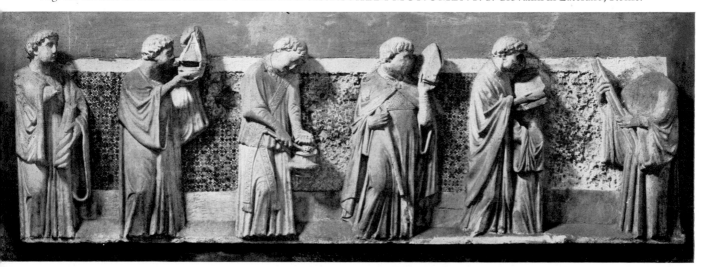

Fig. 22. MONUMENT OF CARDINAL GUGLIELMO FIESCHI. S. Lorenzo

Fig. 23. Arnolfo di Cambio: MONUMENT OF POPE ADRIAN V.

Fig. 25. Arnolfo di Cambio: MONUMENT OF CARDINAL DE BRAYE. S. Domenico, Orvieto.

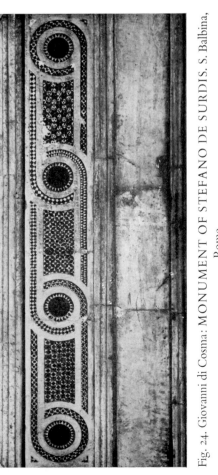

Fig. 24. Giovanni di Cosma: MONUMENT OF STEFANO DE SURDIS. S. Balbina, Rome.

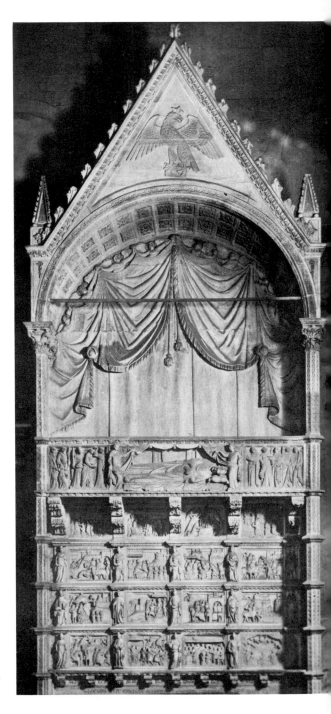

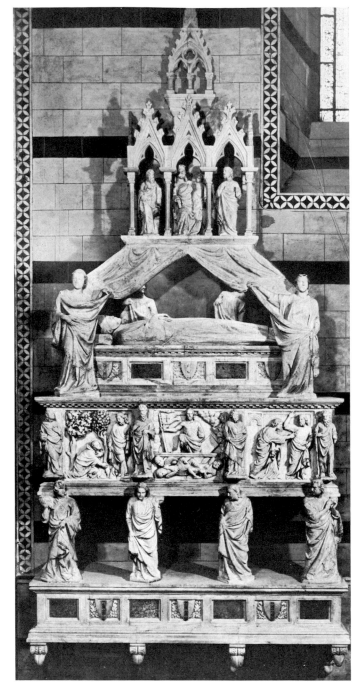

Fig. 27. Agostino di Giovanni and Agnolo di Ventura: TARLATI ▶
MONUMENT. Duomo, Arezzo.

Fig. 29. Ramo di Paganello (?): MONUMENT OF PHILIPPE DE
COURTENAY. S. Francesco, Assisi.

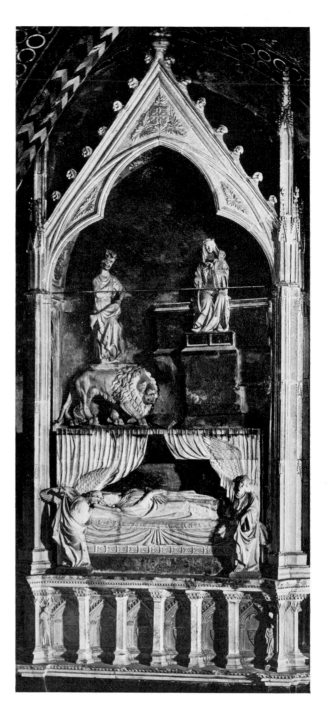

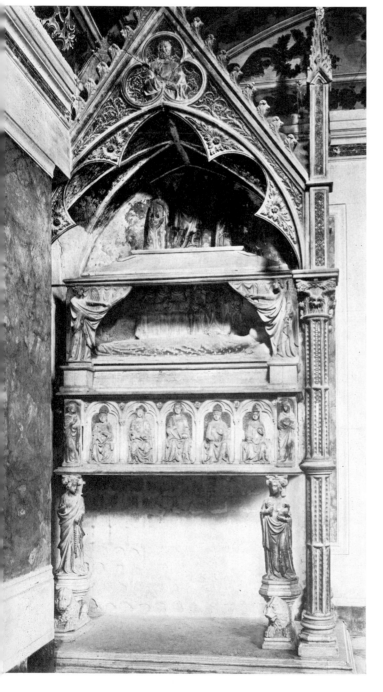

Fig. 28. Tino di Camaino: MONUMENT OF MARY
OF VALOIS. S. Chiara, Naples.

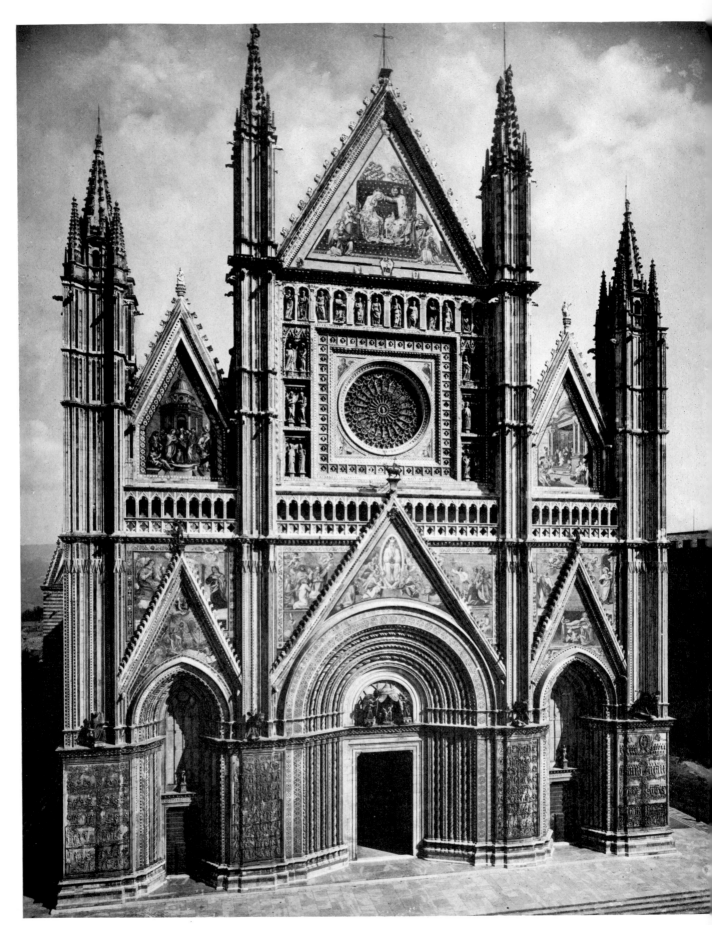

Fig. 30. CATHEDRAL FAÇADE. Orvieto.

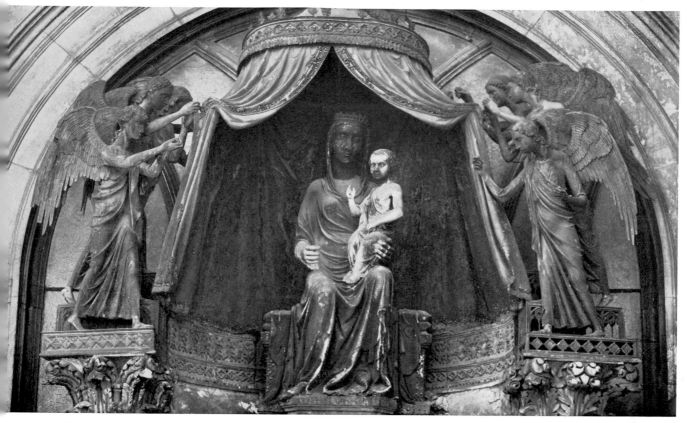

Fig. 31. Style of Maitani: VIRGIN AND CHILD ENTHRONED WITH ANGELS. Duomo, Orvieto.

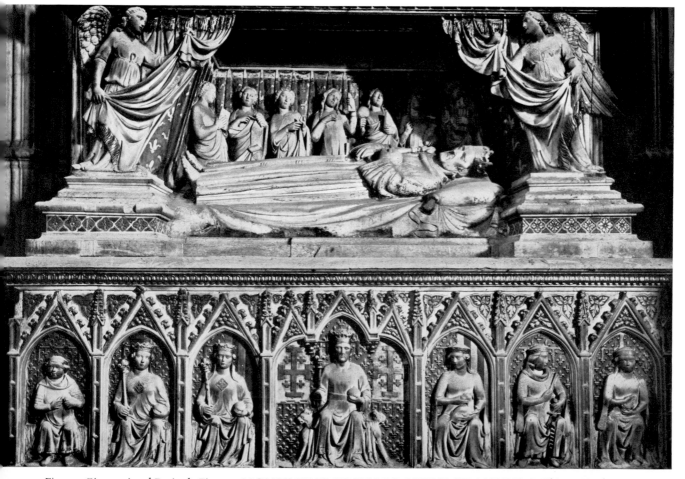

Fig. 32. Giovanni and Pacio da Firenze: MONUMENT OF KING ROBERT OF ANJOU. S. Chiara, Naples.

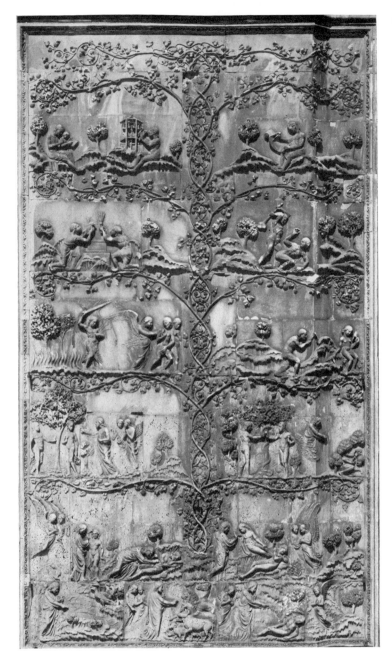

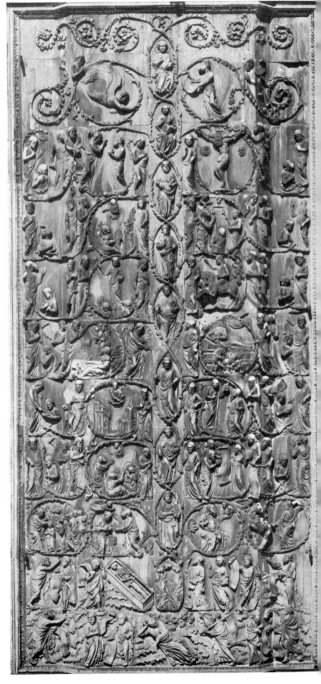

◀ Fig. 33. Lorenzo Maitani: SCENES FROM GENESIS.
Duomo, Orvieto.

Fig. 34. Style of Maitani: THE PROPHECIES OF THE ▶
REDEMPTION. Duomo, Orvieto.

Fig. 36. Lorenzo Maitani: THE LAST JUDGEMENT.
Duomo, Orvieto.

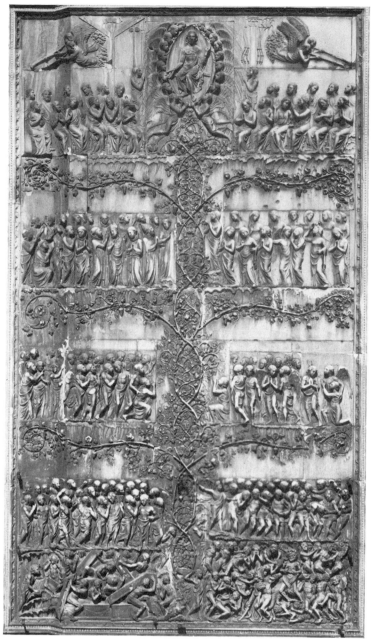

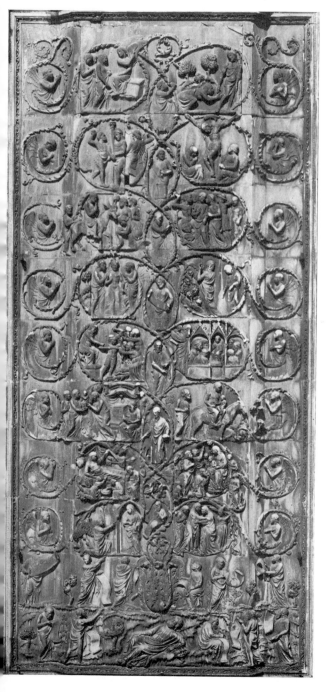

Fig. 35. Style of Maitani: SCENES FROM THE LIFE OF
CHRIST. Duomo, Orvieto.

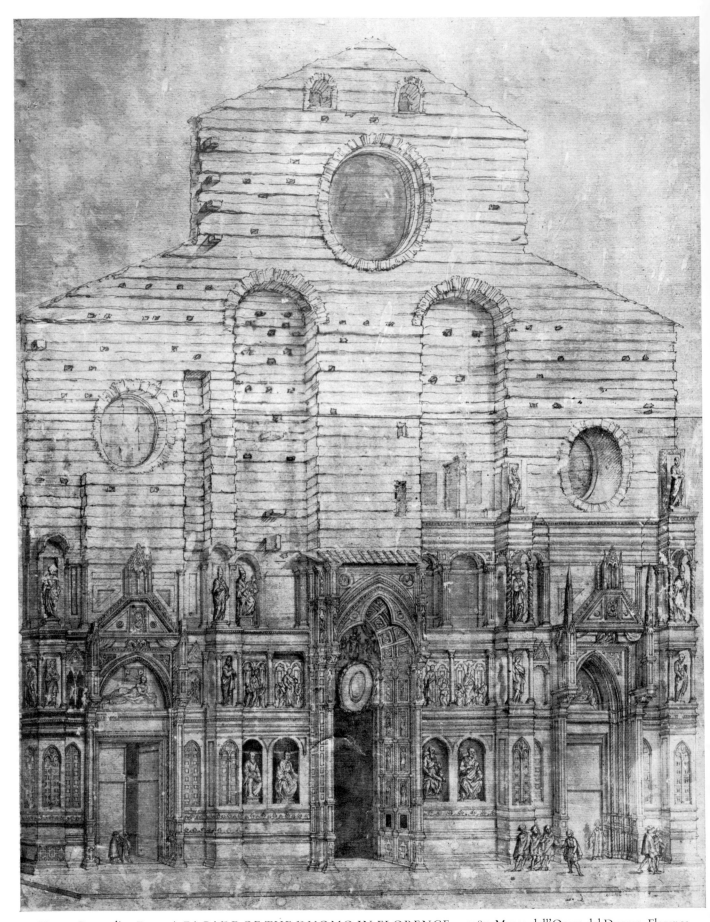

Fig. 37. Bernardino Poccetti: FAÇADE OF THE DUOMO IN FLORENCE. *c.* 1587. Museo dell'Opera del Duomo, Florence.

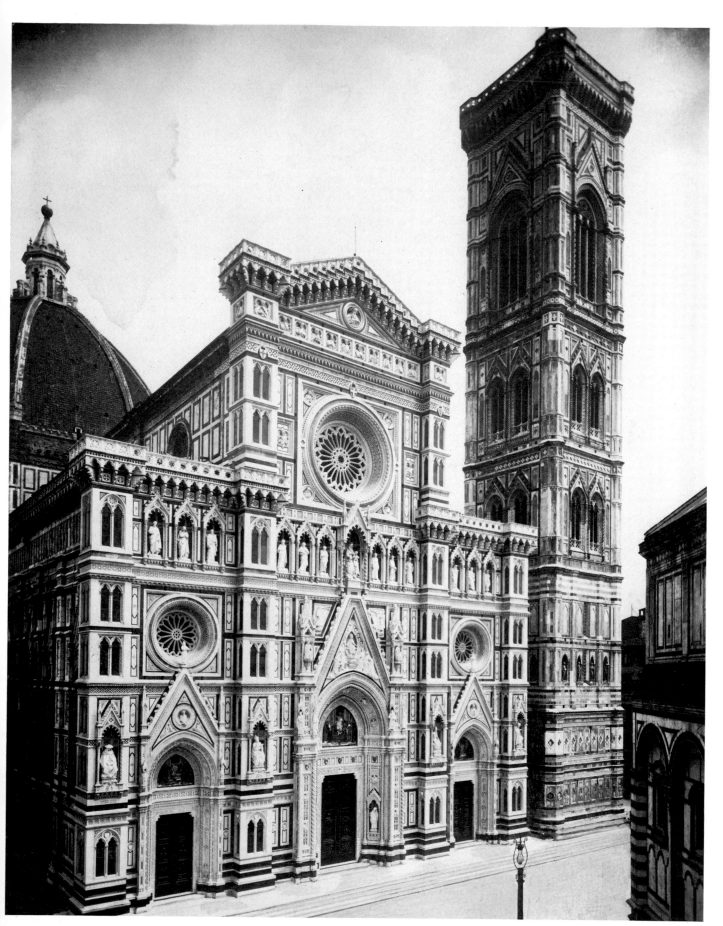

Fig. 38. FAÇADE AND CAMPANILE OF THE DUOMO. Florence.

Fig. 39. Andrea Pisano: BRONZE DOOR.
Baptistry, Florence.

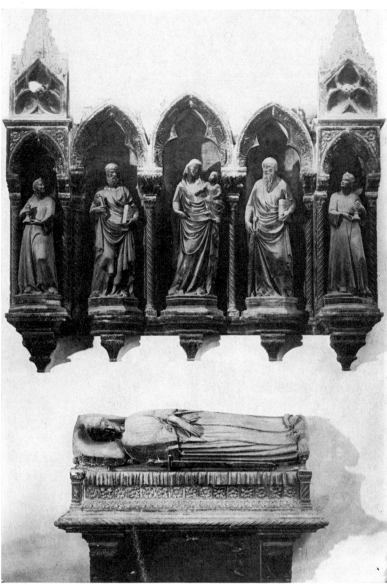

Fig. 41. Nino Pisano: CORNARO MONUMENT. SS. Giovanni e
Paolo, Venice.

Fig. 40. Nino Pisano: MADONNA DEL LATTE. Museo Nazionale di
S. Matteo, Pisa.

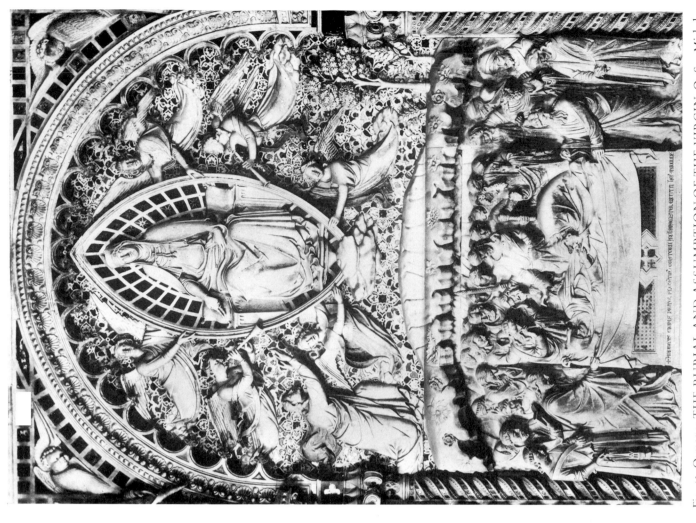

Fig. 43. Orcagna: THE BURIAL AND ASSUMPTION OF THE VIRGIN. Or San Michele, Florence.

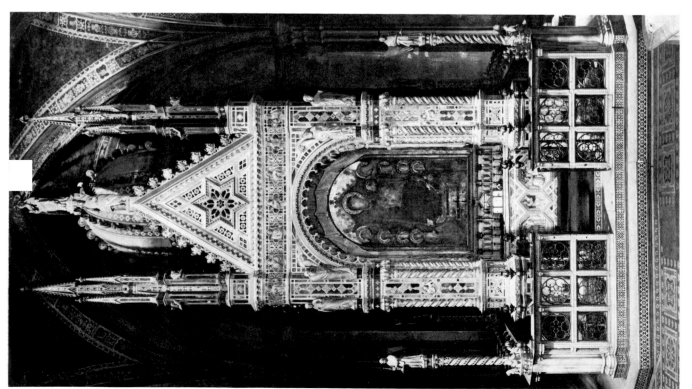

Fig. 42. Orcagna: TABERNACLE. Or San Michele, Florence.

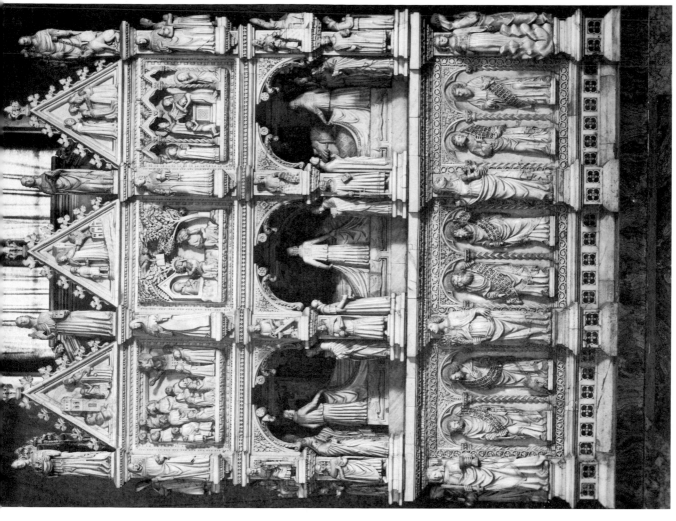

Fig. 45. Giovanni di Balduccio (?): ARCA OF ST. AUGUSTINE.
S. Pietro in Ciel d'Oro, Pavia.

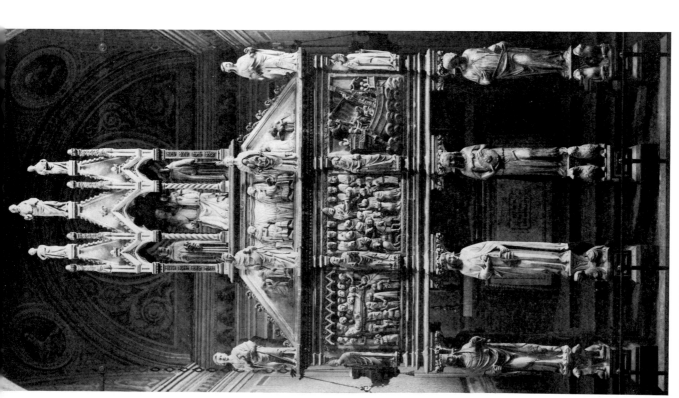

Fig. 44. Giovanni di Balduccio: ARCA OF ST. PETER MARTYR.
S. Eustorgio, Milan.

Fig. 47. MONUMENT OF CARDINAL GUGLIELMO LONGHI.
S. Maria Maggiore, B...

Fig. 46. BAPTISTRY, Bergamo.

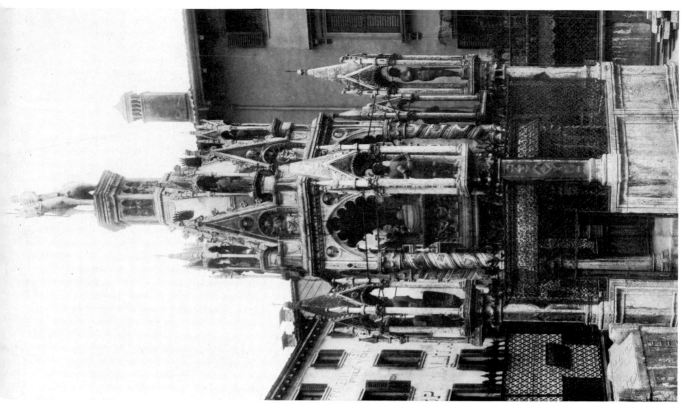

Fig. 49. Bonino da Campione: MONUMENT OF CANSIGNORIO DELLA SCALA. Sagrato di S. Maria Antica, Verona.

Fig. 48. CASTELBARCO MONUMENT. S. Anastasia, Verona.

Fig. 50. *Above, left:* MASTINO II DELLA SCALA.
Sagrato di S. Maria Antica, Verona.

Fig. 51. *Above, right:* CAN GRANDE DELLA SCALA.
Sagrato di S. Maria Antica, Verona.

Fig. 52. *Left:* Bonino da Campione: MONUMENT OF
BERNABÒ VISCONTI. Museo del Castello
Sforzesco, Milan.

Fig. 53. Marco Romano: ST. SIMEON. S. Simeone Grande, Venice.

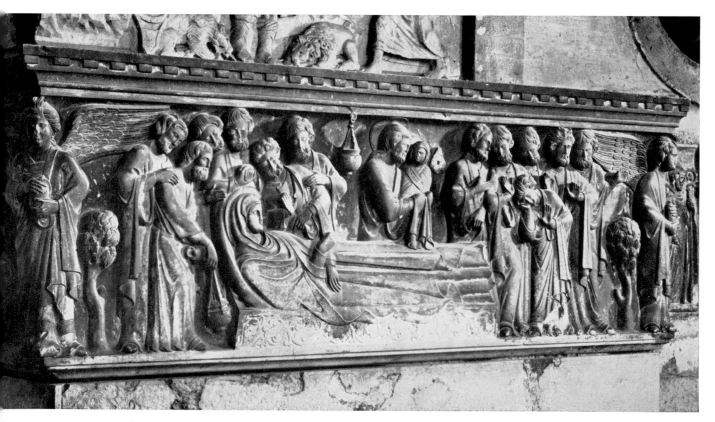

Fig. 54. MONUMENT OF FRANCESCO DANDOLO. S. Maria dei Frari, Venice.

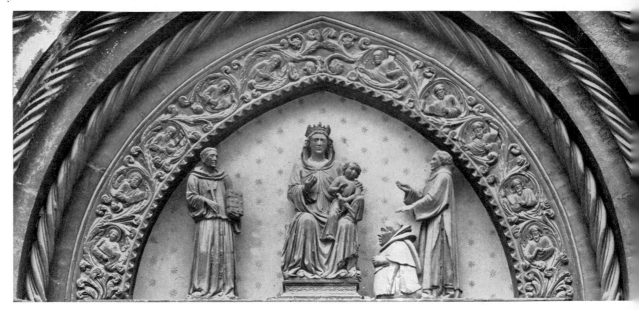

Fig. 55. VIRGIN AND CHILD WITH SS. LAWRENCE AND FRANCIS. S. Lorenzo, Vicenza.

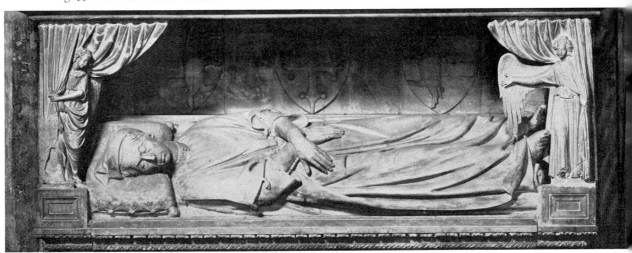

Fig. 56. MONUMENT OF ENRICO SCROVEGNI. Arena Chapel, Padua.

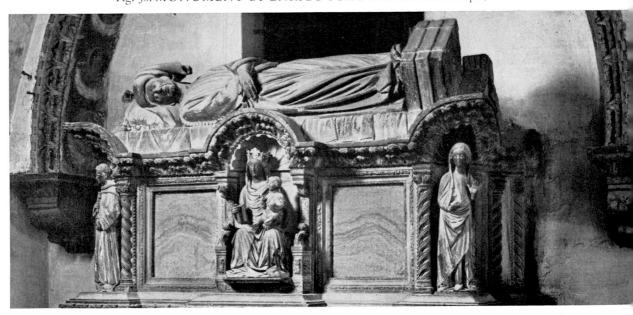

Fig. 57. Andriolo de Sanctis: MONUMENT OF RANIERO DEGLI ARSENDI. Santo, Padua.

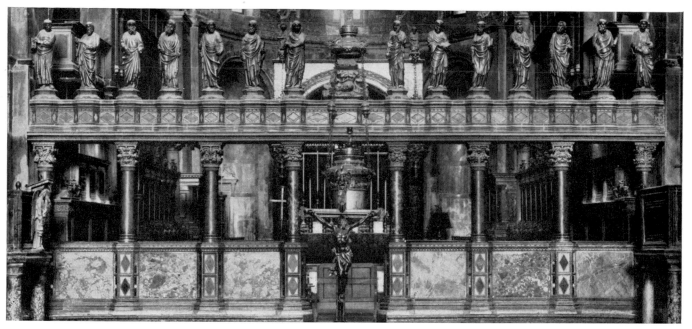

Fig. 58. Jacobello and Pierpaolo dalle Masegne: ICONOSTASIS. St. Mark's, Venice.

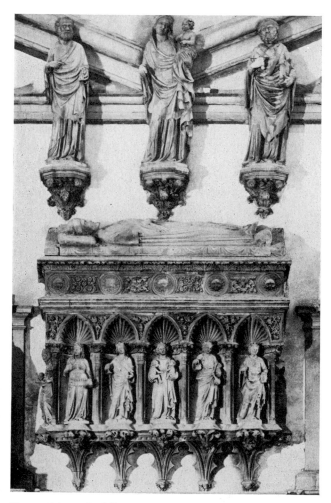

Fig. 59. Pierpaolo dalle Masegne: VENIER MONUMENT.
SS. Giovanni e Paolo, Venice.

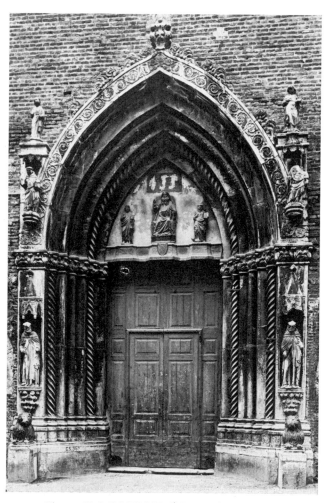

Fig. 60. DOORWAY. S. Domenico, Pesaro.

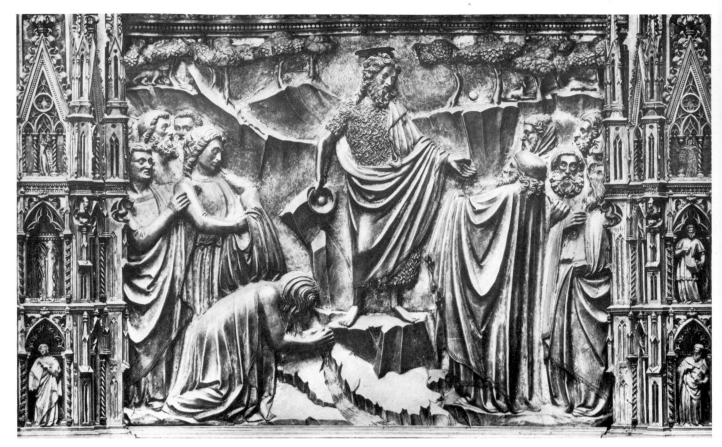

Fig. 61. Leonardo di Giovanni: SCENE FROM THE LIFE OF ST. JOHN THE BAPTIST. Silver Altar, Museo dell'Opera del Duomo, Florence.

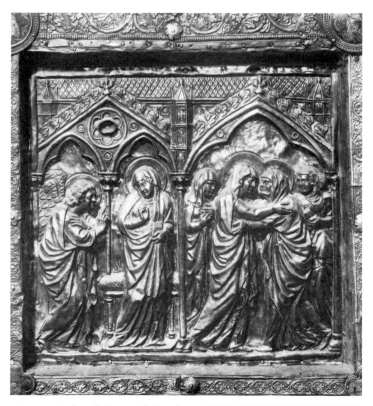

Fig. 62. Andrea di Jacopo d'Ognabene: THE ANNUNCIATION AND VISITATION. Silver Altar, Duomo, Pistoia.

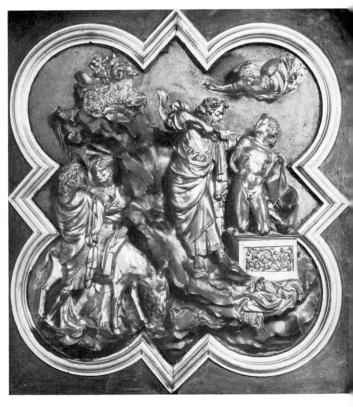

Fig. 63. Ghiberti: THE SACRIFICE OF ISAAC. Museo Nazionale, Florence.

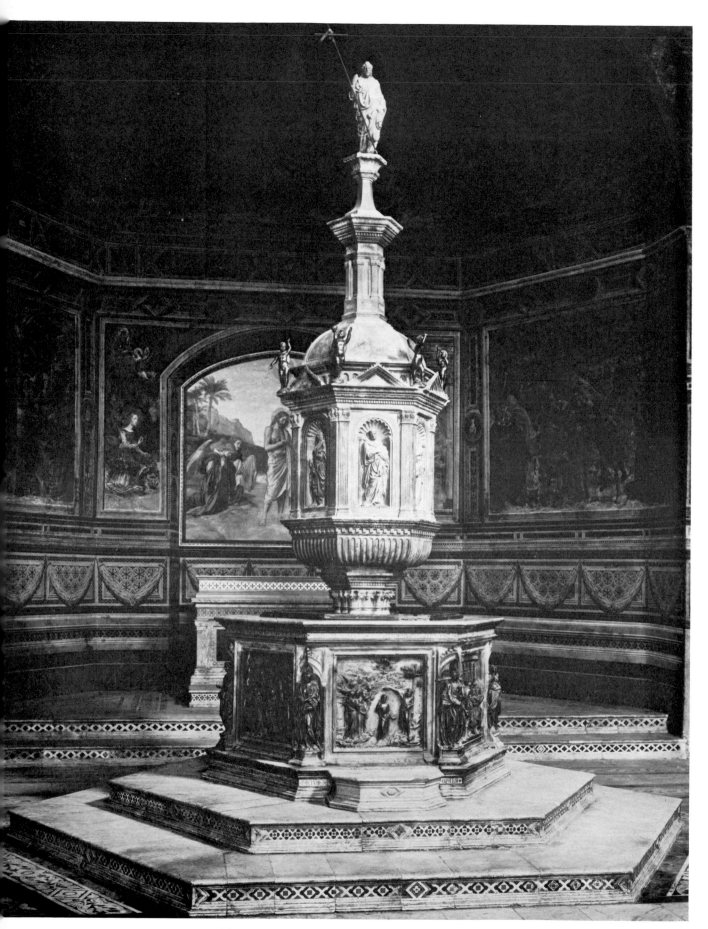

Fig. 64. BAPTISMAL FONT. Baptistry, Siena.

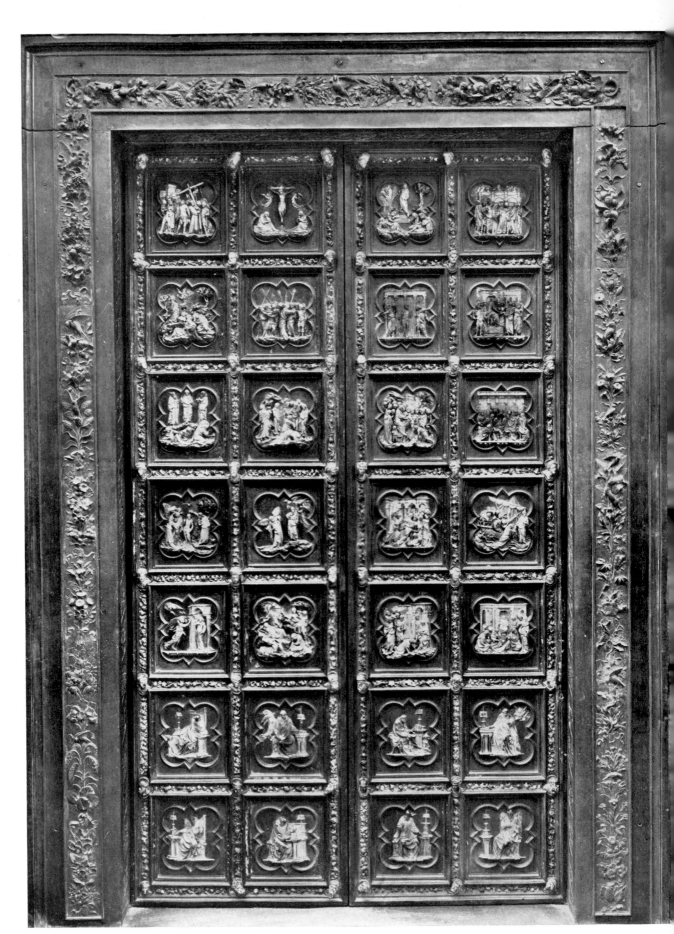

Fig. 65. Ghiberti: FIRST BRONZE DOOR. Baptistry, Florence.

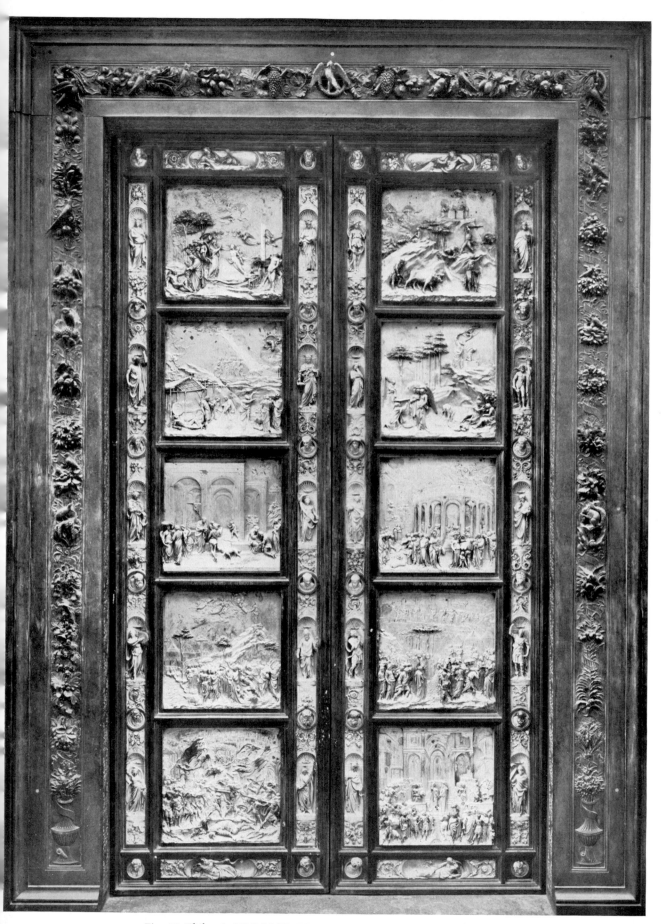

Fig. 66. Ghiberti: SECOND BRONZE DOOR. Baptistry, Florence.

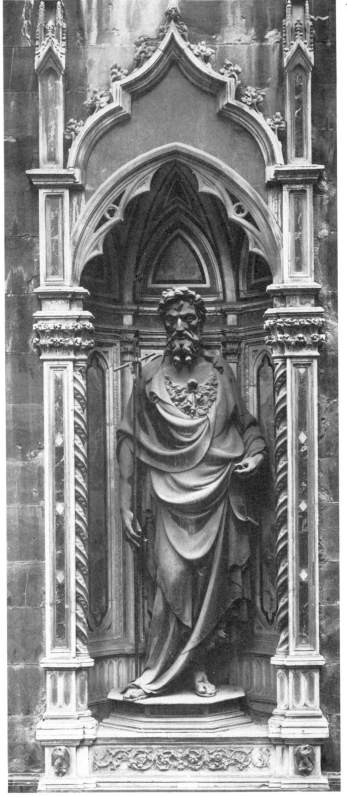

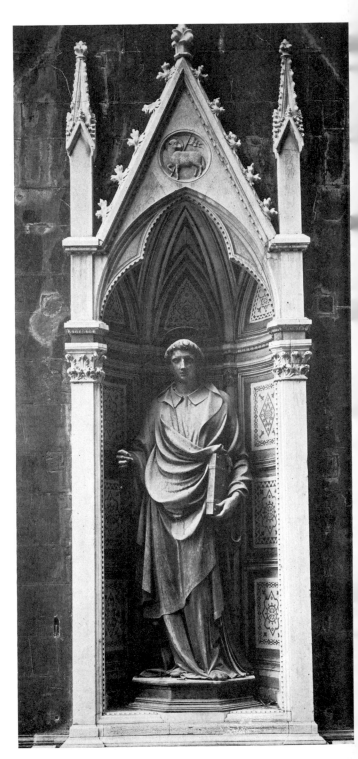

Fig. 67. Ghiberti: ST. JOHN THE BAPTIST. Or San Michele, Florence.

Fig. 68. Ghiberti: ST. STEPHEN. Or San Michele, Florence. ▶

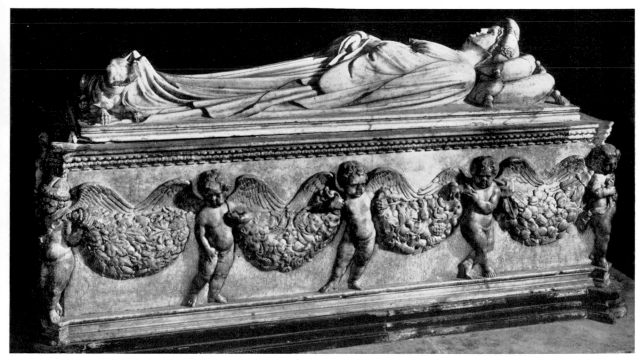

Fig. 69. Jacopo della Quercia: MONUMENT OF ILARIA DEL CARRETTO. Duomo, Lucca.

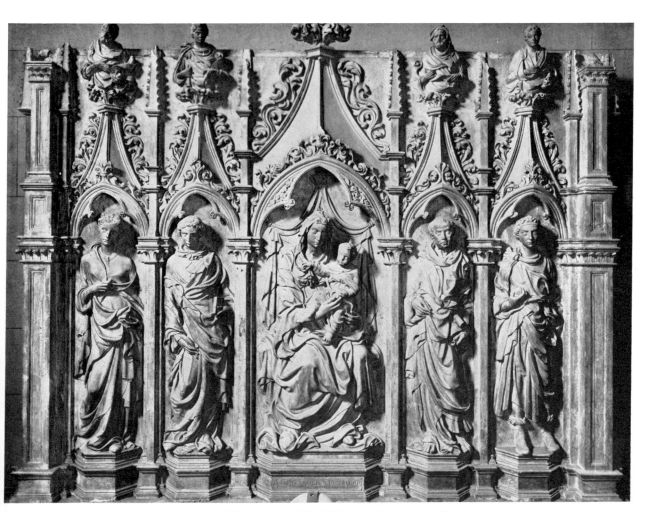

Fig. 70. Jacopo della Quercia: TRENTA ALTAR. S. Frediano, Lucca.

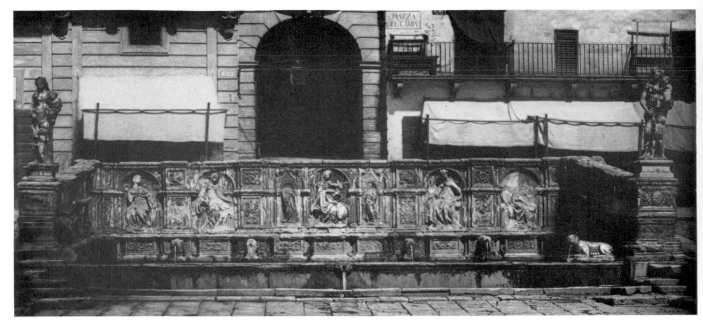

Fig. 71. Jacopo della Quercia: FONTE GAIA. Siena.

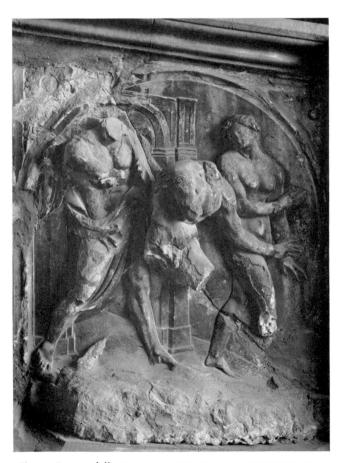

Fig. 72. Jacopo della Quercia: THE EXPULSION FROM
PARADISE. Palazzo Pubblico, Siena.

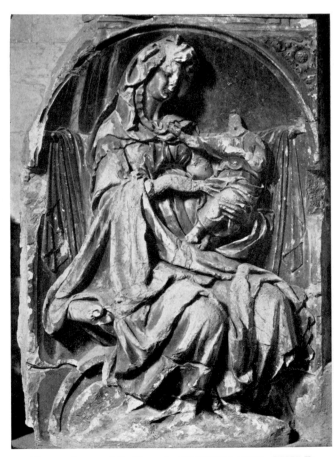

Fig. 73. Jacopo della Quercia: VIRGIN AND CHILD.
Palazzo Pubblico, Siena.

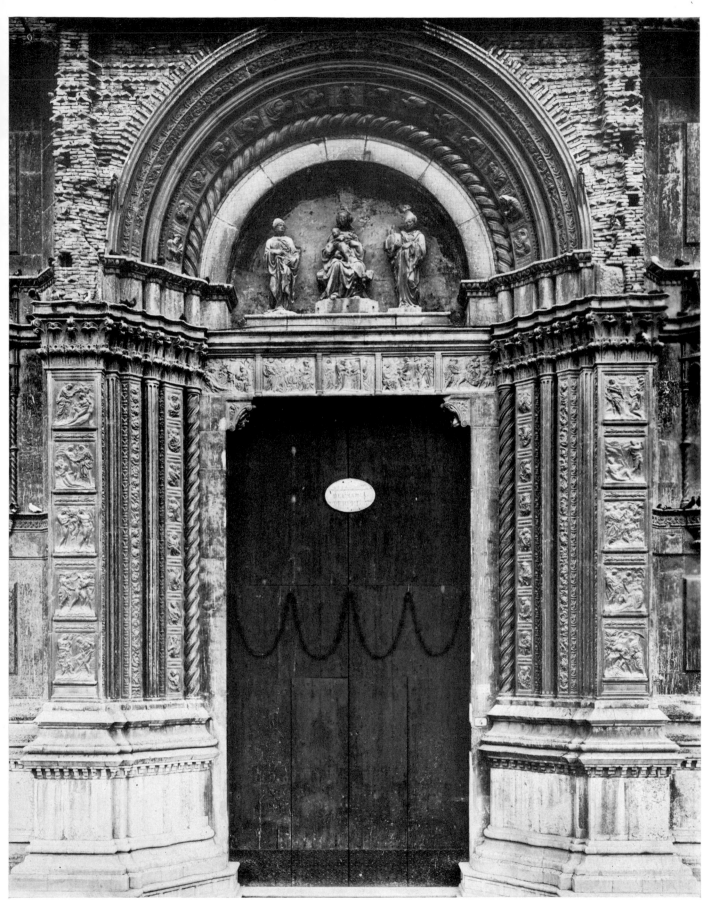

Fig. 74. Jacopo della Quercia: DOORWAY. S. Petronio, Bologna.

Fig. 76. Jacopo della Quercia: THE ANNUNCIATION. Collegiata, San Gimignano.

Fig. 75. Francesco di Valdambrino: THE ANNUNCIATION. Museo d'Arte Sacra, Asciano.

Fig. 78. Michele da Firenze: PELLEGRINI CHAPEL. S. Anastasia, Verona.

Fig. 77. Style of Ghiberti: VIRGIN AND CHILD. Memorial Art Museum, Rochester.

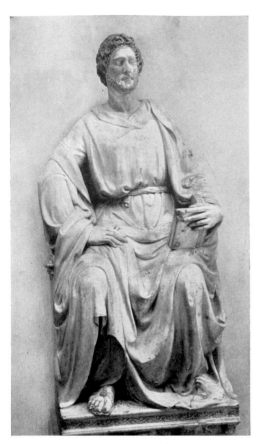

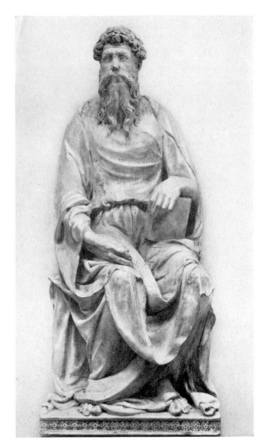

Figs. 79–80. Nanni di Banco: ST. LUKE; Donatello: ST. JOHN THE EVANGELIST.
Museo dell'Opera del Duomo, Florence.

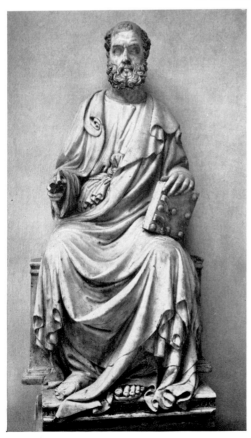

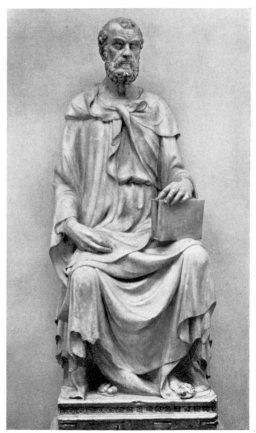

Figs. 81–82. Niccolò di Pietro Lamberti: ST. MARK; Ciuffagni: ST. MATTHEW. Museo
dell'Opera del Duomo, Florence.

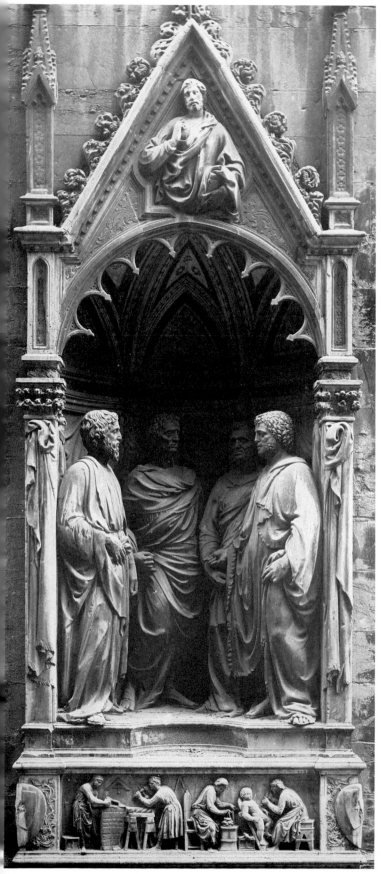

Fig. 84. Nanni di Banco: ST. ELIGIUS. Or San Michele, Florence. ▶

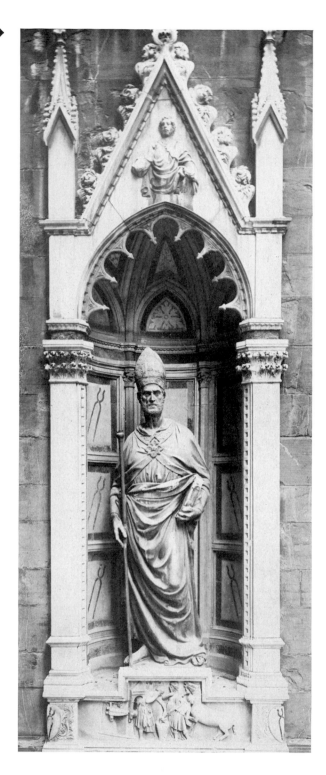

Fig. 83. Nanni di Banco: QUATTRO SANTI CORONATI.
Or San Michele, Florence.

Fig. 86. PORTA DELLA MANDORLA. Duomo, Florence. ▶

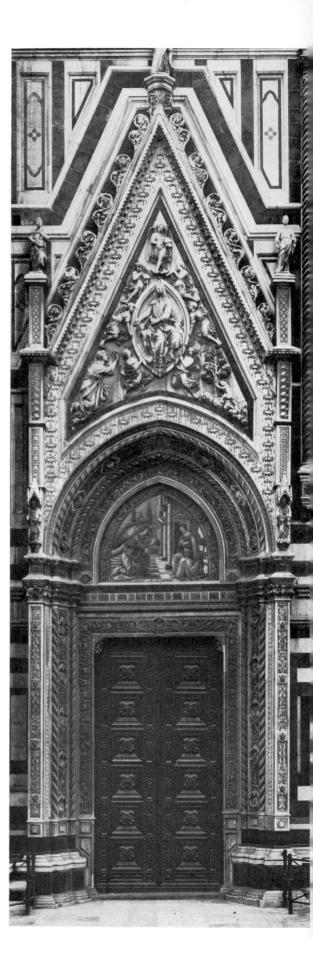

Fig. 85. Nanni di Bartolo: DOORWAY. S. Nicola, Tolentino.

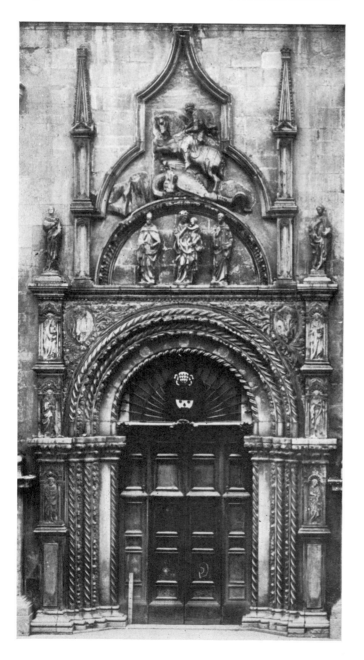

Fig. 87. Giovanni d'Ambrogio (?): DETAIL OF PORTA DELLA MANDORLA. Duomo, Florence

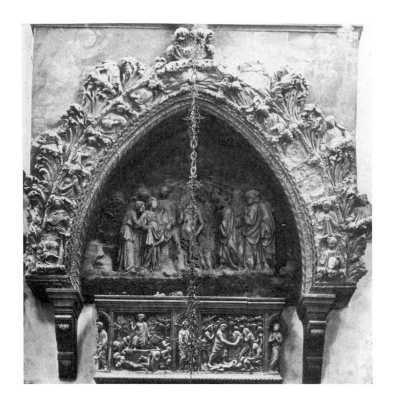

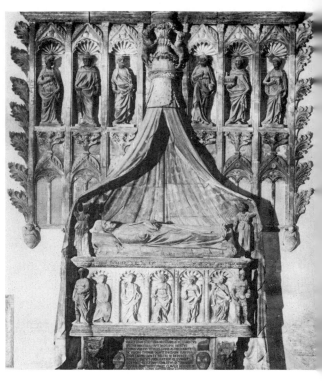

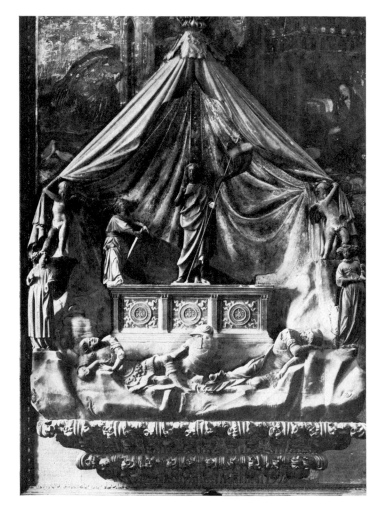

Fig. 88. *Above, left:* MONUMENT OF THE BEATO
PACIFICO. S. Maria dei Frari, Venice.

Fig. 89. *Above, right:* Piero di Niccolò Lamberti and Giovanni
di Martino: MONUMENT OF TOMMASO
MOCENIGO. SS. Giovanni e Paolo, Venice.

Fig. 90. Nanni di Bartolo: BRENZONI MONUMENT.
S. Fermo Maggiore, Verona.

Fig. 91. FAÇADE OF ST. MARK'S. Venice.

Fig. 92. PALAZZO DUCALE. Venice.

Fig. 93. Bartolommeo Buon:
PORTA DELLA CARTA
Palazzo Ducale, Venice.

INDEX OF PLACES

I*

INDEX OF SCULPTORS